LASCAUX

MOVEMENT, SPACE, AND TIME

LASCAUX
MOVEMENT, SPACE, AND TIME
NORBERT AUJOULAT

HARRY N. ABRAMS, INC., PUBLISHERS

The author would like to thank the following people and organizations for allowing him to
publish the documents indicated below: Claude Bassier (ill. 17, based on topographical data
from Claude Bassier); Valérie Feruglio (ill. 42); Philippe Jugie, National Museum of Prehistory,
Les Eyzies-de-Tayac-Sireuil (ill. 43); A. M. Aujoulat, based on A. Glory (ill. 105 and ill. 109).

English-language translation: Martin Street

Library of Congress Cataloging-in-Publication Data
Aujoulat, Norbert.
[Lascaux. English]
Lascaux: movement, space, and time / by Norbert Aujoulat.
p. cm.
Translation of: Lascaux : le geste, l'espace et le temps.
Includes bibliographical references and index.
ISBN 0-8109-5900-3 (hardcover : alk. paper)
1. Cave paintings—France—Montignac. 2. Art, Prehistoric—France—Montignac.
3. Lascaux Cave (France) I. Title.
N5310.A913 2005
759.9364--dc22
 2004029971

First published by Éditions du Seuil, Paris under the title: *Lascaux, le geste, l'espace et le temps*
Text and composition © Éditions du Seuil, Paris, 2005
Illustrations © Norbert Aujoulat, CNP, Ministére de la Culture, 2004
English-language translation copyright © 2005 Thames & Hudson, Ltd., London

Printed and bound in France
10 9 8 7 6 5 4 3 2 1

Harry N. Abrams, Inc.
100 Fifth Avenue
New York, N.Y. 10011
www.abramsbooks.com

Abrams is a subsidiary of
LA MARTINIÈRE

Contents

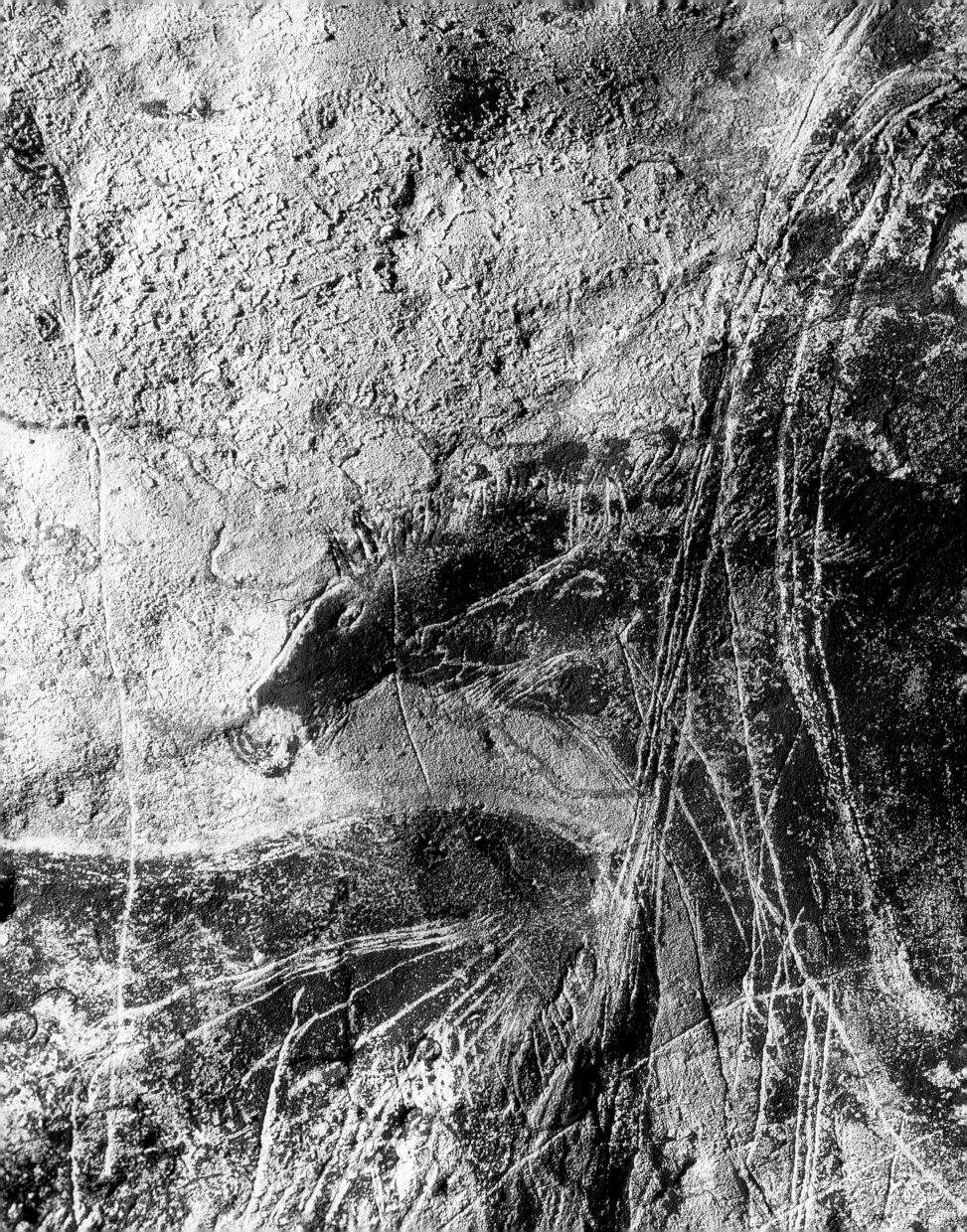

Preface

1 Small engraved and painted horses, partially obscured by the Great Black Cow, Nave.

I first visited the Lascaux Cave on a winter's day in 1970. It was late afternoon, and the massive bronze door that formed the entrance to the cave obscured the diffuse light as it closed behind me. The visit to this prestigious site would take place in semi-darkness, relieved only by a few infrequent hidden lamps emitting a discreet, scattered light. There were five of us on the tour, guided by Jacques Marsal, one of the four men who had discovered the cave back in 1940.

We squeezed through the narrow entrance hall, which had arched, stone-lined walls, and proceeded through a second door to a similarly constructed hall known as the 'pediluvium', or footbath. There, before we entered the cave, we had to rinse the soles of our shoes several times, a ritual designed to eliminate any bacteria, pollen or spores and thus prevent the introduction or proliferation of harmful foreign bodies inside the cave.

As we continued, the formalin fumes of the airlock were replaced by smells that were more characteristic of the subterranean environment – those produced by the rock, the clay in the soil and the constant high level of humidity. The ground sloped, marking the beginning of the underground system, and the impression of the natural shaft that had provided access to the deeper part of the cave at the time of its discovery was visible in the roof.

Heavy precipitation over the past few days had led to the formation of a small natural drain in the highly fractured upper layer of the ceiling. The noise of the water pounding on to a tin sheet-metal cover, which acted as a channel, faded and then disappeared as we shut another door behind us. Passing through each of the different compartments on this fragmented route, there was a perceptible rise in temperature, which finally stabilized at around 12°C.

The gallery widened appreciably as we approached the final door from above. Only twenty-odd steps now separated us from the cave's natural floor and the entrance to the decorated chambers. We remained in total darkness for a few minutes in order to let our eyes grow accustomed to the feeble lighting of the halls and to enable us to discern the colours and contours of the images on the walls more effectively. Only the discreet vibration of the pumps below – used to keep out the water – disturbed the moment somewhat. We opened the second bronze door, decorated with polished stones bearing floral motifs, and entered into the Hall of the Bulls. Silence replaced the sound of falling water, the slamming of doors and the shuffling of feet. The following half an hour was to have a profound effect on the course of my career.

In May 1980, the Superintendence for Archaeology of the Ministry of Culture decided to set up a unit – the Department of Parietal Art – for the research and documentation of prehistoric cave and rock-shelter art at the National Centre of Prehistory. The Department of Parietal Art, which I have headed up since the very start, effectively extended my area of responsibility to include all decorated Palaeolithic sites in France.

I resumed my study of Lascaux in 1988, following in the footsteps of a succession of illustrious predecessors. Strict conservation regulations restricted the amount of time I was able to spend collecting data *in situ*. Being forced to regulate my visits into a number of relatively brief episodes prolonged my research considerably, but it also had its advantages. It enabled me to adjust the methodology applied to the study and the various interpretations of the results, and I was able to develop methods of recording and analysis that were more specifically adapted to this environment.

Above all, this was a field study. Its principal goal was to identify the natural factors that may have contributed to the formation of the cave and to evaluate the ways in which the paintings on the cave walls were structured. The spatial organization of figures in the paintings and their chronological order were thus assessed in detail. I also needed to explore space and time in order to identify and understand the behaviour and motivations of Palaeolithic man.

I approached the analysis of these works of parietal art with the eyes of a natural scientist, basing my findings on research disciplines such as karstology[1] and ethology.[2] Extending the field of study beyond the site of Lascaux itself to the entire drainage basin of the lower Vézère enabled me to place the cave in its geological and archaeological context.

The Geological Context

CHAPTER 1
The Geological Context

The Black Perigord, the north-easternmost region of the Aquitaine Basin, backs on to the crystalline platform of the Massif Central. The area of this study, the lower valley of the Vézère and its tributary valleys, covers two thirds of the region. Archaeological and geological considerations (ill. 4) dictated its boundaries.

The area, which is essentially limestone, extends from Condat-Le-Lardin in the east to Limeuil in the west, where the Vézère River joins the Dordogne River. The Lascaux Cave lies to the north-east, a fair distance from the concentration of decorated caves found around Les Eyzies-de-Tayac in the south-west – a region that effectively boasts the greatest density of prehistoric remains in Western Europe. There are no fewer than thirty-seven decorated caves and rock shelters[3] around Les Eyzies-de-Tayac, and an even greater number of Palaeolithic habitation sites, both under rock shelters and in the open, including Le Moustier, La Madeleine, Tayac and La Micoque.

A succession of parallel strata follow the course of the Vézère from the north-east to the south-west, extending from the primary crystalline bedrock to rocks that were formed during the Jurassic and Cretaceous periods. The Cretaceous period includes the Coniacian, Santonian and Campanian stages (ill. 5). Two geological faults have had a major effect on the area: the La Cassagne fault to the east and the Campagne Saint-Cyprien fault to the west. Both have an Armorican alignment (they run noticeably from the south-east to the north-west). The Sarlat syncline – a fold of stratified rock

Preceding pages
Left:
2 Steep-sided landscape of Coniacian type close to Les Eyzies-de-Tayac-Sireuil.
Right:
3 Gently sloping topography of Santonian type, Grande Beune.

Right:
4 Location of the cave of Lascaux and the studied karst region.

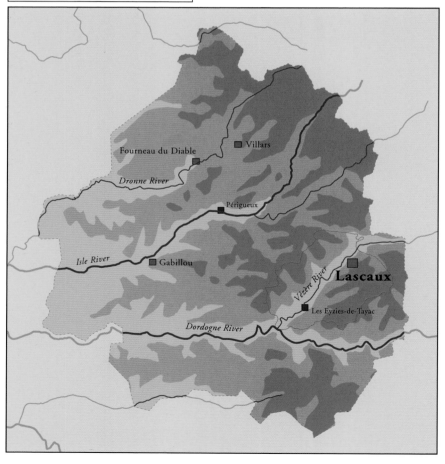

Fourneau du Diable Villars

Dronne River

Périgueux

Isle River Gabillou

Vézère River **Lascaux**

Les Eyzies-de-Tayac

Dordogne River

in which the strata slope up from the axis – was formed between these two features of tectonic origin and was itself interrupted by several secondary folds or anticlines. The latter correspond with valleys such as the Manaurie and the Petite Beune, dictating their relative positions and causing a dip in the course of the rivers flowing through the valleys.

Around Montignac, marly limestones at the base of the Santonian and a greater heterogeneity of the Coniacian layers contributed in widening the valley. Along the western edge of the drainage basin, the exposed Campanian layer also softened the landscape. Between these two poles the scenery is more spectacular. Steep-sided and narrow meanders coincide with the more resistant outcrops of the Middle and Upper Coniacian. As a result, rock faces with an average height of around 40 metres (ill. 2) were formed. These cliffs[4] developed characteristically, both along the central course of the Vézère River and in the valleys of its tributaries, particularly those of the Beune rivers. The gentler landforms of the Santonian and the Campanian, which are more varied and give the landscape a more subdued appearance (ill. 3), have developed above these formations.

The cliffs demonstrate a certain uniformity. In general, they are split into two units of roughly equal thickness, separated by a deep, almost horizontal linear niche

5 Geological map of the lower Vézère drainage basin.

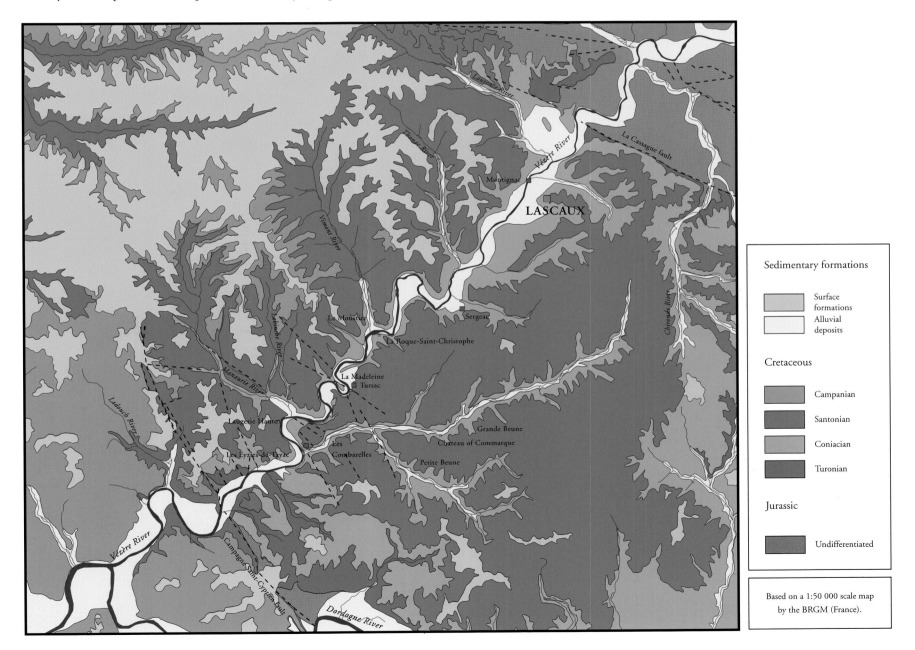

Sedimentary formations

- Surface formations
- Alluvial deposits

Cretaceous

- Campanian
- Santonian
- Coniacian
- Turonian

Jurassic

- Undifferentiated

Based on a 1:50 000 scale map by the BRGM (France).

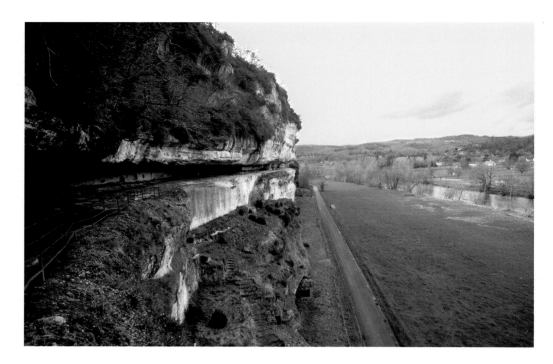

marking the boundary between the Middle and Upper sub-stages of the Coniacian. This geological discontinuity stretches from La Roque-Saint-Christophe,[5] the great terrace dominating the Vézère (ill. 6), to Pech-Saint-Sour, downstream from Les Eyzies-de-Tayac, on the right bank. The niche is a deep cavity, with an even floor and a convex ceiling, which sometimes reaches over 10 metres in height.

This hollow played a major role in the settlement of communities, not only during the Middle and Upper Palaeolithic but also more recently, right up to the sixteenth century. The role of the overhanging formation was fundamental for the Palaeolithic population of the Black Perigord. It shelters the majority of the important sites of the region, such as Le Moustier, La Madeleine, Laugerie-Haute, Laugerie-Basse, Pataud and the terrace of the National Museum of Prehistory at Les Eyzies-de-Tayac. Only a few remnants of the Palaeolithic floor have survived the effects of subsequent activities on the latter terrace, but we can assume that there was an important human presence here during different periods because it is located at the confluence with the Grande Beune and faces south-west.

Along the Vézère, the altitude of this long niche differs by some 20 metres. It follows the warp of the strata that form the Sarlat syncline, which were shaped by tectonic movement. The height of the niche ranges from 35 metres above the valley floor at La Roque-Saint-Christophe to 15 metres near Tursac, a third of the way along its course, before rising once again to 35 metres on the terrace of the National Museum of Prehistory.

In the valleys of the tributaries, particularly those of the Beune rivers, the rock-face formations follow a slightly different pattern. Their profiles consist of a series of steps, which make access to the different terraces much easier.

During the course of the past millennia, several geological phenomena have altered the landscape by increasing the erosion of slopes and the movement of sediments. This has affected both the discovery and the preservation of prehistoric sites, settlements or sanctuaries. A number of rock shelters and cave entrances have no doubt disappeared, having been filled in and concealed.

These processes are an important factor in the study of the region's archaeology. Along the Grande Beune, a survey of the valley floor revealed 14 metres of sedimentary deposits close to its confluence with the Petite Beune. Sampling showed the presence of limestone gravels and peat,

Above, right:
6 The great terrace of La Roque-Saint-Christophe, Peyzac-le-Moustier. This long horizontal incision marks the boundary between the middle and upper layers of the Coniacian.

Above, left:
7 Stretch of the Grande Beune close to the chateau of Commarque, Les Eyzies-de-Tayac-Sireuil. This flat-bottomed valley was filled by peat, breccia and travertine deposits, formed during the Holocene period.

an accumulation of deposits generated by the formation of downstream travertine obstructions composed of a mixture of calcite and vegetation. The formation of these deposits seems to have occurred at the beginning of the Holocene period, well after the Ice Age and the passage of man at Lascaux. Observations made close to the chateau of Commarque (ill. 7) show that aggradation (the deposition of material by a river, stream or current) was equally prevalent along the Grande Beune during the same period. Traces of medieval activity on the rock walls, particularly alignments of scaffolding holes, are well below the present level of the Beune. This suggests that the surface of the land at the beginning of the second millennium was some 3 to 5 metres lower than it is today.

As a result of the altered profile of the tributary valleys, the long sub-horizontal niche marking the transition from Middle to Upper Coniacian has been almost entirely covered up (ill. 8). In fact, it is only visible downstream along the first 2 kilometres of the valley of the Beune rivers. Above Les Combarelles it is buried by Holocene peat and breccias; the northern Grand Abri, one of the springs fed by this decorated cave, marks the last point at which it can be identified. The change in this tributary's profile also means that the majority of traces of Palaeolithic occupation are hidden today, undoubtedly buried below several metres of sediment.

This could explain the relatively low number of inhabited rock shelters discovered in these sections of the tributary valleys: the filling-in process only applies to them, while the Vézère itself remains unaffected by these geological events. The particular distribution of habitation sites in the Black Perigord, with a significant number of prehistoric sites in the Vézère Valley but comparatively low numbers in the valleys of its tributaries, especially the Beune, is thus largely dictated by phenomena operating on a geological scale over the course of the past millennia.

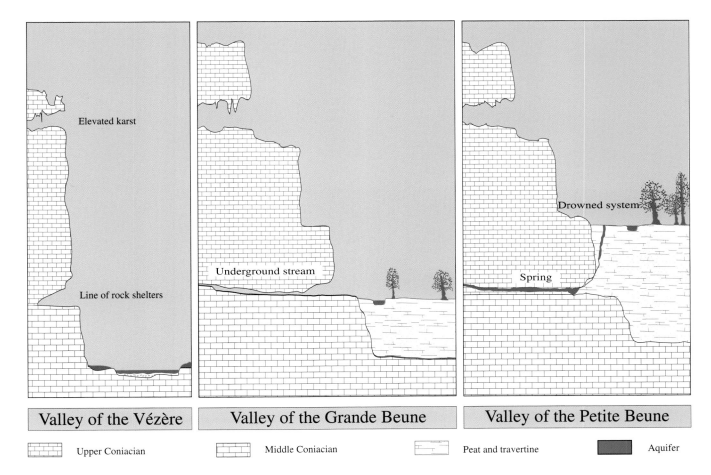

Valley of the Vézère

Valley of the Grande Beune

Valley of the Petite Beune

Elevated karst

Line of rock shelters

Underground stream

Drowned system

Spring

Upper Coniacian Middle Coniacian Peat and travertine Aquifer

8 Schematic representation of the different levels of sedimentation in the valley floors of the Vézère, the Grande Beune and the Petite Beune rivers.

The Underground Environment

A Truly Vast Realm

Tiered Caves

Distribution of Caves and Rock Shelters

The Underground Environment

The caves of the Black Perigord have been little studied until now. Yet, the lower Vézère Valley possesses an extensive underground environment, at the heart of which lies a particularly rich and diverse testimony to human activities.

A Truly Vast Realm

The map opposite (ill. 9), showing the distribution of natural caves in the Vézère Valley, enables us to evaluate the density of sites occupied by man in comparison with the natural potential of the region, and the relative locations of these caves to Lascaux. It also sheds new light on why humans occupied certain caves and rock shelters.

The irregular spread of caves, much denser in some areas, notably in the south-west, hits you immediately when you look at this map. A very high concentration of caves occupies a small area of the Vézère Valley: it extends from the confluence of the Manaurie to the cliff at Guilhem and in an easterly direction towards the Grande Beune, and it includes the entire valley of the Petite Beune.

This limited region – which forms only 15 per cent of the territory in question – contains 153 recorded caves, almost half of the area's total. Of these, eighteen are decorated, making up 72 per cent of the total number of engraved or painted caves found in the Vézère drainage basin and 12 per cent of the overall number of French decorated caves. Beyond this concentration of natural caves, the sites are a lot more scattered.

Another striking observation is the lack of sites above an altitude of 200 metres. Indeed, the majority of caves are found between 100 and 200 metres, with a maximum at around 150 metres. This can be explained in part by the presence of significant deposits of surface sediments.

In most cases, the development of the entrance zones to the caves has been horizontal, which makes access more straightforward. There are only fifteen sites at the very most at which access is obtained by means of a shaft or sinkhole.

Only some twenty of the caves are active (that is, they are traversed partially or entirely by a subterranean stream), the majority of which are located in the north of the region. Caves with sporadic or temporary watercourses are rare. Lascaux has belonged to this group since the end of the Palaeolithic period. During the course of the past millennia, the collapse of the roof at the cave entrance has modified the direction of the

Opposite:
9 Distribution map of karst cavities in the lower Vézère drainage basin.

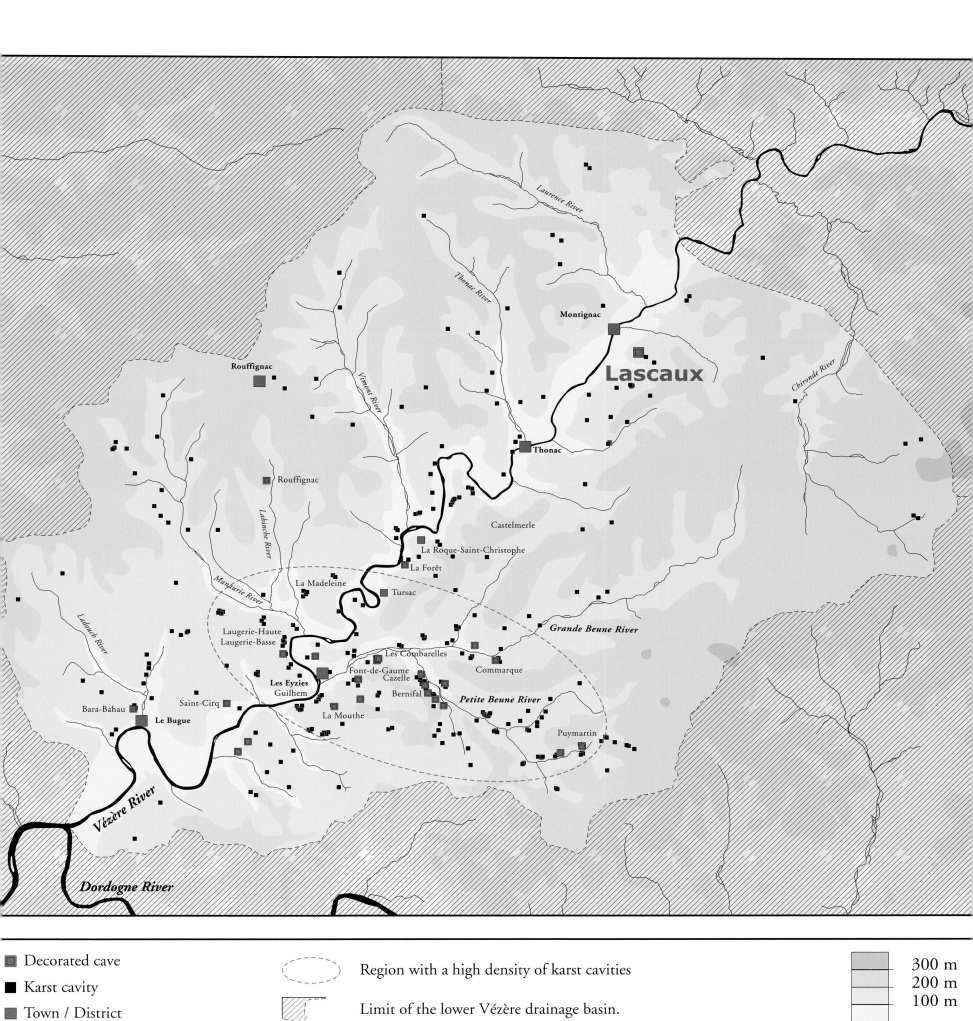

Laurence River

Thonac River

Montignac

Rouffignac

Lascaux

Chironde River

Vimont River

Thonac

Labinche River

Roussignac

Castelmerle

Manfaurie River

La Roque-Saint-Christophe

La Forêt

La Madeleine

Tursac

Grande Beune River

Ladouch River

Laugerie-Haute
Laugerie-Basse

Les Combarelles

Commarque

Font-de-Gaume
Cazelle

Bernifal

Petite Beune River

Bara-Bahau

Les Eyzies
Guilhem

Saint-Cirq

La Mouthe

Puymartin

Le Bugue

Vézère River

Dordogne River

▨ Decorated cave	
■ Karst cavity	
▨ Town / District	

⬭ Region with a high density of karst cavities

▨ Limit of the lower Vézère drainage basin.

300 m
200 m
100 m

flow of water issuing from the interstices of the rock strata in the ceiling. Before certain areas of the cave were altered in the mid-twentieth century in order to facilitate access, this water was able to percolate at the front of the cave and plunge on to the large cone of scree sealing the entrance. The cave then functioned like a drain, with the water moving from the entrance zone towards the deeper regions, in particular the Nave, having once traversed the Hall of the Bulls and the Passageway. Large gours (calcited areas where natural dams occur), created by precipitation of the calcite carried by the stream water, are present along this entire underground course and bear testament to this phenomenon.

Tiered Caves

The formation of caves is subject to many factors, some of which influence the shape of the passages. Numerous examples show that the cross section of galleries and the way in which they develop are often unique to the geological level within which they were cut. In this area of France, the Lower Santonian and the Upper Coniacian are the two principal strata, and Lascaux is in the latter. They are about 40 metres thick. Almost 80 per cent of the group of caves studied are found within these two strata. This high proportion is linked to the optimal conditions for karstification (dissolution) within the strata and the location of so many of the entrances along the front of the cliffs, which not only facilitates their discovery but also limits their concealment behind slope deposits.

At the heart of the Coniacian level, there are two karst horizons, the Font-de-Gaume and Combarelles horizons, which are recognizable by their distinctive physical characteristics. Located at the summit, the Font-de-Gaume horizon contains almost 70 per cent of the decorated and undecorated caves in the Upper Coniacian stratum of the region. Despite the extremely high number of caves, their structural features are not particularly diverse. The most widely distributed form is closely linked to the topography of the external hydrographical system and belongs to the group of so-called 'cutaneous', or superficial, passages. The particular situation of the localities gives their galleries an orientation that is to all intents identical to that of the valleys into which the caves open. Lateral corridors follow a similar logic in that their development copies that of the tributary valleys exactly. As a result, secondary lateral entrances are created. The cave of Pilier, near Beyssac, matches this description to an extreme degree with no fewer than twelve entrances, distributed irregularly in relation to the main axis and orientated on to both the valley of the Petite Beune and the minor valley of Pechmémie.

One of the peculiarities of this topography is that it promotes the exchange of air between the interior of caves and the outside. In summer, this air, which is warmer and charged with humidity, causes condensation to form on the cooler walls of the cave, a phase that is followed by drying. The presence of carbon dioxide, at elevated levels in this context (in the order of 0.2 to 4 per cent, or indeed more), forms carbonic acid, which becomes increasingly concentrated during the period of evaporation until the next cycle. These phenomena degrade the limestone walls through dissolution and can sometimes even cause an accentuated deterioration of painted or engraved prehistoric images. Signs of intense corrosion of the lithic support are observed all the time, and it often affects more than 80 per cent of the surface of the walls. The production of gas is caused by several factors, the most significant of which relates to plant cover. The permanent fluctuations recorded are the result of variations in external atmospheric pressure.

The course of the galleries is most often horizontal and takes the form of a hollow

along the line of a fissure or diaclase, developed in a straight line. The resultant shape often has a greater height than width. The elevation may attain a height of several metres above floor level, between 12 and 15 metres at Font-de-Gaume. The section, relatively broad at the base, becomes progressively narrower towards the top, although it often depends on the nature of the rock. Thus, when the stratification is very heterogeneous, the sections of the gallery are different, resembling a 'keyhole' in terms of shape. This morphology is found at Lascaux.

These natural conditions allow for relatively easy movement in the cave, and major difficulties are encountered rarely. It is unusual to find narrow passages anywhere other than in the deepest branches of the cave system. The floor is sometimes covered with carbonate deposits, in the form of stalagmite floors, but more often by a fill of sandy clay.

Fewer sites belong to the Combarelles horizon, which has a more modest shape than the Font-de-Gaume. Its architecture is more uniform and linear, without side branches. The single passage often keeps to the same section, from the first few metres to the innermost depths of the cave. On the other hand, the scale of development may change significantly from one site to another, from a few dozen metres (at La Forêt or Cazelle, for example) to several hundred metres (600 metres at Les Combarelles). Of the twelve caves with such a contour, four are decorated: Les Combarelles, Cazelle, La Forêt and La Croze-à-Gontrand.

There are numerous springs at such sites owing to the proximity of a more indurated horizon at the base of this geological sequence. In the majority of cases, their outflow is permanent and quite significant. Furthermore, there is a close connection between the entry zone into these systems and the deep sub-horizontal niche, visible on both sides of the Vézère.

Distribution of Caves and Rock Shelters

In this region, most of the decorated and undecorated caves, including Lascaux, are found in the base of the Lower Santonian and the Upper Coniacian. For the most part they open on to a cliff, a position that allows a more explicit perusal of the landscape during prospecting and an immediate identification of the entrances to cave systems. To a certain extent, this explains why there are so many of them. However, this is not the case at Lascaux, where the entrance is on a smooth slope. Nevertheless, a survey using microgravimetry[6] of the subsoil topography, which is today buried below slope deposits, reveals the existence of a small ledge at the present entrance to the site (not to be compared with the cliffs further downstream, however, from Sergeac on). These observations, which were confirmed by archaeological excavations carried out at the base of the entrance, allow us to pinpoint the highly inconspicuous outline of the entrance porch during the Upper Palaeolithic.

The rock faces bordering the Vézère (ill. 10) often appear degraded and give the edges of the plateaux a ruinous appearance, a feature accentuated in some places by the exposure of ancient karst systems dissecting their summits. For the most part, these cliffs do not show any secondary projections, giving an absolutely vertical profile to the entire formation, which can exceed 40 metres in height. In the valleys of the Beune, on the other hand, the formations have less pronounced ridges, and their vertical development is divided into terraces (ill. 11).

These different observations show that the state of preservation of the two geological units differs profoundly from one valley to the next. In the Vézère, karst structures are either high up (and therefore difficult to access) or are broken down by erosion, which explains why so few caves have been

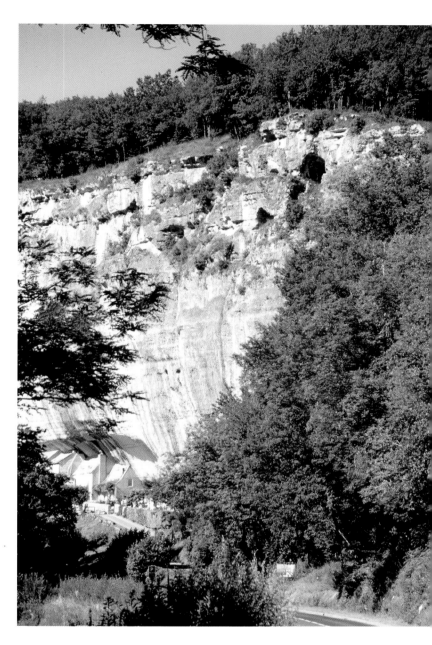

10 Elevated karst in the Vézère Valley. At the foot of this cliff, which has no intermediate terrace, is the horizontal niche that shelters the prehistoric site of Laugerie-Basse.

recorded. In the Beune, however, the same stratigraphic series preserves its entire uniformity from the confluence (with the Vézère) to the heads of the larger and smaller valleys. The terraced form of these cliffs facilitates access to the different levels.

This situation is totally reversed in the rock-shelter formation (in the form of a long horizontal niche). On both sides of the Vézère, it retains the same form throughout the entire steep-sided section of the drainage basin and is only interrupted by the confluences of the tributary valleys, between Thonac and Les Eyzies-de-Tayac. Furthermore, it is not particularly difficult to gain access to this group of rock shelters. They are never more than 30 metres above the valley floor, and access is often facilitated

by a talus deposit. As explained in Chapter 1, however, in the principal tributary valley – that of the Beune – this same horizontal niche disappears below fluviatile deposits above Les Combarelles, which explains why so few shelters were found there.

This topographical difference thus reveals a higher concentration of habitation sites, located mainly in the Vézère Valley, and an inverse proportion in the Beune. Similarly, there are numerous decorated caves in the Beune Valley, in sharp contrast to the Vézère Valley (ill. 12). The specific distribution of sites, caves or rock shelters is essentially governed by a combination of factors of geological origin, linked to the formation of landscapes, the erosion of outcrops and the phenomena of valley infilling.

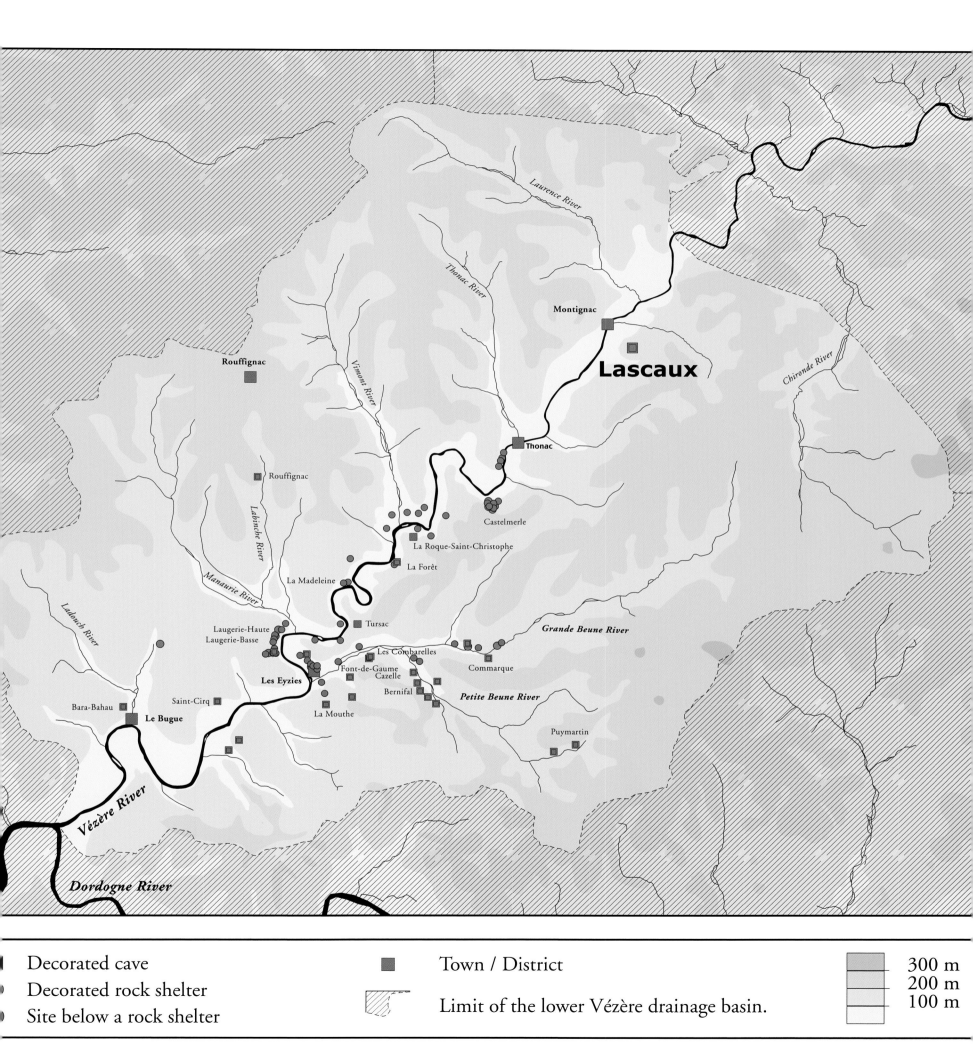

Laurence River

Montignac

Lascaux

Thonac River

Chironde River

Roufﬁgnac

Vimont River

Roufﬁgnac

Thonac

Labinche River

Castelmerle

Manaurie River

La Roque-Saint-Christophe

La Forêt

La Madeleine

Ladouch River

Tursac

Grande Beune River

Laugerie-Haute
Laugerie-Basse

Les Combarelles

Commarque

Font-de-Gaume
Cazelle

Les Eyzies

Bernifal

Petite Beune River

Bara-Bahau

Saint-Cirq

Le Bugue

La Mouthe

Puymartin

Vézère River

Dordogne River

Decorated cave

Decorated rock shelter

Site below a rock shelter

Town / District

Limit of the lower Vézère drainage basin.

300 m
200 m
100 m

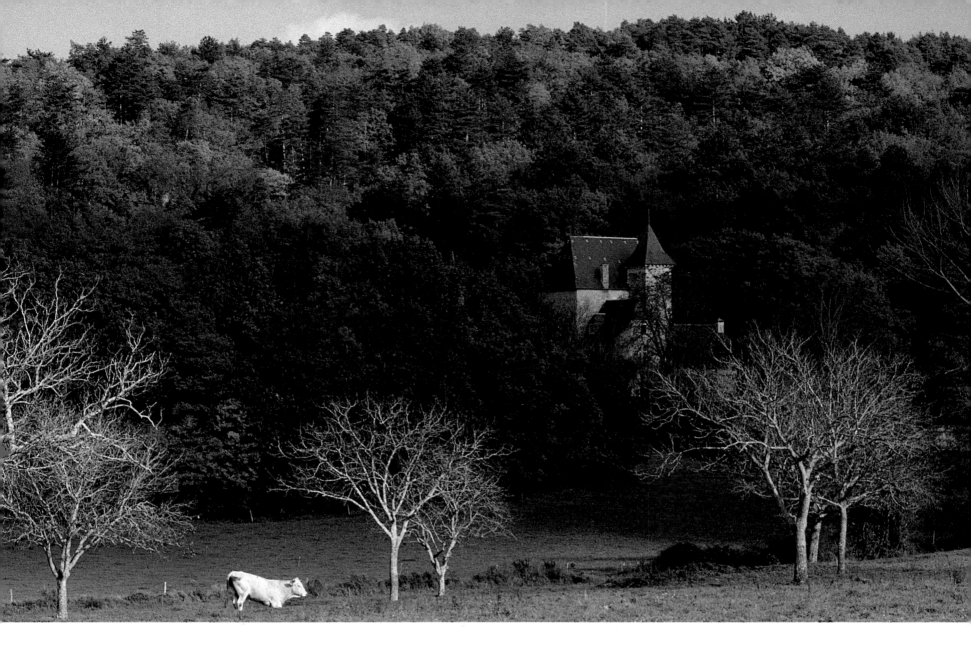

The Cave of Lascaux

The Cave of Lascaux

Lascaux Cave's geographical position places it some distance from the major concentrations of decorated caves and habitation sites that line the downstream stretch of the Vézère and its tributaries.

The present entrance to the cave, 185 metres above sea level, overlooks the valley floor by 105 metres. The road linking Montignac and Lascaux passes through the entire Coniacian sequence. The underground system is developed most completely in the uppermost part of this horizon. The first strata of the Santonian appear approximately 5 metres above the present entrance.

The cave is integrated into a hilltop formation, the summit of which is today masked by important slope deposits. These deposits smooth the outline of the hill, a phenomenon resulting from distortion of the Santonian basement rock (ill. 13). It is one of the characteristic features of the landscape.

Access to the Site

A relevant question is how humans gained access to the cave in the Upper Palaeolithic. As with the other caves in this region, once you get past the first 30 metres, the underground passage has changed very little since that time. Only the sectors close to daylight have been subjected to natural changes, although these have sometimes been considerable.

Several clues allow us to sketch out an initial answer, particularly with regards to possible entrances to the system. Indeed, a group of geological, morphological, palaeontological and conservational arguments allows us to support the hypothesis of a second entrance to

the cave of Lascaux at the end of the Great Fissure.

The level corresponding to the ceiling of the cave is characterized by poorly indurated and highly fractured rock, which makes the formation of a rock face impossible. The entrances used by Palaeolithic man never opened widely on to the valley, in fact quite the opposite. At that time, the immediate landscape was restricted to a barely visible ridge shared by both possible entrances. The similar contours of the openings and their location at the same level suggest that they were filled in at the same moment in time. This could have been caused by the collapse of part of the ceiling of the porch, erosion of their frontages, the influx of mudflows or the effects of solifluction phenomena (the transport of surface sediments resulting from the alternate freezing and thawing of soils). If you compare Lascaux with other caves belonging to the same geological level, you notice the same superficial character of the system, suggesting multiple entrances.

At the end of the Great Fissure, where the second entrance would have been located, the morphology of the chamber confirms that it is identical to that of the present entrance to the site. Its collapsed ceiling is very close to the outside surface and touches the top of a scree deposit that partly fills the gallery. An absolutely identical formation also blocked the present entrance before it was removed to make room for the engine room. At the wall of the Shaft Scene, other elements support this suggestion, notably the initial narrowness of the passageway connecting the Apse to the Shaft and the broadened cross section of the underlying

Preceding pages:
13 The Lascaux hill. The formation projects into the valley.

Opposite:
14 The Shaft. A difference in altitude of 6 metres separates the Apse from the bottom of the Shaft. The Scene, hidden by a projection of the cave wall, unrolls on the wall facing the descent by ladder.

gallery (ill. 14). This combination of factors accentuates the difficulty of passing from one space to the next and makes a return to the upper level almost impossible without proper equipment, something that was recognized at the time of Lascaux's discovery.

During the course of excavations conducted by André Glory, numerous remains of bones were unearthed. Almost 95 per cent of the remains came from cervids (reindeer and red deer), but wild boar and horses were also present. The remains also included microfauna. Apart from bats, several other species were identified: edible dormouse, garden dormouse, hare, water vole, hedgehog and frog. With the exception of the blue hare, all species show differing degrees of affinity with the entrance passages to the subterranean world. J. Bouchud,[7] who analysed the fauna at the site, questioned how these remains of micro-mammals arrived in the cave, attributing their presence to either predators or water. He ruled out the latter, since the Shaft has not been affected by water, with the exception of some percolation that has deposited a fine calcite encrustation over the archaeological levels. A potential predator was a possibility, but this is pure speculation as no bone remains of carnivores have ever been recovered.

Predator or not, an external access to this branch of the system must have existed. Neither the edible nor the garden dormouse penetrates more than a few tens of metres into the interior of caves. The other species – in particular the frog and the hedgehog – were unable to gain access to the upper level, which indicates that these animals were restricted to the Shaft, the Great Fissure and the Silted-up Chamber. This presupposes an opening to the outside world very close to the place of their burial.

One feature of this type of underground architecture with several openings is that the limestone deteriorates by dissolution, a phenomenon related to the exchange of air between the outside and the cave. This

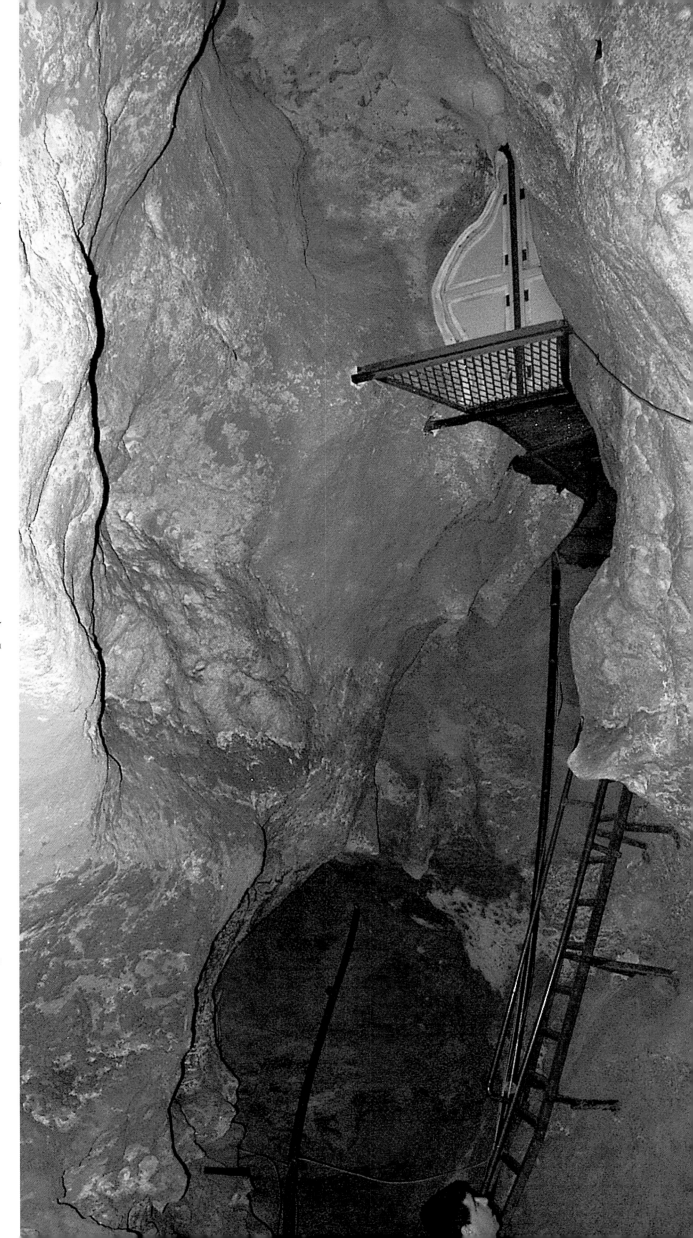

observation and the traces of corrosion on the walls thus give us another clue. We have mentioned the chemical processes linking condensation of water to carbon dioxide, as well as their effects on the limestone support. At Lascaux, this phenomenon is accentuated by the presence of an important updraft of carbon dioxide at the base of the Shaft,[8] and

Above:
15 A ramp provides access to Lascaux, which is sealed from the outside world by a monumental door.

measurements taken daily show that this can reach a concentration of 6 per cent.

The zones affected by this form of deterioration are not distributed randomly but are governed by two factors that determine the different actions of the corrosion: the geometry of the galleries and the direction of atmospheric circulation. This affects the condition of the walls and indicates the main directions of air flow.

A detailed analysis of those sectors affected at Lascaux has highlighted a particular axis of circulation, which has made the deterioration in the Apse and the Passageway more pronounced than in the Nave or the Chamber of the Felines. The majority of the pigment applied to the walls

or the ceiling has disappeared as a result of this decay. The most damaged area is near the opening to the Shaft, but the upper part of the Apse has also been affected: of the two great horses, which decorated the entire ceiling, only a few engraved lines remain, while the colouring matter survives only as a ghostly image. The Passageway bears the same scars, and only the painted figures in the lateral niches (particularly over the first 3 metres) are intact. On the fan-shaped surface on the right wall of the Hall of the Bulls, at the entrance to the Passageway, the hindquarters of the fourth bull and the great aurochs's head have also deteriorated. This series of observations proves the existence of a major flow of air, which made its destructive effects felt throughout all the sections of the gallery between the present-day entrance zone and the top of the scree deposit of the Great Fissure. It would therefore seem that there were indeed two distinct entrances to the Lascaux system: the one that is in use today (ill. 15), and the other, at the end of the Great Fissure, which was filled in by slope deposits and thereby concealed following the passage of Palaeolithic man.[9]

Architecture of the Cave

Lascaux has traditionally been divided into seven sectors (ill. 16) according to topography: the Hall of the Bulls (also known as the Rotunda), the Axial Gallery, the Passageway, the Nave, the Chamber of the Felines, the Apse and the Shaft. The undecorated portions are also included in this book, however, namely the entrance zone, the terminal passage, the Mondmilch Gallery (between the Nave and the Chamber of the Felines), the Great Fissure and the Silted-up Chamber (located beyond the Shaft).

Excluding the terminal passage, the final extension of the Axial Gallery and the umbilicus of the Silted-up Chamber, the system of galleries accessible to man – in all around 235 metres long – can be split

into three distinct rectilinear segments of unequal length. They are divided along three major axes: the first, at an angle of 120° relative to north, comprises the entrance zone, the Hall of the Bulls and the Axial Gallery; the second, orientated north–south, includes the Passageway, the Nave, the Mondmilch Gallery and the Chamber of the Felines; and the third segment, consisting of the Shaft and the Great Fissure, is at right angles to the second, with an east–west orientation. Beyond this, in a chamber following an identical orientation to the first segment, an important scree deposit marks the intersection between the extremity of the Great Fissure and the opening of the Silted-Up Chamber on the left.

The longitudinal sections reveal the different levels of the cave, which gets progressively deeper from the present-day entrance to the Chamber of the Felines. It drops 13 metres from the entrance to the Axial Gallery, a further 19 metres to the base of the Shaft and then another 20 metres to the bottom of the south shaft in the Chamber of the Felines.

The space between the present entrance and the Hall of the Bulls, some 20 metres long, is divided into four sections or airlocks. These partitions are designed to protect the decorated zones from external, potentially harmful climatic influences.

When the cave was first discovered, a great cone of scree filled the entrance zone. In 1948, however, it was levelled off to make the path wider, and access to the cave was facilitated by the introduction of a stairway. The installation of an air-conditioning system a few years later necessitated the removal of part of the sedimentary formation.

Differences in ground level and the changing nature of the porch, the façade of which has been cut back several metres since the Palaeolithic, have altered the appearance of the entrance over time. This is linked to the last incidence of subsidence in the roof, which buried archaeological layers dating to the same period as the parietal works of art. The ground surface formed by the scree cone followed a slight slope of around 20°, and the foot of the talus deposit was 5 metres further back than at the time of the discovery (ill. 17).

From the entrance, the extremely fragmented upper layer acts as a drainage system. Water is filtered through the 1.5-metre-thick rock stratum until it reaches the base, where it is prevented from going any further by a marly layer some 30 centimetres thick (located above the ceiling of the fourth airlock and beyond). The water diverted in this way percolates through the façade, which is chamfered by erosion. It used to flow across the scree talus towards the Hall of the Bulls, but now it is collected and pumped out of the cave.

During the Upper Palaeolithic, the less pronounced slope led towards an oblong hall. Today, this is cut off by the partition that separates the Hall of the Bulls from the rest of the cave system. The cross section of the entrance area prefigures that of the Hall of the Bulls. Shaped like a diabolo, it is divided into two levels of approximately equal height, separated by a ridge.

The Hall of the Bulls is a natural progression from the airlocks and retains the same characteristics (ill. 18). It is 19 metres long and varies in breadth from 5.5 metres at the entrance to 7.5 metres at its widest point, next to the opening to the Passageway.

The walls are made up of three superimposed levels. The upper, concave level features a single line of three cupolas of decreasing diameter, followed by a short row of smaller connecting cupolas, extending over 4 metres at the far end (before the entrance to the Axial Gallery). It is separated from the level below by a pronounced

16 Planimetric record of Lascaux and location of the principal figures and panels.

THE HALL OF THE BULLS
1. Black horse's head
2. Unicorn
3. Frieze of the black horses
4. Head of the first bull
5. Great red and black horse
6. Second bull
7. Brown horse
8. Frieze of the Small Stags
9. Third bull
10. Red cow
11. Fourth bull
12. Black horse in the forequarters of the fourth bull
13. Small black stag
14. Polychrome headless horse
15. Bear
16. Fifth bull
17. Red cow followed by her calf
18. Head of a bull

THE AXIAL GALLERY
1. The Red Cow with the Black Collar
2. Frieze of the yellow small horses
3. The Cow with the Drooping Horn
4. Red cow painted on the ceiling
5. Great Black Bull
6. Frieze of the heads of yellow cattle
7. Red cows covered by the Great Black Bull
8. Panel of the Hemione
9. Galloping Horse
10. Feline
11. Yellow horse and polychrome horse
12. Upside-down Horse
13. Red Panel
14. Confronted Ibexes
15. Superposed horses
16. Large red quadrangular symbol
17. Falling Cow
18. Solitary head of a bull
19. Frieze of the Small Horses
20. Third Chinese horse
21. Second Chinese horse
22. Red cow
23. First Chinese horse
24. Black stag

THE PASSAGEWAY
1. Traces of a painted equid
2. Hindquarters and beginning of the belly line of a painted equid
3. Head of a bison
4. Procession of engraved horses
5. Horse rolling on the ground
6. Engraved ibex and painted hooves of an equid
7. Engraved and black painted horse
8. Horse with the turned-back foot
9. Heads and horns of cows
10. Red drawing of a headless equid
11. Engraved ibexes and horses
12. Two horses engraved one above the other
13. Bearded Horse

THE APSE
1. Stag with Thirteen Arrows
2. Fallen Stag
3. Third great stag
4. Horse and aurochs
5. Confronted stags
6. Confronted ibexes
7. Upward-turned Horse
8. Panel of the Musk Ox
9. Horse with Claviforms
10. Frieze of the painted and engraved stags
11. 'Chimney' sign
12. Small Sorcerer
13. Great Reindeer
14. The two bison
15. 'fend-la-bise' Stag
16. Major Stag
17. Great stag and horse with merged outlines
18. The Hut
19. Engraved stag on black background
20. Great Sorcerer
21. Red horse
22. Yellow horse

THE SHAFT SCENE
1. Rhinoceros
2. Six black dots
3. Man
4. Bison
5. Bird
6. Black horse

THE NAVE
1. Panel of the Ibexes
2. Panel of the Imprint
3. Panel of the Great Black Cow
4. Crossed Bison
5. Frieze of the Swimming Stags

THE CHAMBER OF THE FELINES
1. Niche of the felines
2. Horse in frontal view
3. Quadrangular signs
4. Crossed bison
5. Panel of the horse
6. Tree house
7. Sign XIII
8. Head and horns of a bison
9. Six red dots

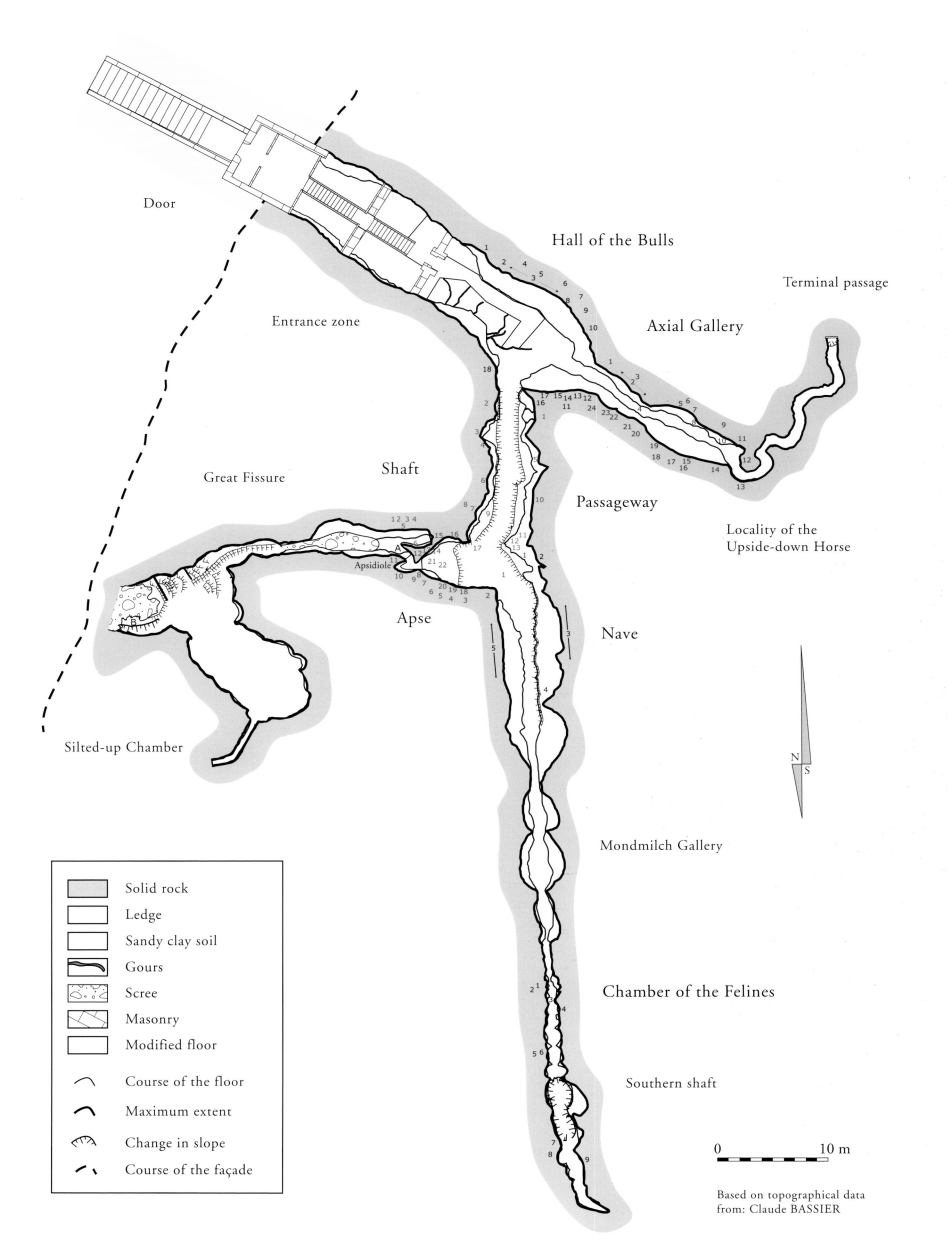

Door

Hall of the Bulls

Terminal passage

Entrance zone

Axial Gallery

Great Fissure

Shaft

Passageway

Locality of the
Upside-down Horse

Apsidiole

Apse

Nave

Silted-up Chamber

Mondmilch Gallery

Chamber of the Felines

Southern shaft

	Solid rock
	Ledge
	Sandy clay soil
	Gours
	Scree
	Masonry
	Modified floor
	Course of the floor
	Maximum extent
	Change in slope
	Course of the façade

N
S

0 10 m

Based on topographical data
from: Claude BASSIER

17 Longitudinal stratigraphic section from the entrance to the Hall of the Bulls at different periods: during the Upper Palaeolithic, the 12 September 1940 and in its present state.

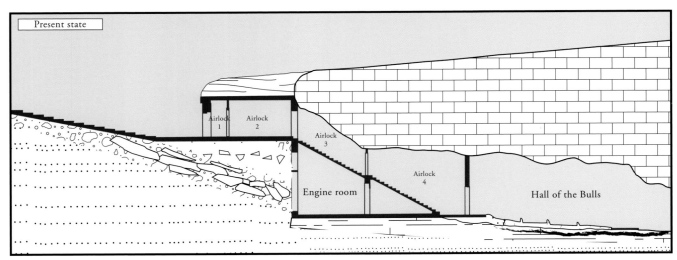

Present state

Airlock 1 Airlock 2

Airlock 3

Airlock 4

Engine room

Hall of the Bulls

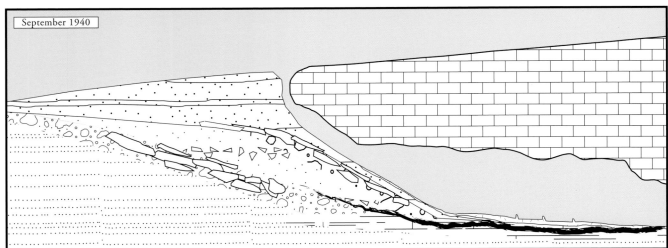

September 1940

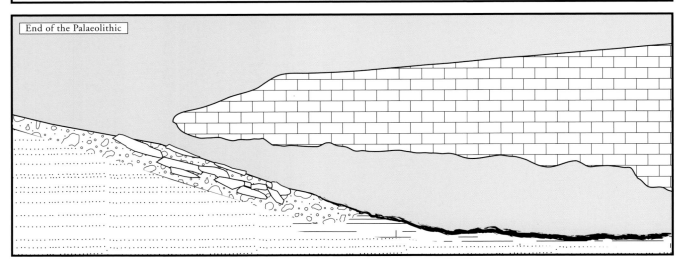

End of the Palaeolithic

Coniacian limestone

Calcite deposit

Calcareous sandy clay soil

Second collapse of the cave roof

Scree

Archaeological layer

First collapse of the cave roof

Sandy clay infill

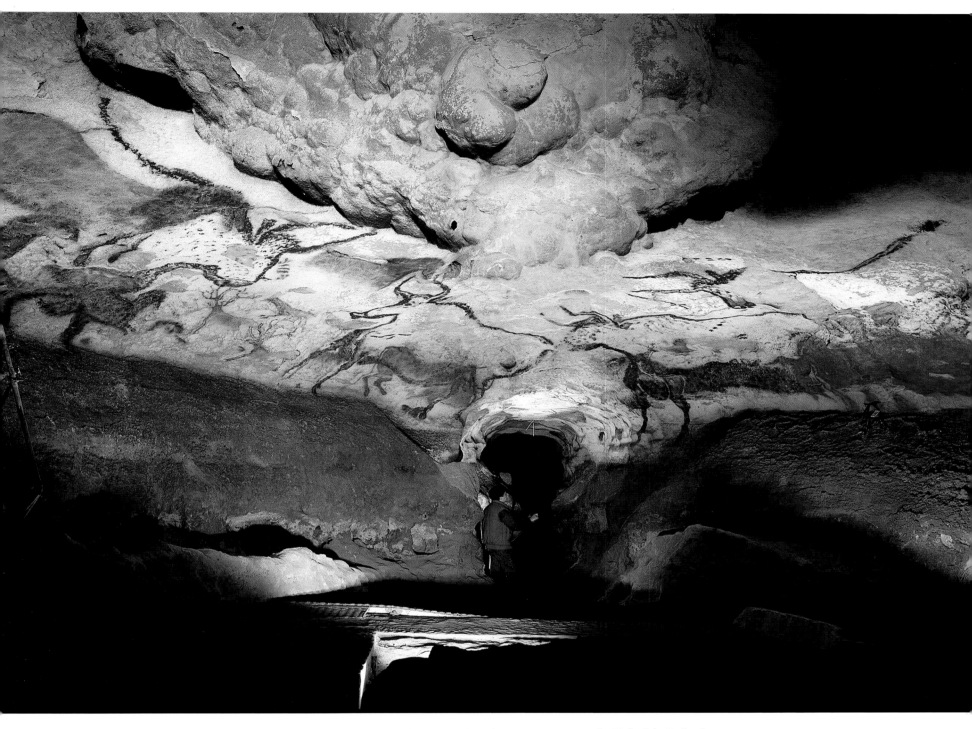

horizontal ridge. The central level, which runs along both walls, evolves from an inconspicuous sub-vertical formation at the entrance into an overhanging mass (with a maximum inclination of 70º) at the far end of the hall. Moreover, its breadth quadruples from 1 to 4 metres. The combined effect of these two layers and the omnipresence of the painted images are significant, making you feel surrounded on all sides, and in this sense the alternative name given to the hall – the Rotunda – is very apt. The third level, which compensates

for the increased difference in altitude, is quite modest at the entrance to the hall, but accounts for a third of the wall's height at its centre. We call it the bench.

Since the departure of Palaeolithic man, only the floors have been modified. In the majority of places, André Glory's test trenches reveal much the same sequence. At the base there is a deposit of alternating layers of fine sand and laminated clay, ranging in thickness from 2 metres in the Passageway to 4 metres in the Shaft and sealed by a compact, sandy band of clay of

18 In the Hall of the Bulls, the decorated surface occupies the central part of the raised wall, which is distinctly corbelled.

between 3 and 10 centimetres. Most of the portable archaeological finds were collected at its surface. A later but similar deposit of sediment only partially covered the Palaeolithic floor. During the Postglacial period, a very significant calcite deposit was formed along the subterranean watercourse. Four major petrified gours, with an average diameter of 4 metres, lie along the central axis of the Hall of the Bulls. The outflow towards the Passageway caused similar sedimentation beyond the hall, right up to the threshold of the Chamber of the Felines. However, the concretion (the hard, solid mass formed by the accumulation of calcite) of the floors allowed the deposition of clay layers along the left side of the gallery up to the foot of the wall.

The calcite cover is 20 centimetres thick on average, although some of the calcite natural dams are as much as 40 centimetres high. The physical traces of prehistoric man are buried below this layer in the clay sediments. The original floor of the gallery lies on average 30 centimetres below its current level.

THE AXIAL GALLERY

The Axial Gallery (ill. 19) is over 22 metres long and follows an almost identical orientation to that of the Hall of the Bulls. The floor has a gradient of 10 per cent, which becomes slightly more pronounced at the far end, beyond the Chinese Horses. For the purposes of this book, the passage has been divided into three sections of roughly equal length. The limits of these sections have been determined by two constrictions in the walls of the gallery, where the passage narrows to less than 60 centimetres wide. With visitors in mind, the first constriction was widened by removing a pronounced formation at the foot of the right wall.

A cross section of the passage shows that the Axial Gallery is shaped like a keyhole. Like the Hall of the Bulls, it has remained unchanged since the Upper

Palaeolithic, with the exception of the floor. Unfortunately, the floor has been disturbed several times since the cave's discovery and there is very little information about its original state. Trenches were dug for electric cables and ventilation ducts from the entrance right up to the terminal passage, disturbing the stratigraphy of the floor along the entire length of the gallery.

The stratigraphic sequence is identical to that in the other sectors of the cave. The archaeological layer, above the sterile fill of alternating bands of laminated clay and pale grey sand, contained a relatively large number of portable items – in particular cores, flint bladelets and knapping waste, with traces of wood charcoal and fragments of colouring materials. This layer was sealed by 10 centimetres of compact clay and a thin calcite encrustation, formed by a flow of water trickling down the entrance. Compared to the palaeosol of the Hall of the Bulls, there is a difference in height of 3 metres. However, preliminary observations made by Henri Breuil[10] shortly after the discovery and recorded by Jacques Marsal showed that the floor at the entrance to the gallery formed a ridge that was almost 1 metre higher than its current level – subsequently worn down by the huge number of visitors passing through. Local drainage of the fill or the collapse of animal burrows may have played their part. Indeed, at the entrance to the Passageway, at the base of the left wall, there were badger claw marks.

The third segment of the Axial Gallery has a relatively complex structure and confined space compared with the linearity and impressive size of the cave system thus far. A major constriction at the base of the passage marks the location of the Upside-down Horse (ill. 20), from which point the passage takes a meandering course, turning through 300°. The ceiling height drops significantly over this 7-metre section, from 3.2 metres at the entrance to 1.2 metres at the far end of the gallery.

Opposite:
19 The entrance to the Axial Gallery illustrates perfectly the morphology of the passageway, showing its 'keyhole-shaped' cross section in particular.

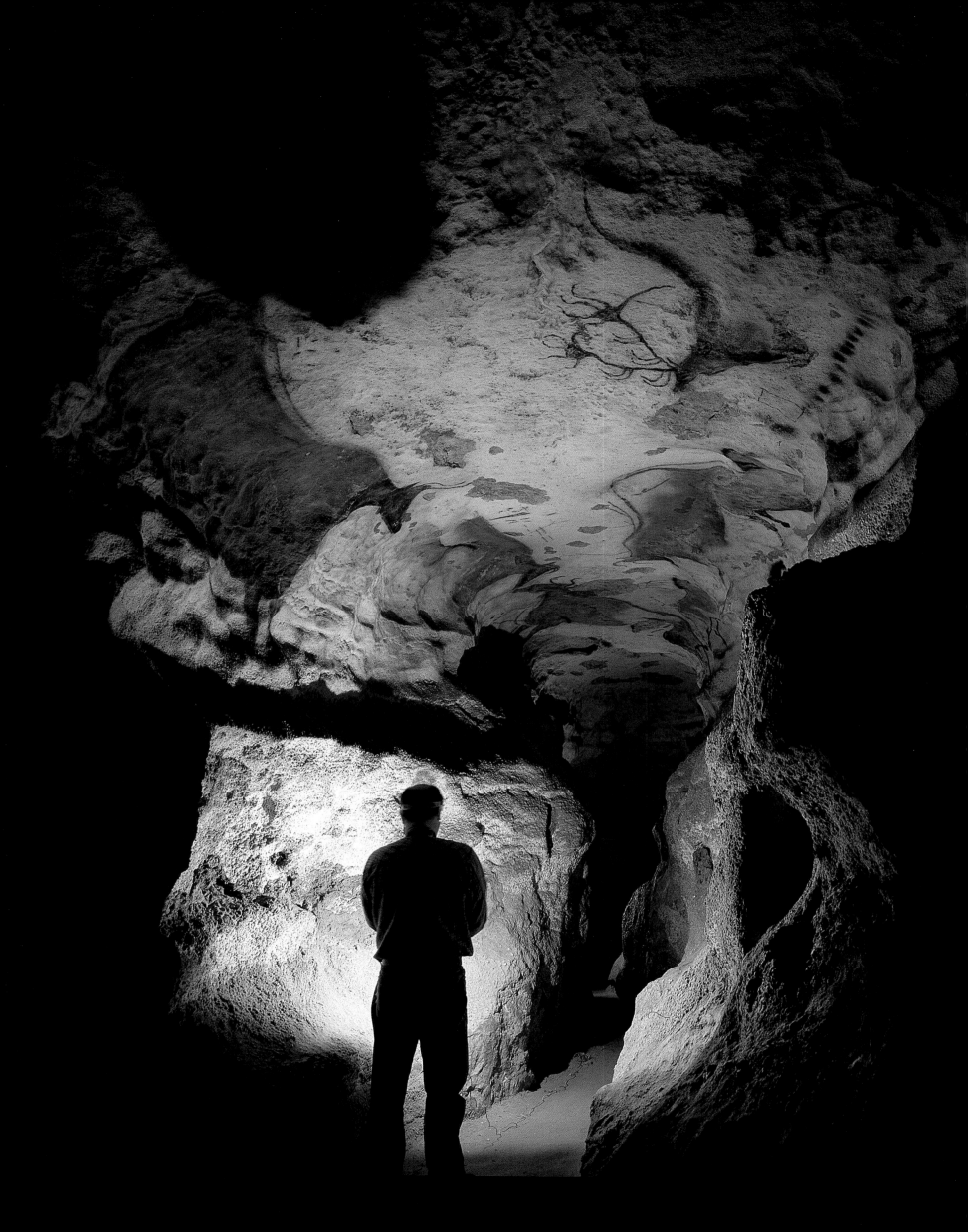

A cross section of the gallery highlights the clear gap at the base of the wall where the lower level has crumbled away, creating a projection in the rock around which the image of the Upside-down Horse unfurls. Immediately before this formation the same break in the strata forms a series of small adjacent cavities, a few centimetres in size. On the opposite wall there is a deep fissure some 20 centimetres wide, which runs the length of the Red Panel, the final composition in this passage.

Beyond these last representations, there is a narrow sub-horizontal passage. It is some 15 metres long, but then becomes blocked by a sandy-clay obstruction.

THE PASSAGEWAY

A gallery of more modest proportions (ill. 21) gives you access to the second part of the system. It is 4 metres wide on average, and no more than 17 metres long, but there is a very noticeable difference in the ceiling height, which ranges from 2 to 2.4 metres. The current ceiling is higher than it used to be: deposits in the central section of the passage were removed to create an extra 1 to 1.4 metres of head room for visitors.

On the whole, the Passageway is rectilinear, but it does not have the symmetrical opposing walls that have been recorded elsewhere. In fact, it is more like a meander. Broader than it is high, its walls are characterized by a series of alternating and staggered hollows and projections. The broad juxtaposed alcoves are known as conches.

Research by André Glory shows a recurring stratigraphy, in every way identical to that already seen, distinguished only by the lateral slope of its layers. This incline has affected the course of the subterranean stream. A stalagmite floor, some tens of centimetres thick and fragmented, is marked by a succession of small petrified pools. It covers the entire width of the gallery at the entrance to the Passageway, but accounts for just one third of the floor at the far end.

THE NAVE

The Passageway opens on to an intersection of galleries. The Apse and the adjoined Nave (ill. 22) are to the right. Eighteen metres long, with an average width of 6 metres

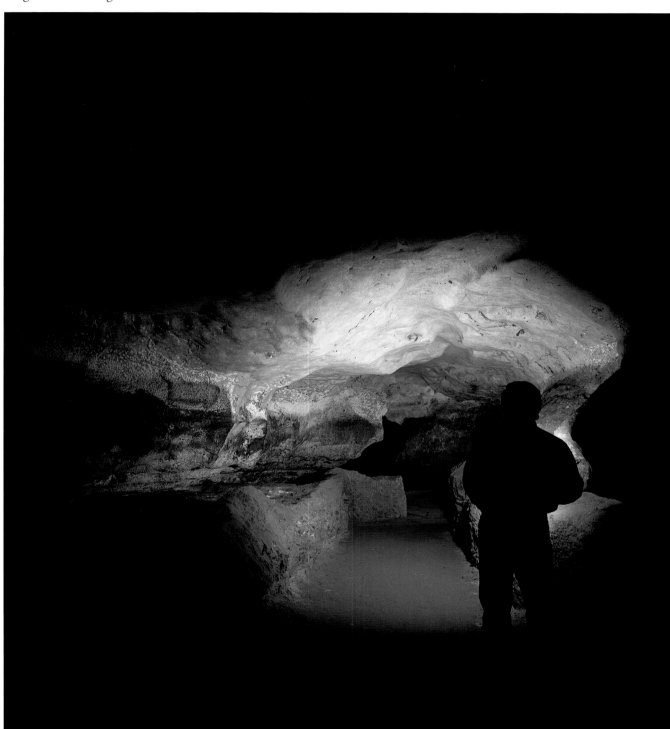

and a ceiling height of between 2.5 metres at the entrance and 8 metres at the far end, the dimensions here are similar to those of the Hall of the Bulls. The floor has a 19 per cent gradient, and a short, more level stretch marks the start of the Mondmilch Gallery.

Opposite:
20 The second narrowing of the Axial Gallery marks the entrance to the location of the Upside-down Horse.

Above:
21 The rectilinear development of the Passageway disguises the meandering form in which it was hollowed out. This can be identified, however, due to a succession of projecting formations that alternate regularly along the two sides of the gallery.

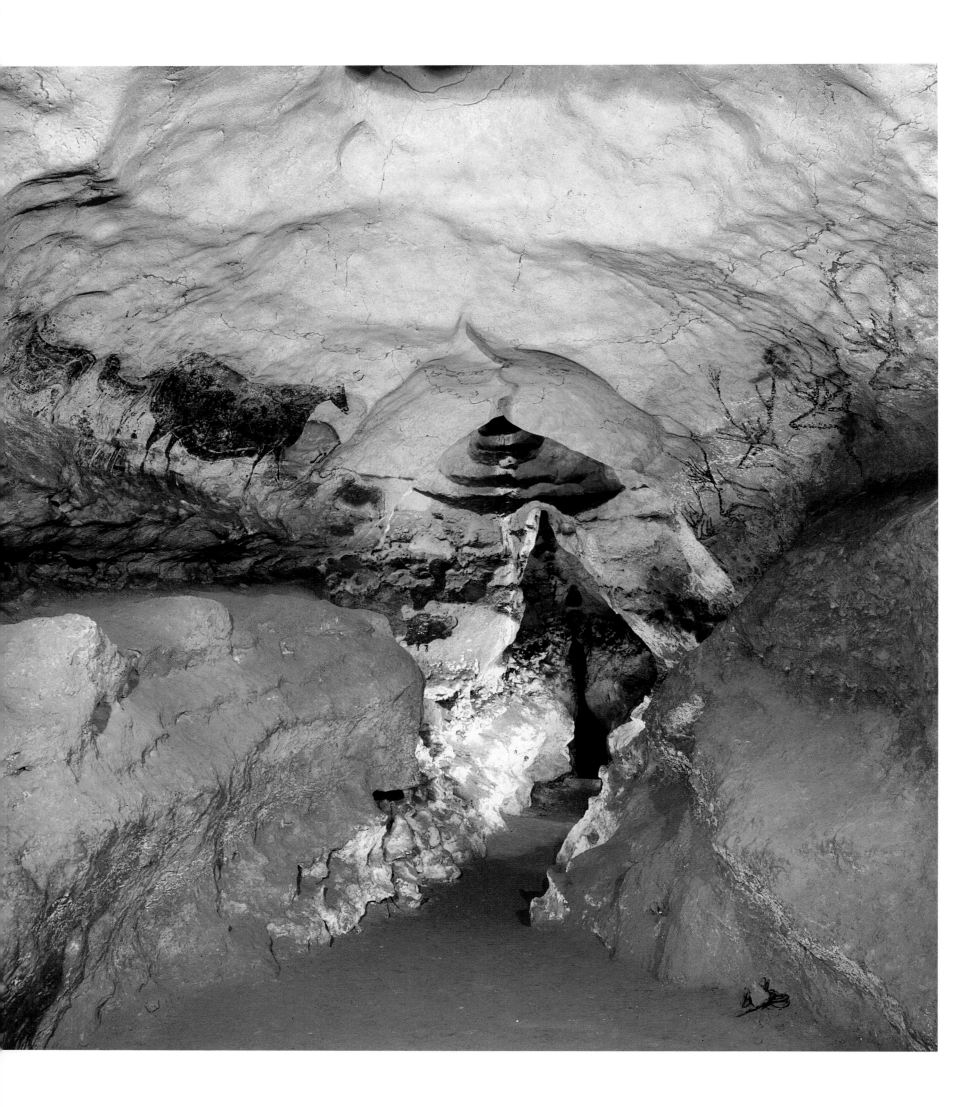

A voluminous oblong cupola covers two thirds of the hall, its formation mirroring the symmetry of the lateral walls. The two walls get progressively wider, and the hall is at its most spacious in the centre. This sub-ovoid structure is typical of Lascaux's different underground spaces and occurs both in isolation and in combination with other components. Examples include the sections from the entrance to the Upside-down Horse, from the Shaft to the Silted-up Chamber, and from this intersection to the Chamber of the Felines.

On the lower section of the wall there is a ledge – otherwise known as the bench – which is separated from the panel above by a pronounced, continuous niche. It begins close to the Panel of the Imprint and reaches a maximum height of 3 metres under the figure of the Great Black Cow. The ledge was very important to the Palaeolithic artist, providing a broad platform on which to work and enabling him to position himself with ease without the need for scaffolding. This natural platform is interrupted close to the panel of the Crossed Bison, in which the bison have been integrated into a deep concave niche in the wall.

The frieze of the Swimming Stags is on the west wall, opposite the Great Black Cow. Here, the surface of the bench, which was narrow and horizontal at the entrance, becomes broader and continues at an oblique angle.

THE MONDMILCH GALLERY

Some 20 metres separate the Nave from the Chamber of the Felines (ill. 23). The zone between these two segments, a more modest extension of the Nave, is usually called the Mondmilch Gallery. The ceiling height here reaches a maximum of 8 metres, although the passage is never more than 2 metres wide. It takes its name from the chalky mondmilch that coats the gallery – a stalagmite encrustation that can reach a height of almost 4 metres. There is a marked absence of

figures in this sector. The friable state of mondmilch surfaces, on which it would be impossible to preserve traces of art even if there were any, makes them highly unsuitable platforms for any form of graphic expression.

THE CHAMBER OF THE FELINES

The Chamber of the Felines is a 30-metre-long rectilinear corridor, blocked at its distal extremity by a plug of argillaceous calcite (ill. 24). It is distinguished from the other galleries by its rather small dimensions and

Opposite:
22 General view of the Nave.

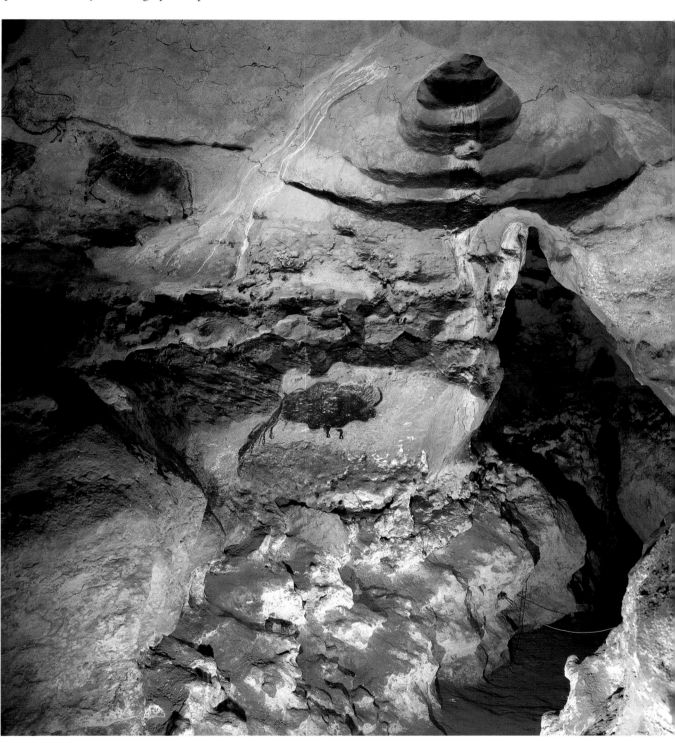

Above:
23 Entrance to the Mondmilch Gallery, which connects the Nave to the Chamber of the Felines. At an undetermined point in time the stalagmitic formations on the walls were subjected to significant deterioration, which explains why they are undecorated.

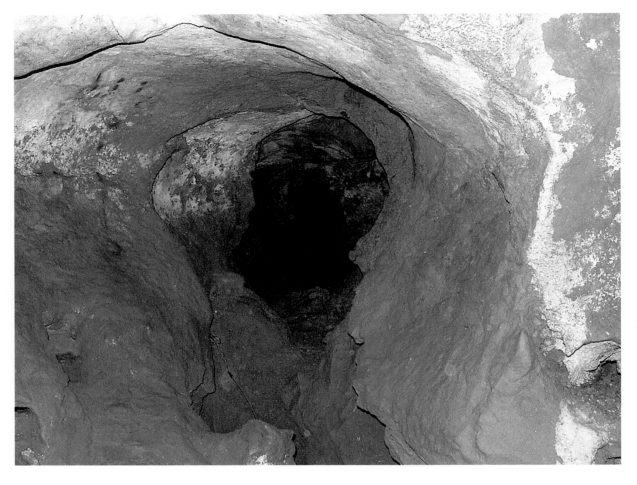

The long gallery runs in a north–south direction and has just one intersection, on its western side. The Apse (ill. 25), leading to the Shaft, the Great Fissure and the Silted-up Chamber, is at this junction. The Apse was created in an identical way to the majority of galleries at the site, as a cross section shows (ill. 26). The overall structure, an oblong cupola, is surmounted by a second enclosed form of similar geometry. There are no traces of calcite on the walls.

In the most remote part, a secondary enlargement called the Apsidiole provides access to the top of the Shaft. When the cave was first discovered, the floor was a lot higher than it is today, but around 1.5 metres of sand and clay were subsequently removed from the surface in order to facilitate tourist access. A metal platform now separates the Apsidiole from the upper Shaft, replacing the original filling.

A more detailed morphological analysis and survey of the events that led to the modification of these spaces can throw light on the difficulties encountered by Palaeolithic man in gaining access to the bottom of the Shaft. At that time, the infill of the Apse was only a fraction of this formation. It was connected to that of the Shaft by a large opening in the rock, hollowed out 2 metres below, and at the front of the Apse. The friable aggregate jutted right out towards the inaccessible lower layers. If this deposit did not exist, the Apse and the Great Fissure would form one and the same gallery. Two factors may have been responsible for the difference in floor height: the greater potential for sediments to drain from the base of the deposit close to the Shaft, and a wider passage below, facilitating the movement of materials through gravity.

The layer of deposit thinned out from the Apse to the Shaft, where it jutted out like a ceiling over the underlying gallery. The longitudinal section reconstructed in the diagram opposite (ill. 26) shows how the line

Above:
24 The approach to the Chamber of the Felines is more constricted than the preceding galleries, marked in particular by the crossing of the southern Shaft. Six red dots signal the end of this final extension.

Opposite, above:
25 General view of the Apse. In the most secluded part of this egg-shaped space is the entrance to the Shaft.

Opposite, below:
26 Longitudinal section of the gallery, across the Apse, the Shaft and the beginning of the Great Fissure.

barely passable nature. The whole length of the route is strewn with small irregularities, all very diverse in character, which make passage arduous.

The walls of the vault are all very fragmented in appearance. A 45° ramp stands at the entrance, leading to the first engravings in a narrow space of ovoid form. This is followed by a still narrower and lower passage, and then a second and third alcove. A narrow channel excavated by André Glory facilitates passage through the Chamber, but you have to crouch down.

Suddenly a vertical shaft appears before you, barring the way: 5 metres deep and 4.5 metres long, it extends across the entire width of the gallery. Today, it is crossed by means of a metal footbridge. Here, from this central point to the far end of the gallery, there is a noticeable increase in humidity. Over the last 10-metre stretch, the floor is characterized by a covering of sticky clay. The Chamber becomes so narrow that you can go no further.

of the floor and the ceiling converged, causing the ceiling height to drop to under 50 centimetres along part of the passage. It was only possible to reach the far end of the passage – and the sheer drop into the gallery below – by crawling.

On the day the cave was discovered, without any special equipment, exploration of the cave was limited to a reconnaissance. The four explorers could only just make out the upper part of the Shaft, but in order to gain access to it Marcel Ravidat had to lower the very loose, powdery floor by some 15 centimetres. The following day, the teenagers returned to the spot with suitable equipment. The edge of the Shaft was weak due to the type of sediments and the thinness of the deposit, and the nature of the place made it impossible to climb down the 5 metres that separated them from the bottom. They were forced to seek another solution. They found it some metres from the edge, in the first part of the meander, where it was possible to stand up. The floor at this point was pierced by a half-moon-shaped hole, some 30 centimetres in diameter. They enlarged it to permit a person to pass through and placed a log across the gallery. This was to prevent their rope from cutting into the filling and causing further sediment to fall.

This piece of information provided by Marcel Ravidat[11] shows the difficulties encountered along this route and the near impossibility of gaining access in this way. The lack of any significant sedimentation since the time of Palaeolithic man – if there has indeed been any at all – means that the passage could not have been refilled or, more precisely, narrowed. Furthermore, owing to the shape of the narrow tunnel, which curves back on itself, it would have been impossible to use a ladder or climbing pole to assist in the descent. Climbing with one's own bare hands would have been a risky option, as the bell-shaped cross section of the underlying gallery prevents any climbing in opposition.

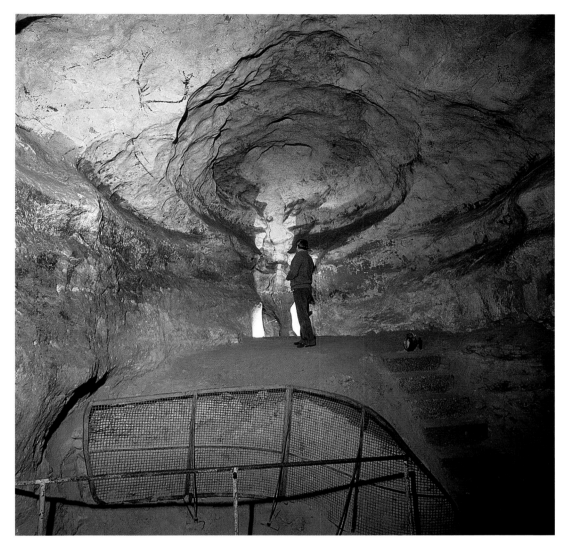

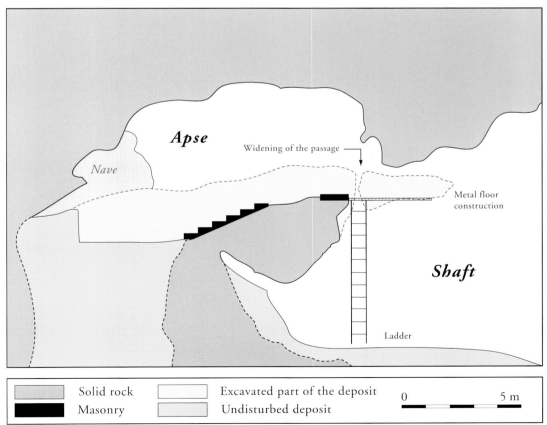

Apse

Nave

Widening of the passage

Metal floor construction

Shaft

Ladder

	Solid rock		Excavated part of the deposit
	Masonry		Undisturbed deposit

0 5 m

THE SHAFT AND THE GREAT FISSURE

Though the name 'the Shaft' is rather inappropriate, the term has been traditional for so long that we will continue to use it. This segment is in fact nothing more than a recess in the proximal part of the Great Fissure. We should make it quite clear that this complex is not on a lower level of the system, as is sometimes stated (although the name 'Shaft' may encourage this confusion), but a continuation of the preceding spaces. In fact, the ceiling of the Shaft is at the same horizontal level as that of the Passageway. The same is true of the Crossed Bison in the Nave and the panel of the Shaft Scene.

The Great Fissure is, at most, 10 metres high and 30 metres long. It is relatively wide at first (over the first third or so of its length), but the walls converge towards the far end, making the passage less than 70 centimetres wide in places. A significant scree deposit, more clayey at the top, obstructs two thirds of this space. A continuous slope at an average angle of 30° brings you up to the same level as the Shaft entrance, and the last third of the gallery takes you higher still.

The profile of the gallery has changed as a result of human intervention. The excavations of Henri Breuil and Séverin Blanc in 1949, followed by those of André Glory between 1960 and 1962, played a significant part. Successive alterations at the entrance to this part of the system have also made their mark – notably the removal of the sandy clay heap that blocked the top of the Shaft, and the transfer of clayey sand from the floor of the Passageway during the modifications for tourists. During his investigations, André Glory removed all the debris and lowered the level of the floor by between 70 centimetres and 3.5 metres compared with its original height at the time of the discovery.

The western end of the Great Fissure finishes in a low, 1-metre-high hall. Ovate in form, it is capped by a truncated cupola. Its centre is blocked by a scree of limestone plaques, the result of a roof collapse. Numerous plant roots tap the moisture of the filling.

THE SILTED-UP CHAMBER

The entrance to the Silted-up Chamber lies at the far end of the Great Fissure, on the lower left side, 3 metres below the top of the scree cone. Twelve metres long and 6 metres wide, the Chamber resembles the entrance zone of the cave in its morphology, although the very significant sandy filling hides this similarity. The rock here is extremely gritty and friable, with numerous scars left by exfoliation. For these reasons the walls were never decorated, or at least we have never discovered any engraving or trace of colouring matter. A partially blocked corridor, some 20 metres long, leads off the Chamber.

The Rock Support

The search for and selection of suitable surfaces for graphic expression was determined by various factors: the mechanical properties of the rocks, for instance, the morphology of the support and the accessibility of the walls. Palaeolithic man had to gauge these different data and then adapt to the circumstances.

Other factors also entered the equation, such as the dirtiness of the walls. Particles of dust are in constant circulation in the atmosphere and often settle on horizontal surfaces. This contamination, which sometimes changes the colour of the wall from a very pure white to dark brown or anthracite grey, can radically reduce the wall's reflective properties. Palaeolithic man clearly took this into account: there are virtually no paintings or engravings on such sloping surfaces, particularly in the Hall of the Bulls, the Axial Gallery and the Nave where the decoration is concentrated on the overhanging level above.

The morphology of the walls results either from the removal of material, by chemical or

Opposite, above:
27 Substrate with a powdery surface. The character of this surface is linked to the very gritty nature of the rock, caused by carbonate and silicate particles rendered friable by corrosion. It extends through the entire southern part of the cavity, from the Passageway to the Chamber of the Felines.

Opposite, below:
28 The carbonate encrustation here takes on a form characterized by spicules, small calcite needles that grow in all directions. This type of surface is found primarily in the Hall of the Bulls.

mechanical decomposition, or from the addition of material by re-crystallization, with or without the incorporation of the residual fill of the cave (particularly clay). Human action reflects this duality as a rock surface is either incised, in order to engrave a line or scrape a surface, or added to in the form of a painting or drawing. The texture of the support and its relief played a major role in deciding which technique or tool to use, as well as determining how well works were preserved over time.

Detailed analysis of the rock supports reveals a great deal of variability in surface conditions. At Lascaux more than a dozen different types have been isolated in this way. They are distinguished by their granularity, their hardness, their morphology and their reflectivity. We have defined these types as 'forms'. They are divided into two basic categories: one relates to the solid rock, and the other incorporates the coating elements that have been added during the course of the evolution of the cave (clay, calcite or other secondary products).

In the first category, the surface condition is the result of decomposition, either by erosion or by corrosion, or most often by a combination of the two. Most of the time the chemical factor obscures the mechanical effects of water or exfoliation, which are always very close to the intersections between strata. This is the most common type of form and covers approximately two thirds of the total surface of the cave. Granularity, but above all the degree of hardness of the material, characterizes these wall surfaces, which are also the most susceptible to decomposition. Many were engraved. The most fragile supports are characteristic of the entrance zone, the Silted-up Chamber and its extension. The rock is plastic for 1 to 2 centimetres and heavily saturated with water, which is not conducive to the long-term preservation of paintings or drawings. Nevertheless, engravings should have been able to survive, but we have discovered no

trace of them. Proximity to the entrance may explain this, as this zone is rarely decorated.

Powdery surfaces are the most common (ill. 27). A certain surface weakness is evident on this fairly dry type of support. Effects of corrosion remain superficial and limited to the upper few millimetres of the much harder rock. It is repeatedly transected by fissures filled with calcite, which is more resistant and thus remained in slight relief, as on the panels of the Swimming Stags or the Great Black Cow. The presence of iron oxide in the limestone gives it an ochreous colour, which reduces its reflective properties.

Concretions in the Hall of the Bulls and the Axial Gallery are riddled with the scars of exfoliation, where the surface of the walls has flaked off. They are generally found at the boundaries of stratified layers and may be caused by tension in the rock. There, the reflection of light is much weaker than on the surface of the concretions, reducing the contrasting effect of colour and thus giving a certain unevenness to the image.

The second category, associated with the deposit of clay and, above all, calcite, affects much of the Hall of the Bulls and the Mondmilch Gallery and the entire Axial Gallery. There are also small islands of calcite along the first few metres of the Passageway. For the most part, these surface conditions result from chemical processes caused by reactions between percolating water, the limestone and carbon dioxide, which is always in a high concentration in this environment. These forms are found most often on the primary surface, but they also affect secondary phenomena, such as deposits of clay. Differences in the level of hardness are so insignificant in this case that it is less relevant as a determining factor. The granularity is far more important: the choice of technique used to execute the figures will often be governed by the extent and configuration of the micro-topography of the support.

The most important form at Lascaux is the spicular one (ill. 28), not in terms of its extent within the cave, which is restricted to the Hall of the Bulls, but because of its exceptional photometric properties. It is created around calcite needles, between 3 and 5 millimetres long and with a diameter of less than 1 millimetre, which are grouped together in small adjoining clusters. The coherence of these surfaces is disturbed only by infrequent gaps, most of which have been filled by a transparent calcite flow. This form covers three quarters of the middle band of the Hall of the Bulls, and there is only one discontinuity (the corroded surface between the hindquarters of the fifth bull and the head of the sixth). The morphology of these concretions reveals minor and very localized variation. Its exceptional optical qualities, with a higher coefficient of reflectivity, compensate for the relative roughness of the background.

The 'cauliflower' form (ill. 29) is equally characteristic of Lascaux's walls. From just inside the entrance, its distribution affects the entire Axial Gallery, with the exception of the upper half of the first third of the gallery and the ceiling of the following enlargement. It is also present at the entrance to the Passageway and, discontinuously, along the left wall. There are numerous indications that the entire ceiling of this last sector was covered by this calcite at an undetermined period. Surfaces less exposed to thermal and hygrometric variation still preserve this evidence, particularly along the first 3 metres from the entrance and on both sides of the gallery, where some large paintings of animals still survive. The white surface has a macroscopically undulating appearance, with randomly distributed, irregular elements measuring between 5 and 15 millimetres in diameter. The majority are solid, although some are shaped like small hollow domes.

The 'rice grain' form (ill. 30) is found less widely than its 'cauliflower' counterpart. However, it is the main reason that the Lascaux works are of such a high quality. Its relatively fine-grained texture and maximum

Opposite, top:
29 The more solid 'cauliflower' concretions cover the walls in the lower part of the Axial Gallery.

Opposite, centre:
30 At the other extreme, this foundation with a micro-topography resembling grains of rice covers the interior surface and the projections of the ceiling in the Axial Gallery.

Opposite, bottom:
31 Due to its unstable plastic properties, intimately linked to the surrounding hygrometry, mondmilch is unsuitable for engraving and even more so for drawing or painting.

reflective properties make it the perfect background. Several of the most prestigious figures of parietal art were executed on this support, despite a lack of accessibility or constraints imposed by a distorted ceiling or wall. The Axial Gallery's four red cows and the frieze of the Chinese Horses are the prime examples. Indeed, only the first third of the Axial Gallery has painted surfaces. Beyond this point, access becomes increasingly difficult, precluding the continued exploitation of this type of surface.

Calcite-covered clay, caused by sediment fill, coats the ledge running around the lower part of the Hall of the Bulls and has a very high optical density. As it dried, the fragmented clay coating was broken up by carbonate infiltration. Subsequent wetting of the walls removed the clay, leaving only its impression, which has led to false interpretations of these phenomena as Palaeolithic images.

Alteration of the calcite results in two differentiated forms, one due to corrosion of the encrustation, and the other to chemical alteration of the surface, which develops into mondmilch. The former has only been identified in the Passageway, particularly along the left wall and on the ceiling. The second is very localized and restricted to a section intermediate between the Nave and the Chamber of the Felines. It extends 1.5 metres above floor level along both sides of the gallery, which is 21 metres long and has an average width of 1.2 metres. Only the basal part is affected by this encrustation. As a result of a biochemical reaction over an undetermined period of time, at least part of the stalagmite deposit developed into mondmilch (ill. 31). The plasticity of this material, which forms a milky, whitish mass, several centimetres thick and with a very irregular surface, varies according to the degree of humidity of the underlying rock. These properties made such walls unsuitable platforms for parietal art. However, before the process of deterioration

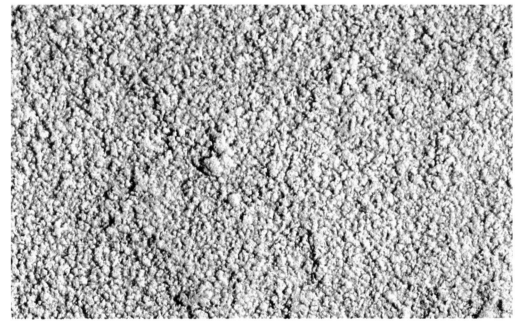

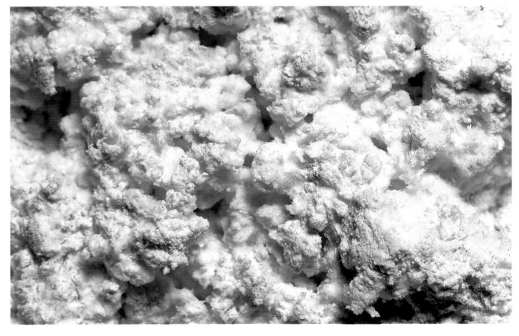

the underlying stalagmite must have had more suitable properties. It cannot be ruled out that Palaeolithic depictions once existed on these walls.

The transparency of the laminar form makes it difficult to find. This calcite veil has concealed some decorated areas, particularly in the Shaft and the Hall of the Bulls, between the third and the fourth bulls. It replaces the spicular encrustation in those parts initially exposed to corrosion, more particularly at the intersection with the Axial Gallery.

The massive form is restricted to the Hall of the Bulls and the Axial Gallery and is always present intermittently. It is linked to the penetration of the coating of marl by thinly scattered, small openings or fissures in the cave roof, which let water drip through. This phenomenon encourages the growth of calcite in the form of short, squat stalactites, some tens of centimetres long, which develop in the hollows of the deep cavities of the roof. The only concretion of this type in the Axial Gallery, immediately next to the Great Black Bull, was formed as a result of a fissure that runs along the ceiling in the central part of the gallery. In the Hall of the Bulls they are more numerous and visible on both sides of the horizontal ridge that marks the uppermost level. Some of them rest on the projection of this formation, above the second and the sixth bulls, and the others are located below the overhang close to the third, fourth and fifth bulls. One variant is formed by a crystallization of 'butterfly wing' type, above the first bull's head. The conjunction of these calcite deposits and the aurochs head theme, which is found as many times as this concretion exists in Lascaux (i.e. seven), is quite remarkable.

The pedunculate form (ill. 32) only applies to a small section of the subterranean space. It is found in two areas: on the lower part of the left wall at the entrance to the Hall of the Bulls and below the first projection to the left of the entrance to the Axial Gallery. Its morphology resembles that of a club: it has a distal excrescence 2 to 3 millimetres in diameter but can be over a centimetre long. The only figure recorded in this environment is a small silhouette of a horse painted in black.

Even less common is the rhomboid form (ill. 33), which is the result of the juxtaposition of macro-crystals measuring some 8–10 millimetres along their edges. Its surface area is limited to some tens of square centimetres at the entrance to the Hall of the Bulls, on the lower ledge of the left wall.

The heterogeneity of supports leads to important variations in their characteristics, particularly in their photometric properties. The ability of a surface to absorb light plays a major role in determining how the parietal art is viewed. It is far harder to make out a painting that absorbs more light than its background, regardless of the colour of pigment used, partly because those areas where the paint has been less thickly applied become less visible. These factors had a huge influence on Palaeolithic man's experiences of the cave, as they affected the type and importance of the material used to light up an area. A chromatically dense wall implies the concomitant use of several sources of light. This might explain the abnormally high number of lamps recovered during excavations carried out at the foot of the Shaft Scene. In a more favourable setting where the surfaces are particularly reflective, such as the Axial Gallery or the Hall of the Bulls, a single lamp would suffice to illuminate the entire hall.

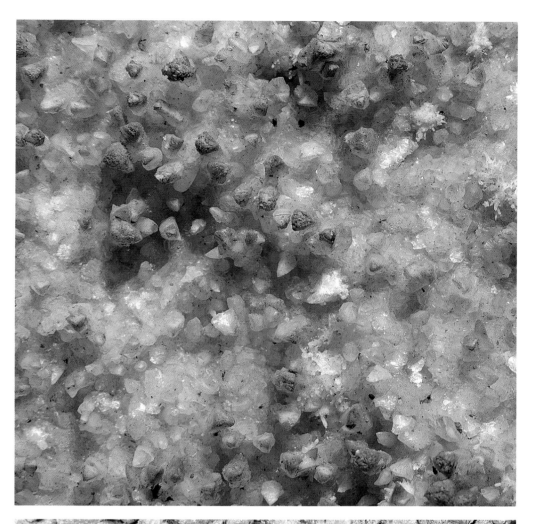

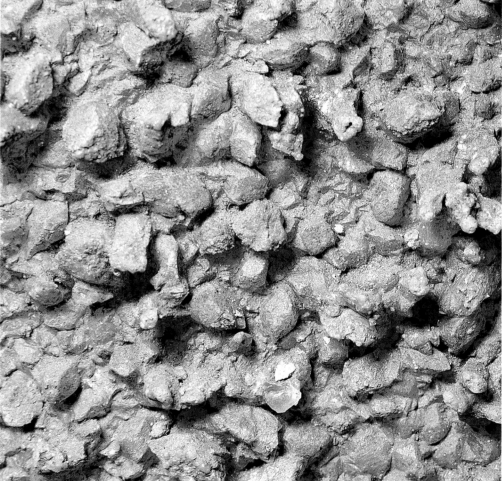

Left, above:
32 The pedunculate form of calcite outgrowths is only found over a small area of the Hall of the Bulls and the Axial Gallery.

Left, below:
33 Even more infrequent is the macro-crystalline type, found only on the left wall close to the entrance to the Hall of the Bulls.

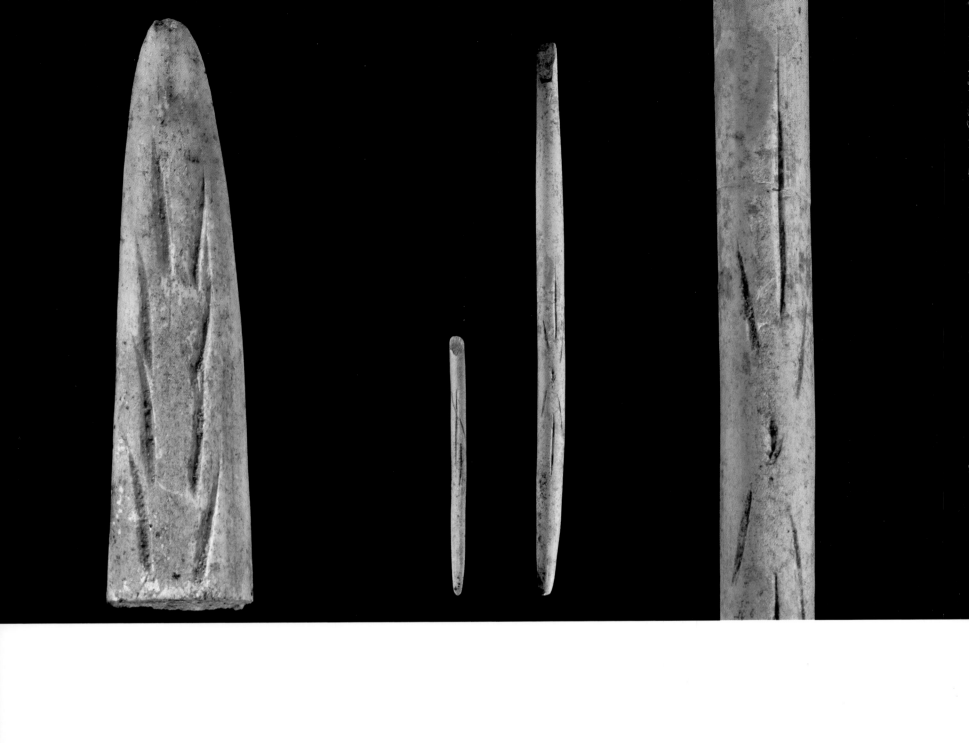

The Archaeological Context

Portable Objects

Lighting

Dating Lascaux

The Archaeological Context

Typically, one special feature of Palaeolithic sanctuaries is the scarcity of objects made of stone and bone. This is true of several recently discovered and well-protected sites, including Cosquer (Bouches-du-Rhône), Chauvet (Ardèche) and Cussac (Dordogne), and cannot therefore be attributed to vandalism. Lascaux is an exception to the rule, however, and is noteworthy for both the relative quantity and the specific nature of the material found there.

Portable Objects

After the discovery of the Lascaux Cave, objects were found on the floor and the slopes of the walls, highlighting how little sedimentation has taken place in the cave since the Palaeolithic. The portable objects left behind by Palaeolithic man are not always easy to find, however. In a few areas of the cave, such as the entrance zone, certain processes have affected the ancient ground surface and hidden any archaeological remains.

Roof collapse has been a key factor in the entrance zone. According to André Glory, there have been two major episodes of destabilization there. Variations in temperature caused the walls and the ceiling over the first few metres of the entrance to deteriorate further to different degrees – ranging from a few flakes to the collapse of blocks of rock. As we have seen, the movement of slope deposits also played a part in its infilling. Another factor is linked to the water collected in the marly layer above the entrance. The flow of this water, directed towards the cave interior by the slope of the cone of scree, disturbed the distribution of archaeological remains lying along its route and deposited a thick layer of calcite on two thirds of the floor, from the Hall of the Bulls to the Mondmilch Gallery and, to a lesser extent, towards the Axial Gallery. Another factor lies in the peculiar configuration of the galleries at the junction of the Apse and the Great Fissure. Before it was modified, the sandy-clay floor formed a plug between the two walls overhanging the Shaft. Small variations in humidity led to its continuous and regular disintegration, and the detached material progressively covered the archaeological floors at the foot of the Shaft Scene, 5 metres below.

There are few surviving records of the exact locations of archaeological finds in the early days. After the Second World War, however, as access to the cave was being

improved for tourists, various excavations were conducted. Henri Breuil, Séverin Blanc and André Glory were the only ones to carry out excavations there in line with the scientific norms of the time. Breuil and Blanc undertook a study of the Shaft in 1949, but between 1952 and 1963 Glory made extensive records of excavations in the whole cave. In the early 1960s, Glory oversaw the installation of an air-conditioning system, which was designed to extract air from various parts of the site – at the foot of the panel of the Upside-down Horse, for example, and at the entrances to the Nave and the Mondmilch Gallery. Work for the air-conditioning system entailed burying sheeting 60 centimetres in diameter 80 centimetres deep, and Glory was thus able to conduct a sample excavation of the entrance zone.

From the data collected during these excavations and their subsequent analysis, it would appear that Lascaux was visited by humans on three occasions during the Upper Palaeolithic. A few rare fragments of charcoal, the oldest proof of human presence, were found in the Passageway, the Nave and the Shaft, indicating that the initial visits were brief. A relatively large number of very diverse objects, dating from the same time as the parietal art, are attributed to a second occupation of the site. The purpose of many of the objects found remains unclear. Some were used for lighting or to decorate the walls. Others appear to have been for everyday use, such as jewelry, various tools and fragments of reindeer or red deer bone. Evidence for the third, most recent period of human use is only found in the first part of the cave on the scree, but it can also be seen in the calcited pools of the Passageway and directly below the Upside-down Horse. It seems that several people occupied the entrance during the Holocene. Rare traces of charcoal are the only evidence of this stay, and it is unclear whether these people penetrated into the sanctuary. The fragments found in the deeper parts of the cave could very well have been transported there by run-off water.

The criteria established to categorize objects by use are sometimes tenuous. The portable objects linked to drawing and painting include five grinding stones, three mortars and twenty-three limestone and schist plaques. The surfaces of these objects were stained by pigments, which enabled us to determine their function. It is more difficult to identify the tools used for engraving, however, and only very hard materials such as flint can be categorized with any certainty. Analysis has shown that only a very limited number of the pieces – bladelets, flakes, burins or scrapers – recovered at Lascaux bore traces that could be attributed to engraving.

Studies carried out on the raw materials used as colouring agents[12] led to the identification of a number of categories, as well as providing some insight into their preparation and utilization. These materials – in the form of powder, small chunks (ill. 34) or plaques – are accretions of metallic oxides, essentially of iron and manganese (ill. 35). Some traces have been interpreted as crayons. Nevertheless, the extensive studies we have made of the paintings and drawings themselves have never provided any evidence to support this hypothesis, even in the initial phases of positioning the figures. In effect, it looks like these marks were caused by scraping with flint tools in order to break down the chunks into powder.

Various clay objects have also been found at the site, although it seems unlikely that they could have served any practical purpose in decorating the cave. Nonetheless, it is through such inconspicuous objects that you sense the presence of the people – adults, adolescents or children. In the shapes of these objects you can see the traces of timeless actions over a plastic type of material. One such object is a roughly rectangular block (ill. 36), which bears traces of fingerprints.

Above:
34 Block of haematite showing traces of use over the entire surface, from the excavations by André Glory, 1959.

Above, top:
35 Block of manganese.

Above, bottom:
36 Block of shaped clay, on which several fingerprints were recorded.

Above, right:
37 Element of jewelry showing the intentional perforation of the shell. This shell of Sipho, collected from a beach, shows the existence at the time of exchange or movements over significant distances.

Opposite:
38 Objects found during the excavations by Henri Breuil and Séverin Blanc, 1947–49. Portable objects, lithic items and bones are rarely found in the context of parietal art. Here too, Lascaux forms an exception. Three hundred and fifty pieces were unearthed, including blades, backed bladelets, scrapers, burins and flakes.

We also managed to identify several small fragments of clay that looked like they had been idly compressed between the thumb, index and middle finger of both hands.

The second assemblage might be related to ritual activities and comprises many different types of objects, including jewelry (mainly shells), spearheads, remains of bones and lithic elements. There are sixteen shells (ill. 37) in total, most of which are fossils, collected randomly at various points since the cave's discovery. Three have perforations, indicating that they were used in items of jewelry. Yvette Taborin[13] identified both their species and their source: originating from Touraine and western France, they demonstrate the existence of exchange patterns or movements of groups of people over distances of several hundred kilometres. Among these objects, there is also a small pebble of ovoid form. Someone has shaped it to look like a marine gastropod, pointing one of its ends and incising its lower surface to imitate the spirals of a shell.

If traces found on some elements of the lithic assemblage (ill. 38) can be linked to engraving, other far more pronounced ones may be associated with woodworking. Indeed, on several occasions a number of relatively large charcoal fragments have been collected in the cave. Furthermore, backed bladelets dominate, making up 70 of the 112 tools identified. They are closely associated with the spearheads, especially in the Shaft and, to a lesser extent, in the Apse and the Passageway. Analysis shows that only one of their two longitudinal edges was sharp. The opposite edge and the ventral face of some of these bladelets were coated in a pinkish organic substance – mastic, which is rarely preserved. One of them revealed the slightly concave imprint of the object it was mounted into, a wooden shaft or baton of cervid antler. These objects therefore belong to the group of complex composite tools.

A significant number of objects, twenty-eight in total, are made of bone and antler, including intact or fragmentary spearheads (ill. 39), three pins, one one-eyed needle and an awl, as well as a worked antler spall and a modified reindeer antler beam. The presence of these objects poses a problem in the underground context. Nevertheless, the decorations on some of them confirm that they are contemporary with the iconography of the walls. On one of the fragments a succession of nested angular motifs is visible, identical to those engraved on the flanks of the red deer and the horse in the Apse, at the junction with the Passageway. This same motif is incised on the handle of the pink sandstone lamp discovered in the Shaft. Identical observations can be made regarding another intact spearhead and on two other fragments, the characteristic cruciform signs of which are repeated on the walls, particularly in the Axial Gallery (behind the

Great Black Bull) but also in the Passageway (on the rump of the horse on the right wall, close to the Apse). On the same horse is engraved a line of dashes in the form of parentheses, motifs resembling those found on the reindeer antler beam. A final example is another spearhead, on which the star-like decoration, composed of unconnected elements, links it to figures on the walls – notably the equid facing the above-mentioned horse.

This catalogue of motifs – found in the parietal works of art, the portable bone and antler assemblage, and the material used for illumination – testify to the homogeneity of the ensemble. Even before undertaking a more thorough analysis of the parietal art, these observations provide an insight into the unique and uniform character of this sanctuary.

Lighting

Palaeolithic man used several types of lighting to explore the underground environment. The narrowness of the cave entrance – limiting the penetration of daylight to only a few metres – and the nature of the system of galleries made it necessary to use some form of lighting. In some caves, marks on walls, ledges or floors, where Palaeolithic man snuffed out torches and lamps, and traces of hearths survive to this day. Different types of lighting were used for different activities: hearths illuminated one whole sector, torches aided passage through the cave, and lamps produced a more defined light for artistic activities.

We know that lamps were certainly used at Lascaux. The other forms of lighting, based on calcined organic material, are more difficult to locate and identify. However, the huge number of charcoal fragments recovered – moved and dispersed by the flow of underground water or the movement of man – would suggest that there were indeed hearths. They were not preserved in their original condition, but pieces of

Above:
39 Spearheads found during the excavations by Henri Breuil and Séverin Blanc, 1947–49, featuring cruciform incisions or convergent nested elements.

Opposite:
40 Lamp of rose-coloured sandstone, found at the foot of the Shaft Scene during excavations by André Glory, 1959. It bears two signs on the upper face of the handle.

charcoal from them were carried away by water and scattered, or trampled. As for torches, no traces of smuts have been discovered on the walls at Lascaux. The high density of the figures painted and engraved on the walls and respect for the art and the walls might explain this absence.

Lamps at that time were made of durable minerals, and many have survived. Chance discoveries and excavations have yielded more than a hundred specimens. The majority are simple limestone slabs, sometimes with a slight concavity where the combustible material (animal fat) would have been placed. This natural depression makes it easy to identify these objects as lamps, but often there are also black carbonaceous residues and, in cases of prolonged use, even red colouration.

Two of the portable objects recovered during André Glory's excavations in the Shaft merit closer inspection. One, a tallow-burning lamp made of pink sandstone (ill. 40), is intact, but the other, a rim, is just a fragment of a second lamp. The complete lamp is much more elaborate than the other examples. Measuring a maximum of 22.4 centimetres by 10.6 centimetres and with an average depth of 3 centimetres, it was manufactured in the shape of a tennis racket. There are remains of combustion in the concave section, identified as carbonized fragments of juniper and coniferous wood. The edge of the hollow is blackened over several centimetres. The handle is decorated with two nested engraved symbols, identical to those found on the walls of the Apse, the Axial Gallery, the Nave and the Chamber of the Felines, as well as on a spear. An engraved longitudinal line runs between and separates the two sets of incisions. The fragmentary rim bears similarities to the intact lamp as they were both manufactured in the same way.

The majority of these objects were found at the foot of the Shaft Scene and the panel of the Great Black Cow in the Nave. These

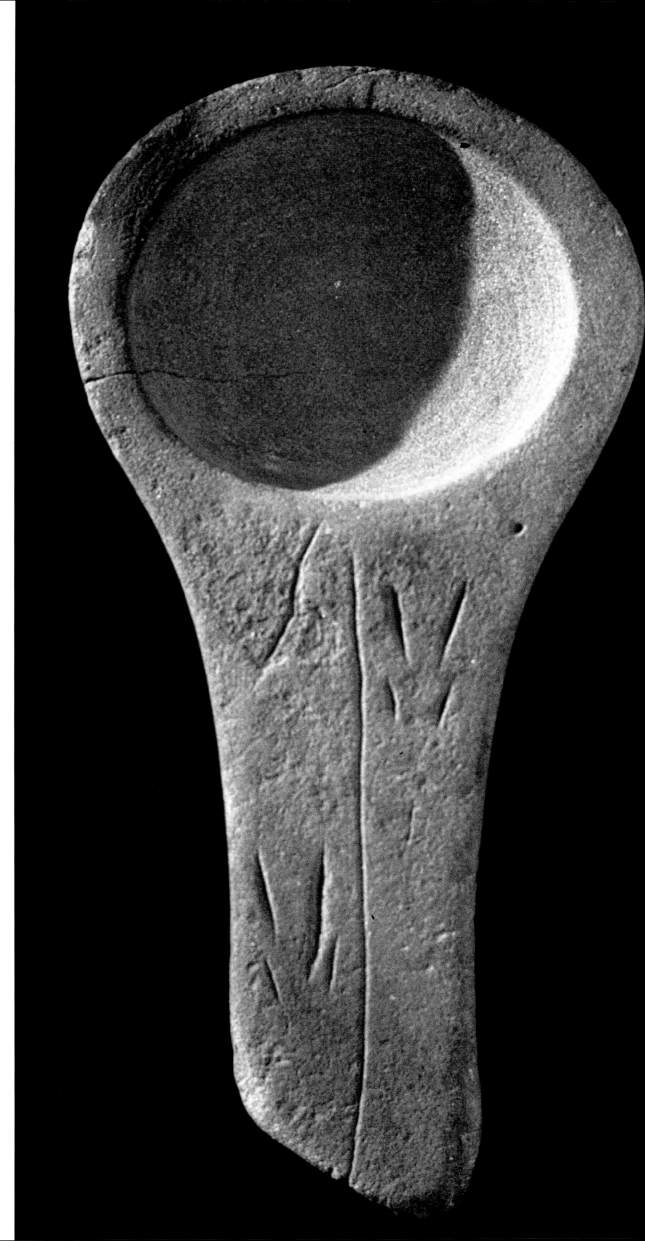

two locations also have the highest levels of carbon dioxide in the cave: here, the concentration of carbon dioxide often lies between 1 and 3 per cent, or indeed more, and it can exceed 6 per cent in the Shaft. These concentrations vary during the year, reaching their highest in summer and autumn. It may just be a coincidence that the majority of lamps were found where carbon dioxide levels are at their highest. However, it is possible that the high concentration of carbon dioxide necessitated the use of the numerous lamps found in those locations, as the flame of a candle or oil lamp would be affected by a carbon dioxide concentration of 2 per cent and is often extinguished when it exceeds 3 per cent.

Dating Lascaux

The relatively important assemblage of portable objects recovered *in situ* and the limited number of incursions into the deep galleries of the cave during the entire Upper Palaeolithic have helped in working out the chronology of Lascaux. The inaccessibility of the entrance – largely due to its position on the mid-slope of a smooth-faced hill, where it has been subject to extensive solifluction, and its instability – ensured that the cave remained relatively undisturbed. During certain periods, the entrance was entirely closed up. The entrances to cave systems in this type of topographical relief are always of modest dimensions and thus difficult to locate, limiting access and human intrusion.

In areas characterized by steep walls and high overhangs, such as the region around Les Eyzies-de-Tayac, the situation could not be more different. These formations favour permanent access to the underground realm. Located at the foot of a cliff, the caves are less susceptible to natural phenomena and have been much easier to find over the course of time. Thus, at Font-de-Gaume, just as at La Mouthe, La Grèze or Oreille-d'Enfer, parietal art and excavations reveal several occupations of the same site, from the Aurignacian up until the Upper Magdalenian (ill. 41). (…)

Henri Breuil and Denis Peyrony were the first to assess the chronology of Lascaux, looking at parietal art and portable objects respectively. Both of them established an association with the Upper Perigordian (known today as the Gravettian). For Breuil, the chronology of the Palaeolithic parietal art depended on two cycles: one Aurignacian-Perigordian, the other Solutrean-Magdalenian. Using the stratigraphy of decorated rock from Abri Labattut and Abri Blanchard (Aurignacian), he was able to date Lascaux's art. The blocks from Abri Labattut and Abri Blanchard depicted a cervid and a bovine, and aurochs or bison respectively. For Breuil, the morphology of the animals and the technique of their engraving bore striking similarities to works in the Hall of the Bulls or the Axial Gallery. But the most marked difference lay in the use of perspective, particularly in the horns and hooves of the bovines. Breuil noticed a distortion of the contours of the great aurochs: the right horns follow a simple curve, whereas the left horns are marked by a double curve. Furthermore, the hooves seem to face the onlooker.

Annette Laming-Emperaire drew a different conclusion from Breuil's findings, pointing out that the features of this iconography could in fact be attributed to both of the two major cycles. Séverin Blanc, on the other hand, thought that part of the art was probably Solutrean-Magdalenian in origin. In support of his thesis, he quoted certain conventions that have little in common with Perigordian art, particularly the treatment of the limbs in the background – the way in which they are separated from the body through the use of a blank, and the animation given to the animals in the double inflection of the legs.

Each theory had its advocates and detractors. In 1951, one of the very first radiocarbon tests was carried out. Fragments

BP	Upper Palaeolithic Technological Stages	Sites	H. Breuil	A. Leroi-Gourhan
			Cycles	Styles

BP	Upper Palaeolithic Technological Stages	Sites	H. Breuil Cycles	A. Leroi-Gourhan Styles
10 000	Azilian	Teyjat	Solutrean-Magdalenian	IV
	Upper Magdalenian	Niaux		
15 000	Middle Magdalenian	Font-de-Gaume		III
	Lower Magdalenian	Lascaux		
20 000	Solutrean	Tête-du-Lion		II
	Proto-Magdalenian			
	Gravettian			I
25 000		Cosquer	Aurignacian-Perigordian	
	Aurignacian	Gargas		
30 000		Chauvet-Pont-d'Arc		
	Châtelperronian			Pre-figurative
35 000				

41 Chronology of parietal art during the Upper Palaeolithic.

of charcoal from excavations in the Shaft were analysed in Chicago at the laboratory of Willard Libby, who pioneered the method. The results seemed to corroborate the second theory, assigning a date of *c.* 15,500 BP (Magdalenian) to Lascaux. (BP stands for 'Before Present'.) After some controversy, the theory developed by Henri Breuil was subsequently abandoned.

André Glory refused to be swayed either way. Then, as his research was at quite an advanced stage, he collected a lot more data and started to develop his own chronology. Furthermore, when he had new samples of charcoal from his excavations in the Passageway and the Shaft dated, the results yielded dates of 17,190 ± 140 BP and 16,000 ± 500 BP respectively, which backed up the theory that the portable objects belonged to an ancient phase of the Magdalenian. On the other hand, the charcoal washed into the cave and found immediately below the calcited basins of the Hall of the Bulls and the Passageway, together with that recovered from the debris cone in the entrance zone, showed a possible occupation of the site during the Mesolithic. This last attempt to enter the cave, which was perhaps merely an occupation close to the entrance, has left absolutely no trace of portable objects or colouring matter. The weighted mean of the five more recent dates is 8380 ± 60 BP.

Another theory came from the prehistorian André Leroi-Gourhan. Distancing himself from Breuil, Leroi-Gourhan subdivided the evolution of prehistoric art into five periods: a pre-figurative period, followed by four phases or styles. His work, though not focusing on Lascaux, made reference to its iconography in the definition of Style III (defined as the end of the Solutrean to the Lower Magdalenian). This Style III possesses specific characteristics: '…animals with inflated bodies and diverging short feet, horns of bovines in which the front horn is a simple curve whereas the rear horn is sinuous, bison horns depicted in front-view, deer antlers in a specific perspective, the brow tine in the background parallel to the beam of the antler in the foreground, and with a double or triple brow tine.'

The well-dated sites of Fourneau-du-Diable and Roc-de-Sers served as reference points. They enabled Leroi-Gourhan to specify that, 'it would be…rational to think that Lascaux is Solutrean and it cannot be ruled out that the most ancient figures are of this period'.[14] This implies multiple occupation of the cave at different periods, suggesting a certain heterogeneity of the works of art involving both the animals and the geometric signs. Leroi-Gourhan emphasized this: 'Lascaux would comprise…three phases: the phase of partitioned rectangular signs…the phase of bracketed signs, which are few in number and correspond to the period in which the Chinese Horses were executed in a style already close to that of the old Style IV and, finally, the phase of true claviform signs which is already in the old Style IV…. This scheme of suppositions is accordingly concrete enough to locate the entire art of Lascaux between the second half of the Solutrean and the beginning of the Middle Magdalenian.'[15]

Nevertheless, a few years later, study of the lithic and organic portable objects and the stratigraphic analysis of the sections cut by André Glory brought further changes to Leroi-Gourhan's scheme. Arlette Leroi-Gourhan and Jacques Allain[16] directed the work, which narrowed down estimates of the chronology and attributed Lascaux to the Magdalenian II. The study convinced André Leroi-Gourhan that the sanctuary was created over a limited period of time with stylistically homogeneous figures.

These successive corrections show the difficulties in establishing a precise and secure chronological scheme. Furthermore, a radiocarbon result of 18,600 ± 190 BP, obtained in 1998[17] on a sample removed

from a fragment of a reindeer antler baton from the excavations of Henri Breuil and Séverin Blanc at the foot of the panel of the Shaft Scene,[18] tends to raise the former age estimates, placing the art at the boundary between the Upper Solutrean and the Badegoulian.

This new information calls for a review of the preceding hypotheses. Unfortunately, the paintings and drawings of Lascaux do not contain charcoal. We therefore have to use other methods of analysis and compare our results with data from better-dated Palaeolithic sites. This comparative analysis is based on a broad range of data, ranging from the portable lithic and organic objects to the formal characteristics of the figures in the paintings and the composition of the panels. The themes depicted in the art and the landscapes surrounding the cave are also important factors to take into consideration.

Analysing the lithic assemblage brought into the cave by Palaeolithic man requires a different approach to the study of habitation sites, be they temporary or permanent, in the open or under rock shelters. The cave functioned as a type of filter, encouraging the painters and engravers to select only part of the range of tools available to them. This is why it is misleading to classify the portable objects by looking merely at the quantities recovered, such as the high number of backed bladelets. Moreover, the majority of collected objects, including the backed bladelets, needles and spearheads, could just as well belong to the Solutrean as the Magdalenian.

As André Leroi-Gourhan originally pointed out, analysing the forms depicted at Lascaux suggests that the cave's parietal art could date back to the Solutrean. The paintings and engravings do call to mind the works at Fourneau-du-Diable or Roc-de-Sers, which have been convincingly identified as Solutrean rather than Magdalenian art. This analysis, based upon morphological comparisons between the outlines of the animals, was recently criticized after radiocarbon tests carried out in other caves seemed to raise doubts over the accuracy of the method. Such was the case at the Chauvet Cave, although careful study of the Chauvet figures shows that the most accomplished ones, particularly those in the panel of the Horses or the End Chamber, do not fit into any defined framework. Indeed, some of their characteristics are unlike any other known specimens.

Form-based comparisons continue to be used today to date parietal art, without recourse to radiocarbon tests. A whole host of decorated caves discovered over the last ten years were originally dated by hypotheses rather than physical methods, including Cussac, Pestillac and Lagrave (Lot) and Cosquer. When radiocarbon dates have been obtained later (as is the case with Cussac and Cosquer), they have confirmed the initial attributions.

Geometrical signs tend to back up the connection made between the Lascaux art and the Solutrean. In the cave of Le Placard (Charente), Louis Duport discovered a long panel, engraved with numerous depictions of animals and signs. Excavations directed by Jean Clottes[19] placed these works in the Solutrean. Among them, he recognized several signs, which he called the 'Placard type'. They are identical in their form to the 'chimney' signs in the caves of Cougnac and Pech-Merle (Lot). Furthermore, he noticed the similarity of the shape with the large black 'curly bracket' sign that underlines the diptych of the first Chinese horse at Lascaux.

In addition, the Confronted Ibexes drawn on the right wall at the end of the Axial Gallery are not dissimilar to those shown in bas-relief at Roc-de-Sers. At this same Upper Solutrean site there is also the rare image of a man confronted by a horned animal, in this case a musk ox. This scene is repeated at Lascaux at the base of the Shaft, with the bison, so it seems, replacing the musk ox. Both of these sites also feature a bird, a theme rarely encountered in this context.

42 Depiction of two aurochs on both faces of a palmate reindeer antler, Le Placard, Vilhonneur, Charente.

The fauna represented on the walls of Lascaux indicates a relatively temperate climate, particularly in those scenes in which aurochs are depicted. However, palaeontological research shows that almost no bone remains of this species have been found from the period in the region. This period, stretching from the Upper Solutrean to the Badegoulian, is regarded as the coldest of the Upper Palaeolithic.[20] One problem is that it is extremely difficult to distinguish between aurochs and bison bones, and a significant proportion of the total recovered remains unidentified. Nonetheless, there are several paintings that show man encountering this species. There are also depictions of aurochs at other, accurately dated sites, including Fourneau-du-Diable and Le Placard, where a palmate reindeer antler was discovered with engravings of aurochs on both faces (ill. 42). One face of the block from Fourneau-du-Diable bears several depictions (ill. 43) in bas-relief. This contemporaneous depiction of bovines on the walls of Lascaux and on the portable

objects of several Solutrean prehistoric sites suggests that this animal was observed in the vicinity of Lascaux or further south, where the recovered fauna has proved its existence. Moreover, studies carried out recently on climatic variation during the Upper Palaeolithic show that – contrary to what had been said up to the 1990s – these fluctuations in temperature were often considerable but very brief. Such abrupt changes of climate would certainly have resulted in north–south migrations of animal populations, with very short periods of stability, which would partly explain the very elusive presence of the aurochs in the Black Perigord.

In a chronological study of the art of Lascaux it is always important to remember that the various hypotheses only contemplate a time scale limited to, at most, one and a half millennia, a relatively short period of time. In the special context of parietal art, where works are only rarely associated with archaeological levels *in situ*, as at Pair-non-Pair or Le Placard, in particular, and in the absence of datable organic pigment, we have little chance of achieving greater accuracy.

The cultural attribution is also worthy of investigation. Once again, analysis of the pictures is able to provide some of the answers. The confrontation between the man and the bison takes on its full significance when it is compared with similar images in other decorated caves. In the Vézère drainage basin, it is found in a less elaborate form at Saint-Cirq (only the head of the bison was engraved), and at Bara-Bahau (an abbreviated version, which

contains the head of a bison and a phallus). A similar image can be seen at Gabillou, in the valley of the Isle, but this time the two motifs are merged into a single representation, that of the bison-man. At Villars, further to the north, in the drainage basin of the Dronne, the scene takes on a form identical to that at Lascaux.

These comparisons can be taken even further, as the locations of the sites provide us with even more information. Indeed, Lascaux, Saint-Cirq, Bara-Bahau, Gabillou and Villars, decorated caves possibly belonging to this chronological period, are all located on smoothly sloping hillsides and share similar landscapes in the immediate proximity of their entrances. This latter point distinguishes them from the decorated caves of the Middle Magdalenian – Font-de-Gaume, Rouffignac, Les Combarelles or Bernifal – which open into the heart of a far more steep-sided relief. The same is true of Solutrean-Badegoulian habitation sites, which are also located on hillsides, overlooking an open landscape, in contrast to the majority of sites of the Middle and Upper Magdalenian. These observations suggest that notions of territory, whether sacred or profane, are linked intimately and uniquely to a specific period of the Upper Palaeolithic, a concept we will need to examine more closely.

43 Aurochs executed in bas-relief (detail and overall view), Abri du Fourneau-du-Diable, Bourdeilles. Research of Denis Peyrony, 1924.

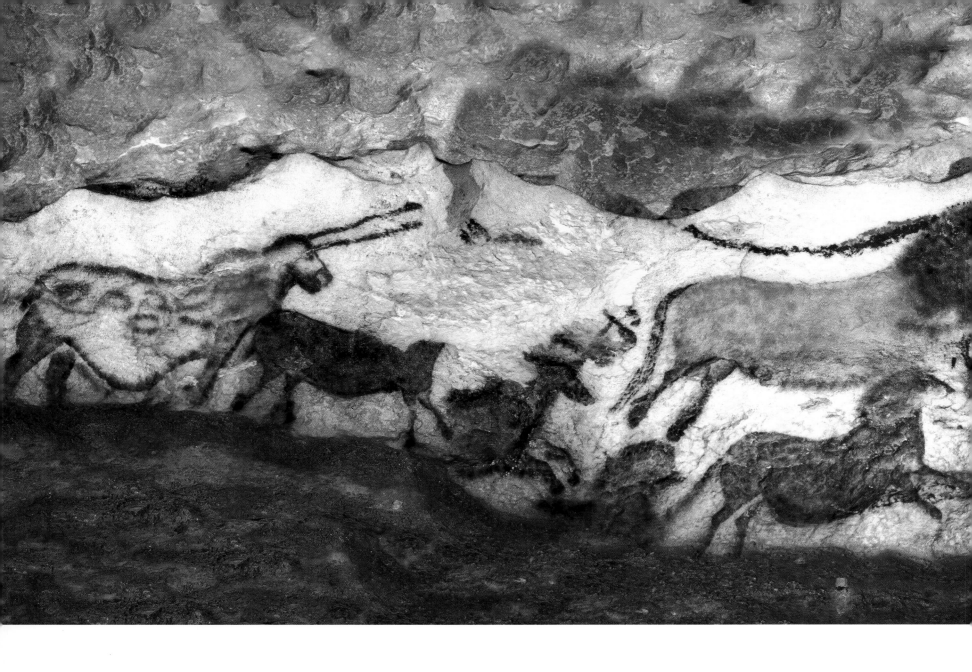

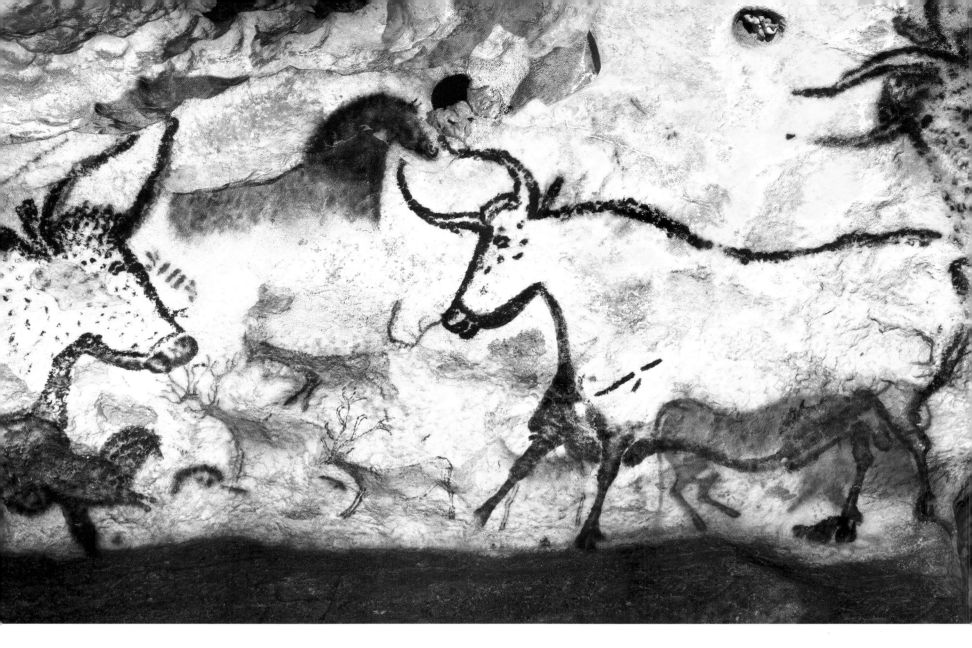

The Art of Lascaux

CHAPTER 5
The Art of Lascaux

In studying the works on the walls of this site, it is necessary to look at not only the figurative representations (animals and man) but also the schematic elements, particularly the signs, and the indeterminate figures. The marks that do not fall into these three categories – such as traces of activities, impacts of tools, sprayed colouring materials, colours for painting, abrasions, smears or deposits of charcoal – will not be taken into account here.

Lascaux boasts 1,963 registered figures, making it the most impressive Palaeolithic decorated cave. With the exception of the Mondmilch Gallery and the Silted-up Chamber, where the walls do not lend themselves to painting or engraving, and the second part of the Great Fissure, which is really only an access area, there are figures in all of the galleries and halls.

The distribution of these figures is uneven (ill. 44). The majority – over half of the total number – are on the walls of the Apse, although it only accounts for an estimated 6 per cent of the total decorated surface of the cave. The density of figures here is exceptional. The Passageway has the second highest number. And yet, because these two sectors lack visual impact, it is not always easy to see the high proportions of figures on first inspection. This has as much to do with the technique used (engraving) as the poor preservation of the figures or the less favourable characteristics of the support.

Humans play an inconspicuous role at Lascaux: the one human depicted is located well away from the more accessible sectors. Animal themes, on the other hand, are distributed throughout the cave and, with 915 figures, dominate the entire iconography. As some are in such a poor state of preservation, only 605 of the 915 have been accurately identified. Some species, especially the bovines, have such strikingly similar characteristics that it is very difficult to tell the bison and aurochs apart. In some cases the features by which we recognize the subject are restricted to the horns or hooves. Both the aurochs and the bison have these features, hence the high number of figures assigned to the general classification of 'bovine family'. Others have been painted or engraved in a highly ambiguous manner, such as the Unicorn.

Horses are depicted the most frequently, with 364 representations, forming 60.2 per cent of all identified animals, followed by

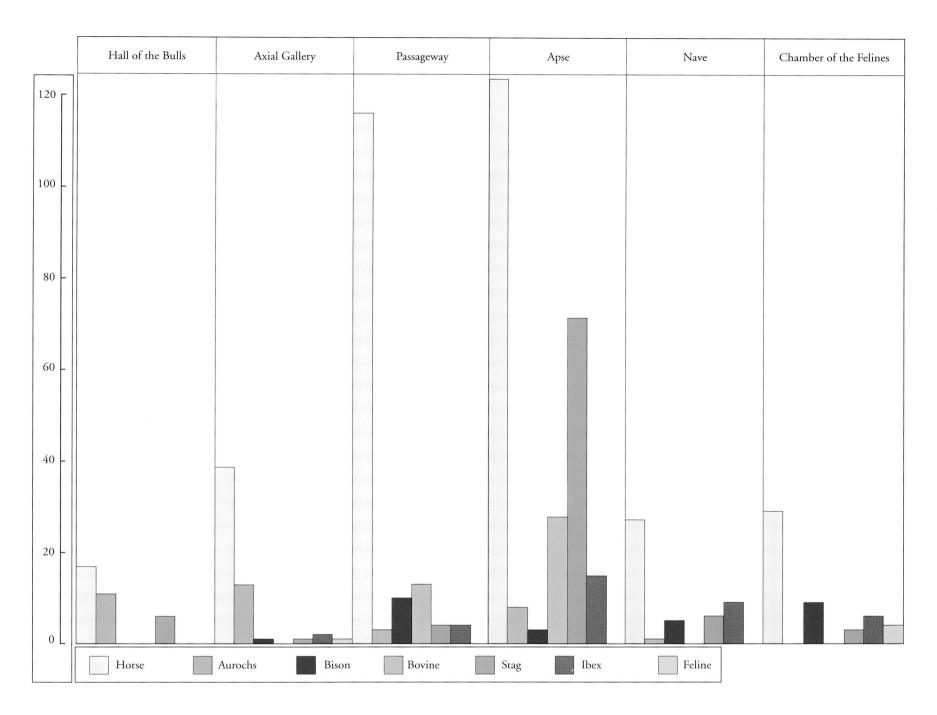

| Hall of the Bulls | Axial Gallery | Passageway | Apse | Nave | Chamber of the Felines |

Horse · Aurochs · Bison · Bovine · Stag · Ibex · Feline

stags with 90 representations (14.9 per cent). Aurochs and bison account for 4.6 per cent and 4.3 per cent respectively, plus there are 51 unidentifiable animals that are classified simply as bovines. Rare animals include 7 felines (1.2 per cent), one bird, one bear and one rhinoceros.

The proportion of each animal type varies from one sector to the next, sometimes to a significant extent. The equids, with quite an even distribution excluding the Shaft, is the only group in which this is not the case. The cervids, well represented in the Hall of the Bulls and, to a lesser extent, in the

Apse and the Nave, are less prominent on the walls of the Axial Gallery, the Passageway and the Chamber of the Felines. The ibexes show an inverse distribution pattern.

This interchange of animals is also recorded for the bovine species. The aurochs, which are particularly prominent in the first two sectors, both in terms of their numbers and especially in their dimensions, are replaced by bison in the other sectors. The very different placement of these two types of bovine is also noteworthy. The bison occupy a marginal position in relation to the different underground spaces, such as the

44 Numerical distribution of the animals represented in the Lascaux Cave.

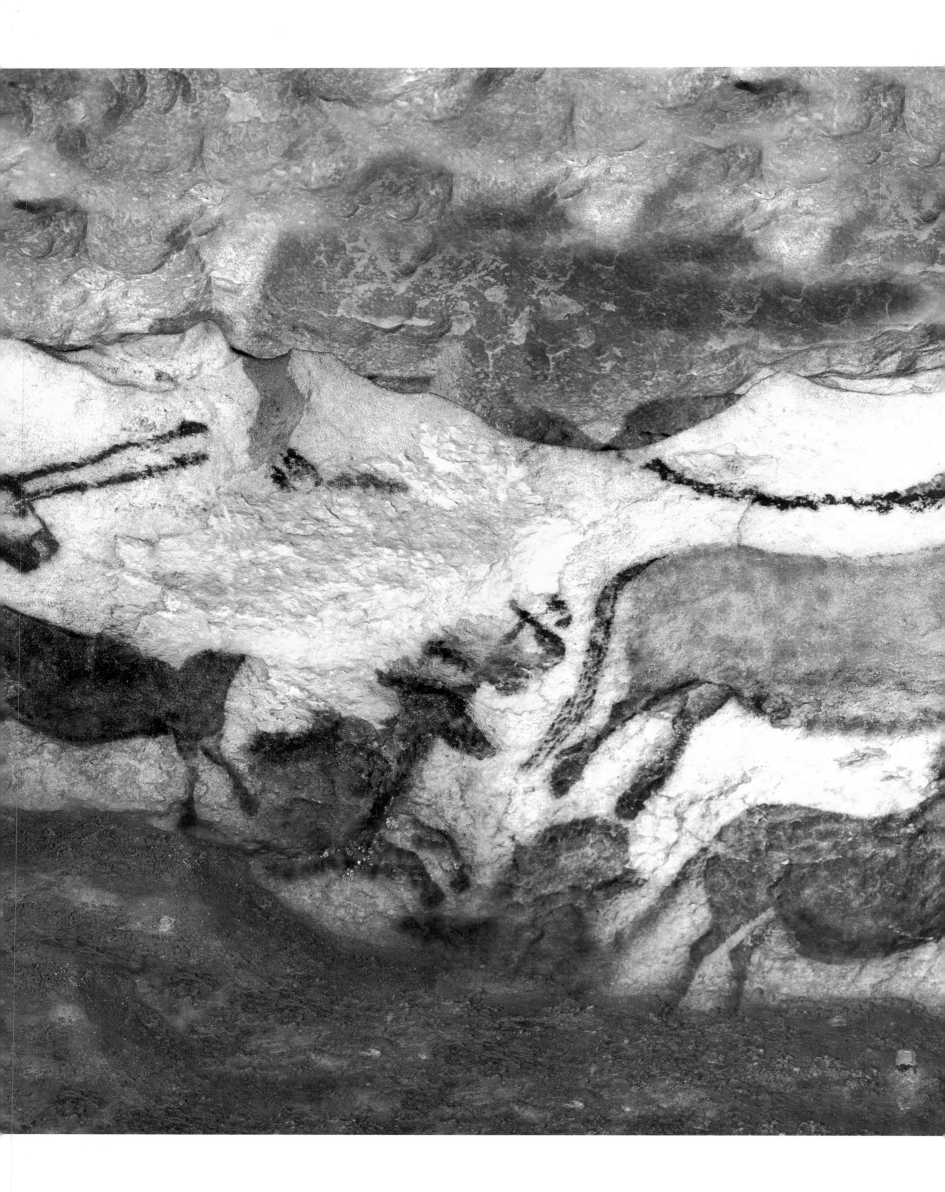

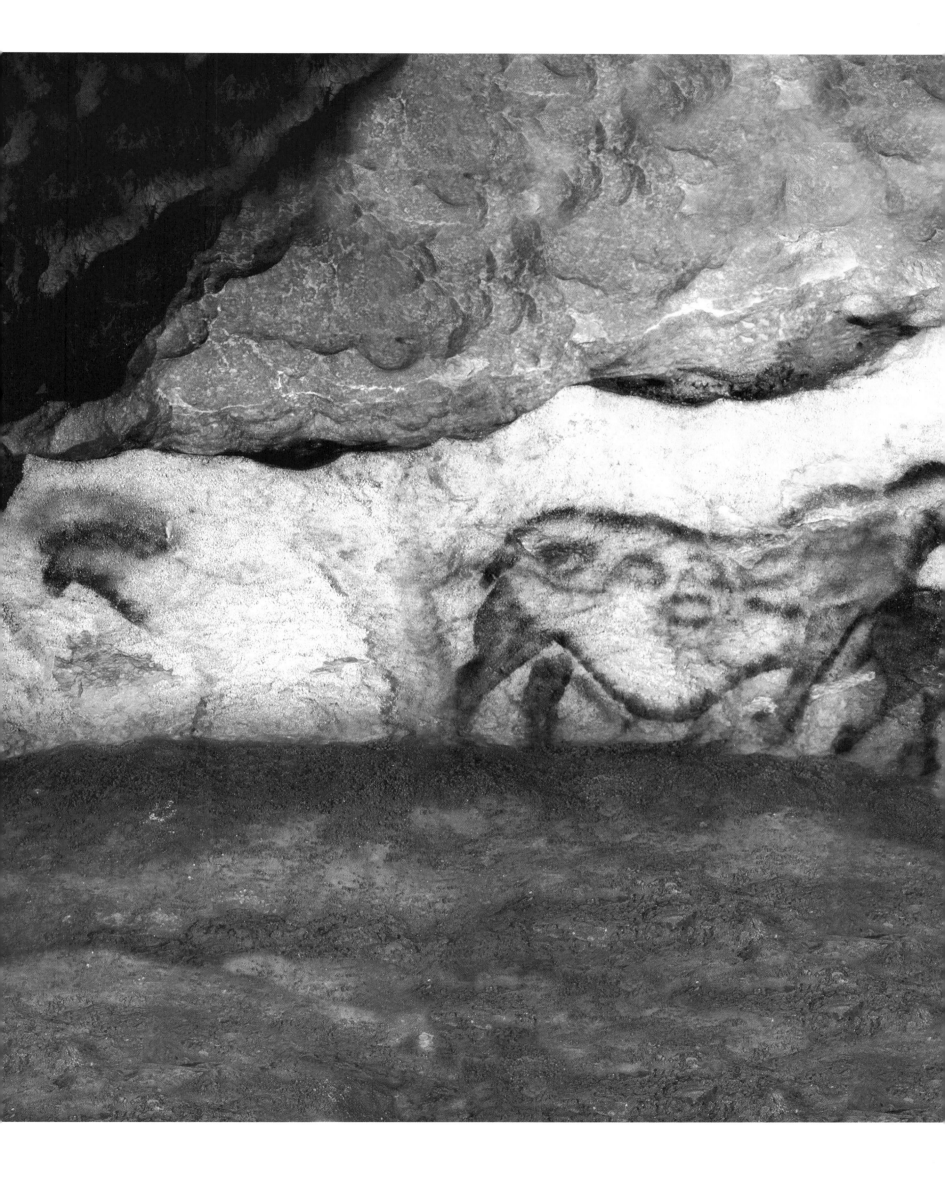

Axial Gallery and the Chamber of the Felines, and in specific compositions, such as the Red Panel, the Imprint and the Shaft Scene. By contrast, the aurochs take a central role in the Hall of the Bulls and the panels of the Great Black Cow and the Falling Cow, in the most easily accessible sectors.

The numerous signs account for almost 22.1 per cent of the ensemble. They have a similar distribution to the animals, but there are some differences. Again, it is the Apse, with 228 units, that contains the greatest number of geometric figures, followed by the Passageway with 81. There are between 25 and 35 signs in each of the other sectors. The huge diversity of the signs is based on three fundamental geometric elements: the dot, the line and surface area.

As we have seen, another special feature is their close graphic relationship to the portable objects – especially the spearheads, which feature motifs that are identical to those engraved or drawn on the walls. The same is true of the pink sandstone lamp previously mentioned. Its handle, decorated with nested signs, features a geometrical image found repeatedly in the iconography of the walls. Thus, there are close connections between the parietal art and the decorations on portable objects, but there are also connections between disparate portable objects with very different functions.

The number of indeterminate figures or incomplete traces in any one sector may have been determined by their location in the sanctuary. While in the first two sectors most of these can be classed as trial paintings and unfinished outlines that are difficult to interpret, the difficulty in identifying the

figures in the Passageway and the Apse lies not in their representation but in their very poor state of preservation. In the worst-affected areas, the heavily corroded and distorted figures often disappear from the more exposed surfaces and only survive in concavities. Another factor that makes figures difficult to identify is the extreme superimposition of the outlines, particularly in the Apse.

Whether the figures were depicted individually or in groups, positioning was influenced by several parameters – constraints connected with problems of perspective or the physical environment. These constraints did not govern the choice of themes, nor did they influence how the elements in different ensembles were ordered, but they did play a major role in determining the general shape of compositions within the limits imposed by structure (the ridges, ledges or projections of the walls, for instance).

The Fragmentary Depictions of the Entrance Zone

Above all, the entrance zone is a means of access. Its function as a transitional space explains to a large extent why so few figures have been identified there. There are only four that have been accepted as Palaeolithic: three red figures on the left wall, and a single broad and diffuse black mark on the opposite wall. They are all situated in the modern engine room, at the same height as the present-day floor and a few decimetres above the deposit that originally filled the entry to the gallery.

45 Sequence of the left wall of the Hall of the Bulls.

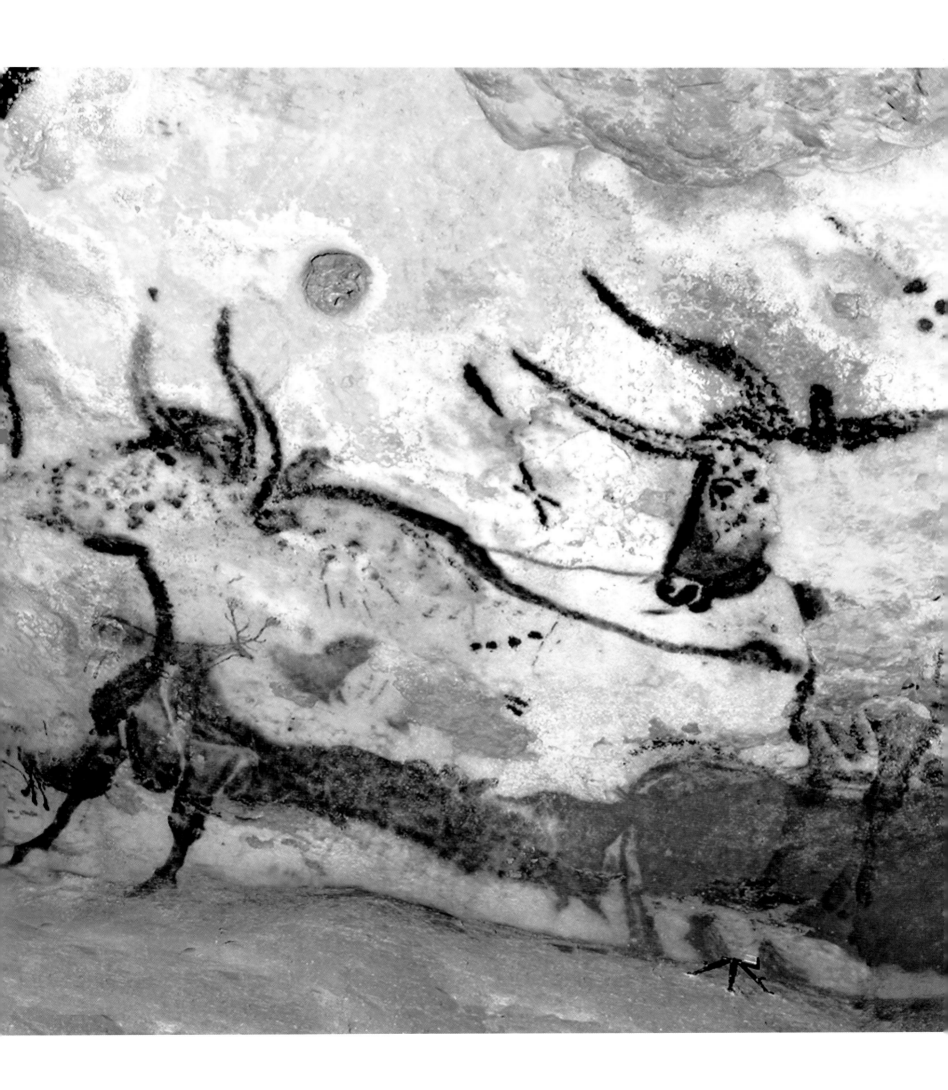

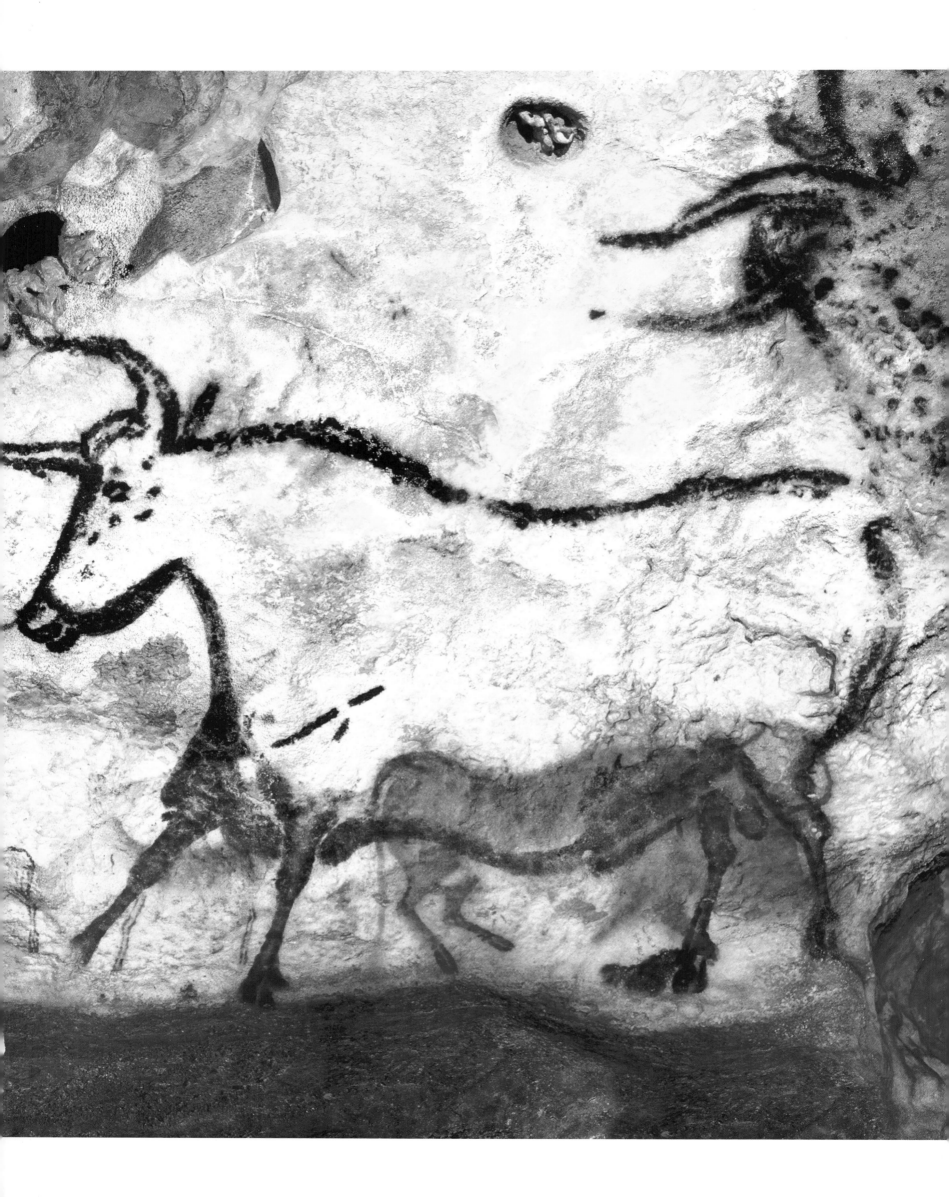

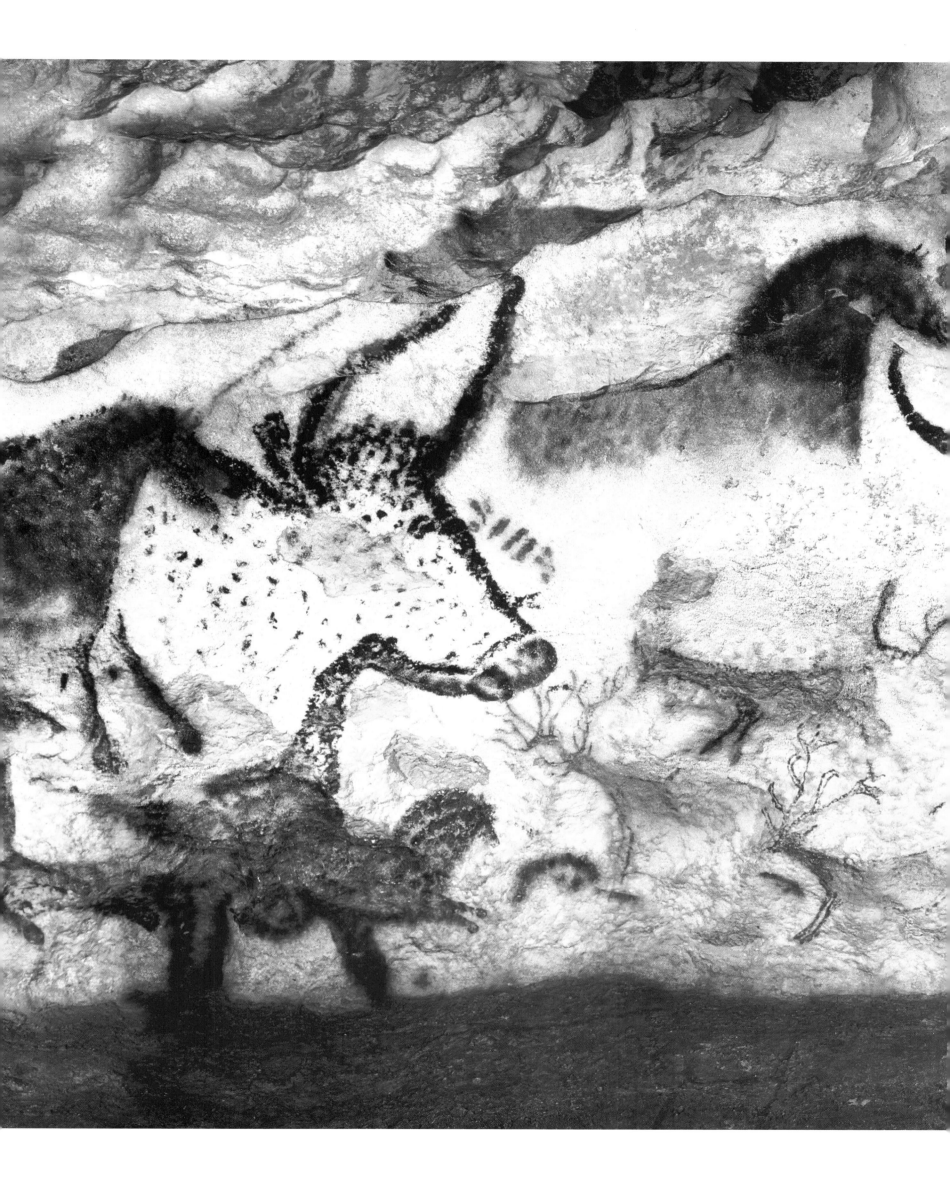

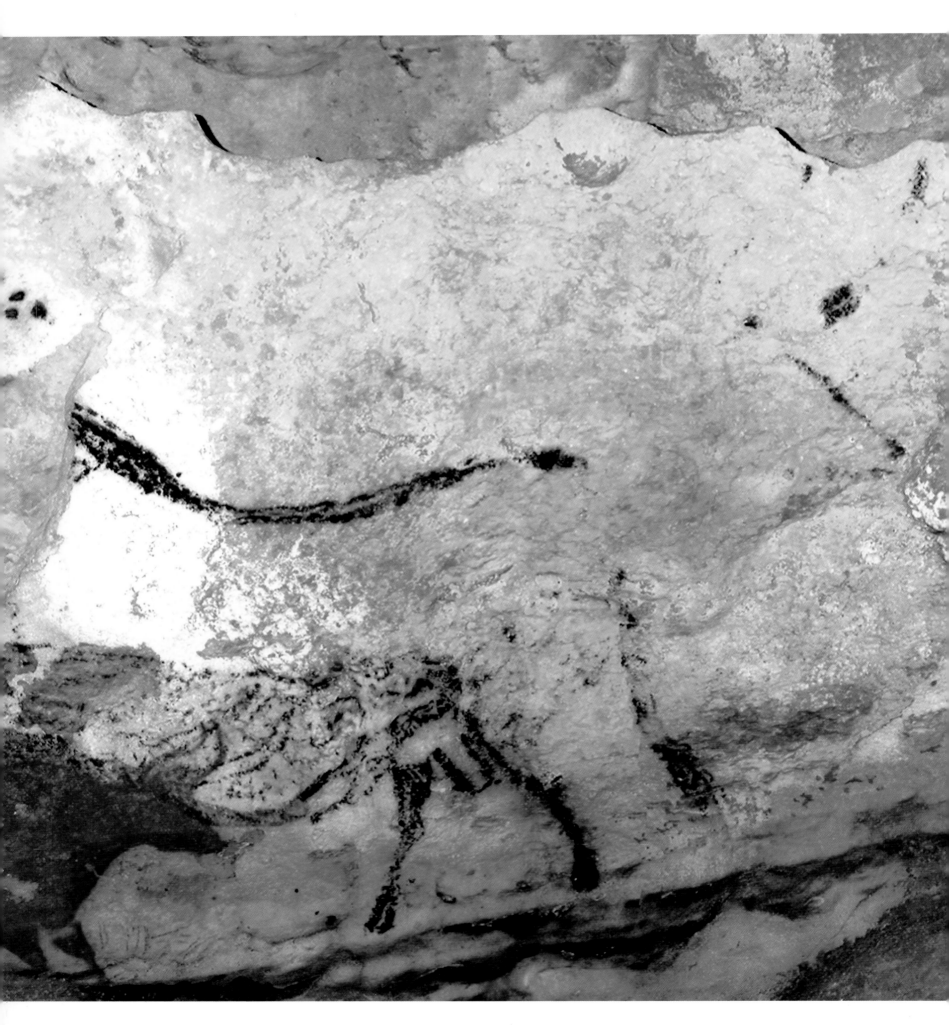

46 The fourth and fifth bulls dominate the right wall graphically. The other themes remain very discreet, varied and few in number, indeed sometimes unfinished, contrasting in this aspect with the panel on the facing wall.

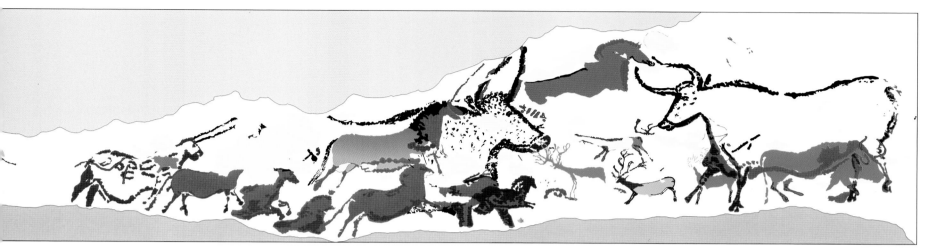

The Hall of the Bulls

Taking into account the morphology, the texture of the lithic support and the works of art themselves (mainly paintings and drawings), the walls of the Hall of the Bulls can be subdivided into three superimposed levels. Only the middle section is decorated. This long panel, following a horseshoe-shaped trajectory, circles the entire hall between the ledge at its base and the ridge marking the beginning of the upper panel. Its width increases from 1 metre at the entrance to 4 metres at the back of the hall, and its inclination gradually becomes more pronounced, reaching an angle of 70° (relative to the vertical) at its most developed. The decorated surface gradually turns into a ceiling formation, although this is difficult to capture in a photograph. When you look at the scene as a whole, however, the animals depicted at this angle are clearly distorted. Only by standing at the base of each figure can you see their true shape. A carbonate crust covers the entire rock surface. The uniformity of this covering is only disturbed at a few points, where scars have been left by flaking and corrosion.

The iconography of the Hall of the Bulls extends from the Unicorn – or, more precisely, from the black head and neck of the equid located on the left wall immediately after the entrance (ill. 45) – to that of the

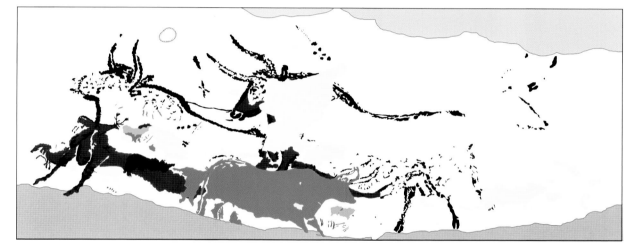

sixth bull on the opposite wall (ill. 46). The decoration is very scanty over the first few metres of the composition, on both sides of the hall, but becomes denser as you move through the hall, and reaches its maximum towards the middle of the hall.

The Hall of the Bulls contains a total of 130 figurative and geometric images (ill. 47). There are 36 identified representations of animals, which can be divided into four types: 17 horses, 11 bovines, 6 stags and one bear. The identity of the remaining two animals – a quadruped and the Unicorn – has been more difficult to determine with any accuracy. There are some 50 signs in total, most often grouped together, but they have less of a visual impact. They fall into two classes: dots and linear figures, such as bars and nested or branching forms.

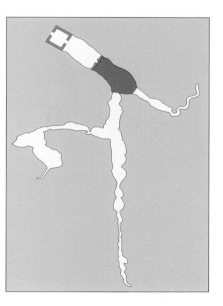

Above, top:
47 Overview of the ensemble of figures in the Hall of the Bulls.

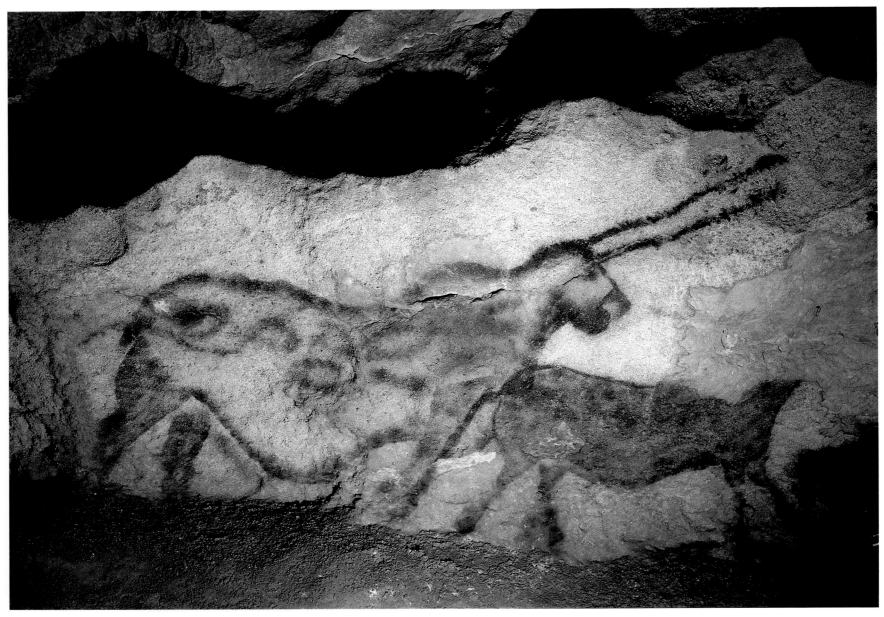

48 An enigmatic creature, the Unicorn appears to be pushing the horses of the two friezes. One of the friezes is achromatic, underscoring the panel, while the second is composed of polychrome figures.

As though forming a prelude to the iconography of both the Hall of the Bulls and the cave as a whole, the Unicorn appears to be pushing all the participants on the left wall towards the back of the gallery (ill. 48). It occupies a relatively elongated rectangle (2.35 metres by 1.08 metres, including its two frontal appendages), and its nature is accentuated by its shape (primarily by the fact that it is somewhat inclined to the front). Its general morphology gives it an undulating appearance, which is reinforced by the double curve of the cervical-dorsal line and the 'M'-shape formed by the line of the belly and the limbs in the foreground. The two straight 'horns' contrast with the rounded shape of the body. A number of peculiarities – including

the undulating outline, the square head, very prominent withers, a highly distended belly, ring-like patterns on the flanks, robust feet, and above all the straightness of the lines replacing the horns and their positioning on the forehead – have prompted numerous interpretations, some of which are very fanciful (reindeer). These observations have helped to maintain the element of confusion that surrounds this figure and its name, fuelling its mythical interpretation.

The two frontal appendages and the body of the Unicorn have not been treated in the same way: a brush was used to paint the former, while the body was created by spraying pigment. This effective break in technique might encourage us to dissociate these two subjects, but image processing

confirms that these elements are closely associated. The end of the upper straight line is not interrupted by the forehead, but extends some 15 centimetres into the interior of the outline of the head, forming an arc identical to the curvature of the cranium. This proves that the two lines belong to the outline of the animal silhouette after all. For a long time it was thought that the silhouette might be a feline, but more recently it has been categorized as a fantasy animal.

This cat-like outline would imply that the animal was deliberately depicted in an ambiguous manner, by concealing its true features through the addition of anatomical fragments that have little in common with the subject, and through the omission of others that are characteristic of felines, such as ears. This type of misrepresentation seems to be common in the depiction of carnivores. The bear painted on the facing wall, for example, shows another form of dissimulation: its silhouette is almost totally hidden by the ventral line of a bull to which it is attached. The feline head in the Axial Gallery, which is assembled from four black smears, follows a different pattern: this is the most minimalist figure, and both the most artificial and the most discreet, because leaving aside any one of these smudges of colour makes its identification impossible. A fourth type of dissimulation – locating the figure far from the most easily accessible areas – is more classic and applies to the lions in the Chamber of the Felines.

With the exception of the emblematic figure of the Unicorn, the iconography of the hall is dominated by four great bulls divided between the two walls. They have been drawn facing each other in an asymmetrical fashion, with one very large and incomplete aurochs on the left set against a group of three others to both sides of the entrance to the Axial Gallery. The entrance to the gallery does not interrupt the equilibrium of the frieze, as it unfolds across the mid level of the wall in the pronounced overhang. The composition is completed by heads of bulls, one at each end of this long creation. These, the most monumental masterpieces of Palaeolithic parietal art, occupy the entire width of the façade. The base line, marked by a horizontal abutment of the wall and by a change in the colour of the underlying rock, has been used as an imaginary floor for the majority of the animal figures in the hall. The elements of this composition remain graphically similar, suggesting that they were all executed by the same person. One could say the same about each of the themes at the core of a single composition, whether they be stags or horses.

The first image of a bull – a head – is located on a large flake of rock that had fallen to the ground before the cave was discovered. The impression left by it (ill. 49) fits between the Unicorn and a bichrome horse. The large block (116 centimetres by 90 centimetres) has the general shape of a lozenge. As it had become an encumbrance during various alterations to the cave, it was moved. As a result, the flake, bearing two images – that of the bull and the neck of a horse – has become dirty very rapidly, a process that cannot be easily reversed. Today, it is difficult to ascertain anything from these traces: only some unclear black traces can be distinguished, buried in a mixture of sandy clay. The first photographs taken do, however, provide a better insight into these works. Here, one sees the fundamental lines of the two figures, the one created by spraying pigment (the equid), the other by a drawn line. Only the ear and poll from the upper part of the aurochs's head and the muzzle from the lower part still survive on the wall. The photographs show that part of the remaining upper section was painted directly on to the rock, proof that a first phase of exfoliation had taken place before prehistoric humans were present.

The virtual repositioning (on a computer) of the block into its original parietal context

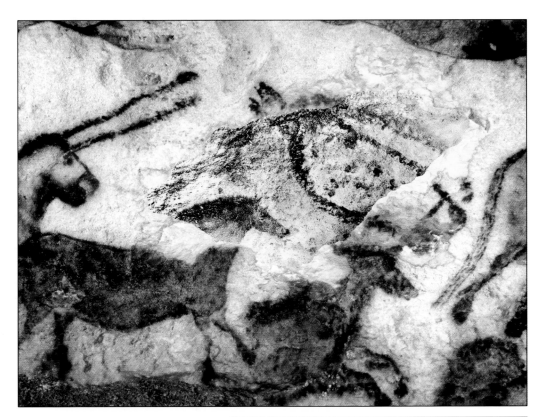

line intended to emphasize the specificity of a theme more clearly, for example that of the horns, is not sufficient proof to reject identification. Moreover, the line depicting the lower jaw, which extends as a steady curve right up to the ear, appears far too developed to be interpreted as a correction. This type of line does not appear on any of the equids.

There are further signs that this is an outline of a bovine. The head is large and can be compared to those of the other five aurochs in the hall, whereas not one of the painted or engraved equid heads at this site measures more than a third of the length of this head. Moreover, the technique used to create the outline – the combination of the outline and internal markings – fits with this thematic group. This can be seen in the depiction of the skin in the jowl area, where a scattering of dots bears a striking resemblance to similar markings on the more intact aurochs. This similarity in the form of these animals suggests the use of the same or at least a similar type of tool.

The analogies of form are equally noteworthy. This is especially true of the quadrangular muzzle, crossed by a line at a right angle to the forehead, which also indicates variations in the hair and the arch of the lines of skin separating the muzzle from the rest of the head. Another detail had so far escaped observation. This is a curved line, underlining the mandible and representing the more or less developed crease of the neck connecting the lower lip and the throat. It is obscured by the mane of the horse immediately underneath, but this graphic feature essentially widens the angle of the face, and has otherwise only been used on aurochs, for example on the first and fourth bulls.

49 Photographic repositioning of the head of the first bull. The image of this bull was preserved on a flake of rock that had fallen to the ground.

on the wall allows a more advanced morphological and technological study, even though the quality of the record is not the best and the obtained image of the outline of the animal not entirely free of ambiguity. It was identified as a bovine by Henri Breuil, Annette Laming-Emperaire and André Glory, but this was recently contested,[21] with the suggestion that it is in fact a horse: the horns and the eyebrow are missing, in contrast to the other representations of bulls in the hall, and the line marking the outline of the mandible seems to resemble that of an equid. At first sight, these arguments appear to be justified. Nevertheless, the absence of a

The first large figure in the cave is located directly in front of this head. This second representation of an aurochs, facing towards the bottom of the gallery, measures 3.5 metres in length from the far end of the line of the back to the muzzle. The numerous

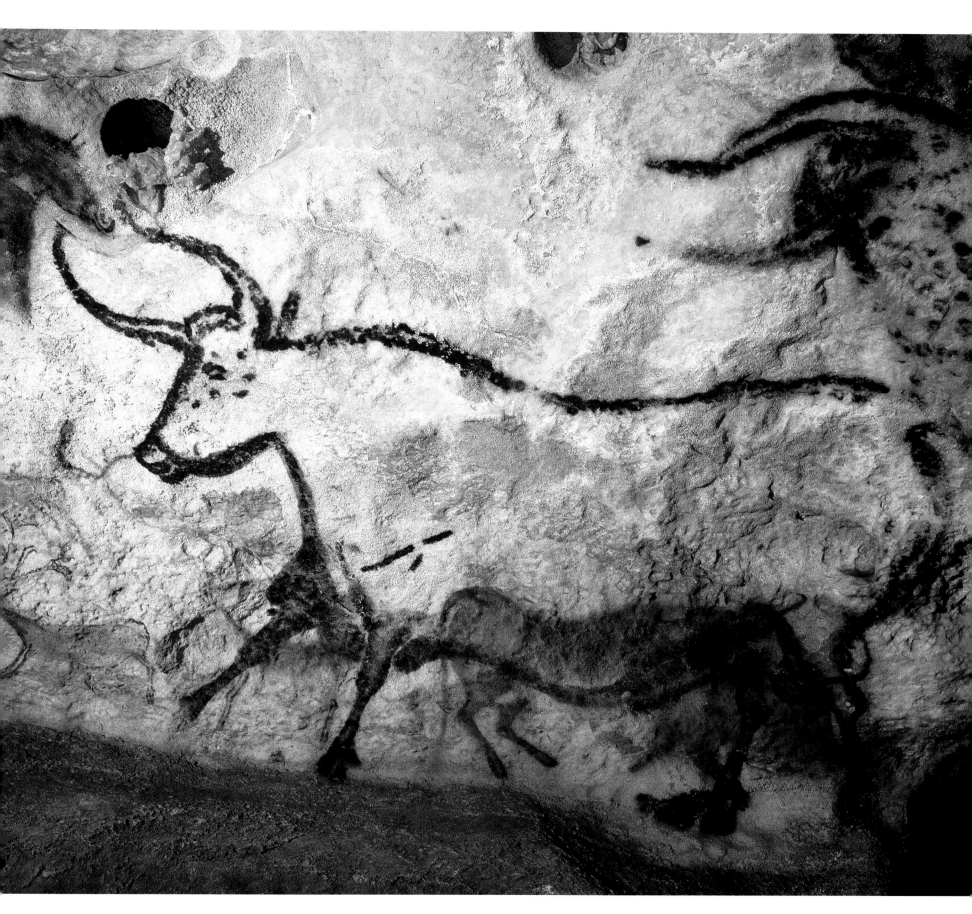

50 The mirror image of its twin, located on the facing wall, the third black bull is painted with a red cow and a young bovine.

equids and cervids that surround or cover the aurochs can detract from its sheer size. The extremely dense representations of horses around the aurochs meant that many of the animal's rear features were not completed. Indeed, only its forequarters are depicted. The figure uses all the available height, some 3 metres in total. The image was centred as accurately as possible, and all of its extremities, the horns, the line of the back and the hooves, reach the edges of the panel. (…)

Compared with the fragmentary character of the work as a whole, the rendition of the head and the neck of the aurochs is very accomplished. There is a huge amount of detail: the eye, the trapezoidal ear, the very dense poll, the muzzle with a detailed outline and the use of pigment to render the hide. This assemblage of graphic elements occurs repeatedly in this hall and in the second third of the Axial Gallery. (…) The horns, unusually, show an almost symmetrical curvature. The one in the foreground continues uninterrupted, rather than having the 'S'-shaped form of the other figures.

Because of the techniques used to create these aurochs, there are further similarities of shape. For all the aurochs in the hall, Palaeolithic man painted the more accessible areas of the animal by spattering colouring matter, switching to a brush or swab for the upper sections. Between the two methods there is also a mixture of procedures – notably for the muzzle, where pulverized pigment was applied with a stencil to create a smooth surface, in sharp contrast to the more abrupt depiction of the forehead. The mandible is always shown by a double line and completed with a series of eight small circular dots in a row. The same is true of the right limb, which is marked out by a line of identically sized and clearly distinct dots at each edge. The aurochs are then depicted with a vertical bipartition of techniques.

Whereas the majority of the outlines have a neutral black colour, the two hooves and the dewlap of the second aurochs look slightly more brown. This is down to the choice of pigments used, rather than a lower density of colouring matter or a variation in the method of its application. This figure also stands out from the other aurochs through the use of red to emphasize the withers, the two horns and the poll (i.e. the lines located on the upper part of the body). The colour was applied to the black at a later stage.

The third bull (ill. 50) is, together with the fifth one of this very long frieze (on the facing wall), the most imposing figure of Palaeolithic art. The frame enclosing these animals extends over a surface of 13 square metres for a field of activity of 4.6 metres. The overhang of the wall is at its greatest here, reaching a gradient of almost 70° to the vertical. A group of stags separates the second aurochs from its neighbouring herd of black horses and the third bull. Three figures obscure the latter's ventral line and hindlimbs: the most important is a red bovine; the other two are less conspicuous, representing a head of a calf and a small incomplete silhouette of a horse (partly hidden by the right hind hoof).

The monumental proportions of this work of art certainly influenced the technique used – here restricted to drawing. The bull shares this technique with the ibex, notably those depicted in the panel of the Falling Cow. Effectively only the outlines have been drawn. In the past, the shape of this third bull has been criticized, but the proportions are in fact accurate. The pronounced overhang of the wall makes the images look compressed and somewhat top-heavy, with massive forequarters and weaker hindquarters. Almost all of the anatomical details of the aurochs are present, although the front right hoof is missing, cut off at the pastern. The developed horns protrude from the head in the form of a divided semi-circle. The are fewer dots around the eye compared with the other aurochs. They simulate the curly hair specific to the bulls, while the rest of the body has

a smooth coat. The penile sheath is portrayed distinctly.

The signs may have smaller dimensions than this great bull, but they make up for it in their number. Several types of signs are concentrated in the area between the shoulder and the chest and nowhere else. Dots are used both individually and in groups – most notably in the arc of a circle at the proximal end of the limb, which is composed of five dots. There is also a hooked sign of three lines, and a red linear mark, although the latter may just be what remains of a draft of a figurative drawing. Finally, some distance away, above the withers and at the top of the subject, there is a brick-red sign composed of a line and three oblong dots.

The fourth aurochs is located on the wall linking the entrance to the Axial Gallery to that of the Passageway (ill. 46) further down. Here, only the lines of the forequarters are visible, possibly because the artist did not wish to obliterate the fifth bull, which is located directly behind it. This would have given the artist an extremely limited space to work with, insufficient for the depiction of the entire animal. Several other clues support this hypothesis. The ends of the upper and lower lines stop a few centimetres before the aurochs to its right and the pelvic region of the red cow, which overlays the same fifth bull. Furthermore, there is an abnormal elongation of these two lines compared with the shape of the complete aurochs figures. (…) The anatomical details are consistent with the other depictions of aurochs: the use of pointillism for the hide, extending from the head to the withers, and the double line of the mandible, indicating the folds of skin. There is one unique feature, however: an oblong shape at the base of one of its horns, which may represent the outline of the bull's left ear. It is shorter than it would be in real life, but its position at the base of the horn reflects the bovine anatomy. (…) There are traces of fine scraping to both sides of the bull's right knee. This is

where the artist tried to rub out the black colour of an existing painted horse in order to make the bull's joint stand out from the dark background. This bull differs from the other bovines in the Hall of the Bulls through the abnormal length of its front limbs, particularly the right one. Unlike the body and the head of this animal, which are located on the overhanging wall of the Hall of the Bulls, the two feet stand at the entrance to the Axial Gallery.

An ensemble of sixteen associated depictions includes both figurative and geometric elements. Their spatial distribution is limited to the thoracic region of the fourth bull. They consist of a relatively large number of figures of small dimensions: a group of signs located towards the top of the figure, on the withers, and six animals bordering, indeed fusing with the lower line. The thematic associations recorded here reveal striking similarities with its alter ego, the aurochs located immediately in front, on the facing wall: the presence of the stag, the horse, the cow and a young bovine. Only the bear strikes a different note.

The fifth aurochs boasts exceptional dimensions. Measuring no less than 5.6 metres from the point of the right horn to the tip of the tail, this is the most imposing work of Palaeolithic parietal art discovered to date. It is also noted for the huge number of signs, lines and dots found in its immediate vicinity, particularly around the head, the horns and the ventral line.

All of the anatomical details conventionally associated with and specific to this theme are represented, but some are exceptional, particularly the head. The eye is highlighted by the arc of the orbit, and there is an outline of a second, identically shaped form (ill. 51) just a few centimetres above on the forehead. The detail in the lines of the mandible and the dewlap, or folds of the neck, is also remarkable. The developed horns, with their very ample curvature, nevertheless demand a closer look –

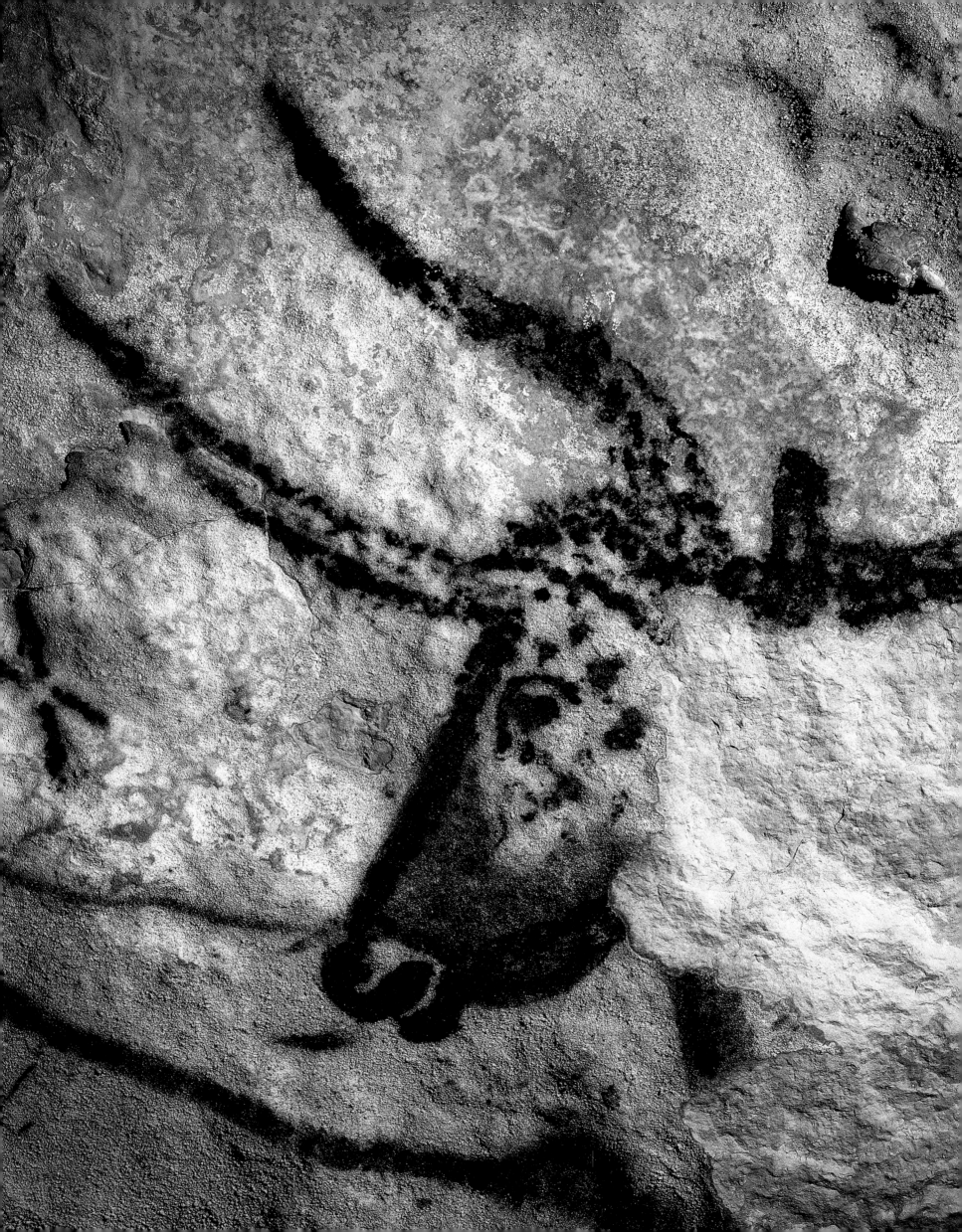

particularly at the bases, where the horns connect to the top of the head. A curving line running parallel to the poll causes some confusion of perspective, making the horn on the right look as if it were attached to the opposite side of the skull. On closer inspection, however, this line does not seem to be linked to the horn, and the impression that it gives of the slightly shorter horn being in the foreground is perhaps accidental. (…)

Spray and brush techniques were used to create the black outline of this fifth aurochs. Pigment was sprayed on to the lower, more accessible part of the body – more specifically the axis connecting the snout and the ventral line – but a brush was used on the upper areas. Different methods of application are apparent on the upper body, including the juxtaposition of single dots. The curving line on the forehead has a special character. It is composed of a series of dots sufficiently close to one another to give them a linear appearance and limit their punctuated impact. The diameter of the dots generally ranges from 2 to 3 centimetres, apart from the tracing of the supra-orbital arch, the poll and the horns where it is 1 centimetre. (…)

Slightly apart from the two great bovines on the right wall, at the extreme right of this panel, there is the large head of an aurochs (ill. 52) facing towards the entrance. The entrance to the Passageway lies at its base. Here, the wall has deteriorated so much that only a few fragments of the original image can be identified – notably the tips of the horns, rounded off by a scatter of very faint dots evoking the initial outline, the forehead, the tip of the nose and the beginning of the mandible. Of the poll, only a small group of dots with a diffuse border survives. Despite the advanced state of deterioration, this figure can be compared to the other aurochs. It was drawn entirely in black, using a brush. A small number of dots and an indeterminate triangular drawing mark the end of the panel.

Two red female aurochs are also depicted on the panel and accentuate the outlines of the third and fifth bulls respectively. Each is accompanied by a small bovine in its immediate vicinity, one black (for the left cow) and the other red. The first female is 1.1 metres tall and 2 metres long. Its forelimb touches the incomplete shape of a small black horse, whose head disappears behind one of the bull's hooves. Five black dots and a hooked symbol are also clearly visible. The identification of this first red female has been the subject of much debate and wavers between aurochs and bison. There are many convincing arguments to suggest that it is in fact an aurochs. The tail is very long and falls vertically to the floor – a feature that is consistently present in all the representations of cows at Lascaux. The line of the back is sub-horizontal and marked by a depression midway along, before extending to the pronounced base of the tail. The lower half

Opposite:
51 Head of the fifth bull, constructed on the basis of a sequence of black dots placed close enough together to appear as a line.

Above:
52 The broken line of the very badly preserved head of the sixth aurochs was drawn on a surface exposed to processes of corrosion. It is located at the point where the exchange of air from the outside, between the present entrance and that located at the end of the Great Fissure, was at its greatest.

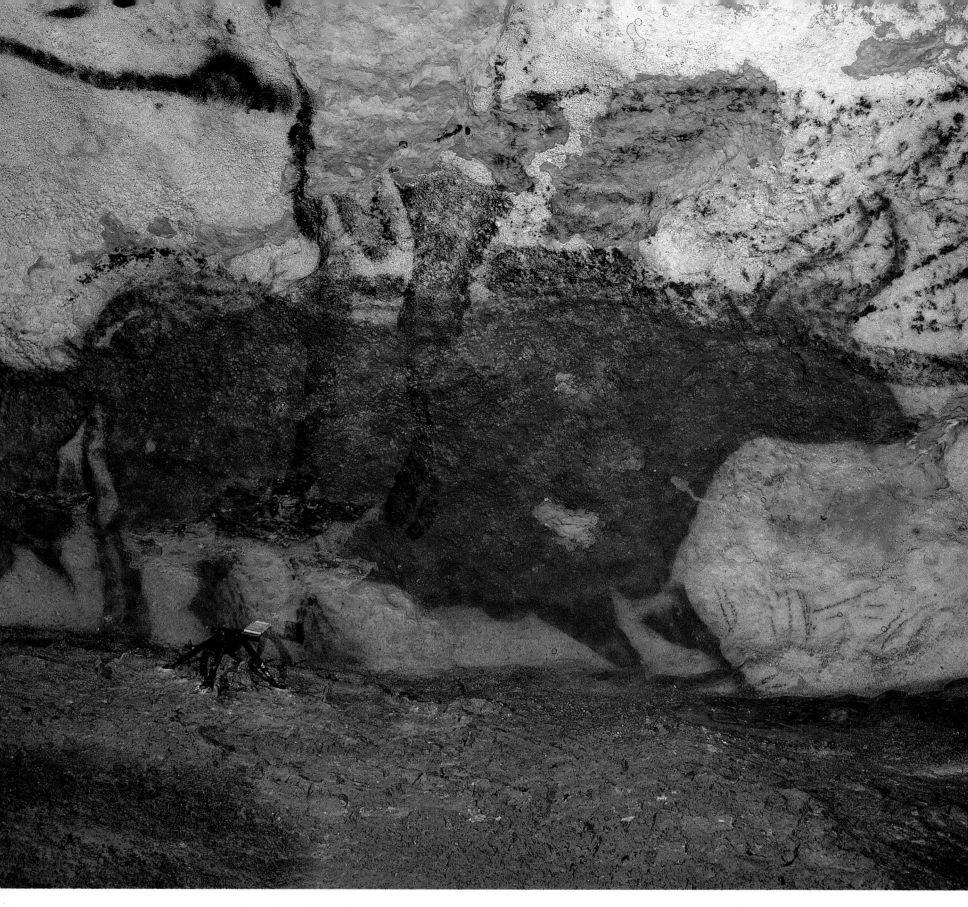

53 The outlines of this red cow, painted over the forelimbs of the fifth aurochs, are partly in contact with the upper line of a male aurochs drawn in black.

of the flank has not been painted, which softens the animal's outline and exaggerates its anterior-posterior dimorphism. Metrical analysis of the image shows that the relationship between the dimensions of the croup, on the one hand, and the withers and the chest, on the other, are faithfully rendered and are comparable to those of other depictions of cows. The horns, with their gracile character and the very thin

section of their twisted lines, again support this identification. This figure is without any doubt a representation of a female aurochs.

As a matter of fact, Henri Breuil had correctly analysed it when he suggested that it was a depiction of an animal collapsing, its muzzle touching the floor. In fact, at this position, the lower line of the head merges with that of the chest, resulting in a somewhat shapeless mass, such as is rarely

depicted in Palaeolithic art. The shape of the wall contributes to this. The sharp bend in the rocky ledge is exaggerated by the opening of the Axial Gallery below, producing an image of the floor falling away below the feet.

Above the internal edge of the line of the belly of the third bull there is an incomplete animal. The red cow described above masks the entire painted surface at the level of the withers. Despite these modifications, it is possible to make out the outline of a head and the beginning of the neck of an animal turned towards the left. A stocky head, a convex brow, a deep muzzle – in outline a quarter-circle – and the lower forehead marked by a hollow are all elements characteristic of bovines. Moreover, the apex of the skull is marked by a poll and, some centimetres behind this a leaf-like appendage rises from the line of the neck. This looks like it may be a horn, although its position is not quite right, or an ear. It is clearly a representation of a juvenile bovine, although it is not possible to specify whether it is an aurochs or bison.

The massive red silhouette of a bovine (ill. 53), the second cow in this hall, looms up on the facing wall. Its somewhat male characteristics – including the great depth of the head, which has a similar facial angle to that of the bulls – accentuate its size. However, the delicacy of the horns and the four limbs tell us that it is a female, as does the pelvic region, where the base of the tail is more marked and projecting than in a male. The extremities of the feet and the tail are not depicted and seem to vanish below the imaginary floor line. The red colour applied to the entire silhouette is unusually even.

There are other drawings around this bovine. Apart from the great bull, which seems to envelop it completely, there is a representation of a calf (ill. 54) to the rear. Only the outline of the calf's forequarters is shown, mostly only partially, and two parallel ears are clearly marked at the height of the junction between the head and the neck.

The graphical association of calf and cow is accentuated by two gaps in colour, which mark the point of contact between the two figures: one at the junction of the edge of the

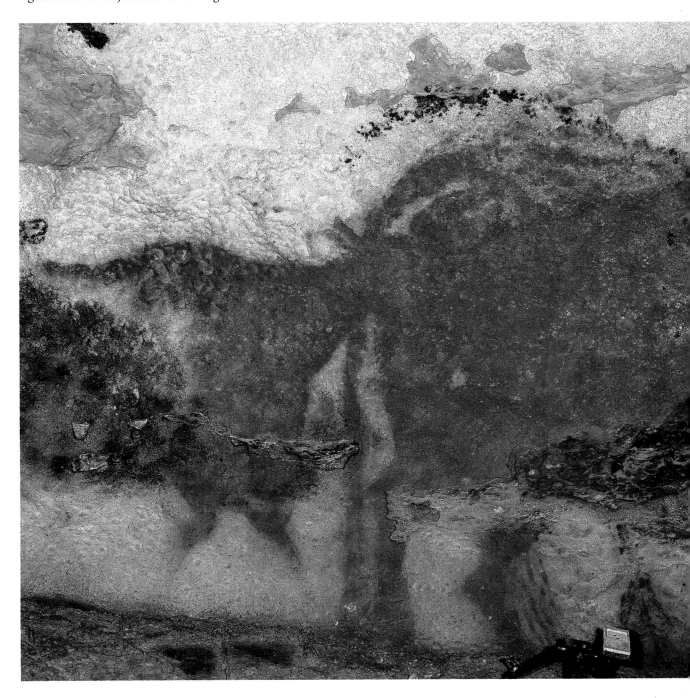

cow's leg and the top of the head of the small bovine, and the other at the proximal end of the tail below the neck of the calf. By using an identical colour for both animals, the artist clearly intended to fuse the two images and highlight the relationship between calf and mother. This dual image is the result of one phase of activity, with the figure of the young aurochs being simply the graphical extension of that of the mother.

54 The incomplete depiction of this calf is fused with that of the cow in front of it. The gaps in colour at their point of contact bear witness to the close interdependence of the two figures.

The rump and the horns of another bovine lie parallel to the upper line of the red cow, and were painted later. The twist of the horns – the simple curve of the left horn and the double twist of the right – and a much more massive morphology than that recorded for the cows suggest that this animal is the seventh bull of the Hall of the Bulls. An important ensemble of signs (particularly lines) was traced directly in front of the red cow, in the arch defined by the head, the neck, the chest and the forelimbs.

Equids, always numerous at Lascaux, account for 48 per cent of all the animals depicted in the Hall of the Bulls. There are two distinct groups on the left wall and another, more scattered concentration on the facing wall. Even though there are far more horses than bovines, they have less of a visual impact. However, horses become increasingly more important in the other sectors of the sanctuary at the expense of the aurochs.

A procession of six black horses, facing the bottom of the hall, extends along a single horizontal line between the Unicorn and the third aurochs. On the left of the frieze, a head introduces the procession, and two manes on the far right mark its end. A small silhouette of a horse immediately next to the entrance to the Axial Gallery is also noteworthy. Masked by the hind hoof of the third aurochs, only its head and neck are visible.

A second line of animals runs above the six black horses, made up of four predominantly red horses. On the far left of the frieze, the lines of a sketched horse on the flanks of the Unicorn and the head of another horse on the latter's shoulder mark the start of this second line. The third horse – a very large figure – lies at the centre of the composition, superimposed over the second bull. A brown and black head with an extended upper line, located between the horns of the two aurochs, marks the end of this line.

On the facing wall a number of sketches continue the horse theme. One of these is located in front of the fourth bull, at the entrance to the Axial Gallery. The second, in three colours, occupies the centre of the same bull. The third – an unclear yellow smear with an equid-like outline – is located in front of the red cow.

The sequence of black horses on the left wall begins with the head and neck of one figure, which are covered by a large yellow blotch. This is the first animal representation in the cave (ill. 55). This outline, turned towards the entrance, has been placed in a natural frame, the borders of which are formed by the rocky ledge above, the line of the shelf at its base and by small calcite flows to both sides. Its outline is limited to the neck, the poll, a sketch of the head with neither nostrils nor mouth, and to the very inconspicuous outline of the back, traced in red using a brush. The second horse is located immediately in front of the Unicorn, marking the start of the procession.

The composition of horses extends over a length of 9 metres. They all appear to move along the same sub-horizontal line of the floor, which materializes in a change of colours and an incline of the wall towards what we call the bench. Major deterioration of the underlying surface has virtually destroyed the second horse: when a large flake of the wall fell to the floor, it took the horse's head and neck with it, together with the head of the first bovine. Its entire surface is painted black, as are the outlines of the line of the neck, the chest, the line of the back, the croup and the hindquarters, carried out by spraying and bilateral masking of the parallel edges. A stencil was used for its feet. The tail consists of a series of oblong smears, aligned in a row, and ends in a diffuse tuft.

The third horse is incomplete owing to the limited space available. Only its forequarters are shown. Nevertheless, it has been treated in exactly the same way as the complete animal representations, with numerous anatomical details. The ears and eye are not drawn, and only in exceptional

cases are the horses of Lascaux given eyes. The location of this animal, on the lower level of the wall, influenced the technical methods used in its creation. This area of the wall is characterized by large depressions, forcing the artist to rely predominantly on the spray technique. The exception is the back, the broad line of which differs from the rest of the body. A linear series of adjacent dots represents the line of the belly. Four other dots extend this line and emphasize the lower edge of the limb.

A fourth, partial silhouette of a horse emerges from the obscure darkness of the bench. This sketch, limited to the head, the neck and the beginning of the line of the back, was created entirely by spraying. The juxtaposition of small dots in two lines represents the upper part of the mane. Another line of dots inside the head may represent a sketched neckline, later replaced by the more generous thickening of the neck.

The fifth horse is at the centre of the frieze, immediately below the great red horse with the black neck. Its general morphology follows an elongated 'S'-shaped curve, the character of which is accentuated by the strong downward curvature of the back and the alignment of the rounded mane with the forehead. This deliberately accentuates the movement of the forelimbs, with the hindlimbs supporting the body. Very few details of the head remain, so much so that its features are essentially limited to a traced outline. The reduced size of the head contrasts strongly with the mass of the neck. Two juxtaposed broad lines, which are of a slightly denser shade of black than that of the flanks, emphasize the abdomen and appear to be structural elements. (…)

The extensive application of black pigment marking the chest of the second bull conceals the outline of a sixth equid. Overwhelmed by the different neighbouring shapes, only the head, neck and back of the horse are visible. Despite its incomplete nature, we can identify this figure as a horse simply by looking at its cervical-dorsal line: the straight back and regular curvature to the line of the neck, and the angle that is formed where the neck and back meet, are specific to the representation of these animals.

In the vanguard of the long frieze of the black horses, the outline of the seventh equid merges partly with the chest of the second bull. Indeed, the croup and the hindlimbs

disappear in the thick application of black pigment, entangled with the outline of another horse and the dewlap and the forelimbs of the aurochs. The entire figure was executed by spraying pigment, with the exception of the outline of the hooves and an interior line that follows the line of the back 3 centimetres away. Whereas the distribution of the internal dots seems to be random, those of the outlines seem to be

55 A black head of a horse is the first figurative unit of the sanctuary.

more coordinated. For tracing the shape of the body they follow a continuous line, with no interruption between each element, from the base of the mane to the articulation of the forelimbs. The application of colour to the interior is in the form of large dots, creating a relatively diffuse scatter.

The right edge of the frieze of the black horses finishes with two sketches. The rudimentary nature of the left-hand figure has prompted various interpretations, including a mask or the head of a nocturnal bird of prey. Analysis using graphical analogy suggests that it is an incomplete outline of a horse, limited to the forehead, the poll, the mane and the beginning of the line of the back. Two juxtaposed smudges may be markings of the neck. The second sketch of a horse consists of only three elements: the mane, which is linear in nature, and two lines of the neck, composed of dots.

A tenth horse is hidden in the distal extremity of the third bull's right posterior limb. Only the head, neck and back are visible. There are two parallel lines of clay between the neck of the horse and the forelimbs of the red bovine, but it is uncertain whether they are Palaeolithic.

The second sequence of equids on this wall is more restricted in number and is located at the same height as the Unicorn. Only the neck and the line of the back of the first figure are shown, drawn in red. The brushstroke is 3 to 4 centimetres wide and shows the cervical-dorsal trajectory as a regular line with a triple curvature.

Several animals obscure the body of the Unicorn, including the second figure in this sequence, which appears as a large red smudge on the withers (ill. 56). It was very difficult to identify this figure, and in the end we had to resort to image processing in order to define the outline better and to bring out the original effects (ill. 57). Eventually, it was possible to recognize the shape of a horse head, with the mane, poll, forehead, mandible and neck all depicted.

The extremity of the muzzle (nostrils and lower lip) is not shown, which is true of all the horse heads at Lascaux (ill. 58).

The largest horse of the panel, the great red and black horse, occupies a central position, both vertically and horizontally. It is the most consummate (ill. 59), with all the classic anatomical details. Moreover, the head seems to be split in two: one head is black and lower down, and the other is red with a black forehead. Nevertheless, it would appear that the former outline is external, rather than an artistic correction. Another peculiar feature of this figure relates to two black, oblong marks behind the two forelimbs. They are associated with two series of sub-parallel striations – one red, the other black – drawn at the left of each mark. The belly is marked by a scatter of large black smudges. Furthermore, at the base of the mane it is possible to recognize a slightly arched line composed of six large black dots, an arrangement that has still not been interpreted.

Various techniques were used to depict this animal. A fine red border applied with a brush marks the limit of the back and the croup, while a black border shows the lower line of the neck linking the upright chest to the throat. An alignment of markedly similar black marks follows the ventral curve, but the form of the thigh is less solid and was carried out using a stencil. The lines of the back and neck and the outlines of the forehead and peripheral elements (the feet and tail) were all drawn with the same tool, which cannot have been more than 1 centimetre wide. By contrast, a much broader and flexible brush, coated with a more diluted red material, was used on what appears to be the ears. There are certain similarities between this colour and the pigment used to highlight the back of the bull, suggesting that they may have been painted at the same time. The head is carried high and lies along the same axis as the body. The back feet are at their maximum extension and parallel

Opposite, top:
56 The shoulder of the Unicorn is marked by a red smear.

Opposite, centre:
57 Image processing allows the separation of the outline of this figure for a more critical interpretation. It shows the head and neck of a horse.

Opposite, bottom:
58 The identification of the preceding image is supported by a comparison with this small depiction of a horse head, painted below the first Chinese horse in the Axial Gallery.

to each other, whereas the front feet are less extended and diverge at an angle of some 20°.

The brown horse faces towards the back of the gallery, and only the outlines of its head, neck and back (ill. 60) are shown. The pointed, parallel and slender ears are located perpendicularly at the beginning of the mane. The tip of the nose, the nostrils and the lower lip are shown in detail. The depiction of the mandible and the beginning of the line of the neck are also carried out meticulously. The underlying surface is relatively fine grained, which the artist has worked to his advantage with the use of shades of brown and black and the dispersion of colour. These two features are found only rarely in the cave. The mane, in particular, shows off this technique. The same fine-grained texture enabled the artist to draw the head in detail, from the nasal opening to the lower lip. The passage to the mouth is marked by a succession of small parallel dashes covering the entire tip of the snout. Sprayed pigment was used to create the collection of oblong shapes that make up the mane and the lower line of the neck. The dorsal outline, shown as a continuous and regular line, is somewhat curved. The effect is intensified by the presence of a fracture line in the rock formed by a longitudinal fault.

On the right wall, only one of the three horses faces the end of the gallery. Located at the boundary of the Axial Gallery and the Hall of the Bulls and partially overlapping the fourth bull, it nevertheless belongs to the latter by association. The outline appears to be slightly disturbed, both in its form and by the nature of the underlying surface. The incomplete outline is marked by the absence of the withers, the back and the hindquarters. Difficulties in positioning the subject cannot have helped. Several lines, apparently unconnected to the outline, cluster around this image, in particular an arched line underlining the neck. One of those lines – a thick one that crosses the front limbs diagonally and looks like the hoof of a horse

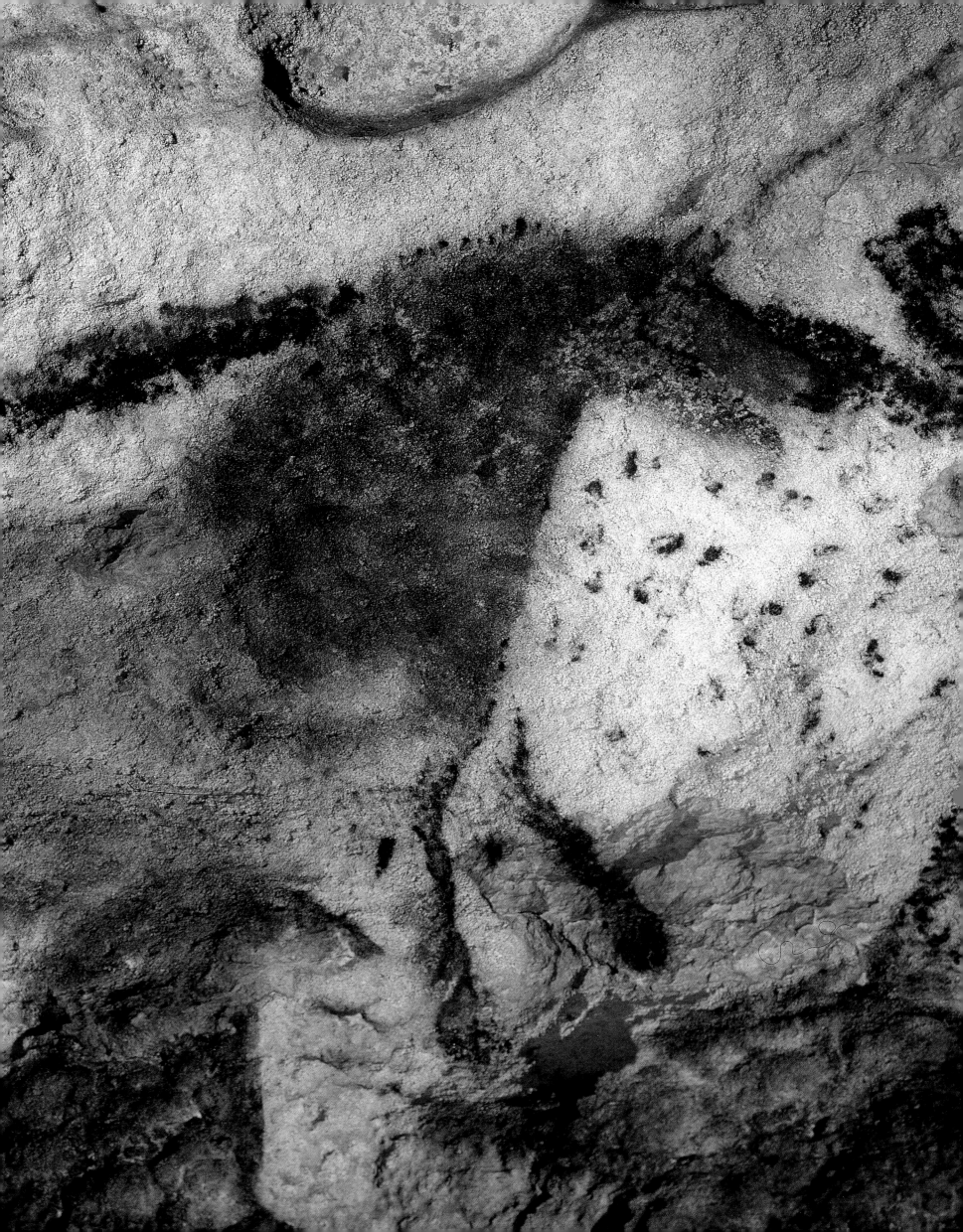

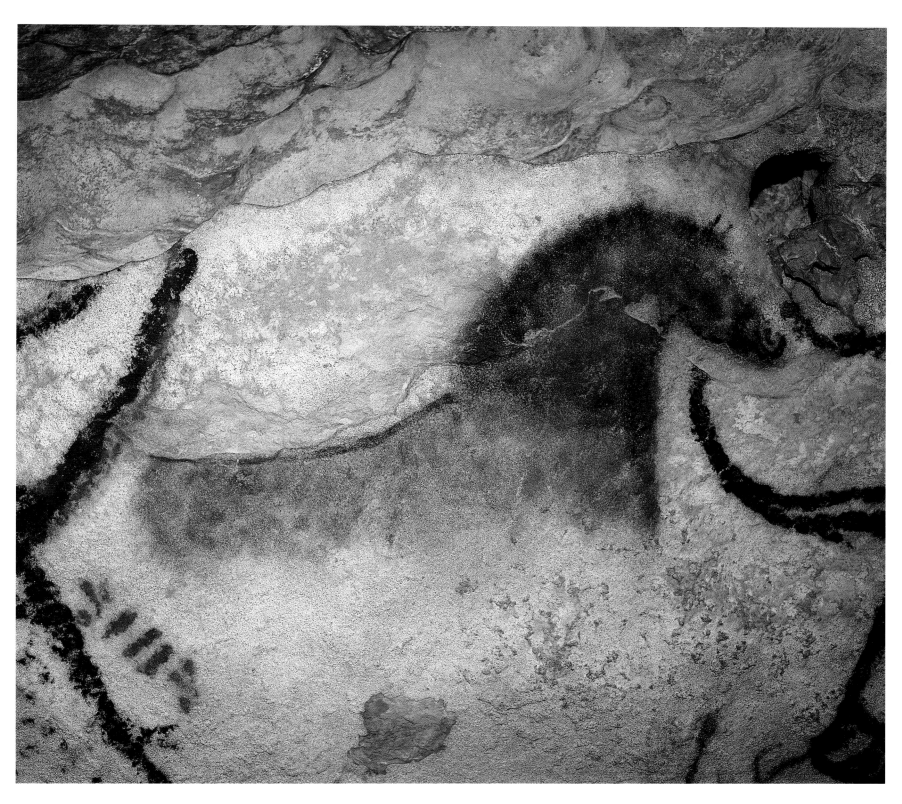

Opposite:
59 Forequarters of a great red and black horse.

Above:
60 The outlines of a brown horse with a black mane form the graphic connection between the two large depictions of aurochs on the left wall.

– may well be a correction to the painting. The presence of a coating of clay to lessen the impact of this poorly placed limb would support this hypothesis. There are also incised marks, or more precisely very superficial removals of pigment, on the flanks in the shape of a cross.

In this case, as for the majority of depictions, a mixture of techniques has been used. The outlines have been drawn, while painting has been used to fill in forms. Often the animal looks elongated. This distortion is caused by the shape of the wall and the need to get the proportions right. The image was intended to be viewed from the centre of the Hall of the Bulls rather than from its closest point, the entrance to the Axial Gallery. This distortion of the picture is similar to that used on the fourth bull.

There are numerous signs, dots and bars and animal figures around the forequarters of the fourth bull. A partial silhouette of a horse stands at the centre of the composition, apparently at random. Only the front half of its body can be seen. Several colours have been applied by spraying: yellow for the neck and the coat of the animal, black for its mane and red for its chest and legs.

On the surface marked out by the forequarters of the red cow, painted within the forelimbs of the fifth bull, are several associated signs and another horse (ill. 61). It is not instantly recognizable: the yellow colour provides only limited contrast, and the outlines of the animal are incomplete, reduced to the mane, the neck and the beginning of the back. Nevertheless, you can see a sketch of the forehead leading to a developed poll. The artist painted the cow by spraying a succession of applications of powdered colouring matter next to each other, their impact being more marked at the level of the neck than the rest of the image.

The third theme of the panel is that of the stags, divided into two groups of uneven size. There are five stags on the left wall (ill. 62). This group is interesting because its composition differs from the others in this chamber. The sixth stag, which is black, forms part of the small group of incomplete figures and sketches that decorate the forequarters of the fourth bull.

The group of five stags, all of which face the entrance, stand in a trapezoidal area, bounded laterally by the second and third bulls and vertically by the brown horse and the line of the floor. They are of substantially identical proportions and are arranged in a herd-like formation. They are divided between three levels: the yellow and black stag at the bottom, the incomplete red stags and the two outlines. Despite the very great diversity of the antlers, there are certain characteristics that are shared by all the stags, such as the parallelism of the limbs or the rendition of the cervical-dorsal line by a continuous curve, without the projection of the withers. The symmetry of the figures is not only achieved by the spatial distribution of the different subjects of the composition but also by their animation: both subjects on the far left and far right are static, whereas the superimposed figures placed at the centre are shown in motion.

The outline of the red stag, to the left, occupies an almost perfect square. Neither the hindlimbs nor the line of the belly have been depicted. The dissymmetry of its antler tines is more accentuated than in the other stags, particularly at their base. The stag's right-hand antler, with a very thick section and the form of a crescent, appears to reproduce the outline of the head and the neck below it. No fewer than twenty-two tines can be counted on this antler. The great diameter of the antlers might suggest that this is a picture of a very old stag. Red is the only colour used for this animal. The antlers, the head, the neck, the legs and the curve of the back were painted with a brush, but the internal colour was sprayed.

The second stag takes up the space between the muzzles of the second and the third bulls. It is slightly smaller than

the stags below it and has fewer anatomical features. Only the neck, the outline of the body and the limbs have been depicted. Some diffuse vertical lines above and in front of the stag suggest the antlers. The natural forms of the rock surface played an important role in the representation of this animal: two large scars, where flakes of the wall surface have fallen away, suggest an angular head and the antlers. It is not the relief caused by the loss of material that creates this effect, however, but rather the difference in colour produced by the juxtaposition of the underlying ochreous rock and the white calcite. The powerfully depicted forelimbs are shorter and denser than those of the figures below, contrasting with the limbs of the hindquarters, which are reduced to a faint trace of colour. The inconspicuous red line of the croup is emphasized by an irregular arrangement of black points and dashes.

The central animal of the group, the yellow and black stag, is also the most accomplished (ill. 63). The position of this figure on the lower level of the tableau, a zone marked by deep hollows, makes the high number of anatomical details all the more remarkable. The work of art's graphical qualities are maintained: it fits exactly into a square. Its oversized antlers double its height. Certain anatomical details are unique, such as the extremities of the limbs, which are drawn with the hooves and the dewclaw. Yellow is used to show variation in the thickness of the coat, which is always more substantial on the neck than on the rest of the body. A black linear stroke marks the outline of the coat. It is very different from that of the neck, where the length and density of the fur is implied by a looser arrangement of colour applied by spraying and with no clear boundary. The depiction of the antlers is broadly naturalistic, showing, from the bottom to the top, the brow tines, the bez tines, the trez tines and the crown, but asymmetrically from one antler to the

other and with a doubling of some elements. The stifle (the joint in the leg) in the foreground follows the line of the belly; the other traces a straight line sub-parallel to the lumbar region. The limbs are parallel and vary in thickness along their entire length, thereby showing their different sections and articulations, unlike the somewhat spindly legs of the two red stags to either side. The morphology of the wall has played a role. The front part of the stag (forehead and bez tines)

Above:
61 There are numerous signs on the walls of the Hall of the Bulls, but in outline they are essentially limited to dotted or linear forms.

Overleaf:
62 The frieze of the Small Stags occupies a special position between two great opposed bulls. It forms the geometrical and, perhaps also, dramatic centre of the very long composition that unfolds along the two walls of the Hall of the Bulls.

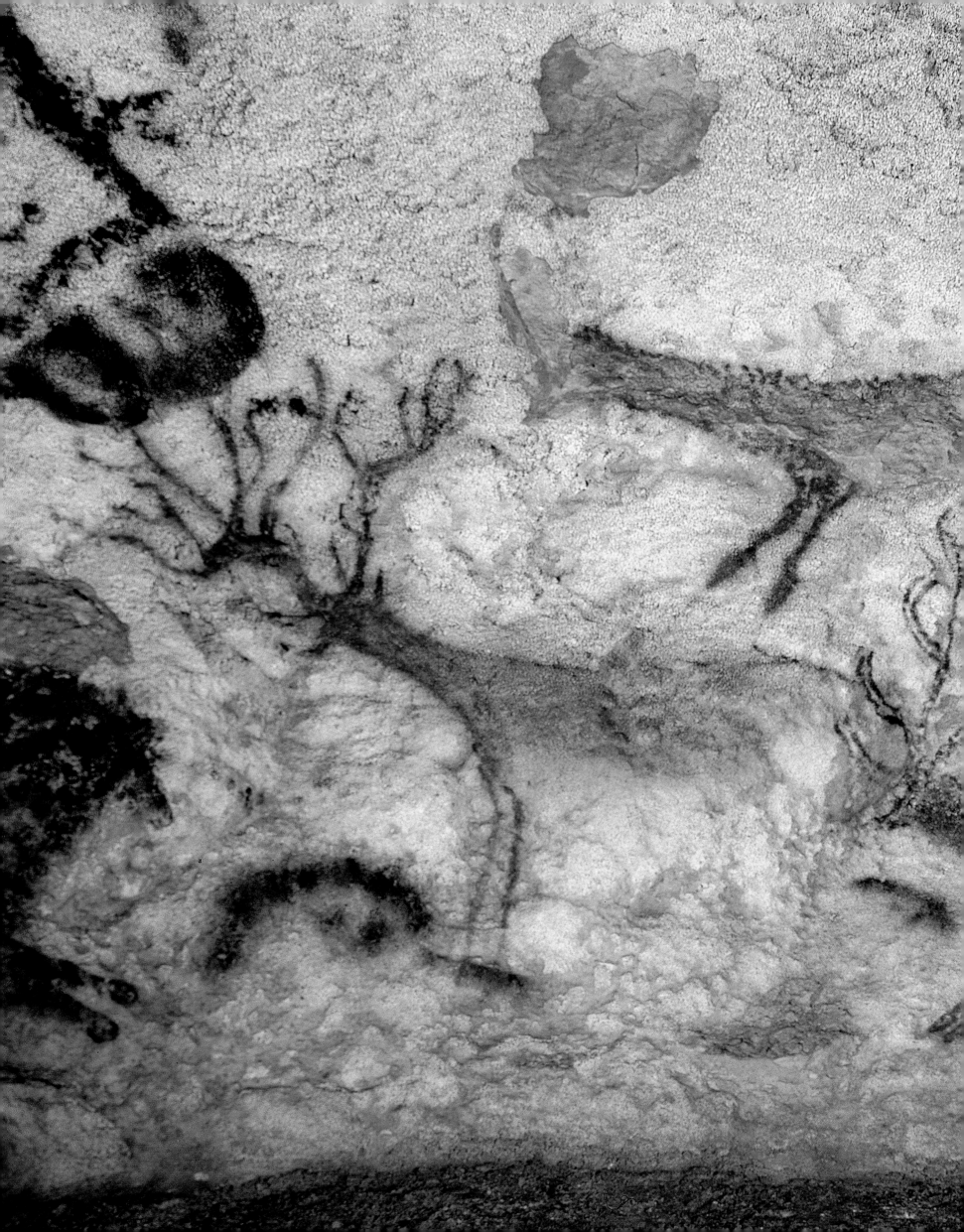

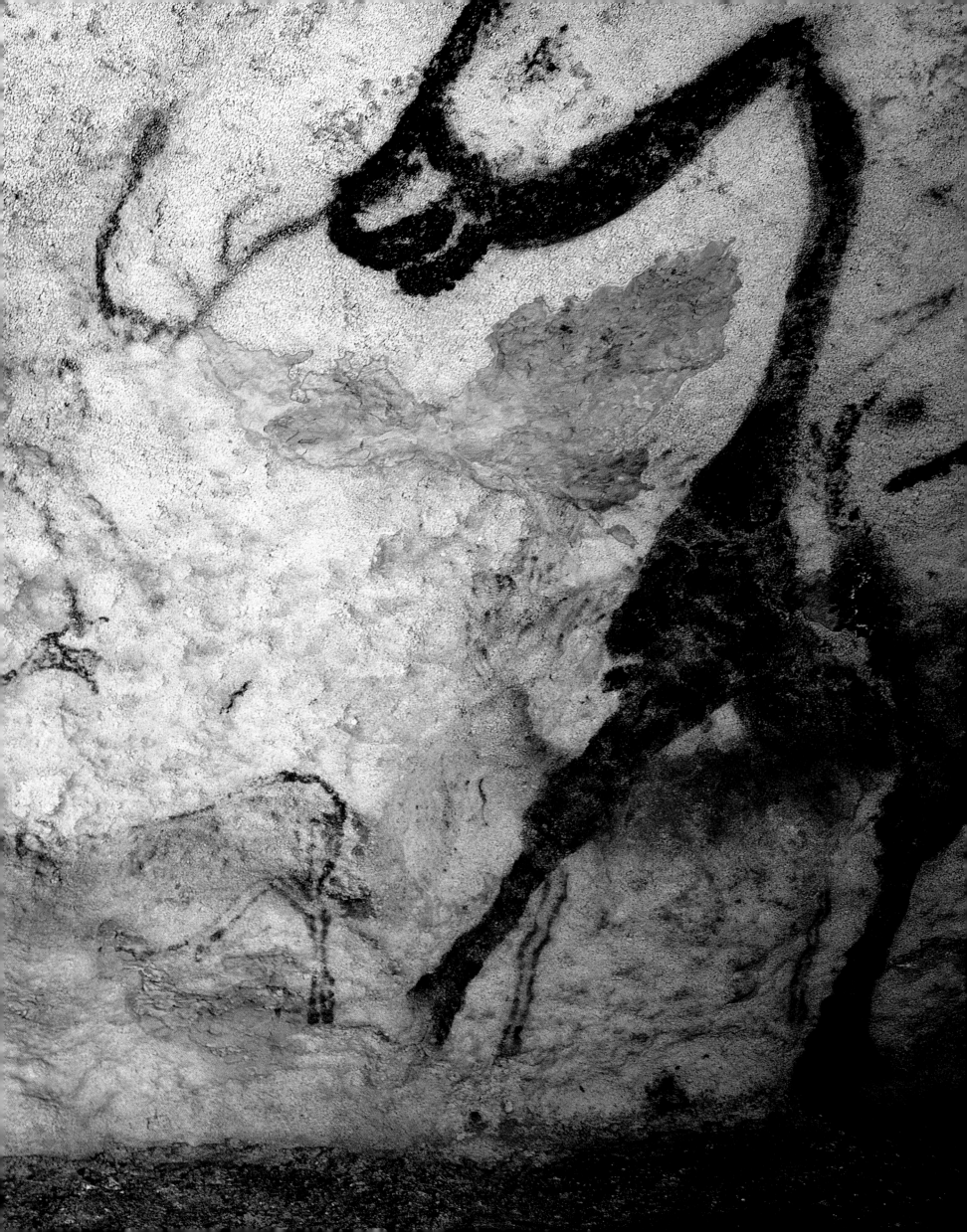

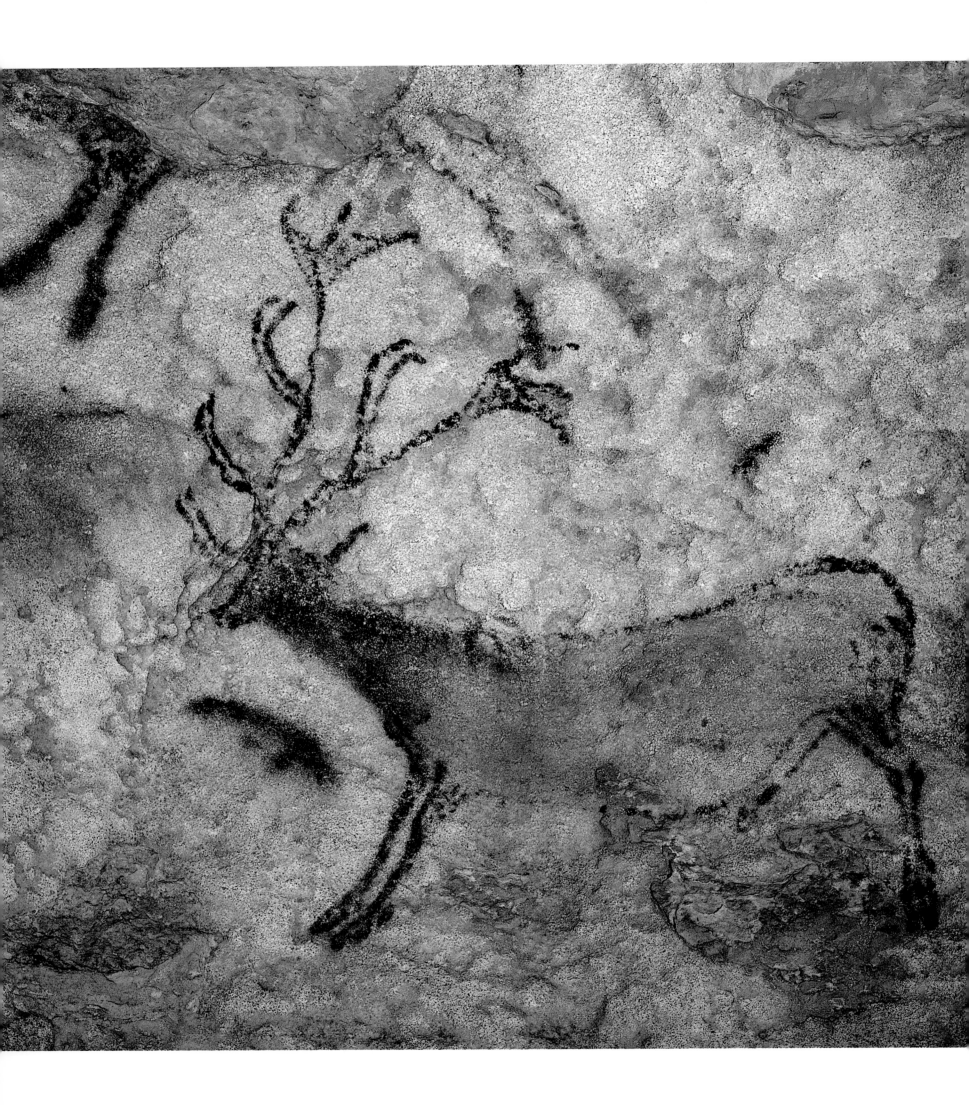

follows, at a short distance, the curve of a ridge formed by a large and deep cavity just in front of this animal. Where the eye should be, a calcite growth takes its place, an interpretation rendered all the more probable since this feature retains its original white colour, having been left unpainted in the middle of the black surface.

Only the antlers of the black stag are visible, but natural elements of the wall help you to imagine what the animal's body was like. Indeed, there is a degree of affinity between the cervid's antlers and the scar left by a flake, which might suggest the body. Very faint and disjointed black marks below the right antler evoke an eye, a forehead and the tip of the muzzle, merged into the line of the croup of the red stag.

Like the other cervids of this group, the red feet of the fifth stag do not rest on the line marking the separation of the tableau from the bench. Only the large animals and the majority of the horses obey this rule. The silhouette preserves all the outlines of the upper body, the line of the back and neck, to the detriment of the ventral line, the chest, the throat and the head. The long and fine legs are in pairs and absolutely parallel, perpendicular to the line of the floor. The straight fore- and hindlimbs are characterized by a single curve at the knee and the hock respectively. But it is the antlers that are the unique feature of this figure, both in their shape and dimensions: they form a veritable bush of forty-odd tines, partially drowned in

the black mass of the chest of the third bull, and their surface area approximately equals that of the body.

On the facing wall, the small black stag that stands close to the entrance of the Axial Gallery is depicted with almost all of the traditional anatomical features. Only the line of the belly has not been drawn, and the forelimbs are merely sketched. The outlines of this animal, represented in right profile, differ very little from the other stags. The few differences relate to the antlers, which are much less developed and have fewer tines, and to the position of the head, which is carried noticeably lower. There are many similarities with the yellow and black stag: the treatment of the croup, the articulation of the hindlimb drawn in the background, the static nature of the parallel and outstretched back legs. Outline drawing is not common in the Hall of the Bulls, but this figure has been executed using mainly this technique. The outline and the fur of the neck have been drawn with a brush. Only a few areas of the back and croup were sprayed.

Hidden in the ventral band of the fourth aurochs, the image of the bear (ill. 190) is only recognizable by the line of the upper body, the ears, the front edge of the raised head and the distal end of the right hindlimb, on which three claws are clearly visible. Nevertheless, a more in-depth analysis of the subject, following image processing, has led to the identification of the croup, the thigh and the second hindlimb.

Opposite:
63 Unlike the four other cervids of this group, which surround it, the yellow and black stag has all the anatomical details that are traditionally depicted.

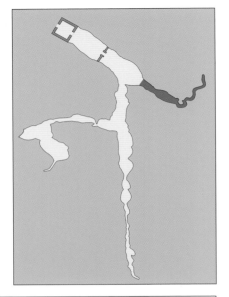

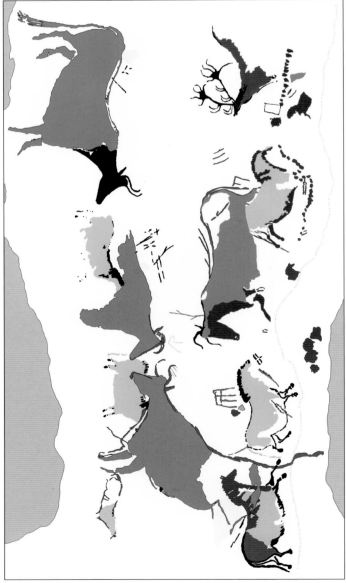

The Sistine Chapel of Prehistory

Continuing the axis of the Hall of the Bulls is the opening of the Axial Gallery, deservedly regarded as the pinnacle of Palaeolithic parietal art. The depictions occupy the entire upper level of the walls and the underside of the vault along the first few metres. The classic themes of the prehistoric bestiary are found here: aurochs, equids, ibexes, with the suggestion of a stag at the entrance and a bison at the back. It is an uninterrupted succession of major works of art, including the Chinese Horses, the four red cows, the Great Black Bull, the Falling Cow, the frieze of the Small Horses, the Confronted Ibexes and the Upside-down Horse. Geometrical signs are particularly abundant.

The collection brings together 190 representations, of which 58 are figurative and 35 are signs of various types, including quadrangular, branching, rectilinear, cruciform and nested elements and fields of dots. There are 97 indeterminate figures, the majority of which may well be signs.

The linear organization of this sector and the distribution of the figures allow the works of art to be divided into seven groups. Four are on the left wall: the Red Cow with the Black Collar, the Great Black Bull, the Hemione and the Upside-down Horse. Three are on the right wall: the Chinese Horses, the Falling Cow and the Red Panel. There are also a few lines and dots in the terminal passage.

THE CEILING OF THE RED COWS

The first third of the Axial Gallery is thematically dominated by several large red bovines, resembling the bulls of the Hall of the Bulls in their asymmetrical distribution. Three of the four cows, with almost identical proportions, mark the left wall. Two face the same direction. The third one faces them, but its body extends on to the opposite wall, crossing the entire underside of the vault at an angle. Its croup is located on the right wall, immediately in front of the fourth cow (ill. 64). Thus we have a composition with four cows, two in front of the others.

Three equids, organized as a frieze, are placed alternately between the bovines. The other remarkable figure, the Black Stag (ill. 65), is depicted on the right. Its peculiarity lies in its position, at the beginning of the very long graphical sequence that opens out along both sides of the gallery. It is also the only stag in the corridor. While its lower outline is missing, the figured elements reveal a high degree of finishing, particularly of the head. The open mouth is enveloped by a cloud of red; the same association is also found on the black stag in the Hall of the Bulls, a figure located a mere 3 metres away. The eye is rarely drawn on the cervids of these two adjacent spaces, but it is one of the most detailed elements of this stag. The black pupil, at the bottom of a blank area, gives the impression that the stag is looking back. The antlers feature oversized crowns, with unusual tines, some of which are more developed than others. The lower tines are doubled, like the other stags at this site. The curve of the body is accentuated by the antlers, which are pushed back towards the rear. The singular outline depicts the rut, an interpretation confirmed by the distorted eye. The location of this figure, immediately next to the fourth bull of the Hall of the Bulls, its unique nature in this sector and its

Above:
64 Composition of the ensemble of depictions over the two walls and the vault of the first third of the Axial Gallery.

Opposite:
65 The cervid theme, which is reproduced several times in the Hall of the Bulls, is only represented in the Axial Gallery by the black stag.

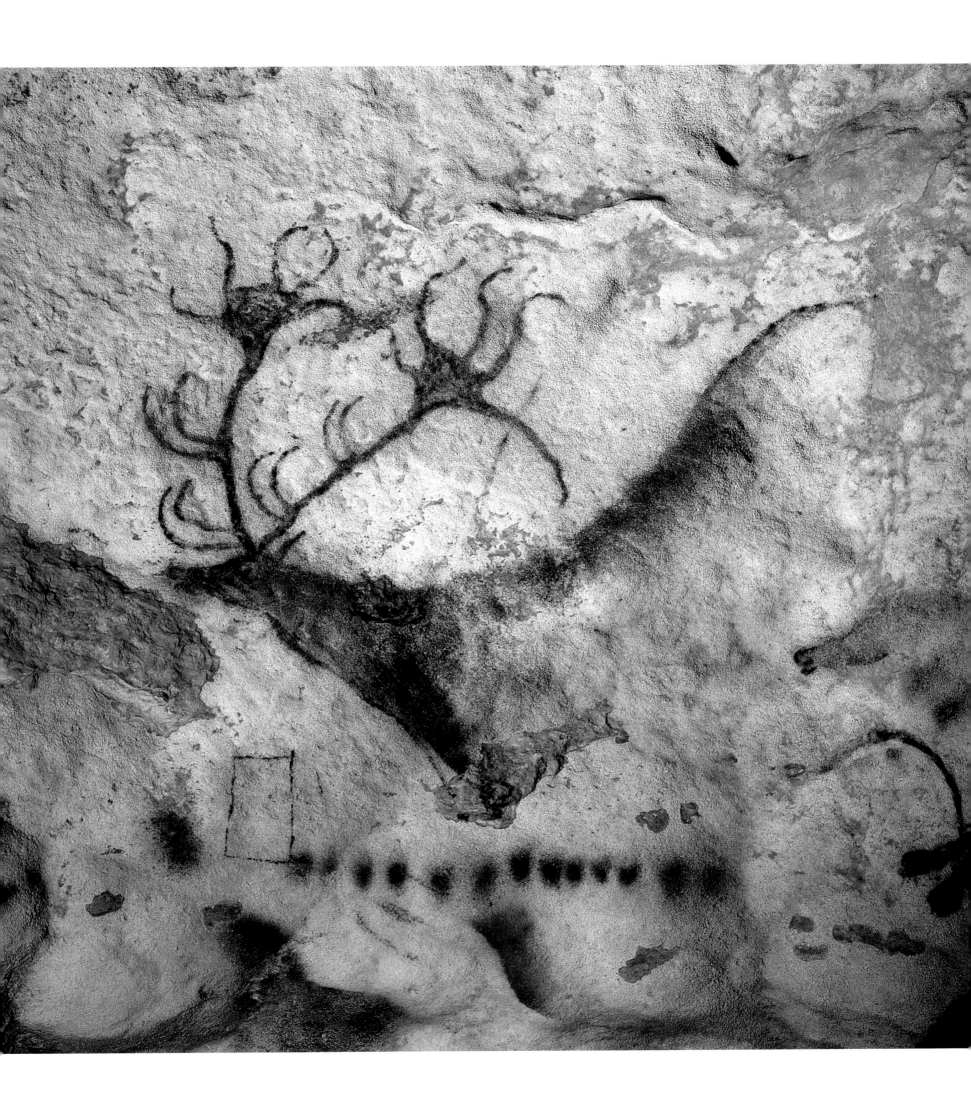

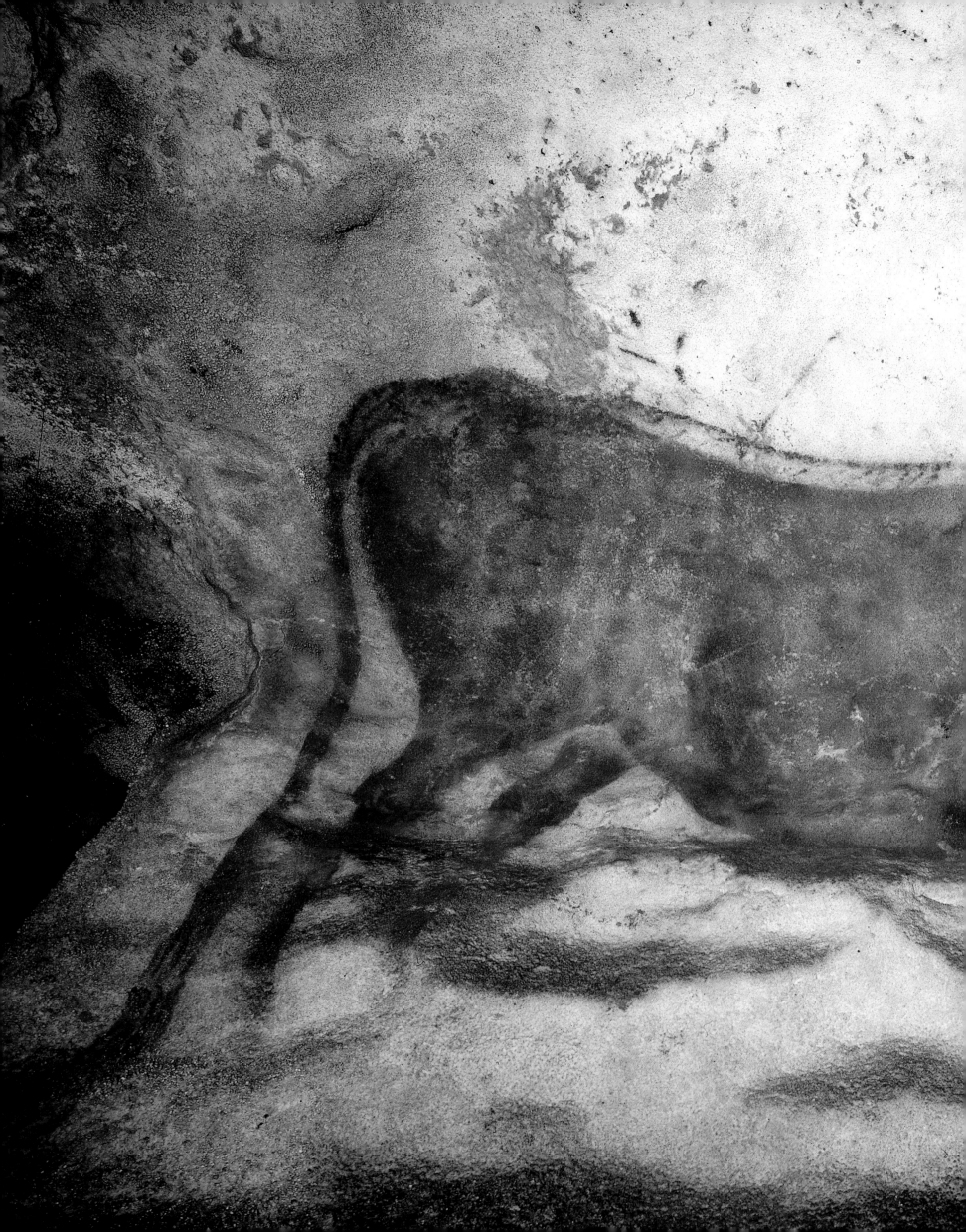

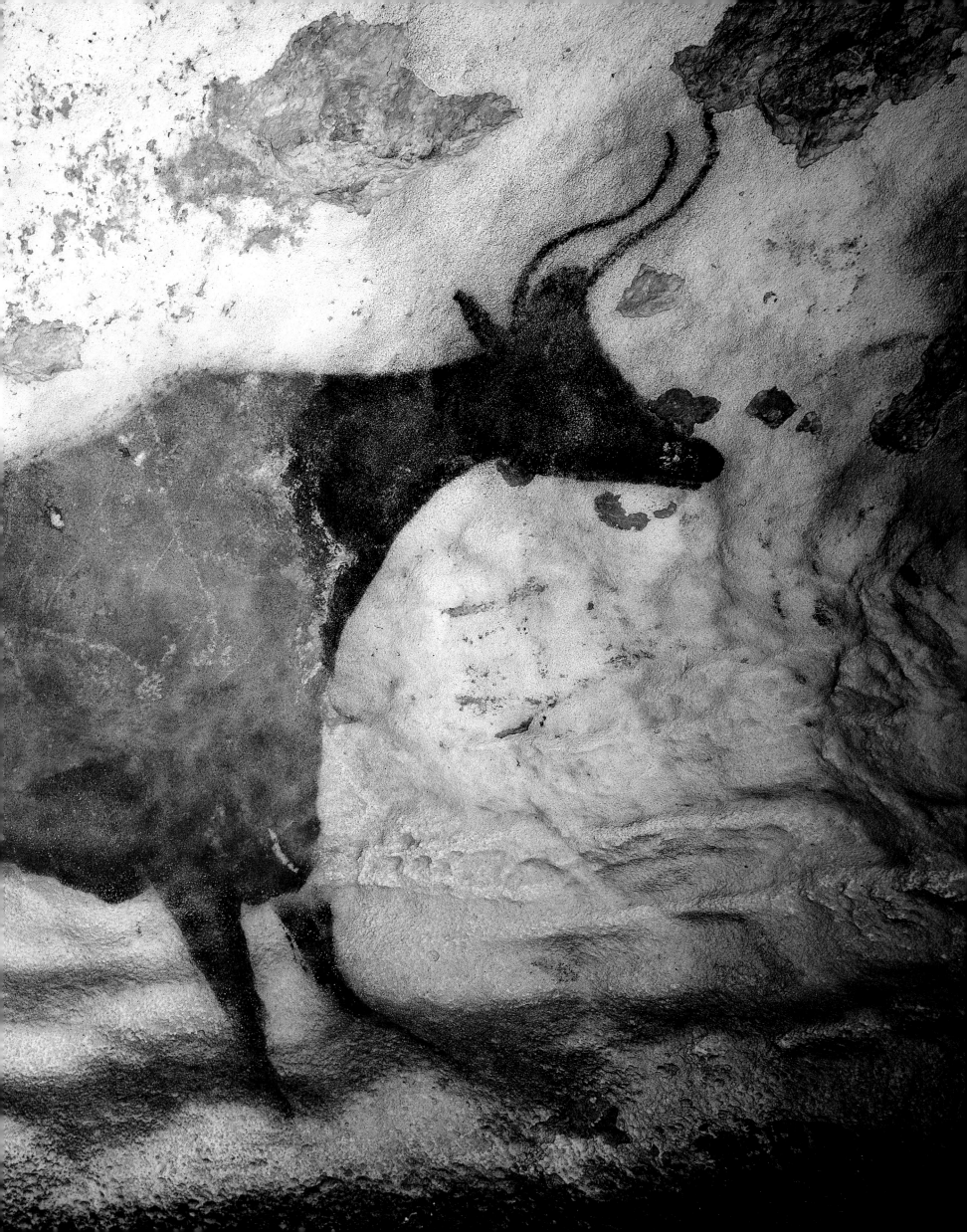

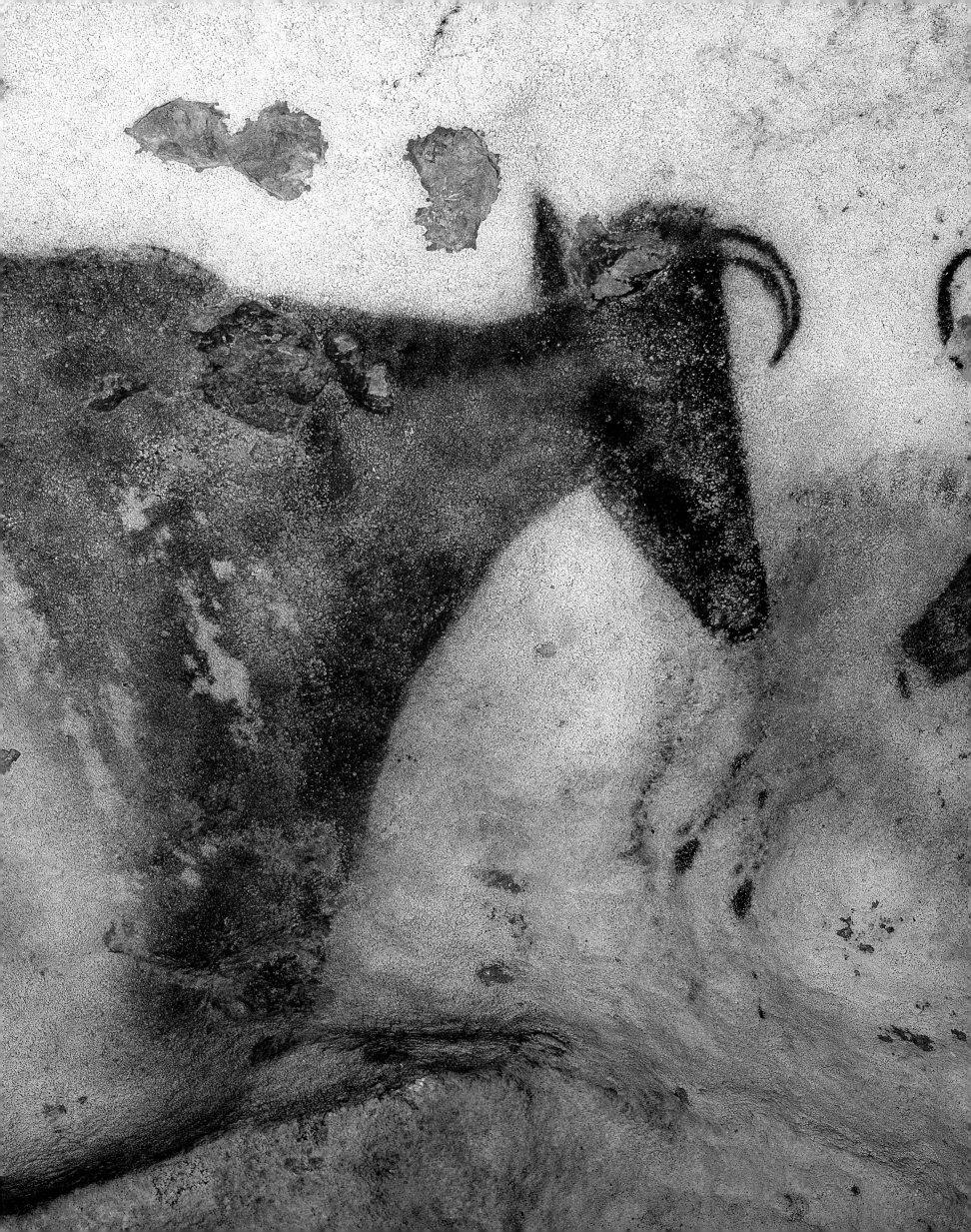

black colour, which contrasts with the warm tones of the majority of the other figures, support the association of this representation with the ensemble in the Hall of the Bulls.

On the left wall, the aurochs closest to the threshold of the gallery, popularly called the Red Cow with the Black Collar (ill. 66), stands next to the boundary between the Hall of the Bulls and the Axial Gallery. With the exception of the four hooves, the animal is anatomically complete. The numerous similarities of general morphology and of details with the other cows of Lascaux – whether they belong to this sector, to the Hall of the Bulls, the Passageway or the Nave – demonstrate the very great unity of this theme. Only a few small and very specific variations in shape give a certain individuality to their outlines. Thus, the forehead of the Red Cow with the Black Collar follows a continuous curve from the poll to the snout. Its entire body is red, but its head and neck are black. The bipartition is not only chromatic but is connected with the morphology of the wall, as the ridge separating two concave surfaces of the tableau accentuates the border. There are several very superficial incisions at the level of the shoulder: the broader ones possibly sketch an animal head, while the finer ones are restricted to a few parallel straight lines.

The Cow with the Drooping Horn (ill. 67) is directly in front of the Red Cow with the Black Collar. It is incomplete: the head, with an acute facial angle, the rather gracile neck, throat, withers and the beginning of the back. The whole occupies a frame measuring 1.82 metres in width and less than 1 metre in height. The major anatomical difference, in comparison with the other paintings of cows at Lascaux, is the feeble development of the horns, which are painted with a brush. Whereas the left one emerges perfectly (short, curved back, pointing towards the forehead), the right horn, of equivalent form and length, could only be revealed by image processing

and leaves the poll in the direction of the upper cheek.

Dichromatic representation, based on red and black, is a constant feature of the first three bovines of this corridor on both the right and left walls. All have a black anterior sector, which contrasts with the red body. Nevertheless, only the head of the Cow with the Drooping Horn profits from this treatment; the horns, ear and neck are untouched. There is also a superimposition of the two colours, unlike the Red Cow with the Black Collar. Above the line of the back of these two bovines are several assembled signs, the majority of which are cruciform.

Despite its favourable texture and chromatic properties, the ceiling of the Axial Gallery has only been used to a modest extent. Only two animal representations are found here: a very inconspicuous yellow head of an equid and another complete representation of a bovine. The latter boasts huge dimensions, extending over 2.87 metres across the entire width of the vault and on to the walls at both sides. This figure would have been difficult to position owing to the accentuated curvature of the underlying surface and its inaccessibility, but its proportions are comparable to those of the cows immediately adjacent. However, although the thoracic region is shown in detail, the red colouring depicting the croup and the thigh of the animal is only partial and the hindlimbs are only sketched, so as not to encroach upon the second Chinese horse below. Numerous indications show the technical difficulties encountered during the positioning of the outlines of this monochrome picture. This is one of the few figures in the cave to have been corrected, at the level of the left forelimb (ill. 68).

To the right, the Red Cow with the Black Head (ill. 69) occupies the upper part of the gallery. The outline is classic, but it has unique details – such as the muzzle, which is distinctive due to its slight lateral

Preceding pages:
66 The Red Cow with the Black Collar.
67 The unfinished outline of the Cow with the Drooping Horn partly envelops the first subject of the very discrete frieze of horses on the left wall.

Opposite:
68 The first third of the Axial Gallery assembles on the ceiling and the two walls a group of four female aurochs, which are very similar in their execution, and two friezes of horses.

Overleaf:
69 This diptych of the red cow and the first Chinese horse is rightly considered to be one of the pinnacles of Palaeolithic parietal art. Nevertheless, in this setting of quite modest proportions, several other compositions can equally lay claim to this distinction.

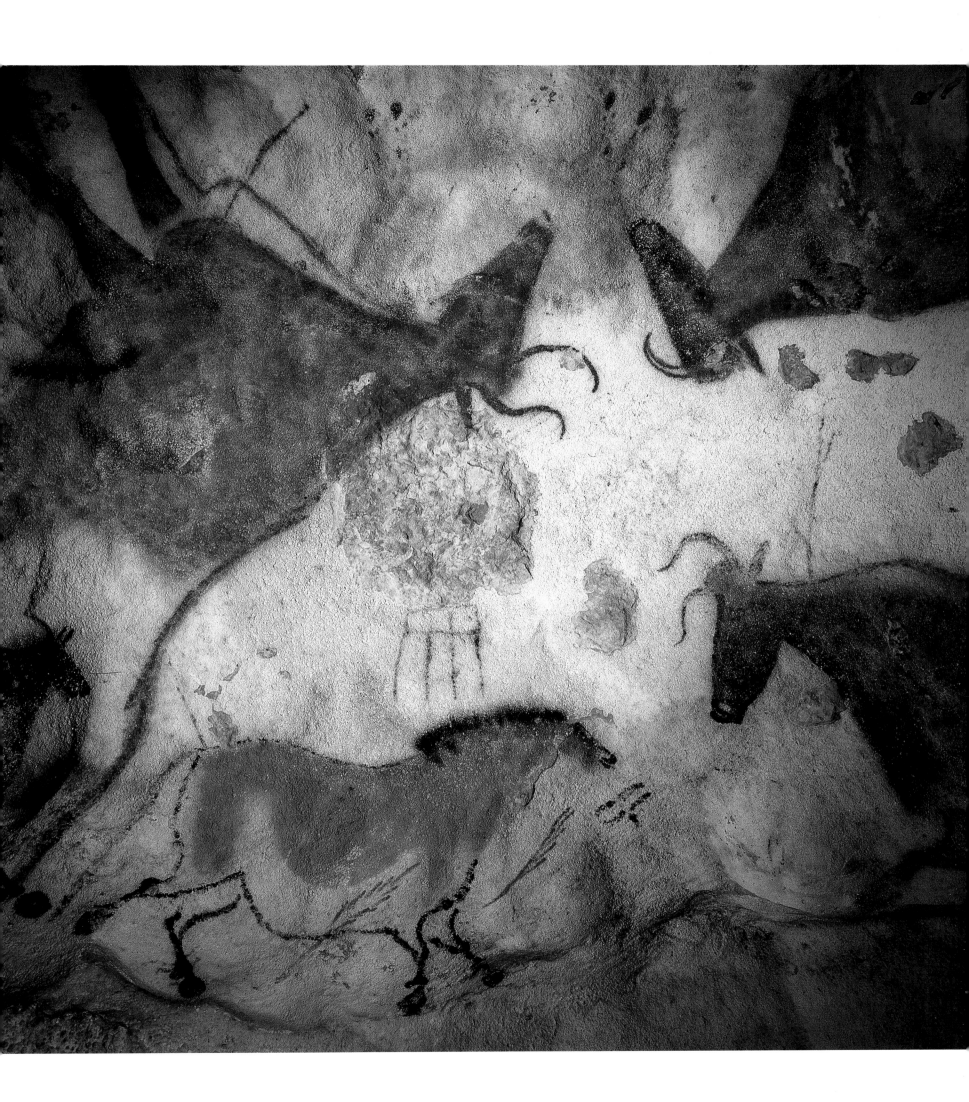

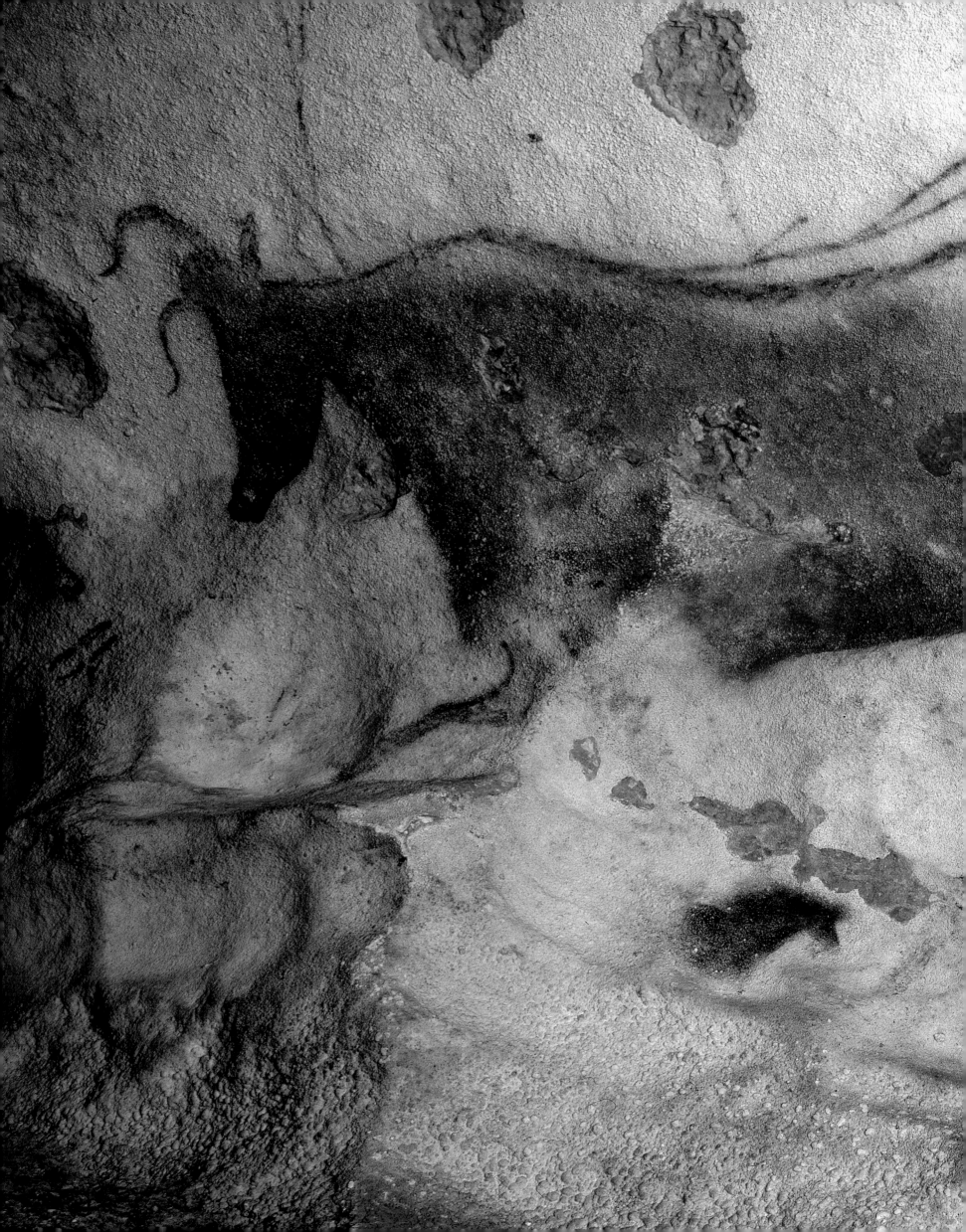

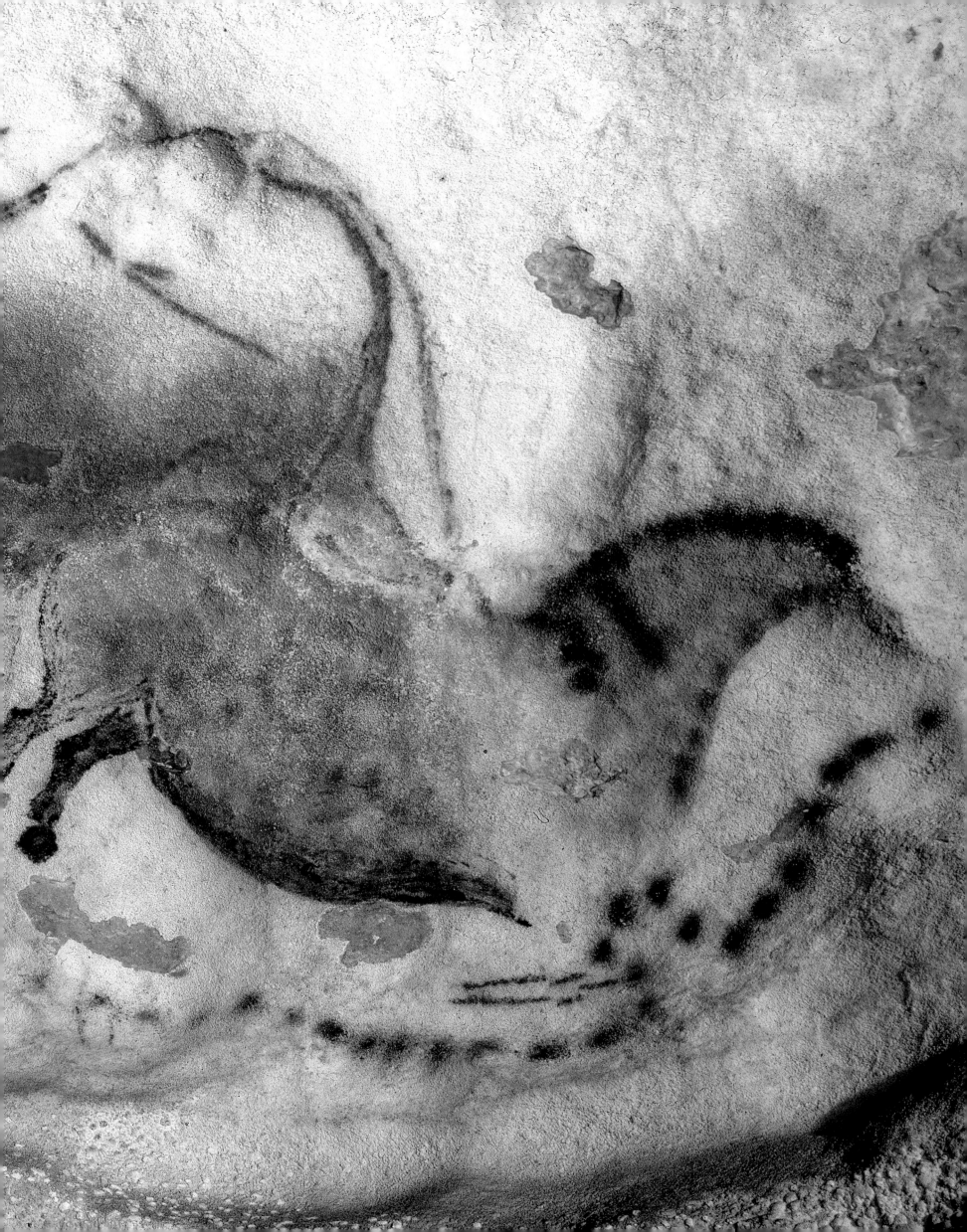

displacement, and it is enhanced by the addition of the nasal orifice (a blank area). The forelimbs lie to both sides of a vertical ridge. The one on the right extends forwards, but the other one is folded back below the chest. The connection with the body is not very confident. The two hooves have been drawn, but their outline is very tenuous and disappears at the left below an efflorescence of calcite. The outline of the hindlimbs was predetermined by the first Chinese horse. The extended right hindlimb is shown as far as the end of the hock, while the second limb is only suggested by the start of the leg. The tail is shown by a simple line, reduced to a faint trace at its proximal end; its outline becomes thicker and then breaks off at the point of contact with the dorsal line of the Chinese horse. A brush was used a lot in painting this figure (to outline the forelimbs, for example). One notices the uniform and continuous execution of the lines of the head and beyond that, from the neck to the start of the hindlimbs. At the withers these lines change colour, from black to red. The tail is subjected to a similar process. Detailed examination shows that the depiction of the poll is not restricted to a simple line of demarcation, but that the hairiness of the forehead is represented by several short, parallel dashes. A sketchy yellow quadrangular sign (above the middle of the tail), branching lines and hooked signs are the only non-figurative elements associated with this animal.

As has already been mentioned, there are two distinct groups of equids, each containing three individuals. The main group of horses, of noticeably similar proportions, face the entrance and extend in a line over 5.5 metres. The polychromatic horse, or first Chinese horse, occupies a position midway between the black stag and the Red Cow with the Black Head (ill. 69). Three colours were used: red for the throat and the beginning of the chest, yellow for the body and black for textural

lines. (…) Symbols are particularly evident here, both in terms of number and size, and include the 'curly bracket' sign. They are found outside and below the horse, particularly parallel lines and a red nested sign, but also on its flanks, where a series of black dashes is submerged in the brown mass of the abdomen.

The second Chinese horse is the most famous (ill. 70). The regular lines of its composition, together with the extreme precision of its coat and anatomical details, contribute to the excellence of this work of art. Taking into account the colour of the underlying surface, a regular colour was applied for the coat. The anatomical features are reduced to their essentials or evoked cautiously, such as the two short and triangular-shaped markings on the neck. The mane is composed of a slightly arched alignment of fifteen oblong, clearly distinct marks. Exfoliation of the underlying surface has caused deterioration and erased the poll. The snout, on the other hand, preserves its original appearance, both in its material and form. A long and narrow scar marks out the line of the chest. The sub-circular back hooves are more accomplished than those at the front, which are more irregular and lack colour.

The third Chinese horse has most of the anatomical features usually depicted, apart from the eye, although this omission reinforces its relationship to the others. The mane is of medium thickness and ends at a pair of well-developed ears, which are perpendicular to the top of the forehead. This horse is distinguished by its coat, which is more precise than usual, both in terms of structure and colours. The five marks on the neck are broad but get gradually shorter from the shoulder to the middle of the back. Fifteen short, parallel, thin lines mark the periphery of the abdomen. Colour is used to differentiate the parts of the body. The yellow of the flanks is associated with shades of black on the pelvic region and along the

upper outline of the animal, creating subtle combinations and an accurate reproduction of the coat. It is rare for the skin to be rendered in this way, not only at Lascaux but in Western European parietal art generally. Associated signs are limited to two adjacent lines drawn above the dorsal line of the horse.

The left wall bears many similarities in its technical features, composition and themes. It opens out over 6 metres, beyond the Red Cow with the Black Collar.

The three horses of this frieze are unusual in possessing somewhat ethereal outlines. The first, painted between the two cows, is dichromatic: black pigments for the outlines and yellow to fill in the figure. Calcite has covered the applications and has reduced the contrasts, making it more difficult to identify the figure. Only the mane, the two marks on the shoulder and the beginning of the line of the back are clearly visible. The tail, suggested by some dots of black colour, is discreetly underlined by a very faint and broken thin red line. The central subject of this frieze intervenes between the head of the Cow with the Drooping Horn and the neck of the red bovine painted on the underside of the ceiling. This horse preserves the translucent appearance of its predecessor. However, it is almost complete, with some minor exceptions, which were either not depicted or have been obliterated by calcite or by the neck of the cow drawn on the ceiling. This affects, above all, details relating to the head, the mandible and the two ears. There are two marks on the neck and the tail, partially masked by the muzzle of the Cow with the Drooping Horn.

The third horse of the composition is to the right, some distance away from the others. It is drawn in the hollow of a concavity and partially hidden by a large projection of the wall that underlies it. Although all the lines of the outline of the body are present, only fragments of the

lines of the tail and the forelimbs, which are reduced to stumps, are visible; of the head only the forehead is drawn. A tentative line, limited to a loop, is intended to mark the twofold division of the coat. The poorness of these outlines is matched by the fairly summary technique of their execution. The outline of the body, the tail, the forelimbs, the mane and the forehead is traced with a brush using red pigment. Infilling is only partial: a field of yellow covers the neck and the first third of the body.

On the facing wall, the head of a bull (ill. 71) is drawn on the same horizontal line as the long frieze of the Chinese Horses and functions as a transition to the deeper panels. Due to the slope of the floor, it dominates the graphic composition of the second third of the Axial Gallery. This depiction, incomplete but of impressive dimensions, is comparable to those of the Hall of the Bulls in every respect. Only the outline has been reproduced here, using similar graphic conventions: curved horns, the poll, the massive muzzle and chin, a central stripe and the divided edge of the cheek (the jaw and beginning of the dewlap). No detail of the interior is recorded, neither the eye nor markings of the coat. The awkward location of this bull prompted the artist to create the lines with a series of dots, using a tool long enough to bridge the great distance between his hand and the wall. This technique was used for the main anatomical features (forehead, muzzle and chin), and daubing was employed elsewhere.

The three panels of the central sector of the Axial Gallery occupy a keeled space, 8 metres long and with an average width of 4 metres. The two panels of the Great Black Bull and the Hemione are located on different levels of the left wall, while the Falling Cow is on the right wall. This is one of the major sequences of decoration at Lascaux, extending continuously from the entrance of the Hall of the Bulls to this point. These three panels

Overleaf:
70 The second and third Chinese horses complete the composition initially dominated by the four red cows. One of these, painted on the ceiling, marks with its tail the boundary between the two equids.

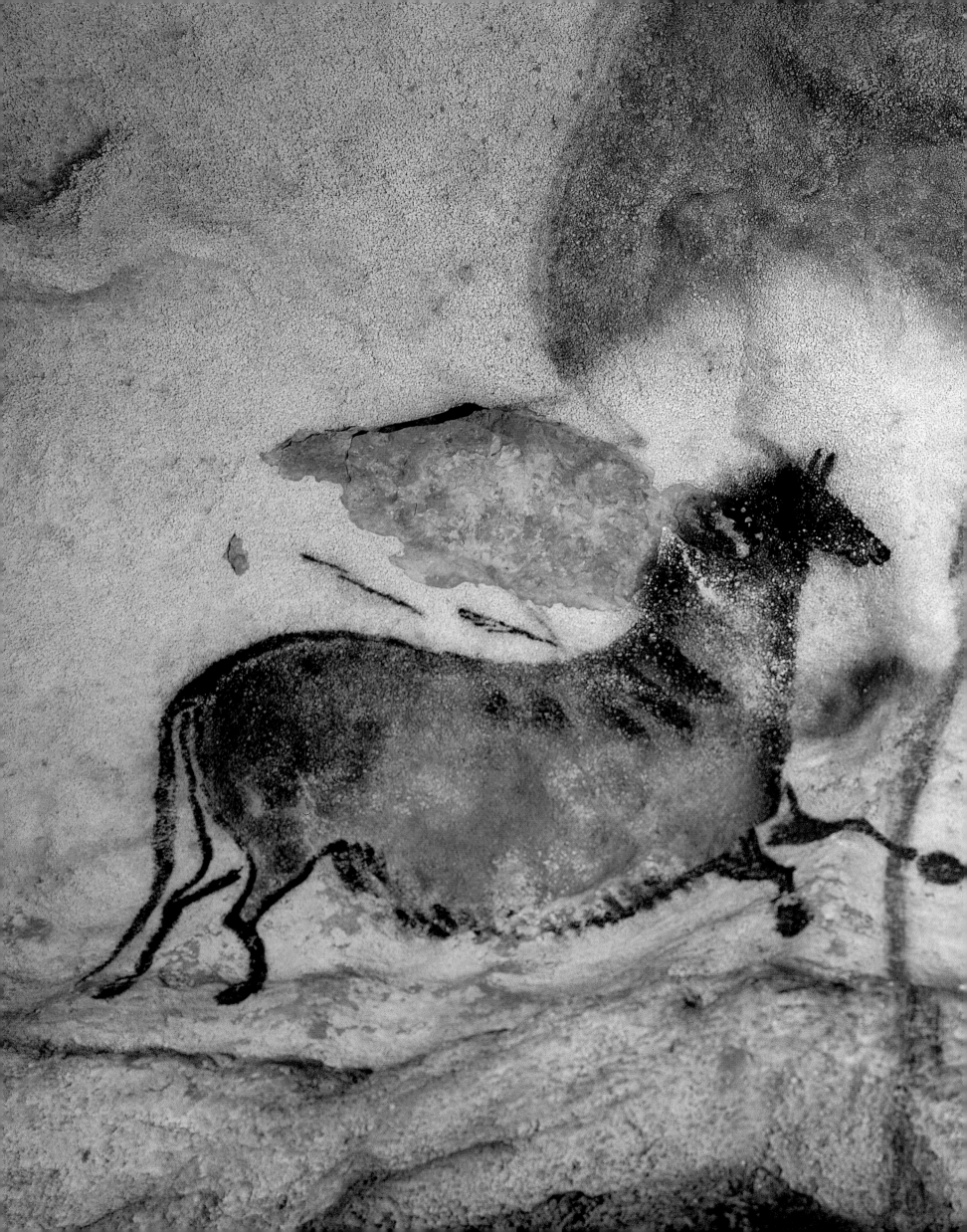

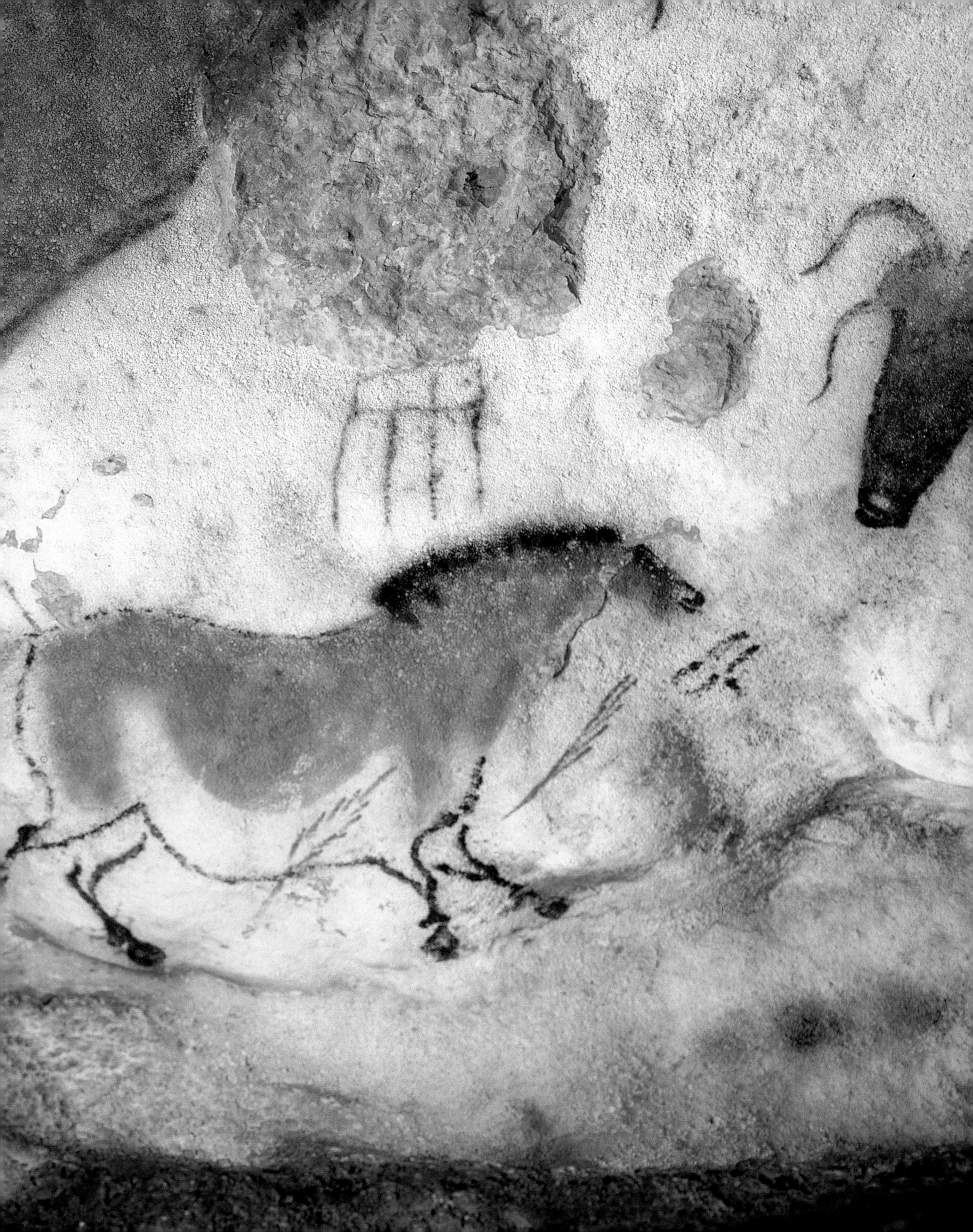

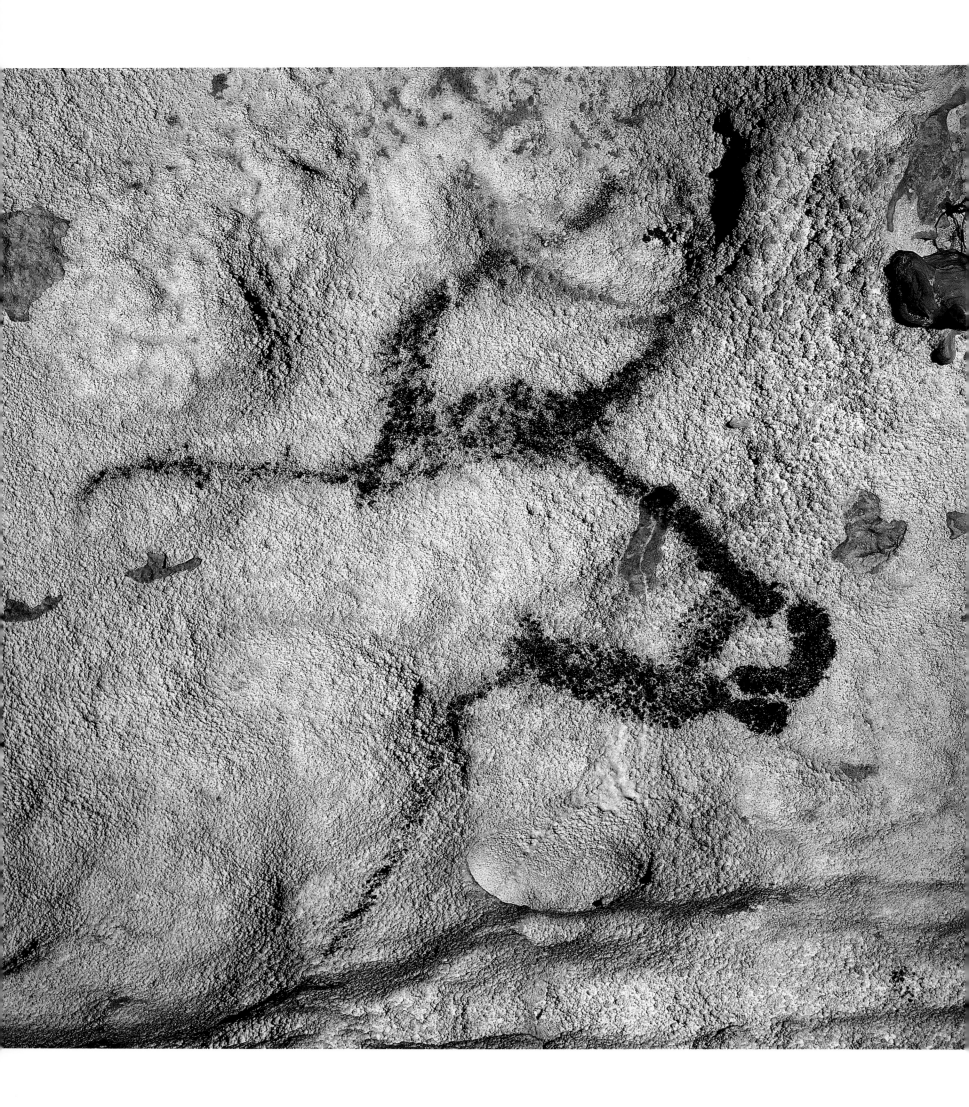

assemble 35 animals, 7 signs and 32 indeterminate markings.

THE PANEL OF THE GREAT BLACK BULL

The figures here are located on two panels, formed by two broad adjacent concavities and separated from each other by a sub-vertical ridge. The base of this group runs horizontally over 7 metres, overhanging the present-day floor, which slopes from 1.8 metres near the entrance to 2.8 metres at the far end.

A dozen figurative images, thematically restricted to aurochs, horses and a feline, have a very uneven distribution (ill. 72). On the panel to the left, which only comes into sight after the first constriction of the corridor, there are no fewer than six aurochs whose outlines merge into the mass of black colour of the seventh bovine, the Great Black Bull. Other, more modest figures are identifiable to both sides of this group. There are two sketches of equids and

possibly an ibex. Some signs, two cruciform and one branching, complete the tableau. The second panel comprises a large horse and a very inconspicuous head of a feline. The composition is completed by a number of signs, including a branching sign in front of the solitary horse.

The Great Black Bull (ill. 73) faces the entrance of the sanctuary and, at 3.71 metres long and 1.93 metres tall, is the most monumental work of the Axial Gallery. Two factors accentuate the bull's sheer size: the way in which the black hide is depicted against the flawless background and a lack of neighbouring figures of comparable size. Most of the anatomical features are represented, except for the front left hoof. The morphology of the animal is comparable to that of the great bovines of the Hall of the Bulls. The treatment of the horns is classic, with a double curve for the element in the foreground and a simple curve for the one behind. The same is true of the outline of the muzzle, where a continuous spiral curve

Opposite:
71 Some distance away, this head of a bull, painted on the upper level of the wall, dominates the group of depictions of the panel of the Falling Cow.

Below:
72 Panel of the Great Black Bull. The distribution of the animal figures on the two wings of this panel, which is composed around a vertical ridge, is very uneven. The confronted equids of the panel of the Hemione occupy the lower frieze of the wall.

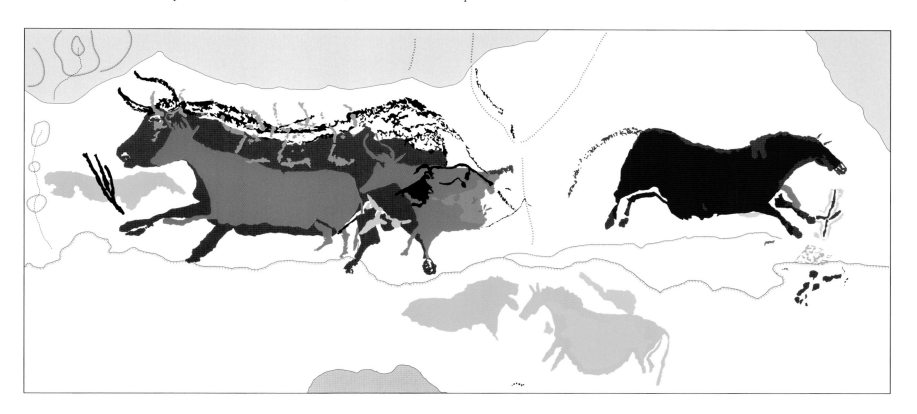

represents the nasal opening, the upper lip and the external margin in succession. The hooves have an asymmetrical bilobate form, and the eye is shown.

The entire animal has been sprayed, with the exception of the horns, the line of the back and the tail. Only rarely are gaps in the colouration visible on the lower two thirds, even in those areas that are close to extremely uneven surfaces. This implies that colour was sprayed in different directions in order to paint even the smallest projections and hollows. Some gaps were left in this huge area of colour on purpose in order to preserve the figures below, particularly the two red cows. The homogeneity of the spread of colour has been broken up through the use of different techniques. This transitional zone follows a regular curve, from the nape to the thigh. Above this, a brush has been used to finish the work. Despite difficulties identifying the first red cow, due to its location within the coat of the Great Black Bull, it is nevertheless possible to identify almost all the elements of its silhouette, with the exception of the left forelimb. This figure is comparable with those on the ceiling at the entrance to the Axial Gallery, in particular the Red Cow with the Black Collar. (…)

The second red cow has very similar proportions and outlines, but is not as complete as only its forequarters are shown. Generally, this unusual technique is restricted to the smallest figures. Nevertheless, at the lower border of the application of colour a black line tenuously extends the abdominal margin with the beginning of a leg. Difficulties of access may explain the incomplete nature of this figure. The absence of hooves on the two forelimbs is not an exceptional feature at Lascaux. The profile of the forehead is demarcated by a broken line. One peculiarity of this painting is the absence of the withers, following a straight cervical-dorsal contour. Anatomical features drawn with a brush are rare, but this technique has been used on the horns, the ear and part of the line of the belly. Other elements, such as the head, the neck, the thoracic region or the forelimbs, were sprayed. The colour of the animal's coat becomes progressively weaker from the base of the neck to the rear.

The line of the back of the imposing aurochs obliterates four aurochs heads in a line, all facing towards the entrance. This frieze is 1.8 metres long, from the head of the Great Black Bull to the beginning of its croup. The heads are yellow (ill. 74) and not immediately recognizable: only the horns extend beyond the black mass; the rest is overwhelmed by the very dense coat of the animal (ill. 75).

The first head, at the extreme left of this composition, can only be identified by its horns, which alternate with those of the Great Black Bull, and forehead, the line of which crosses the bull's eye. The second head has more details – notably the eye which is only sketched. The third aurochs head is the most complete, representing the beginning of the line of the throat, the muzzle and the

Opposite:
73 The Great Black Bull. This large aurochs, whose entire body is blanketed with black colour, is one of the most symbolic figures of the Lascaux Cave.

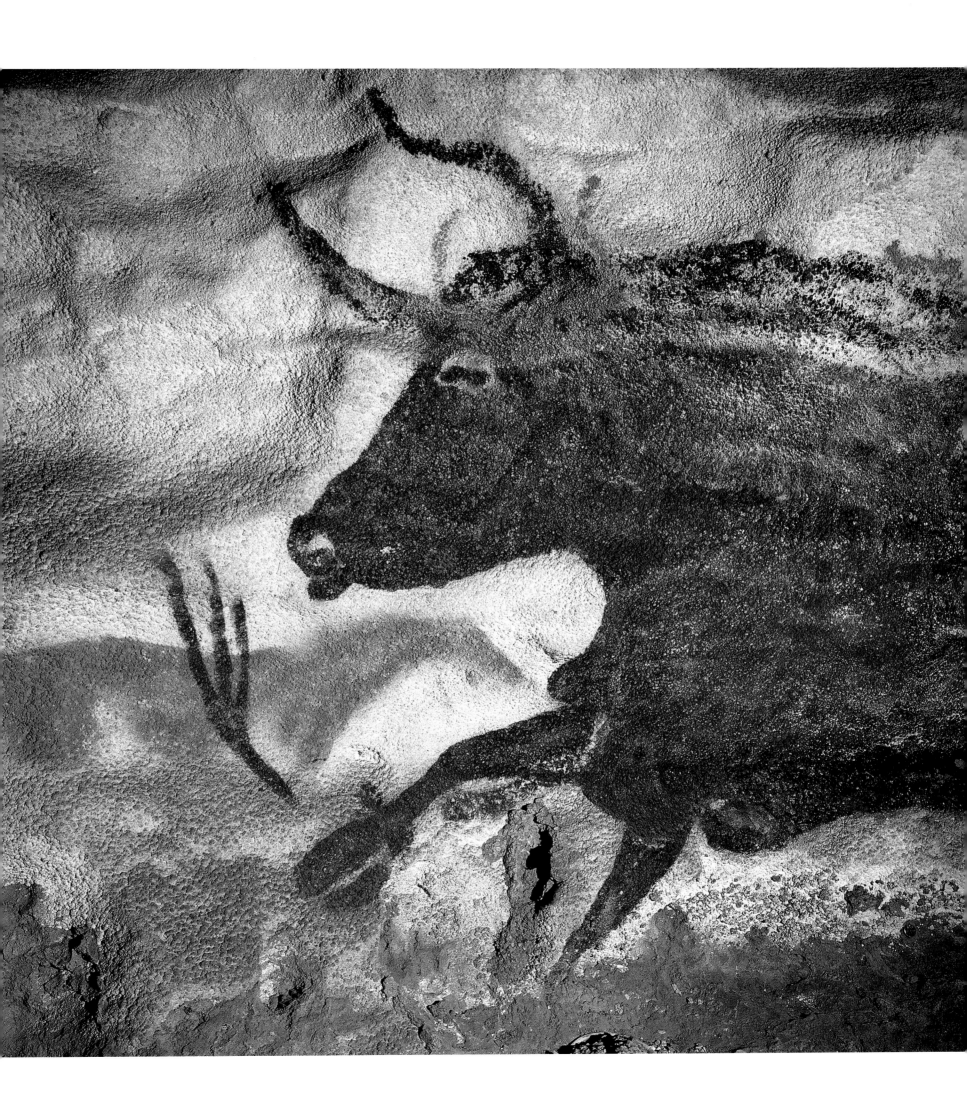

mandible. The scatter of colour for the coat is similar to that of the great bulls of the Hall of the Bulls, supporting an affiliation with the bovines of the first hall. An identical conformation of the horns is also seen in the final head. There are fewer dots on the cheek, although they are just as complete as on the preceding figure. None of the four heads overlap the red cow below, which is undoubtedly why the first two figures are so incomplete.

A yellow equid, cut in half by a black branching sign, stands in front of the Great Black Bull. This figure occupies a marginal position in the composition of the frieze, at the edge of the left panel. It is limited to elements in uniform flat colours. The head, neck and body are depicted, and the division of the flank of the animal into an 'M'-shape suggests a relationship with other equids in the Axial Gallery – notably with the second Chinese horse, located on the facing wall.

On the withers of the red cow behind the Great Black Bull there are the black, very tenuous outlines of another animal, seemingly a horse. It is possible to discern the line of the back, the croup, the tail, the hind leg in the foreground and the line of the belly. The forequarters merge into the black thigh of the aurochs. (…) The animal appears to have been headless.

The last figure of this panel is also difficult to define, as it is buried by the uniform black thigh of the Great Black Bull and by the red neck of the cow to the rear. A second figure, just as inconspicuous as the former, adds to the confusion of the lines. The entire figure is black. Image processing reveals the outline of an animal with a stocky shape, a very small head and a weakly indented back, with the tail reduced to a short appendage. We could tentatively interpret the animal as an ibex.

The second wing of the panel is marked by a very large silhouette of an equid (ill. 76), which, at more than 2 metres long, must be classed among the most imposing horses

74 These three yellow aurochs heads belong to the first figures drawn on this panel. They were, to a great extent, obliterated by the silhouette of the Great Black Bull.

of the cave. A horizontal fissure in the wall partially underlines the painting, from the front right hoof to the left extremity of the body. The forelimbs extend beyond the imaginary line of the floor created by this natural formation, which has the effect of thrusting the figure forwards, evoking a gallop. All anatomical parts have been depicted. The eye is represented by two

small, slightly arched and opposed lines, although this feature – unusual at Lascaux – is difficult to see in the very dense colour of the coat. A strong dilation of the abdominal region highlights the difficulties experienced by the artist here, working in a framework that is limited by two natural formations. Image processing shows that he made several corrections to the line of the belly. The underlying formation obscures part of the flank, reducing the depth of the body, hence the great dilation of the shape.

A second narrowing of the Axial Gallery marks the entrance to the locality of the

Upside-down Horse. The gallery retains its 'keyhole' cross section. On the same left side, 1.8 metres above the present floor, is an unobtrusive figure of an animal – an abbreviated silhouette of a feline sprayed on to the wall. The ears, forehead and square muzzle of the animal are shown, but their separation and the technique used have added to the uncertainty surrounding this figure.

THE PANEL OF THE HEMIONE
This modest panel contains only three horses. The one furthest to the right merges with the convoluted wall, while

Above:
75 Depiction (after image processing) of the heads of the yellow aurochs hidden by the silhouette of the Great Black Bull.

Overleaf:
76 Isolated on the right wing of the panel of the Great Black Bull, the Galloping Horse is one of the most imposing depictions of an equid at the site, a distinction it shares with the red and black horse of the Hall of the Bulls and the two confronted horses engraved on the ceiling of the Apse.

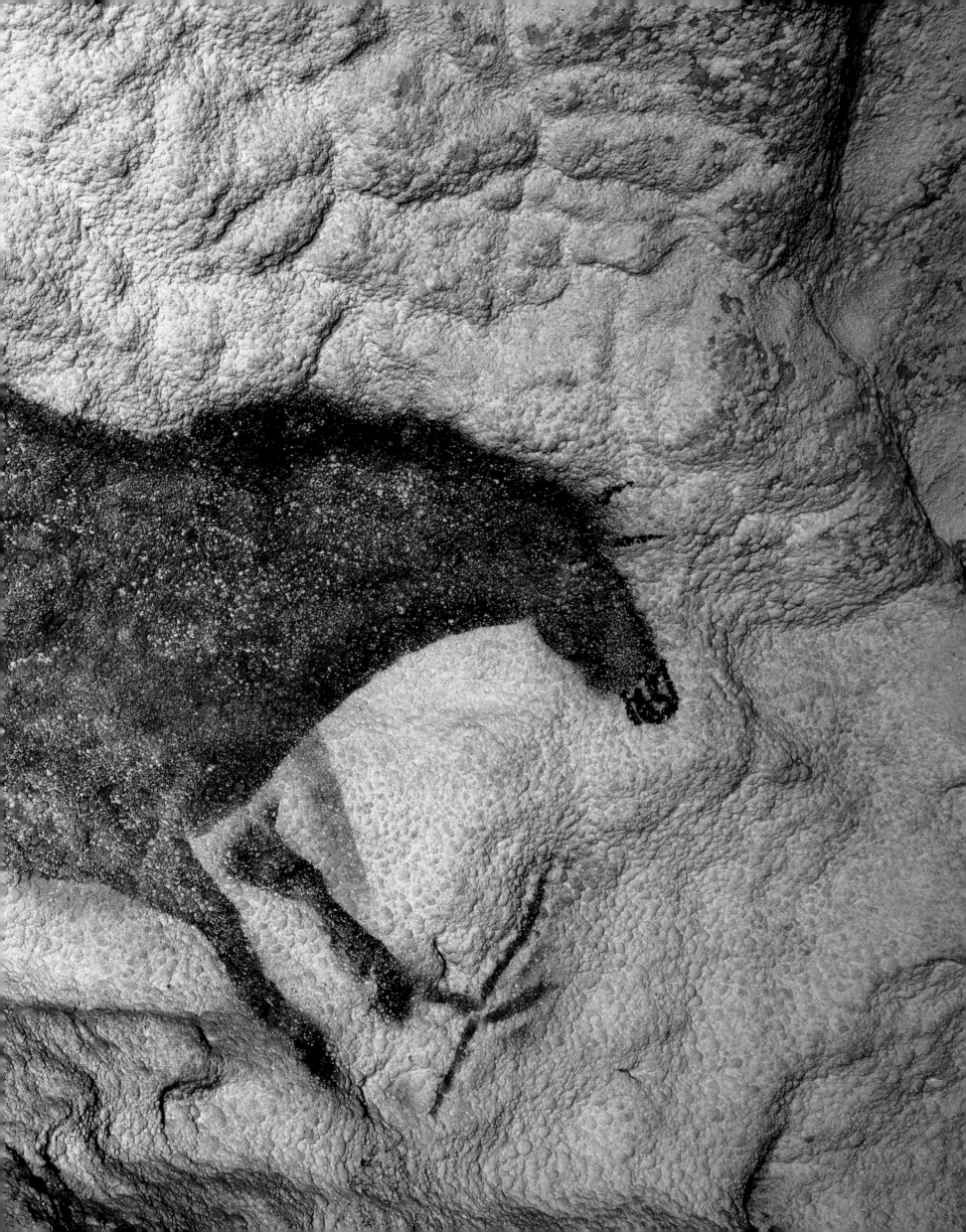

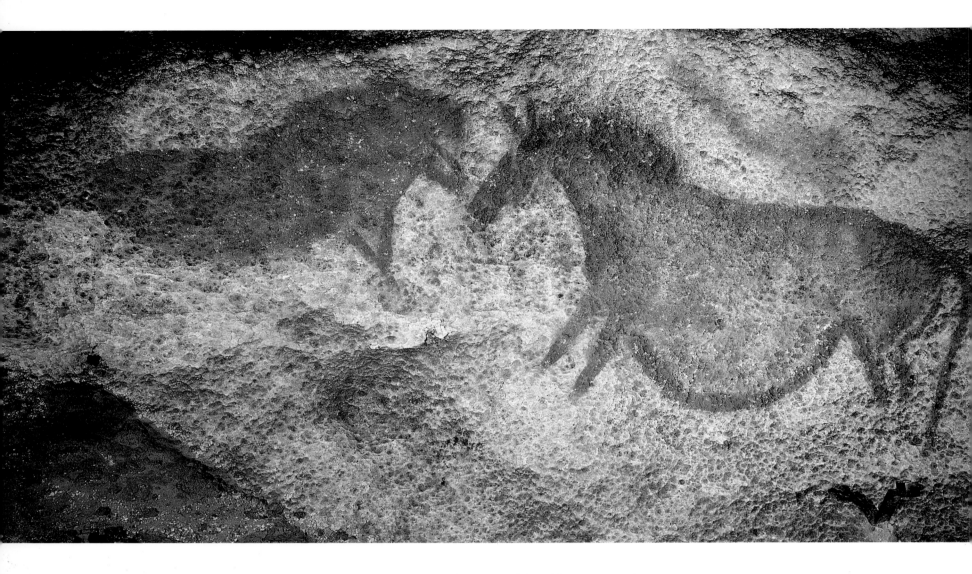

77 These two representations of equids painted face to face are drawn on one of the quite uncommon, relatively flat surfaces of the lower level of the Axial Gallery.

at the centre of the tableau two equids (ill. 77), one of them incomplete, face each other. This group occupies the stratum below the Great Black Bull.

Despite the use of only one colour (yellow), the 'hemione' (an extinct wild ass) is quite detailed; only the extremities, the hooves and the tip of the nose are absent. The differentiation between horse and hemione was based on several observations: the more developed ears, the slender neck, the very steep croup and the convex lower line, characteristics that are more typical of the hemione than of the horse. Nevertheless, one finds these same elements, but more scattered, on many of the Lascaux horses. The differences observed merely put this figure on the borderline between the two species. The animal is not sufficiently distinct from the others to be identified unreservedly as a hemione, and we should therefore

conclude that there are no hemiones in the Lascaux bestiary. Moreover, to date, not a single bone of this animal has been recovered in the Upper Palaeolithic of Western Europe.

The second horse lies between the head and the complete animal. Only its forequarters are shown, but it has its own features nevertheless: a particularly developed poll, a less pronounced transition from the mane to the back and the unbroken line of the heavy front body.

The natural wall reliefs have been used extensively in the depiction of the last horse of this small panel. The only painted element is a very elongated yellow field, which maintains a constant width over its first 30 centimetres but then broadens into a sub-triangular form. Interpretation of this figure is facilitated by its proximity to a similar shape within the outline of the

'hemione', at chest height and extending from the head to the right forelimb. The stencil technique is identical. The same goes for their orientation and inclination. The natural upper line of the panel, highlighted by lateral lighting, reveals the neck, the line of the back and the croup of the animal. The particular morphology of the wall also suggests the presence of the tail and the beginning of a hindlimb. At Lascaux, figures in which the background has made such a major contribution are the exception, and this is the most extreme example.

THE FALLING COW

This panel assembles most of the different forms of composition encountered at Lascaux (ill. 78), including animals in single file, as mirror images, in tiers or in groups. Three types of animal share the space: the aurochs (the Falling Cow, roughly in the centre), the ibex (the animals facing each other on the far left of the panel) and the horse, numerous examples of which are scattered across the entire surface. There are two large

78 Positioning of the figures on the panel of the Falling Cow.

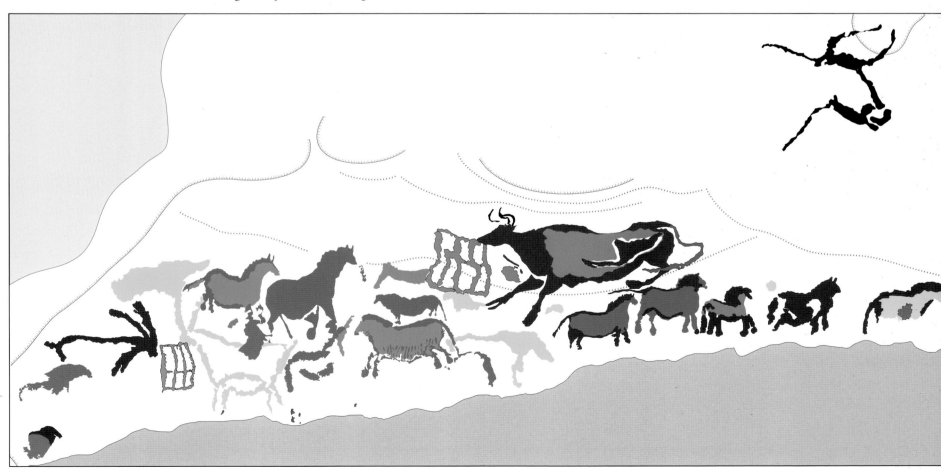

quadrangular signs, one between the two ibexes, the other in front of the aurochs (ill. 79). Of the 23 recorded figures, 20 are animals and 3 are signs. The interpretation of 29 other representations ranges from undetermined signs to mere traces of activity.

The horizontally elongated frieze extends over 7.2 metres and is no more than 1.2 metres high. All the animals have been sprayed (both their contours and their hides). Still, the end result is not monotonous as this panel has a wider range of colours than any other at Lascaux, a skilful unison of the background colour with fields of uniformly flat pigment. A prime example is the black piebald horse, located on the right-hand side of the panel.

The number of figurative works is high, given the available space, but there are few superimpositions and they are always very marginal. The artist or artists overcame space constraints by miniaturizing the horses, which are among the smallest figures of this gallery and of the Hall of the Bulls. This is perhaps surprising considering how difficult it is to paint miniature subjects on a coarse-grained background, even when spraying is the only method used.

The spatial organization of the panel is determined by the Falling Cow (ill. 80), which dominates the whole due to both its elevated position and its dimensions. This is one of the most accomplished figures of the cave. Its originality lies both in the abundance and the quality of the anatomical details and in its motion, which is rare in Palaeolithic art (ill. 81). Its contracted hindlimbs are drawn flattened against the body: the right one follows the outer edge of the abdomen; the other, its outline indicated by a blank area, is drawn upon the flank of the animal. Originally, this figure was called the 'Leaping Cow', but its posture does not suggest leaping. Closer analysis shows that the hindquarters do not lie along the extension of the forequarters, but there is pronounced twisting of the pelvic region,

Opposite:
79 Absent from the Hall of the Bulls, quadrangular signs are the dominant geometric unit in the Axial Gallery. Nevertheless, their occurrence is limited to the right wall, on the panel of the Chinese Horses and that of the Falling Cow, where they appear twice.

Overleaf:
80 The graphic surroundings of the Falling Cow remain limited to horses, to quadrangular signs and, at its edge, to ibexes. This distribution is not dissimilar to that of the panel of the Great Black Cow in the Nave.
81 The spatial organization of this panel is subordinate to the Falling Cow, which dominates the whole due to both its dimensions and its position at the apex of the composition.

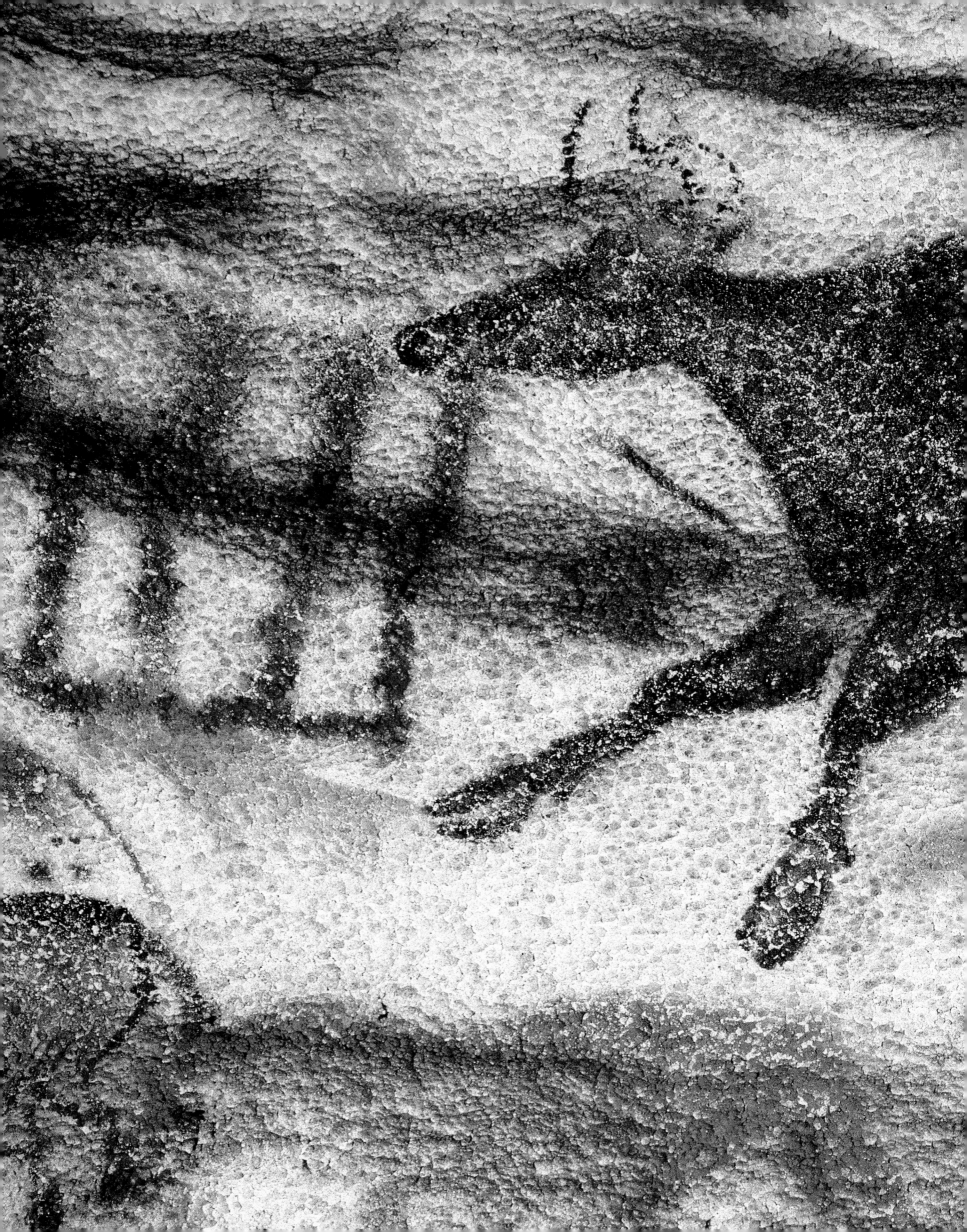

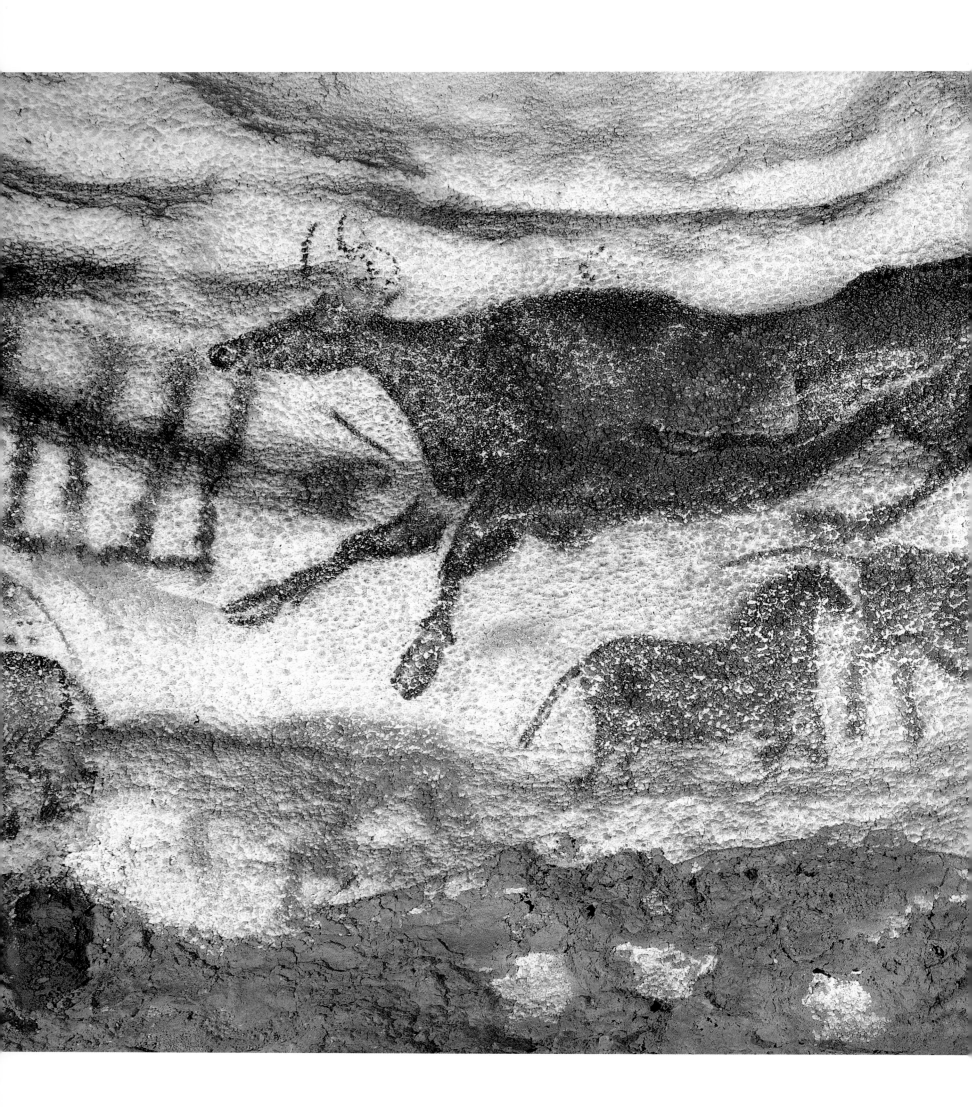

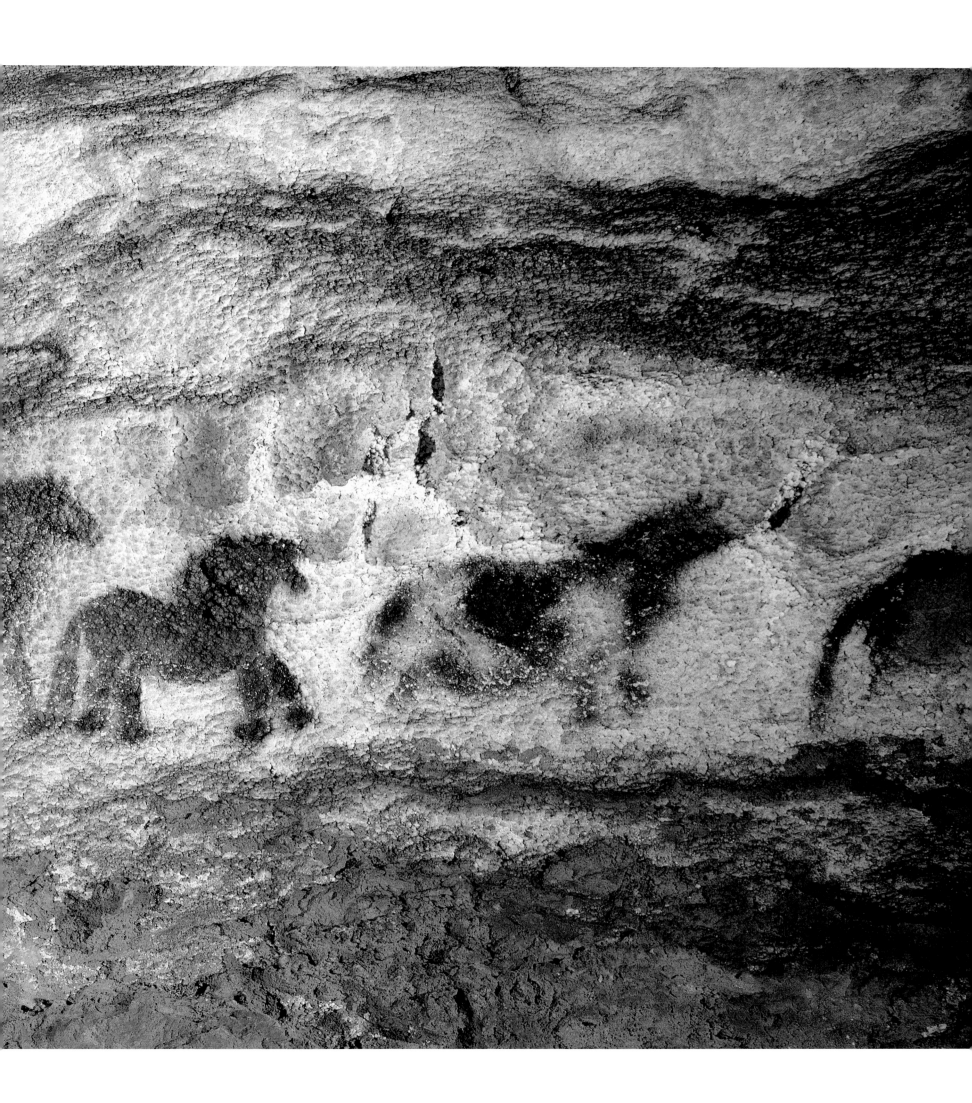

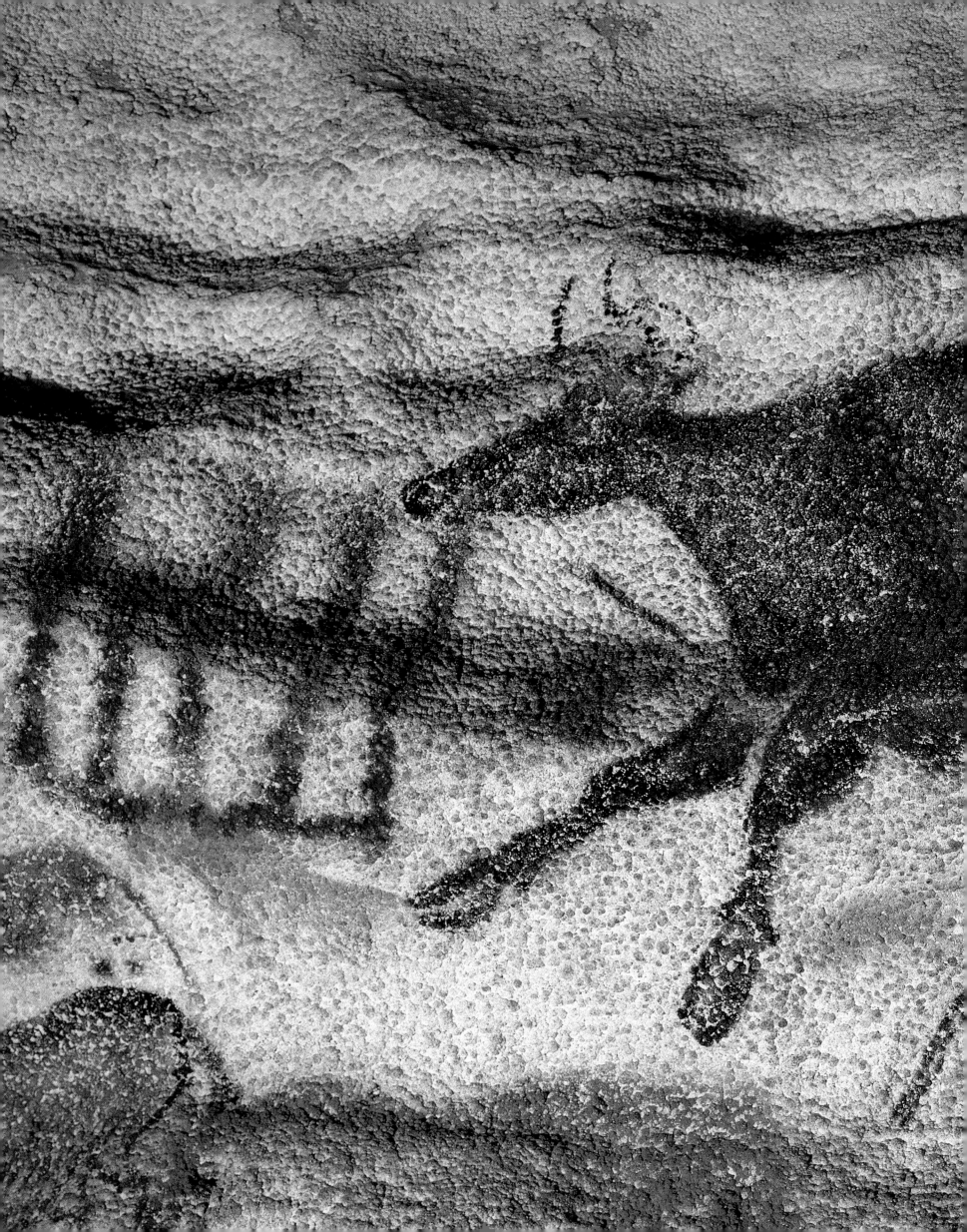

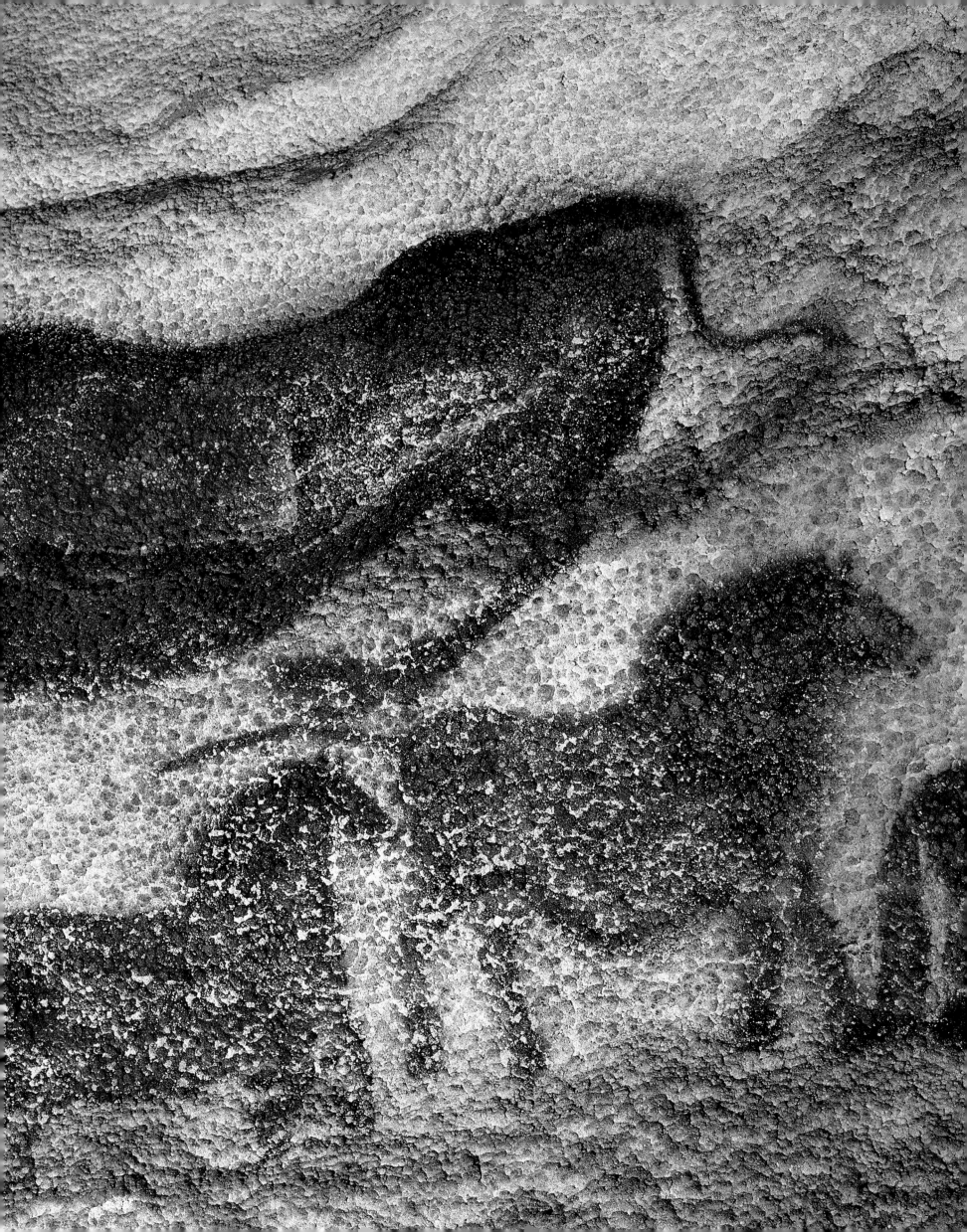

associated with a forward projection of the forelimbs and the head. The rotation of the pelvis outlines the iliac crest and reduces the bulge formed by the articulation of the tail. The cow is clearly in an unstable position, and may be either slipping or falling.

The Falling Cow has a very delicate head, with the horns projected forwards. Denser dots have been used on the nasal opening, which has been partially outlined by a calcite outgrowth of more recent origin. The black tail, highlighted by a red line, follows a long and very sinuous trajectory, curving a few times before crossing the right hindlimb to finish below the abdomen. The ensemble of lines and panels of colour have been sprayed, although a brush was used on the snout and horns – hence the latter's dotted appearance due to the existence of reliefs that fixed the pigment here and there. Avoiding this difficulty, the use of lateral stencils on the lines of the body, the head and the front and hindlimbs produced an unbroken line with an average width of 3 centimetres. Prior to this phase, the oblong area marking the central part of the body was coated with red pigment. This superimposition of colours made the surfaces mauve.

The Confronted Ibexes (ill. 83), located at the extreme left of the panel, are of a similar technique and size, and differ only in some anatomical details and their colour, one being black and the other yellow. A red quadrangular sign is inserted between the two belligerents. The black ibex (ill. 82) is noteworthy: few animals are depicted in such a precise and consummate manner with so few lines (six in total). The two horns seem to cross at their base in order to depict both the mandible and the bridge of the nose and muzzle. An identical technique is used for the chest and the two forelimbs as well as for the cervical-dorsal line and the tail. There is a slight convexity on the line of the back, suggesting the withers and distinguishing the alignment of the neck from the back

and croup. The beginning of the rump is sketched. The conciseness of the outline makes the animal instantly recognizable and accentuates the stocky appearance of the silhouette. The powerful character of the animal comes through, emphasized by its developed horns. The lines were sprayed with the use of a stencil. (…)

Although more complete than its black counterpart, the yellow ibex does not have all the classical secondary anatomical details, in particular the ears, the eye, the beard and the hooves. (…) It differs from the black ibex in the angular shape of the croup, undoubtedly because the artist did not wish to paint over the horse to its rear. The tail is a simple, straight mark, without the usual curvature. The coarse head is not detailed. The divided line of the belly is a unique feature. This could be a correction, but it is more likely to mark the border of the twofold division of the coat along the loin, which is darker over the upper part of the body and white around the belly of living ibexes. This animal, facing the back of the gallery, seems to be the product of a less skilful hand. The techniques used (spraying and stencil) are the same, although masking is less prominent and limited to the inner edge of the front legs and the outside of the ventral line. The treatment of the horns is incomplete.

The first group of horses face the entrance and occupy the entire left half of the panel. Three of them are aligned in the upper section; the others, which are incomplete, are distributed around the Confronted Ibexes. There is a sketchy image of a yellow horse at the extreme left of this group, recognizable by two small indentations (one for the poll and the other for the transition from the mandible to the lower line of the throat). Its characteristic elongated form is linked to the choice of anatomical parts depicted and its animation. The head, the neck and the back are aligned along the same horizontal line. The animal stretches its neck forwards, its head greatly raised, in

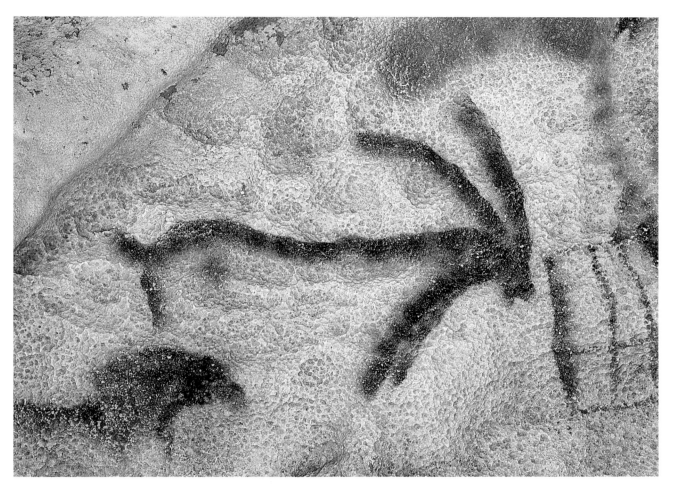

a motion covering the croup of the animal in front of it.

The split tail and the bayonet form of the forelimbs contribute to the latter's (ill. 84) individuality. The flanks and chest are a lighter brown than the neck and back. (…) At first sight, both horses look a similar shape, an impression that is highlighted by the colours used, but there are some differences. The anterior-posterior dimensions of the forelimbs of the horse on the right are very long and thick, and they look out of proportion. The front hooves are also somewhat disproportionate in size, and the bulge of the knee has not been depicted. The left hindlimb is shown

Above:
82 This black ibex is depicted in a precise and consummate manner with only six lines. The lines were created by the juxtaposition of impacts of colouring matter sprayed on the wall.

Overleaf:
83 Located at the extreme left of the panel, these two ibexes were created in a similar way and are of roughly equal size; only a few anatomical details and their colour differentiate them. The suggested liveliness has the quality of a confrontation. A red quadrangular sign was inserted between the two belligerents.

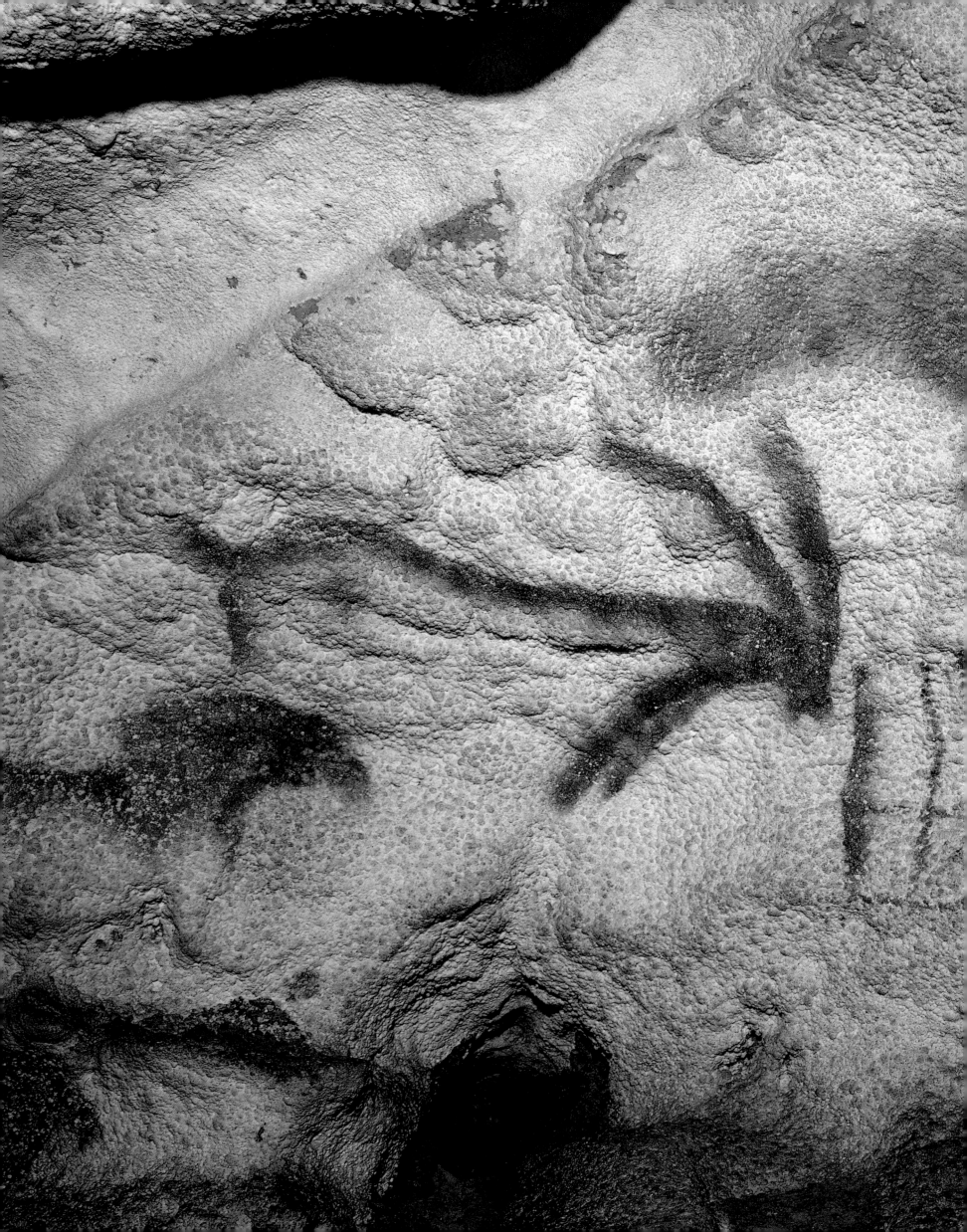

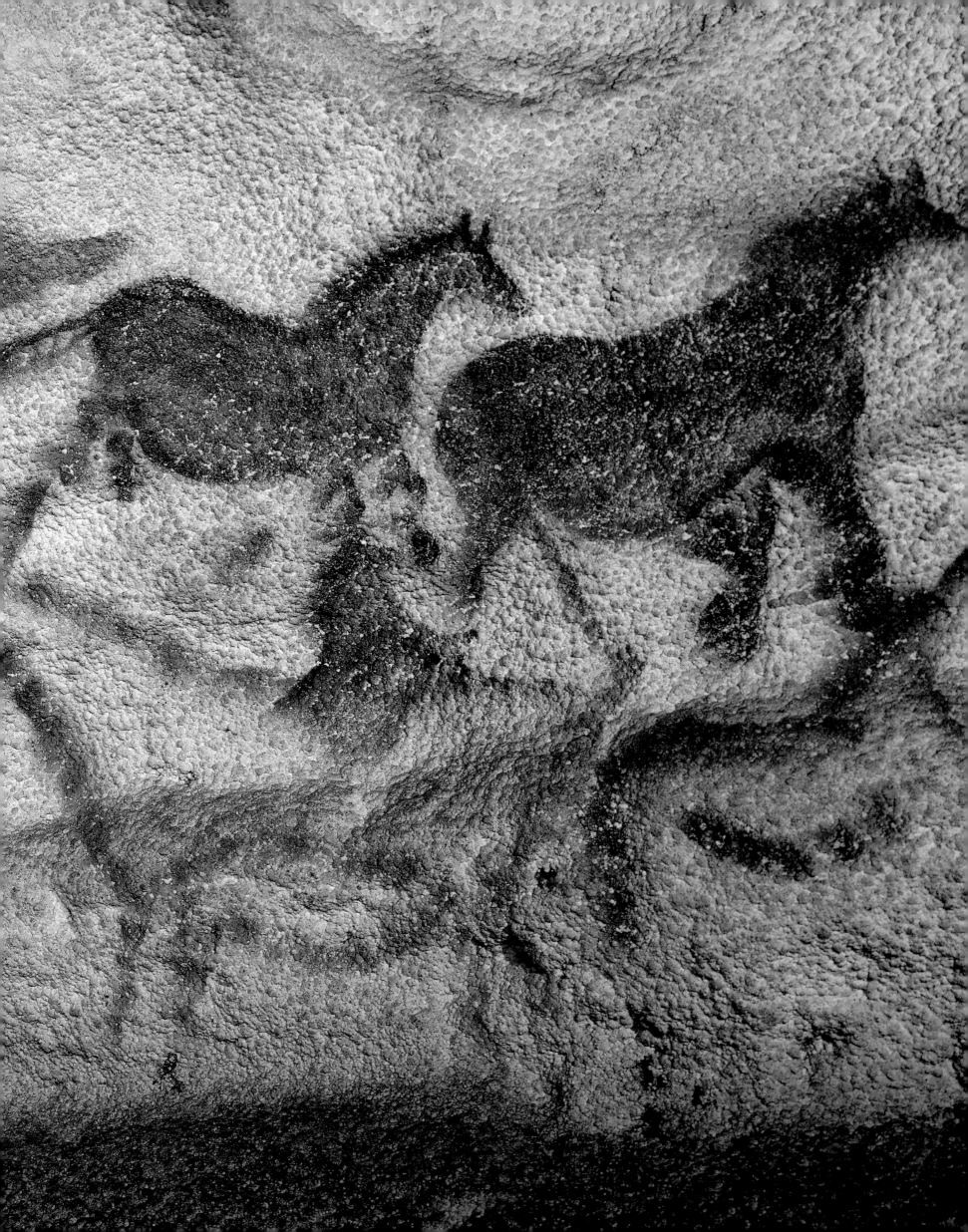

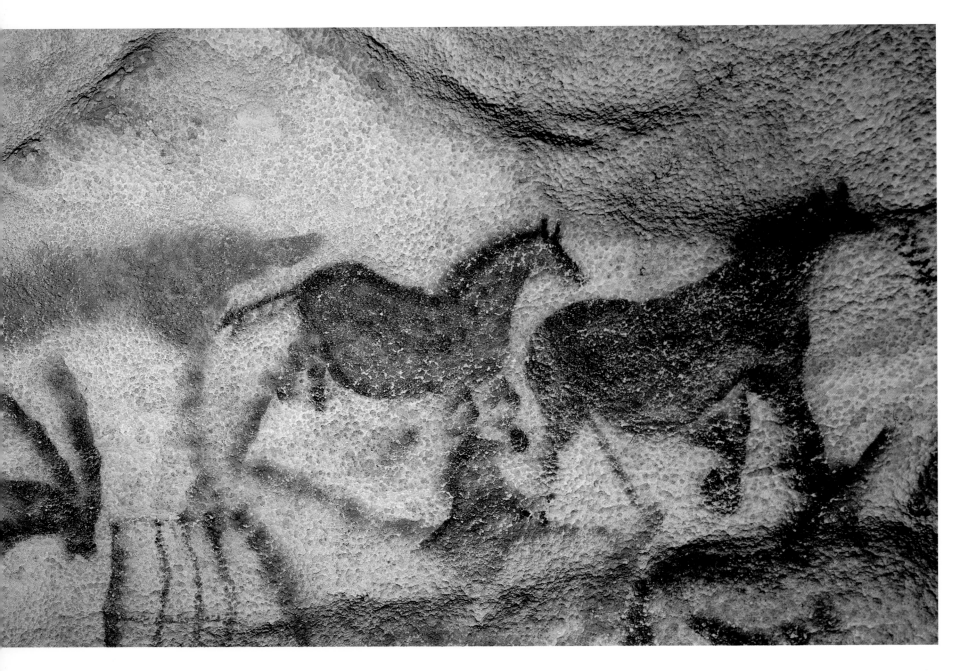

84 Orientated towards the entrance, as are all the horses of the panel of the Falling Cow, this group of three equids, located above the Confronted Ibexes, share in the extraordinary agitation that dominates this composition.

by an oblique straight line, extending from the knee. The right hindlimb has no hoof, but the outline corresponds perfectly with the majority of horses at Lascaux. The thickening of the triangular left lower forelimb cannot be interpreted as a correction; the desired form was modified by a second, denser border.

The four sketches of single horses located to both sides of the Confronted Ibexes have very varied forms. (…) The red horse under the black ibex is worth a particular mention as it has sometimes been interpreted as another ibex. The thrown-back head – a position that would place the horns along the line of the back – seems to be the only criterion to justify

this interpretation. However, image processing shows that the colour of the head blends with that of the neck, indicating that there are no horns. The indentation at shoulder level, possibly the end of a mane, also suggests that this is a horse. (…)

Standing in front of the cow and facing the back of the gallery, the second group of horses contains four superimposed subjects. The most detailed horse is set in a deep concavity at the centre of the panel. Despite its modest dimensions and the constraints of a coarse-grained surface, it has a lot of anatomical details, particularly in its coat, the arch of the tip of the nose, the chin and the nostril. The well-developed tail descends

to the imaginary floorline, retaining a constant width.

The outlines of a smaller horse painted immediately above are not as precise. This animal occupies an intermediate position in the panel, both in terms of its location in the middle of the group and in its degree of sophistication. It is given many more details than the other two on its right or above. Its contours are not underlined. This horse was almost entirely sprayed, although a brush was used on the knees and the hocks. Both techniques were used on the hooves.

There is an inconspicuous, orange-coloured sketch of a horse directly in front of the quadrangular red sign. It is difficult to identify because there are so few details. The head is represented only by the triangular bridge of the nose. The neck, which is very short but painted with the poll, has a diffuse periphery, while the line of the back shows a slight curvature. The quadrangular sign is also adjacent to another horse with a yellow coat, the head, neck and back of which can be recognized without too much difficulty. (…)

The third group of horses, all turned to the right, underlies the image of the Falling Cow and is referred to as the frieze of the Small Horses. Five horses, aligned along the same level, have been traditionally assigned to the frieze, but there is a sixth individual on the far left. It is highly inconspicuous with its poorly contrasted lines and sketchy outline, and the poor quality of the substratum has also played a part. Only the animal's forequarters and back have been depicted. One of the forelimbs breaks off in the middle, while the other has no hoof.

The second subject of this frieze is fairly accomplished and possesses all the details of the external outline while being uniform internally. The line of the belly shows a peculiar sinuosity, formed by two juxtaposed curves, and the fetlocks on the forelimbs are very developed. The uniform brown colour was sprayed and gives form to the body, neck and head. This outline was

85 Despite its modest dimensions and location in the midst of a multitude of small horses, it is still this outline of an equid that first catches our eye and is remembered.

86 This horse in the Axial Gallery is one of the very rare images of an equid with a piebald coat. The underlying surface has been used in the play of colours.

Opposite:
87 General view of the locality of the Upside-down Horse, at the far end of the Axial Gallery.

subsequently underscored by discreet black lines, which were also used on the ears, the lines of the back and the belly, and the legs.

The third subject of the frieze was painted on a slightly overhanging surface. It has a more conventional general form, including a pronouncedly convex abdominal line. No details have been forgotten, except the fetlocks. The brown body is partly covered in black around the forequarters, and in a more scattered manner elsewhere. A brush was used for the tip of the nose and the lower lip.

beginning of the tail; and black to give structure to the form and the limbs, and for the two neck markings.

The fifth horse (ill. 86) stands out owing to its piebald coat, marked out by areas of black colour on the white base of the underlying surface. The ears are clearly separated, planted perpendicular to the axis of the bridge of the nose. The silhouette of the sixth and last horse was entirely sprayed and, with its restrained lines, contrasts with the more accomplished motifs of the

The remarkable fourth horse (ill. 85) has most of its anatomical features. The work is sturdy, but as a result some details are blurred – notably the ears, which disappear in the very thick poll. Nevertheless, the silhouette does not look heavy due to the undulating, slender body of the horse. The miniaturization of this figure on this coarse wall made it difficult to paint, and consequently the artist was only able to include certain details, such as the tip of the nose, the chin or the curve of the mandible. Two colours have been used: brick red for the general silhouette of the body and the

composition. The outline of the massive head, the neck, the back, the croup and the tail emerge from a yellow field encircled by black, but the other anatomical details are absent.

THE LOCALITY OF THE UPSIDE-DOWN HORSE

The third part of the Axial Gallery is a more confined space with a much more complex architecture. A major constriction at the end of the passage marks the threshold to the locality of the Upside-down Horse (ill. 87). The gallery continues as a meander, and the

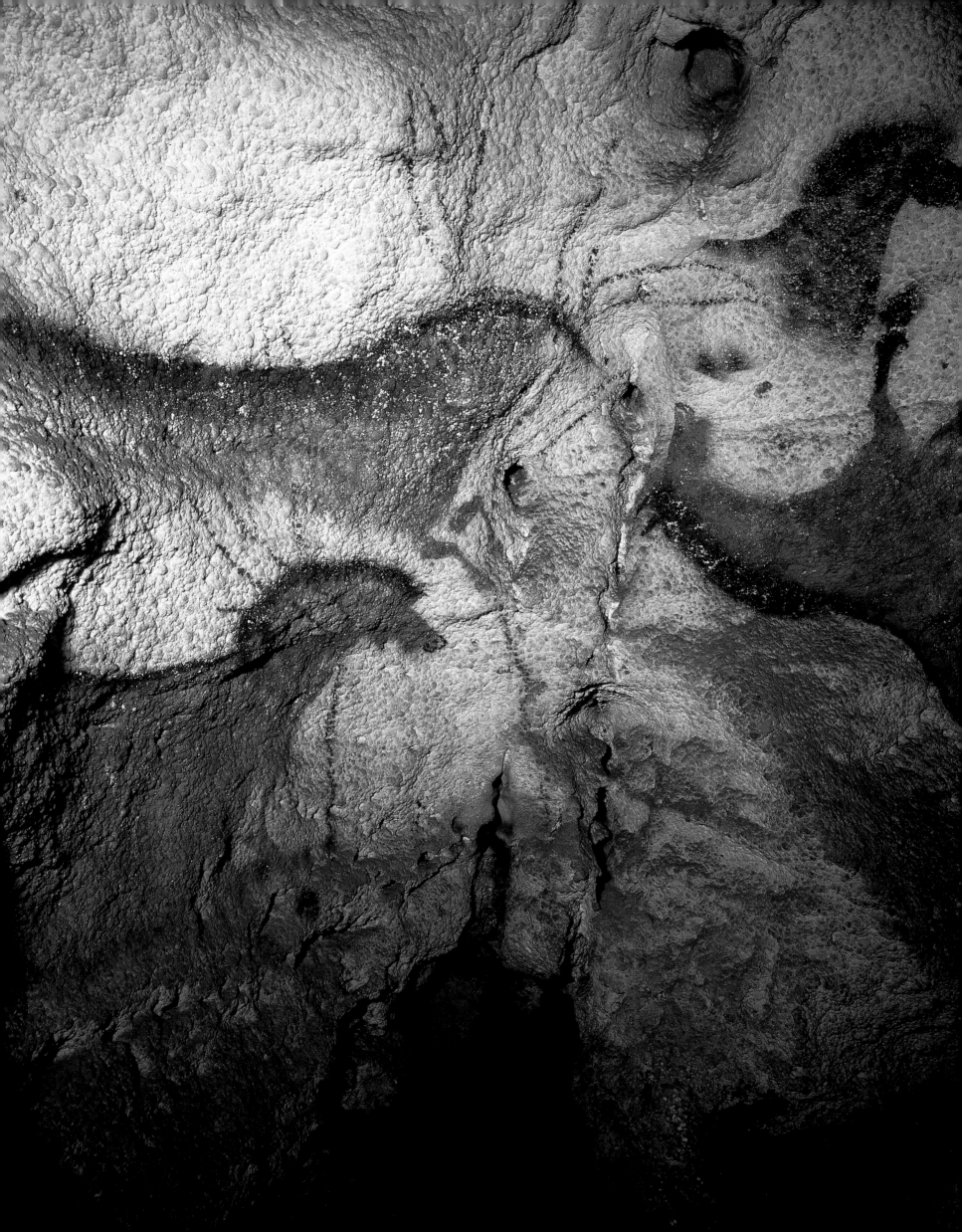

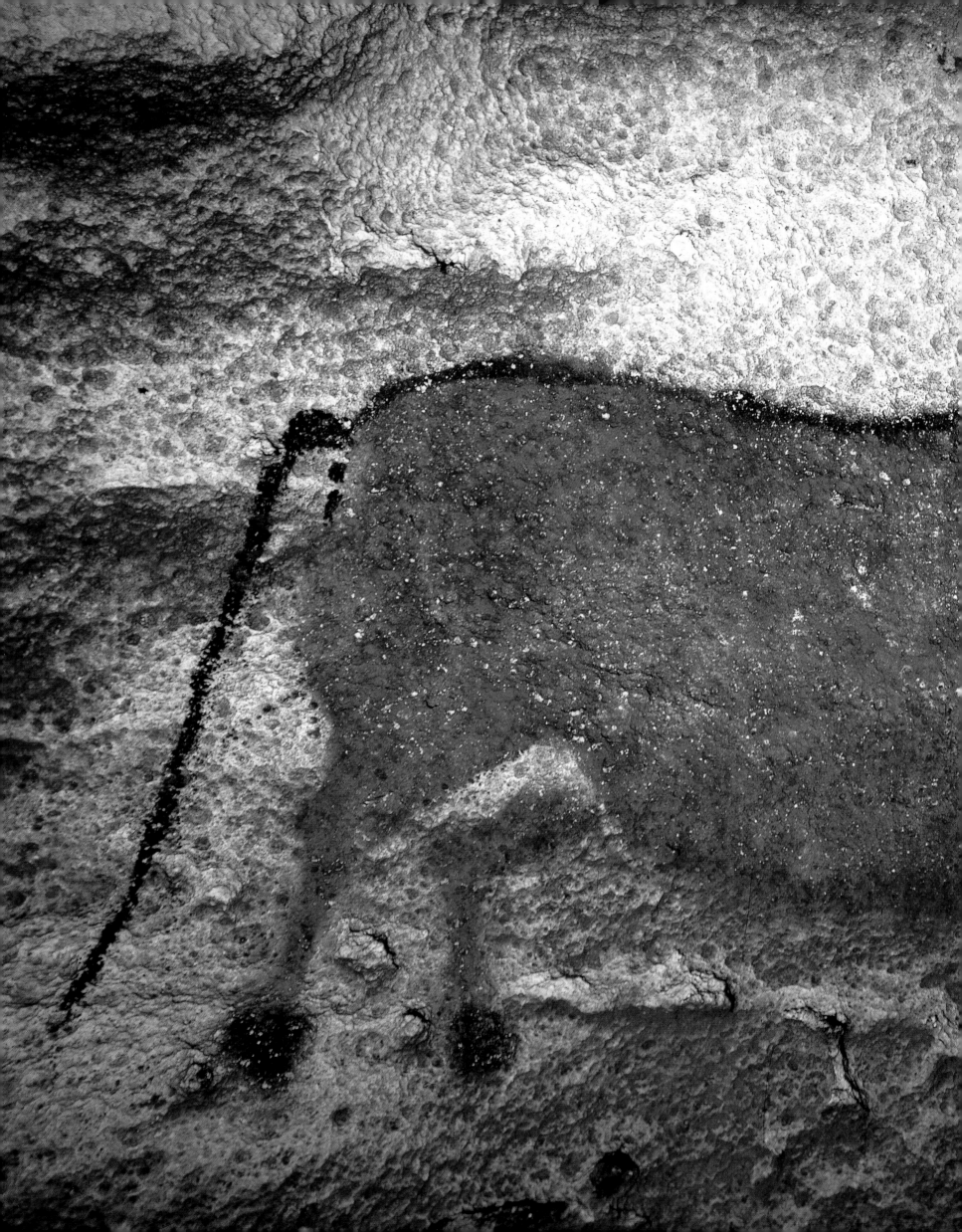

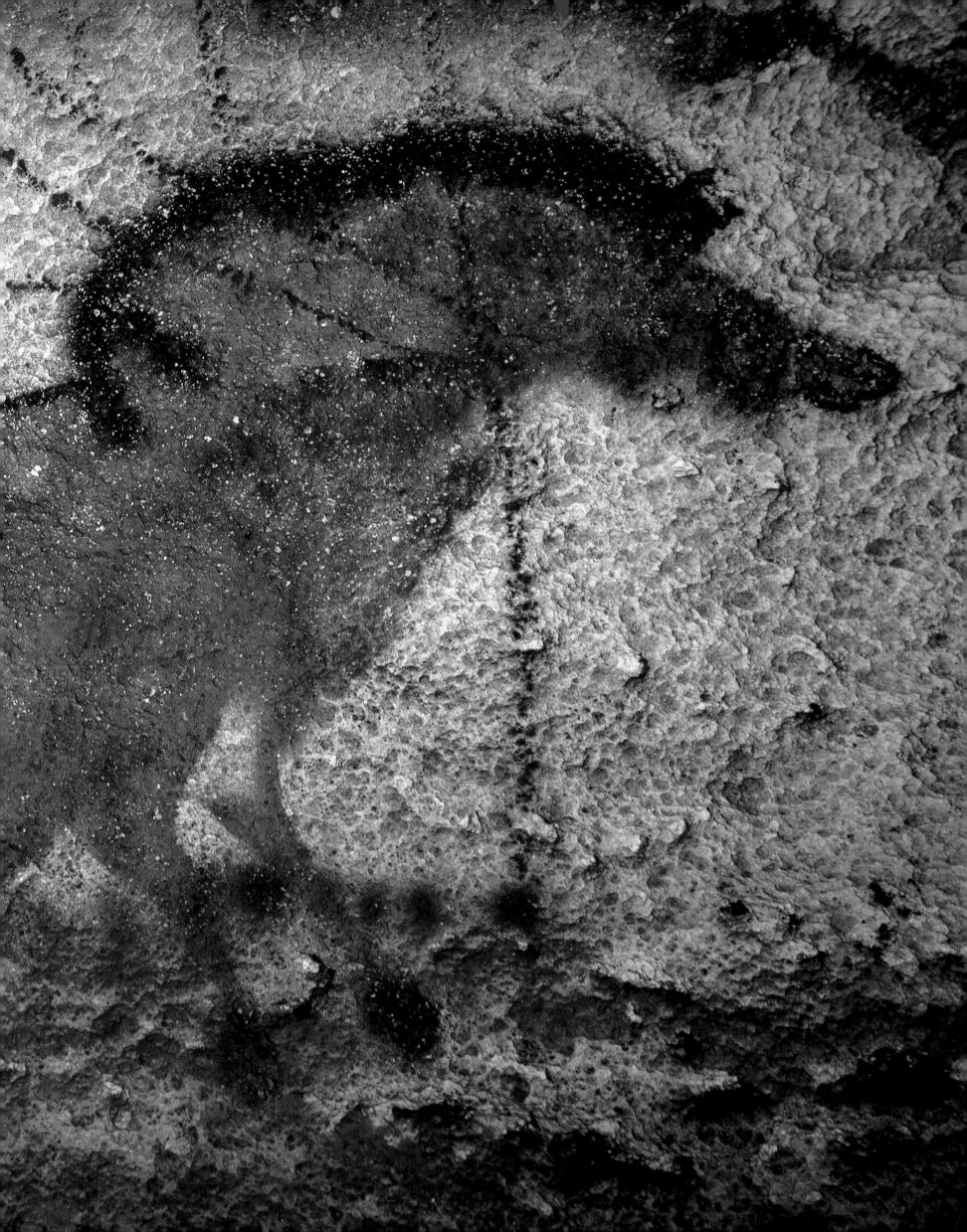

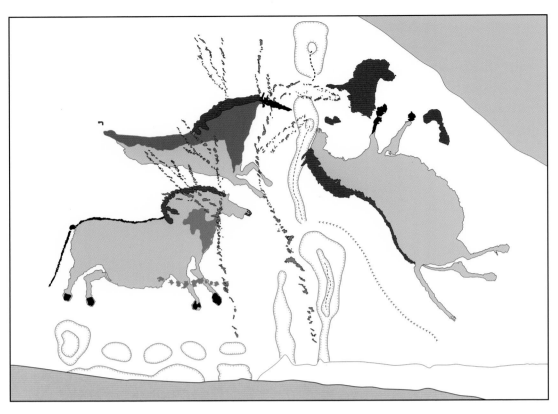

Preceding pages:
88 Numerous anatomical details have been included in this yellow horse: the two marks on the neck, the tip of the nose (with the nasal opening), the lower lip and the two ears in the poll.

Above:
89 Arrangement of the panel of the Upside-down Horse. The two wings of this composition are aligned around a very large figure, the form of which is not unlike that of a tree.

Opposite:
90 Despite the very disturbed structure of the background and the dynamism given to the Upside-down Horse, it retains proportions in every detail identical to those of the other horses at the site. Moreover, there is not a single observation point from which this subject can be viewed in its entirety, which must have made the positioning of this figure extremely difficult.

ceiling becomes appreciably lower. At the foot of the left wall a broad fissure has caused the lower level to detach – hence the name 'false pillar' given to this formation. The Upside-down Horse is wrapped around the false pillar. To the left are several cavities, all a few centimetres in size. Opposite, a deep horizontal groove, some 20 centimetres high, underlies the entire Red Panel.

Here, the fairly large dimensions of the figures and the narrowness of the locality give the impression of a dense concentration of animals. Each of these walls is decorated with a composition – the Upside-down Horse to the left and the Red Panel to the right.

THE PANEL OF THE UPSIDE-DOWN HORSE

The Panel of the Upside-down Horse contains thirty-seven figures, only four of which are animals, all horses (ill. 89). The yellow horse and the Upside-down Horse, which are at the same level but separate, are complete. The outlines of the third horse are higher up but limited to the forequarters and part of the back. On the right, overlooking the Upside-down Horse, is the head of a fourth equid. A black line at the top right of

the panel may be the end of a leg. There are a number of signs, including a series of ten red dots aligned horizontally, a field of red marks grouped in a triangular formation and an angular red sign above the croup of the uppermost horse. A large tree-like sign extends parallel to the fissure, partially obliterating the two superimposed horses on the left. Several black dots, either isolated or in groups, underline the whole panel.

The wall juts out just before this panel, hiding the yellow horse (ill. 88) from view. It is very detailed, with two neck markings, a particularly well-executed tip of the nose (drawn with the nasal orifice), a lower lip and two ears on top of the forelock. The black hooves are oblong at the front but less oval on the hindlimbs. The spraying technique was used to depict most of this animal, with the exception of the tail and the tip of the nose, which were painted with a brush. (…) The attachment of the tail is identical to that of the Galloping Horse of the panel of the Great Black Bull – very short and horizontal at its start, then forming a right angle and continuing almost vertically, away from the body. These graphic conventions recur several times within the space of a few metres, suggesting that a single person may have been responsible. (…)

Only the forequarters and the back of the polychrome horse located above (ill. 91) have been depicted. The arch of the mane follows the line of the back and makes the neck of this animal look very tense, an attitude stressed by the beginning of a horizontal head. Although not exceptional, the use of three colours is nonetheless quite rare, particularly the use of three true colours – that is to say, the background was not utilized in order to provide an additional hue. Furthermore, the distribution of the colours follows a reasoning that is stratigraphic in its sequence: yellow rendering the two legs and the lower part of the body, violet-red for the neck and the back, and black for the uninterrupted upper line.

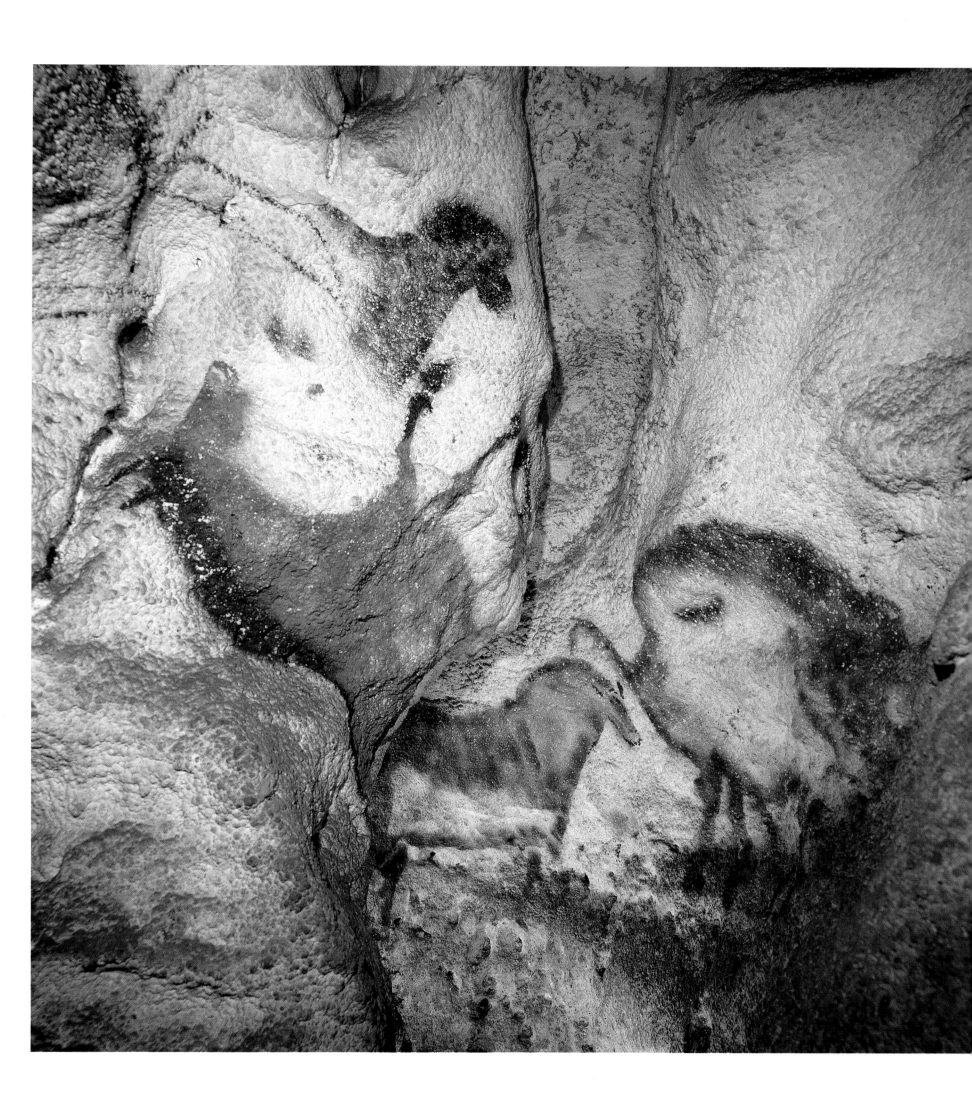

91 The use of three tones in the construction of this incomplete image of a horse is not very common, particularly as they are three true colours (for this work, the background was not used to provide a supplementary hue).

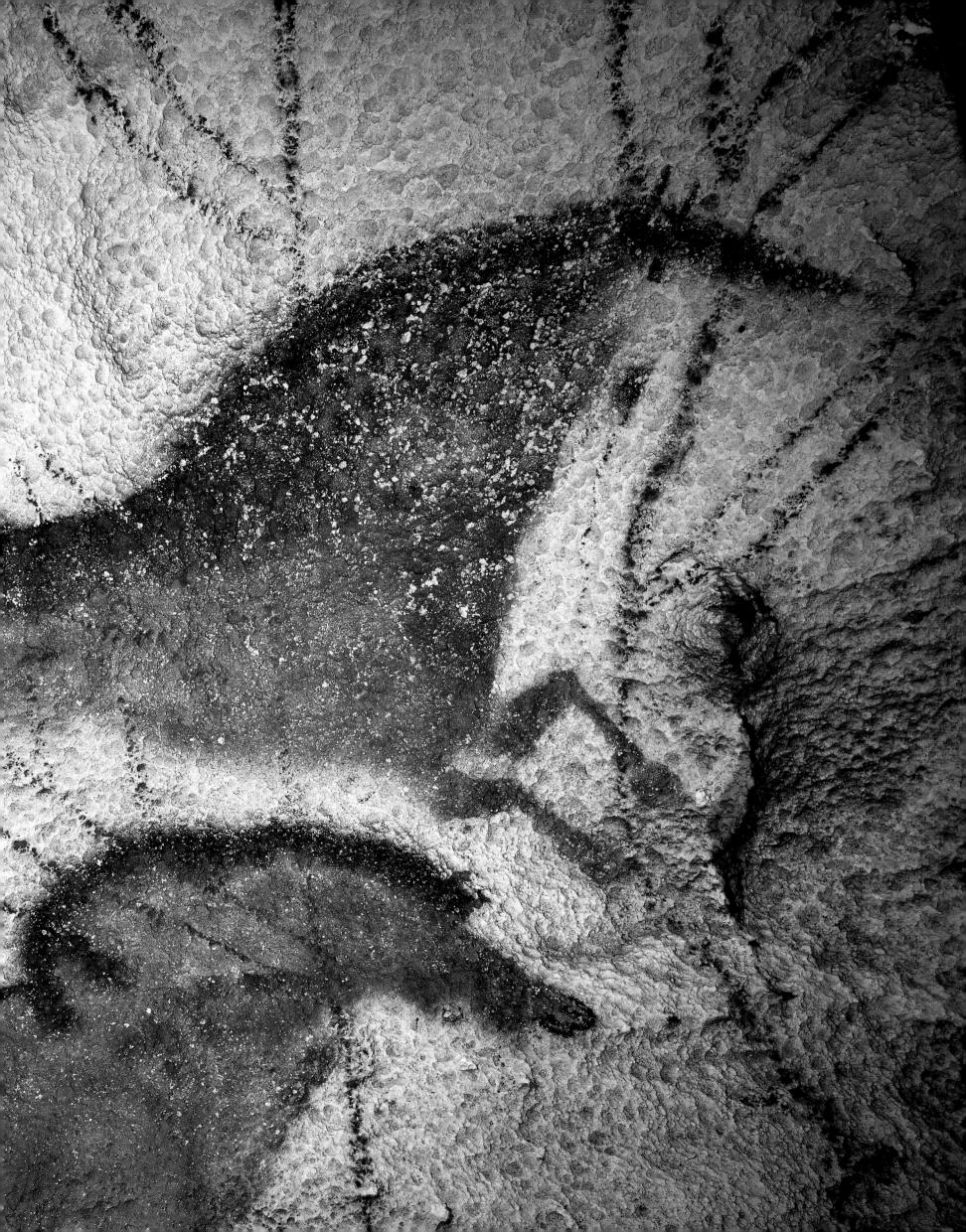

Despite the very uneven form of the support and its animated nature, the Upside-down Horse (ill. 90) retains proportions in every way identical to those of the other horses at the site. No anatomical elements have been left out. The large figure extends around the false pillar, its head following the lateral margin of the fissure. The forequarters remain visible during the entire approach, but only on entering the meander is it possible to see the hindquarters. There is no part of the gallery from which the figure is visible in its entirety. The uniqueness of this figure lies in its animation. The position of the body evokes a fall, a motion rendered not only by the orientation given to the image of the horse (the forequarters of which are pointed towards the apex of the vault and the hindlimbs towards the back of the gallery), but also by specific anatomical details (notably the ears, which are turned back towards the rear). The unusually dilated nostril also contributes to this uniqueness. The yellow pigment covers the entire body, without the slightest gap. The slight contrast in this material is due to consecutive episodes of spraying, repeated in different directions in order to cover all the projections on the wall. Black was used for the hooves and the mane, which were sprayed, and for the ears and the line of the back, which were drawn with a brush.

Another figure in this space is unique in Palaeolithic parietal art. It takes the form of two large red branching lines, positioned vertically and facing each other. The outline extends to a height of 2.4 metres and reaches a maximum width of 1.6 metres. The base is only some 40 centimetres above the floor. Despite its dimensions, it is only possible to make out these outlines after a careful perusal of the wall, and indeed little comment has been made on them. André Leroi-Gourhan thought they were the antlers of a cervid – an interpretation to which we do not subscribe. Leroi-Gourhan hypothesized that the entire graphic series of a given sector may begin and end with an image of a cervid. This branching drawing at the back of the Axial Gallery would then pair up with the black stag painted at its entrance.

THE RED PANEL

This final composition is quite inconspicuous and has only rarely been mentioned. Its very remote location has played a major role in this, as there is very little space for an observer to view the work. This panel is of interest, however: it contains the only bison in the Axial Gallery and boasts graphic and chromatic homogeneity. (...)

The panel is trapezoidal with a sub-horizontal base. It decreases in height from 1.8 metres at the entrance to 0.7 metres at the far end, and is 6 metres long. A bison and two horses are depicted in red and cover the entire surface of the wall. They share the space with a crosier-shaped figure, drawn in the channel of the roof, a few single or grouped dots and some rods.

The large figure of the bison (ill. 92) turned to the right is situated in an oblong concavity inside a 1.8-metre-long and 1.13-metre-high frame. The morphology of the wall entailed an enlargement of the body, which looks bulky. Shaped like a lyre, the horns differ from those of the other bison of Lascaux, most of which are crescent-shaped. The black hooves do not have the cloven shape associated with bovines, and their oval form is more reminiscent of equids. The raised tail resembles that of the bison of the Shaft, but the tuft is in this case turned towards the back. The resulting animation of the bison may have been unintentional, as the artist may have wanted to avoid the horse located behind it. The outline of this figure was executed entirely by spraying. There is a short, black, curved band in the upper part of the unfilled area.

The middle figure is a horse (ill. 94). It covers quite an extensive area considering the limited amount of space available, and fits closely between the channel in the ceiling

and the strata joint that underlines the entire panel. The mane comes quite far forward, accentuating the outline and the poorly positioned head. The sloping chest is straight, as is the line of the belly, which more or less follows the edge of the ledge.

placed too low. The entire field of colour was sprayed. Only the ears, the muzzle, the lower line of the head and the beginning of the neck were highlighted using a brush.

The third horse (ill. 93) of this panel is rarely mentioned and is the last figure of the

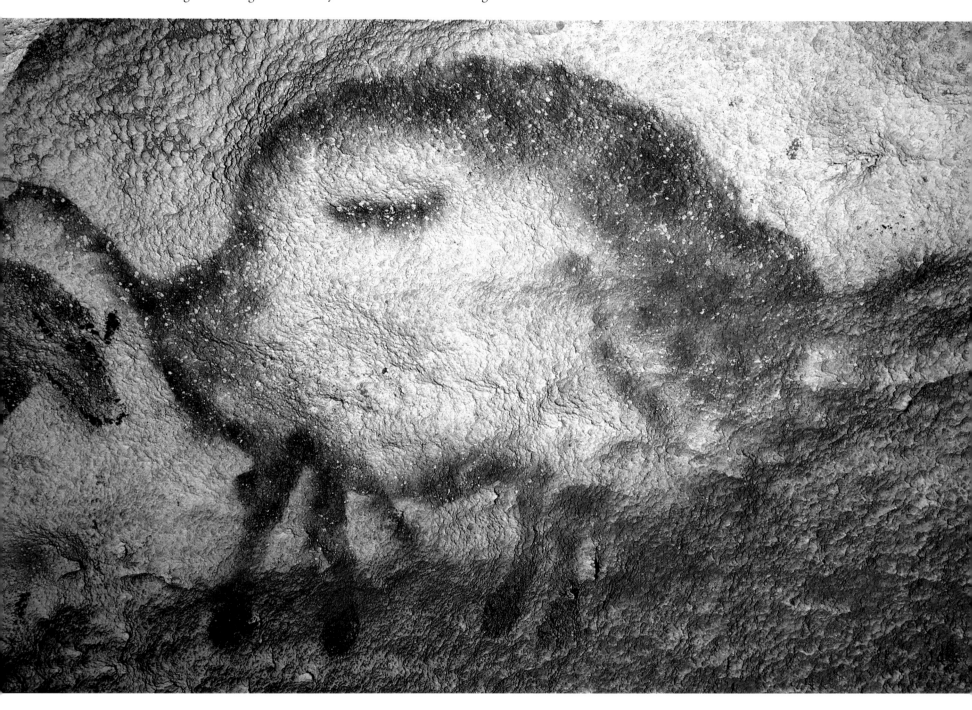

The parallel and stiff forelimbs are aligned vertically, whereas the hindlimbs are at a slight angle. The tail is short, has a constant breadth and is attached unusually low on the body. It is noteworthy that there are two parallel bands on the withers, which might be where the shoulder markings have been

Axial Gallery. The figure almost entirely fills the triangular-shaped space and, as a result, is greatly distorted. The line approximately follows the natural boundaries of the wall, defined by the edge of the channel in the ceiling, in particular the line of the head, the mane, the back and the croup, which are

92 The morphology of the wall determined or supported the general form of the body of this bison with a red outline, increasing its size and creating a massive silhouette.

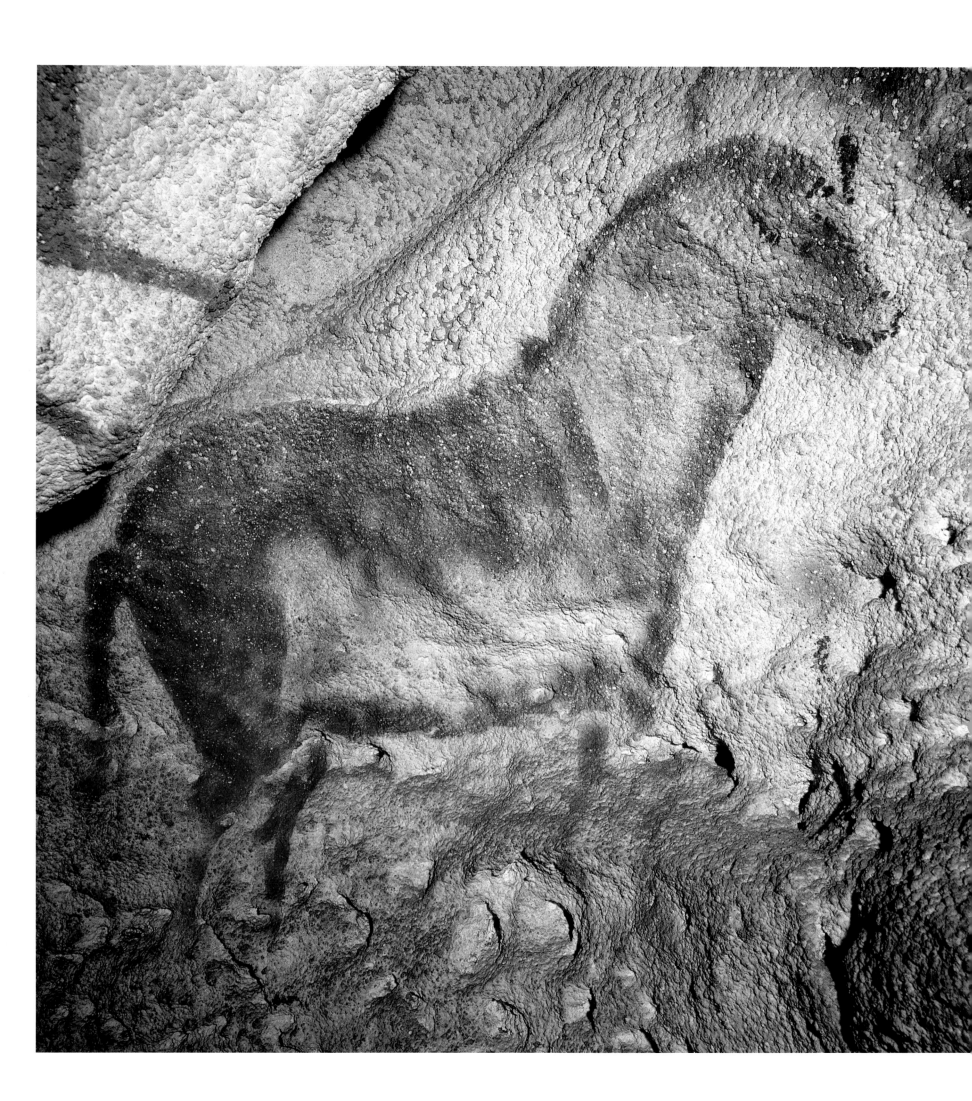

Preceding pages
Left:
93 Very rarely mentioned, this second, somewhat misshapen horse of the Red Panel is the last figurative theme of the Axial Gallery.
Right:
94 Painted with two other red figures, a horse behind and a bison in front, this very large equid fits narrowly between the channel in the ceiling and the fold of the layer that underlines the entire panel.

Above:
95 Crosier-shaped sign, the final structured element of the Axial Gallery.

arranged in a straight line at 45°. Opposite, the lines of the throat and the chest are aligned along the edge of a deep concavity. The artist more or less adapted to the constraints of the wall, playing with its irregularities by adopting certain shapes and evading others that were perhaps less suggestive. This dialogue with the background resulted in a somewhat unusual image. The colouring matter was applied to the whole figure by spraying, except for the lower line which was traced with a brush.

The ceiling has been virtually unused. Behind the last horse is a single crosier-shaped figure (ill. 95), in the same red as the rest of this panel and made up of four segments of uneven length. Beyond the Upside-down Horse, a small sub-horizontal passage opens and extends over a dozen metres or so. This final gallery is 0.8 metres high and, on average, 1 metre wide. At the end of the 1950s, the floor was lowered by some 20 centimetres as a result of excavations led by André Glory, who hoped to find other extensions to the cave in this direction. Only four traces of painting were recorded: on the ceiling and the right wall.

The Passageway

The present-day view of the structure of the cave has led to the segment of the gallery connecting the Hall of the Bulls to the Nave being referred to as the Passageway. It is doubtful whether, for Palaeolithic people, this corridor would have had the transitional function implied by this name. Indeed, the great concentration of figures on the walls of this passage indicates that it should not be considered as a simple punctuation mark between two much more developed sectors (and therefore of no great significance) but, rather, that it had great intrinsic importance in the eyes of those who frequented it.

This corridor, which was originally a lot lower before alteration work to create more head room, is straight, although numerous clues suggest that it was cut as

a meander, supported by the succession of hollows and projections that extend alternately along both sides of the passage. This relief allows the space to be divided into five parts of unequal importance. The particular topography determined, to a certain extent, the distribution of the figures, which are grouped in clusters at each of these localities, rather than in friezes as in the preceding spaces. The ceiling was just 1.2 metres high on average before the discovery, which encouraged the artists to use the accessible parts of the roof, except for the remotest part of the passage. Up to this point the smoothness of the wall was only disturbed by a narrow, winding channel running along the axis of the ceiling, but here corrosion has affected the surface over several square metres.

Judging by the condition of the rock surfaces, active phenomena of corrosion on the walls – their effects exaggerated by the relative narrowness of the passage – have been extremely detrimental to the preservation of the figures. The narrowness of the passage also brought visitors closer to the walls, which were consequently more exposed to abrasion. Effectively, only some fragmentary (mostly painted or engraved) parietal depictions survive in the Passageway, and many are undecipherable for the modern observer. The presence of numerous traces of colourants in the smaller cavities of the rock suggests that the entire wall and ceiling were once covered with figures.

André Glory identified 279 figures, a remarkably high number compared with the Hall of the Bulls (130) or the Nave (79), although these latter two are much more extensive spaces. Of the 221 recognized animal representations, there are no fewer than 158 horses, 33 bovines (17 of which are bison), 10 ibexes and 4 stags. There are only 57 signs. As in the Hall of the Bulls, there are no quadrangular geometric figures.

A more recent analysis was carried out by D. Vialou,[22] taking into account the previous interpretative studies and tracings. He came

up with 377 figures, broken down into 239 complete or fragmentary animals, 81 signs and 57 indeterminate units. The difference lies in the decision to take the fragmentary and unintelligible markings into account, which were previously judged as insignificant. The studies of André Leroi-Gourhan demonstrated their particular interest. This difference also highlights the difficulties of interpretation as a result of the very poor condition of the evidence.

This corridor's comparatively modest proportions are reflected in the size of the figures, which are in a smaller format and were clearly adapted to the limited space. This does not apply to the parietal depictions framing the entrance of the Passageway, however, which are not dissimilar to those of the Hall of the Bulls and Axial Gallery. Some areas of 'cauliflower' calcite have survived along the first few metres as well as in the central part of the Passageway. As a result, the same techniques have been used here as in the Hall of the Bulls. In the central part of the Passageway, somewhat apart from the other compositions, which are mainly on the right wall, the outlines of a headless brown horse have been drawn on this background (ill. 96).

Top:
96 The painted outline of a headless horse survives on a small surface that was spared by processes of natural corrosion.

Centre:
97 Processes of corrosion on the underlying limestone have most notably affected the walls of the Passageway, as demonstrated by this depiction of a horse, the uniform colour of which has been heavily degraded.

Bottom:
98 Originally interpreted as a bovine, this animal figure, with a much accentuated ventral line, seems to represent a horse. Moreover, an interpretation of the front hoof as cloven, which would resemble that of an aurochs or a bison, does not appear to be correct: the supposed second claw looks more like the pastern.

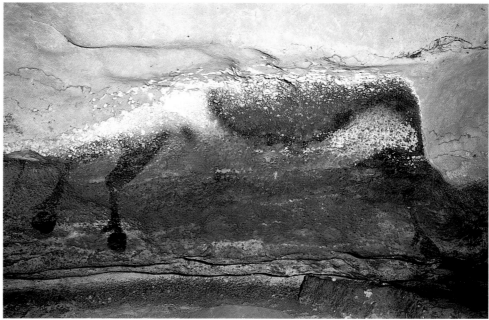

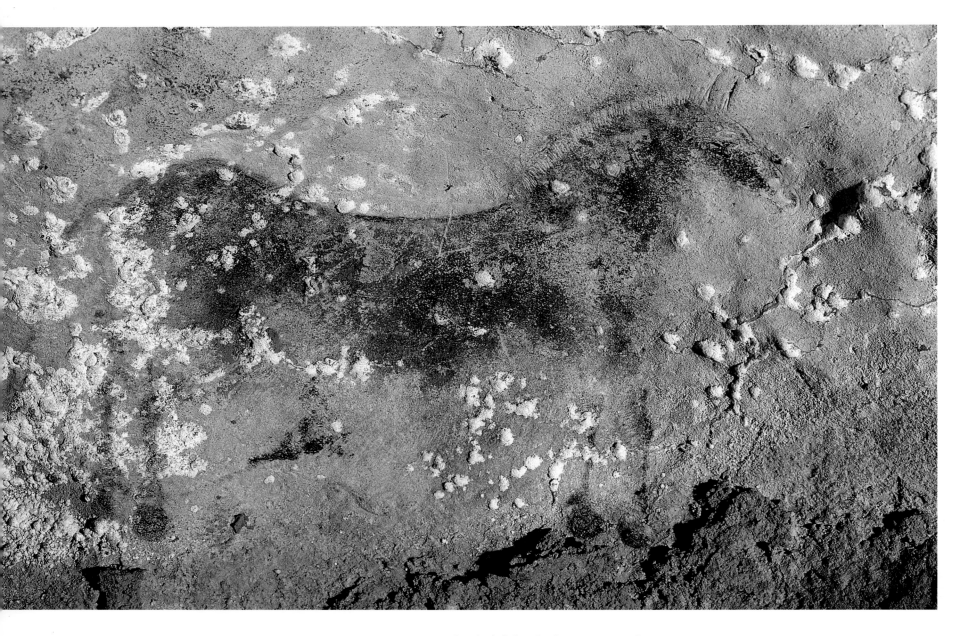

99 In the depths of a concavity, at a greater distance from exchanges of air than the other figures, this horse, engraved and painted in black, remains one of the best-preserved elements of the Passageway.

On the left-hand side as you enter the gallery, traces of an equid (ill. 97) survive, shown by its bottom line, fore- and hindlimbs and belly. The throat, neck and head, painted on a more exposed projection of the wall, have been totally destroyed. Of the rest of the body, only traces of incised lines remain.

On the facing wall, the group of lines formed by the tail, a hindlimb and a forelimb, together with the beginning of the belly, has often been interpreted as a bovine, but it could actually be another horse (ill. 98). Indeed, the cloven nature of the front hoof does not seem obvious, because the supposed second claw resembles the pastern of an equid. Furthermore, the curving brown line of the belly is far too pronounced to belong to an aurochs, whether cow or bull.

It is crossed by regularly spaced, parallel black dashes, which resemble the long hair of horses in winter and spring. There is also a particularly well-executed black horse hoof overlying this same ventral stripe.

Beyond this, the calcite is replaced by limestone bedrock. As a result, a combination of engraving and painting techniques were used to create the parietal works, stretching from the Passageway to the Chamber of the Felines.

Among this collection of deteriorated figures are several less damaged representations. Some have very clear outlines; others show a certain originality, such as a head of a bison turned to the left at the centre of the deepest concavity of the right wall, crowned by crescent-shaped horns.

In front, a tail-less horse takes its place in the niche of a cupola. This first concentration of figures is completed by a procession of horses heading towards the back.

In order to find some traces of black pigment in the third part of the gallery, it is necessary to move 3 metres along the left side of the ceiling. Here, one sees the hooves and the croup of a horse, very close to the more complete and very pronounced outline of another horse, the hooves of which are also painted. It is distinguished by its hindlimb, which is folded back towards the inside of the body. This suggests that the animal is rolling on the ground. Some distance away, a large headless horse completes this composition.

Unlike the previous figures, those in the fourth section are distributed more clearly along the right-hand side. At the edge of the composition, which is once again dedicated to the horse, lateral lighting reveals the head of an ibex with very developed horns. It is superimposed over an equid, the discrete outline of which is interrupted only by the extremities of the black fore- and hindlimbs.

The fifth and last part of the corridor exhibits a greater density of figures, and the outlines are relatively better preserved. The cavity on the right, extending all the way to the ceiling, is dominated by two themes: the horse and, to a lesser extent, the aurochs. More than thirty subjects are spread out like a fan. An extremely beautiful representation of an equid (ill. 99) is the major figure of this panel. A field of flat black colour reproduces the shape, which is given structure by

100 This engraved horse differs from the others in its turned-back right hindlimb, an idiosyncrasy possibly rendering the impression of perspective.

engraving, but also by a chromatically denser line suggesting the sinuosity of the line of the back. The background is harder at this point, enabling the artist to use a brush to draw this line. Another horse (ill. 100) stands less than 1 metre above this figure, at the centre of the broad composition. With its very small head and turned-back hindlimb at a 30° angle, it stands out from the others. The proportions of these animals are more or less the same – around 60 centimetres, with a few exceptions around 80 centimetres – and are fairly representative of the other figures in this sector. The peculiarity of the horses of the middle level lies in the greatly exaggerated development of their tail ends.

Several representations of bovines complement the horses. One large aurochs (ill. 101) is superimposed over two horses. A very fine cow head occupies the upper part

wall facing the entrance to the gallery. A second head, facing in the opposite direction, underlies this image. Placed immediately next to each other, the identical outlines of these two figures show that the grouping of these bovines on a limited surface area is far from random.

Two inconspicuous ibex heads intervene between two groups of horses in front of the Apse, on the facing wall. The ibex on the left has engraved signs on its body, including real cruciforms, some others disjointed, and a series of superimposed bracketed motifs.

This long series of horses finishes on the right wing of this little panel. Located immediately next to the end of the Passageway, two complete horses are engraved one above the other. Finally, the most remote subject of the Passageway, the Bearded Horse (ill. 102), as Jacques Marsal

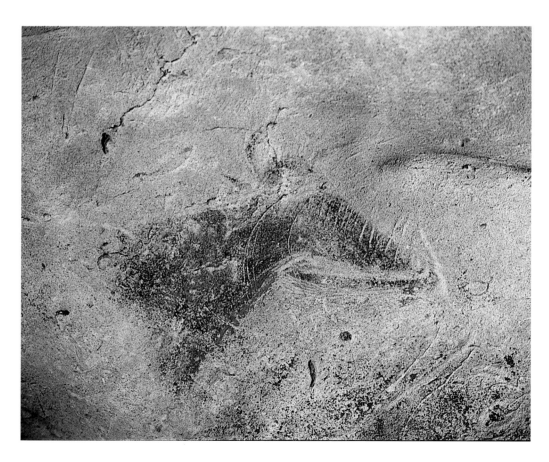

101 The reduced dimensions of this cow head are surprising, but all of the anatomical details specific to this theme are represented.

of the panel. Its less open facial angle and slender horns enable us to identify it as a cow. Painted in red and then engraved, this head has escaped natural chemical attack to some degree due to its position in a hollow in the

liked to call it, marks the boundary between the frieze of the ibexes and the other panels of the Nave beyond. The Bearded Horse bears testament to Palaeolithic man's artistic skill: its neck, which stretches towards the

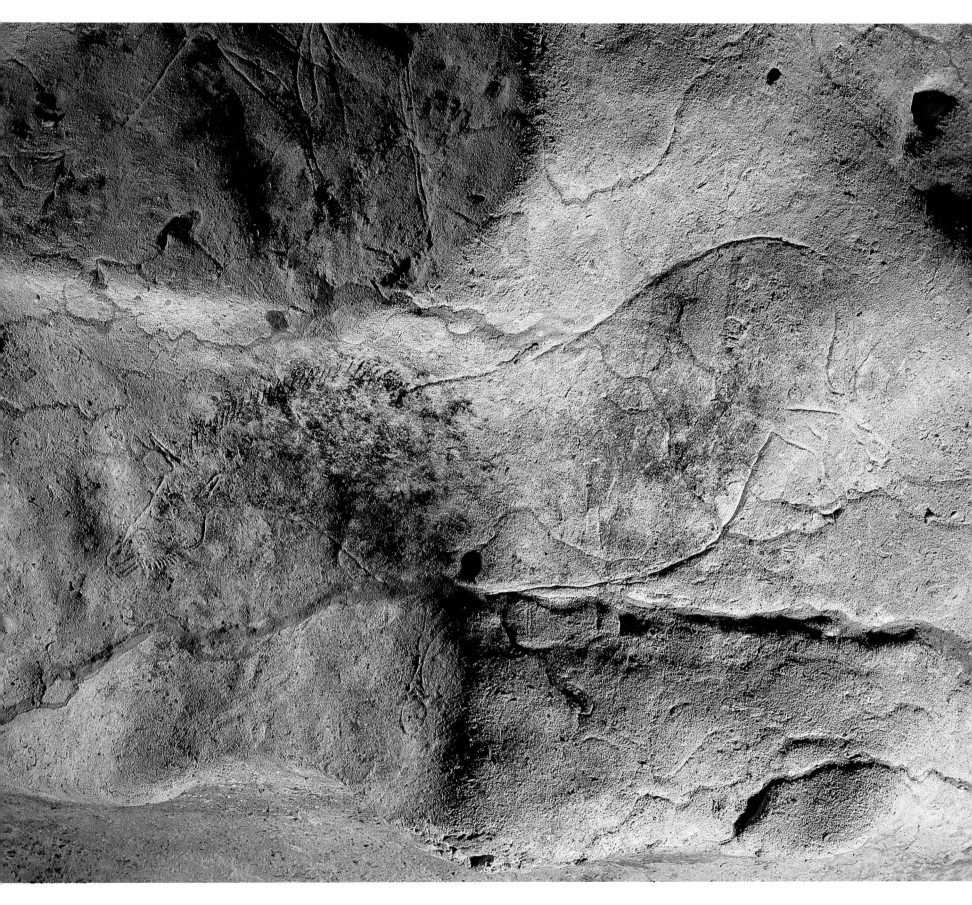

entrance, showing the movement of the head, is accentuated by the low and slightly elongated body. This movement, reinforced by the turned-back left ear, indicates a certain aggressiveness in the animal.

The body covers two projecting surfaces at a very oblique angle to each other. The sub-vertical axis of their interface is the boundary between the two sectors of the Passageway and the Nave.

102 The Bearded Horse forms the topographic link between the Passageway, the Nave and the Apse. It is one of the most remarkable engravings of the sanctuary.

The Palimpsest
of the Apse

Examining the parietal iconography of the Apse in depth would certainly require an entire book of its own. In fact, within this space of relatively modest dimensions, more than a thousand figures were painted or engraved, making up more than half of the representations in the cave, which itself contains approximately one tenth of the Palaeolithic parietal art discovered in France. For this reason, only the most representative and original figures will be reviewed here.

This very high concentration of engraved representations, augmented in the present state of preservation by a few rare, discreet fields of colour, does not even begin to reflect the visual impact that it must have had originally. There is a huge contrast between the figures here and those in the previous sectors. As you approach this area, entering from below, there is nothing to suggest the amazing profusion of animal and geometric motifs that is about to come into view up there. A few vestiges of colour certainly catch the eye, but not for long. To study the walls carefully, it is necessary to use lateral lighting: beneath the beam of the lamp, an unbelievable tangle of complete and fragmentary images emerges. The outlines of several hundred figures appear higgledy-piggledy before you, ranging in size from very large to a few decimetres or centimetres.

The density of the decoration increases from the entrance to the back, and from the ground to the ceiling. A lot of figures are engraved and unpainted; others bear traces of colour, which show how different the original condition must have been. Natural deterioration has affected the majority of the drawings, but it is also important to remember that the floor of this sector was lowered by, on average, 1 metre to make the Shaft more accessible. Morphologically, the Apse is not very different from the Nave or the Hall of the Bulls. (…) From the ceiling, in the form of an oblong, shallow dome, the vault follows a very pronounced overhang, then reverts to a sloping ledge or bench, marked by a central projection, before finally reaching the floor as a sub-vertical wall. Only this last level is undecorated, except along the first few metres of the left wall. On the others, André Glory recognized a thematic distribution of the most remarkable figures. Each section is dominated by a specific theme: equids on the upper level, cervids in an intermediate position and bovids at the base. This distribution loses some of its unity when the more modest depictions are integrated.

The most remote part of this hall, in front of the descent towards the Shaft, is a special space. Both its shape, a quarter-sphere, and its location, adjoining the Apse, make it tempting to give it the name Apsidiole. The parietal depictions – or, more precisely, their proportions in relation to the smaller dimensions of this recess – show a rather accomplished level of execution. More than one hundred and fifty intact or vestigial animal or schematic figures share the available space. It basically has the same thematic distribution as in the Apse, but with just two components: eighteen equids in the upper part and twenty-six cervids below. Ibexes occupy above all the left wall of this small hollow. Fourteen have been identified in total, although only three have been determined with any certainty. The aurochs and the bison make inconspicuous appearances.

A vertical fissure splits the decoration into two tableaux. The right panel, close to the beginning of the passage leading to the Shaft, contains sixty-seven signs and animal images. For the most part they occur on seemingly unrelated engraved surfaces. These fields, mostly geometric in nature but sometimes with no particular organization, are a peculiarity of the Apse. They repeatedly cover very large surfaces, hindering accurate interpretation and making the setting look like a palimpsest.

Complete animals are rare on the panel of the Apsidiole, partly due to the unfavourable conditions of preservation. There seems to be no recognizable pattern to the bestiary as a whole. To a large extent, horses and stags share the available space equally. The geometric motifs are quite interesting, both because of their quantity and the huge diversity of forms, with most of the Lascaux signs represented. One example has a particularly unique form that is reminiscent of the 'chimney'-style 'Placard type', also found at Cougnac, Pech-Merle and Cosquer.[23]

The stags on the left panel, most of which face the Shaft, take up almost three quarters of the accessible surface. Four of them (ill. 103), all fairly similar, are assembled in a 1.3-metre-long frieze, which underlies the entire panel. They all have complete outlines, which are engraved and bolstered by black lines on the dorsal, ventral and frontal structural contours. Colour has also been added to the flanks, where it takes on a brown hue. The antlers of the animals located at each end of the procession are particularly large. The line of the floor has been influenced by two factors: the horizontal retreat of the wall and the original level of the fill, which reached as far as the forelimbs of the second cervid. The engraved forequarters of a fifth subject occupy a central position in the composition, although it must be dissociated from the group, which forms an intrinsically homogeneous work.

Two horses are engraved, head to tail, in the upper part of the panel. They have similar dimensions to the figures of the above-mentioned small frieze. The immediate geometric background is formed by numerous signs based on mostly parallel marking. Four adjacent quadrangular examples, in black, yellow and mauve, can be distinguished clearly. There are similar signs in the Nave, at the ends of the hindlimbs and the tail of the Great Black Cow.

The intervening wall between the small frieze of the painted and engraved stags and the head-to-tail horses is covered by a multitude of overlapping figures. Numerous outlines of cervids are present, along with three other, more or less aligned, quadrangular signs. (…)

After the Apsidiole, the Apse is a much more extensive space, but the morphology of the walls there, and its density of figures and distribution of themes, are all very similar to the Apsidiole. A diptych composed of two very large confronted horses dominates the decoration of the ceiling. One of them is yellow (ill. 104) with a black mane, line of the back, tail and fore- and hindlimbs. Its dimensions are in proportion with the large surface of this domed formation. It fits into a framework measuring 2.5 by 1.1 metres. Along with the red and black horse of the Hall of the Bulls, it is one of the largest equids in the cave. The position of the ear, flattened back against the front of the mane, seems to confirm its aggressive stance.

The other horse is less imposing in its proportions but still measures up to 1.9 metres from its head to tail end. It has a red coat, but the head, the limbs and the line of the back are black. The very large head of an aurochs is inserted between these two animals, but there are also numerous further depictions of horses and some cervids in this area. The cervids are generally either very incomplete or miniaturized – the one located above the croup of the yellow horse, for example, is engraved with numerous anatomical details and is less than 25 centimetres long. Immediately below this oblong dome, the course of the wall takes on a pronounced overhang and then crosses a short projecting section. Coinciding with this double bend, the rock changes colour significantly. While the surfaces of the roof show no traces of a material that could have stained the straw-coloured underlying rock, all of the sloping surfaces (we call them ledges) have been covered by the 'dust of centuries', as Breuil liked to say. This increases the optical density

Overleaf:
103 Close to the passage opening on to the Shaft, the base of the wall is decorated with a frieze of small painted and engraved stags. Before the modification of this section, the level of the floor was only a few centimetres below this group of cervids.

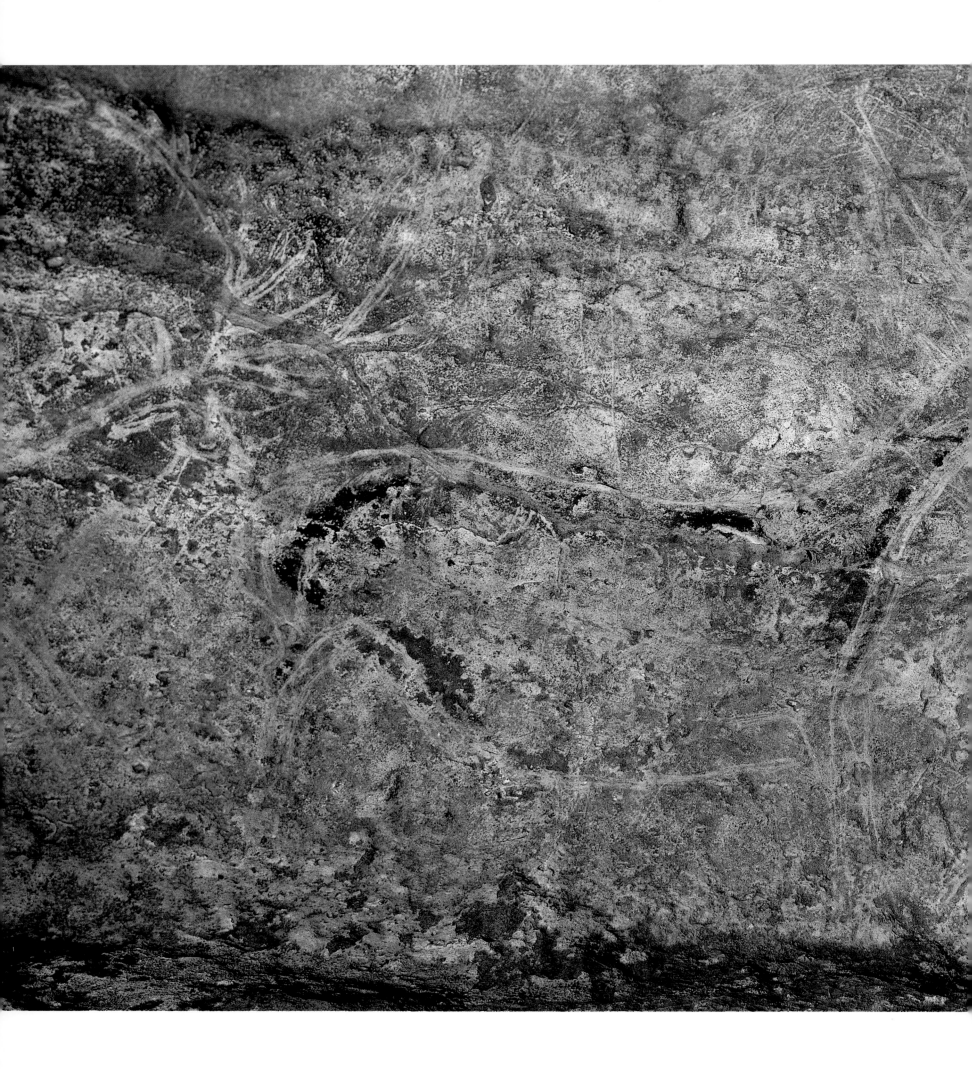

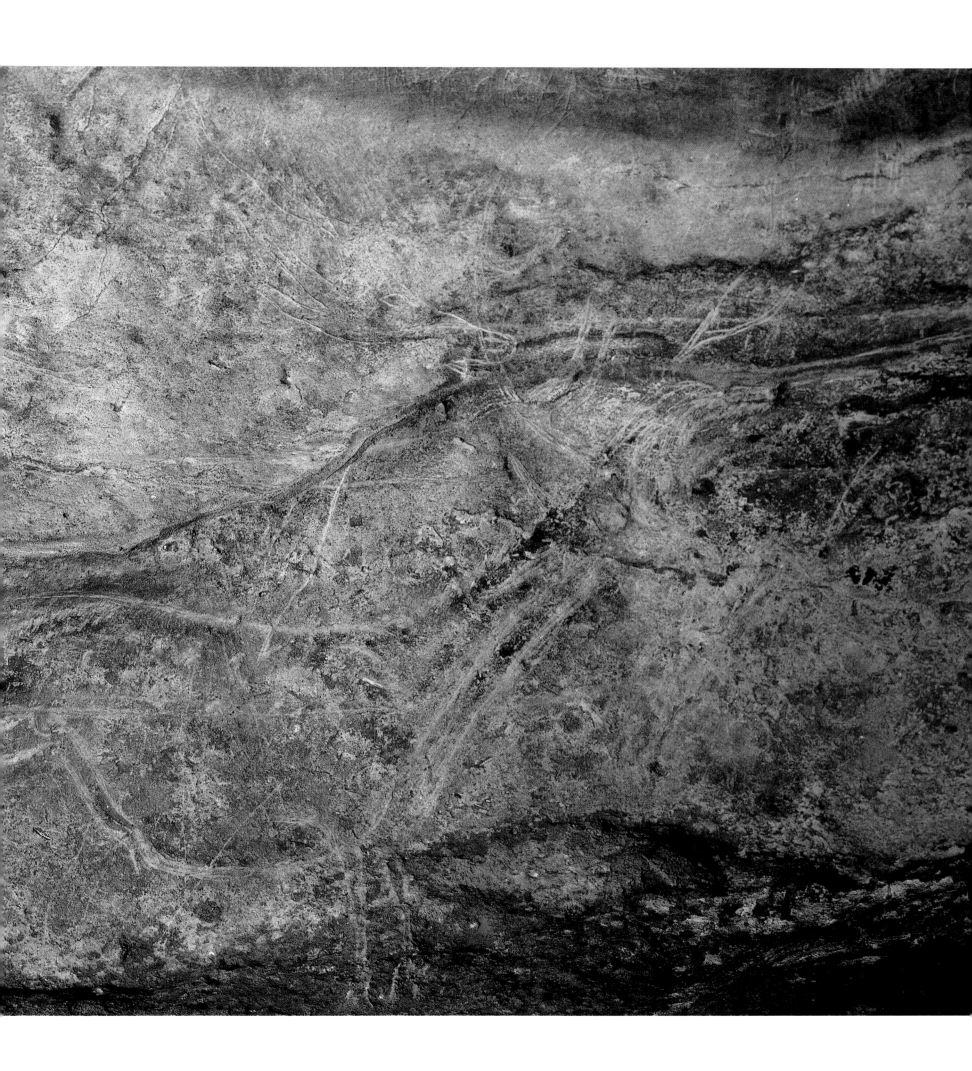

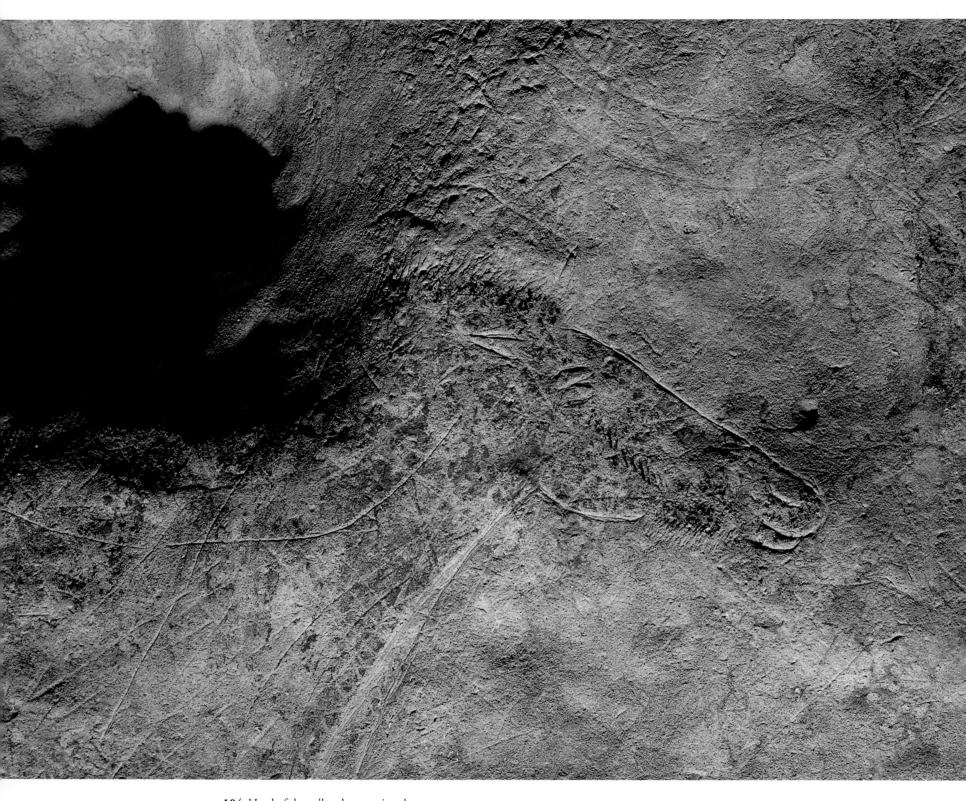

104 Head of the yellow horse painted
and engraved on the ceiling of the Apse.
The aggressiveness produced by its
location, confronting another equid,
seems confirmed by the orientation of
the ear, folded back against the start of
the mane.

of the background, which becomes brown or even anthracite grey. In the other sectors of the cave, Palaeolithic people ignored this type of background, which was scarcely suitable for their activities. In the Apse, however, all the surfaces are covered in figures. This change in approach shows that they wanted to bring together engravings and paintings in the same location, marking the special value given to this place and its originality.

The decoration of the long panel formed by these two superimposed surfaces extends around the entire circumference of the hall. The number of figures, which is more limited at the front, increases in the direction of the Apsidiole. This is the case along both walls. The nature of the walls and the inaccessibility of certain sections have both contributed. It is likely that Palaeolithic man used a wooden construction for extra stability when he was engraving one very large cervid – the Stag with the Thirteen Arrows, which stands on the left wall and dominates the threshold of the Nave. The engraved surface is at least 2.25 metres high and 1.9 metres wide. Some traces of red and black coloured pigment survive, notably on the hooves. The series of signs covering the body and its periphery is heterogeneous: some evoke shapes of arrows, others signs with barbs, cross-like signs and hooked signs.

In front of this engraving facing right there is a sequence of animal depictions, punctuated at more or less regular intervals by large figures of stags, dominating the frieze with their imposing dimensions. The Fallen Stag (ill. 105), which is the closest to the above-mentioned large cervid and of an equivalent size, is only separated from the latter by a few seemingly meaningless engraved traces. The way in which its colouring extends over the antlers and the chest and its somewhat unusual posture make it different. The neck and the head are straight, the antlers turned down to the rear, and the forelimbs folded below the body. Two arrows – one engraved, the other

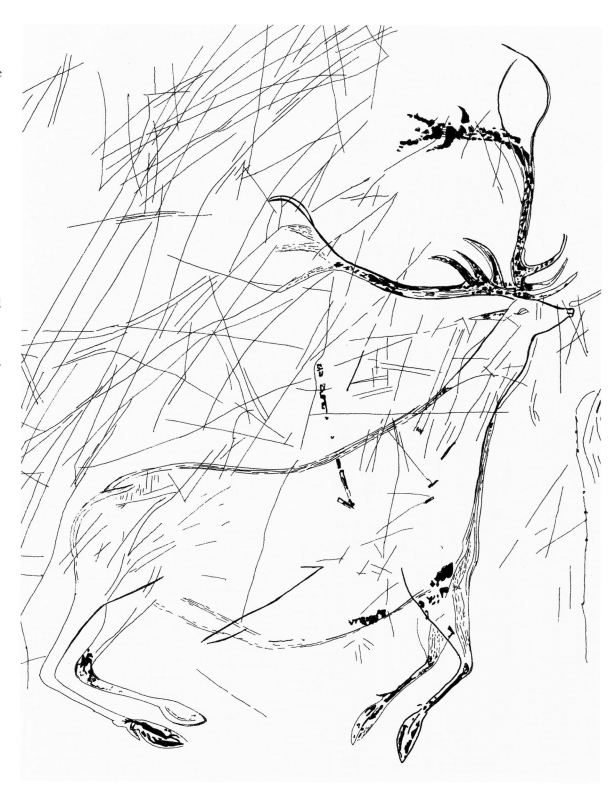

105 With its half folded fore- and hindlimbs, the movement given to the Fallen Stag is not unlike that of the Major Stag.

106 Two engraved stags confront each other on a dark-coloured background. This arrangement is found on several occasions in the sanctuary.

painted – converge towards the centre of the figure.

Up to this point, the elements of the decoration remain distinct. The first depictions of this level emerge perfectly from the background, barely disturbed by the presence of minor figures. Moving towards the right, however, the density of lines increases considerably. There is a third large stag, which is also engraved and painted in a static position. Immediately below, a very large figure is difficult to identify accurately, as it has anatomical characteristics shared

by different types of animals. The double line of the back would suggest that there are two animals – one a horse, the other an aurochs. Two heads that might belong to these animals, however, are so disproportionate that this is just a hypothesis.

Less than 1 metre away, two confronted stags with clear outlines emerge visibly from the brown-black wall (ill. 106). Of far more modest dimensions than their predecessors, they boast almost mirror-image symmetry. One of the two rivals, the one on the left, is firmly planted on its forelimbs with

its head raised; the other has a horizontal upper line, with the croup, the back and the neck all in the same alignment. Behind the cervid on the right and inside a quadrangular marking, an identical scene is repeated. Two ibexes are seen in confrontation, their outlines reduced to their heads. The whole field is covered with bands and geometric zones of striations, combined with less conspicuous figures of horses and cervids.

Two superimposed panels signal the proximity of the Apsidiole: that of the Upward-turned Horse and the Musk Ox.

Immediately to the right of the two engraved ibex heads, it is possible to make out the two hindlimbs, the croup and the belly of a very large equid. An abnormally broad line has been used for the outline. It differs from the other representations of horses, not only in terms of the anatomical parts depicted, but also in the orientation of the body, which is turned upwards. A band engraved with a double row of short parallel incisions crosses the central part of the panel over a length of 1.2 metres, attaching the hindlimbs of the Upward-turned Horse to a cervid

107 Two twinned signs cross the flank of the Horse with Claviform Signs. Claviform signs are interpreted as chronological markers.

head with very developed antlers and a
deeply incised outline.

The panel of the Musk Ox is over
2 metres below the level of the previous
body of figures. The figure from which this
composition takes its name stands at the
centre of the piece and is thought to be a
musk ox, even though its horns appear to
be the only feature relating to this animal,
marked by the coiling so characteristic of the
species. The other figure has the features of
an equid. The outline of its poorly formed
head merges with the horns of the Musk Ox,
but there are no points of contact to suggest
that the artist used the graphic elements of
the one to complete the outlines of the other.
The incisions are much more distinct on the
Musk Ox than on the horse.

Another remarkable figure, the Horse
with Claviform Signs (ill. 107), is located
20 centimetres above. A quadrangular sign
of 'blazon' type muddies the interpretation
of the figure. On its own, this animal is no
different from the other horses, but two
club-like figures nearby have made it stand
out somewhat. Even if this pattern is similar
to a true claviform, this pair of signs (which
are strongly associated with the three signs
above the small frieze of stags) are, alone,
not enough to prove the presence of man
at the site during the middle Magdalenian.
It would appear that the real claviform was
'invented' much later.

These last two panels, which abut the
entrance to the Apsidiole, mark the end
of the long decorated band of the central level
on the left wall. An equally dense composition
of animal and geometric figures extends at the
same height along the right wall, right up
to the Passageway. On the sloping surface
of the right wall, three small cervids surround
converging bands of striations – otherwise
known as the Small Sorcerer, although this
interpretation, assigning a human outline
to the figure, seems implausible.

Divided into three panels for the purpose
of this descriptive analysis, the bestiary

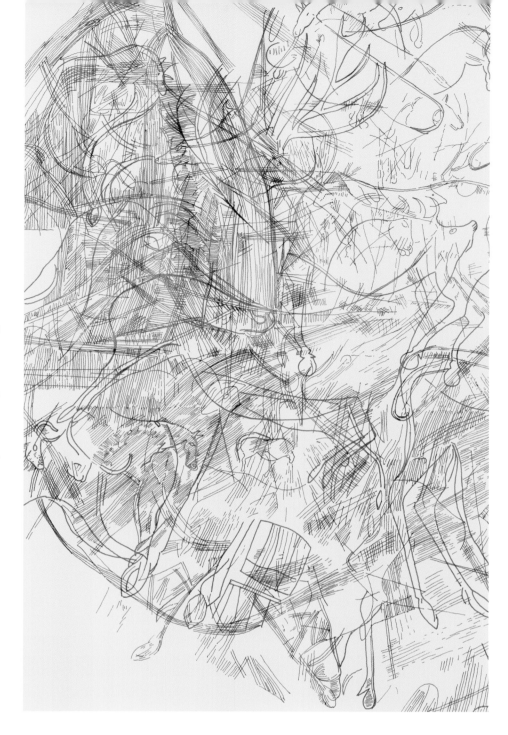

projected on to this wall remains dominated
by stags, which are both large and numerous.
One of them, called the Great Reindeer (ill.
108), engraved next to the ridge marking the
base of the dome, raises some questions
about the correct classification of the species
as red deer or reindeer. These difficulties of
identification have arisen through the clumsy
execution of the general shape and certain
anatomical details. This is in stark contrast
to the more detailed figures of the Apse. Two
bison at the bottom of the panel are the main
protagonists of this first section. Their sex
obvious, and moving apart, they are
reminiscent of the diptych of the Crossed
Bison of the Nave. Very large bands of
vertical and diagonal striations cross the
entire field, adding to the confusion

Opposite:
108 Difficulties in the identification
of this cervid, as reindeer or red deer,
are related to the clumsy execution
of its general form and certain
anatomical details relative to the other,
more detailed figures of the sanctuary.

Above:
109 The outlines of the 'fend-la-bise'
Stag merge into an inextricable body
of lines in which geometric and
animal images collide. This
reproduction shows the difficulties
encountered during the identification
of themes and their interpretation.

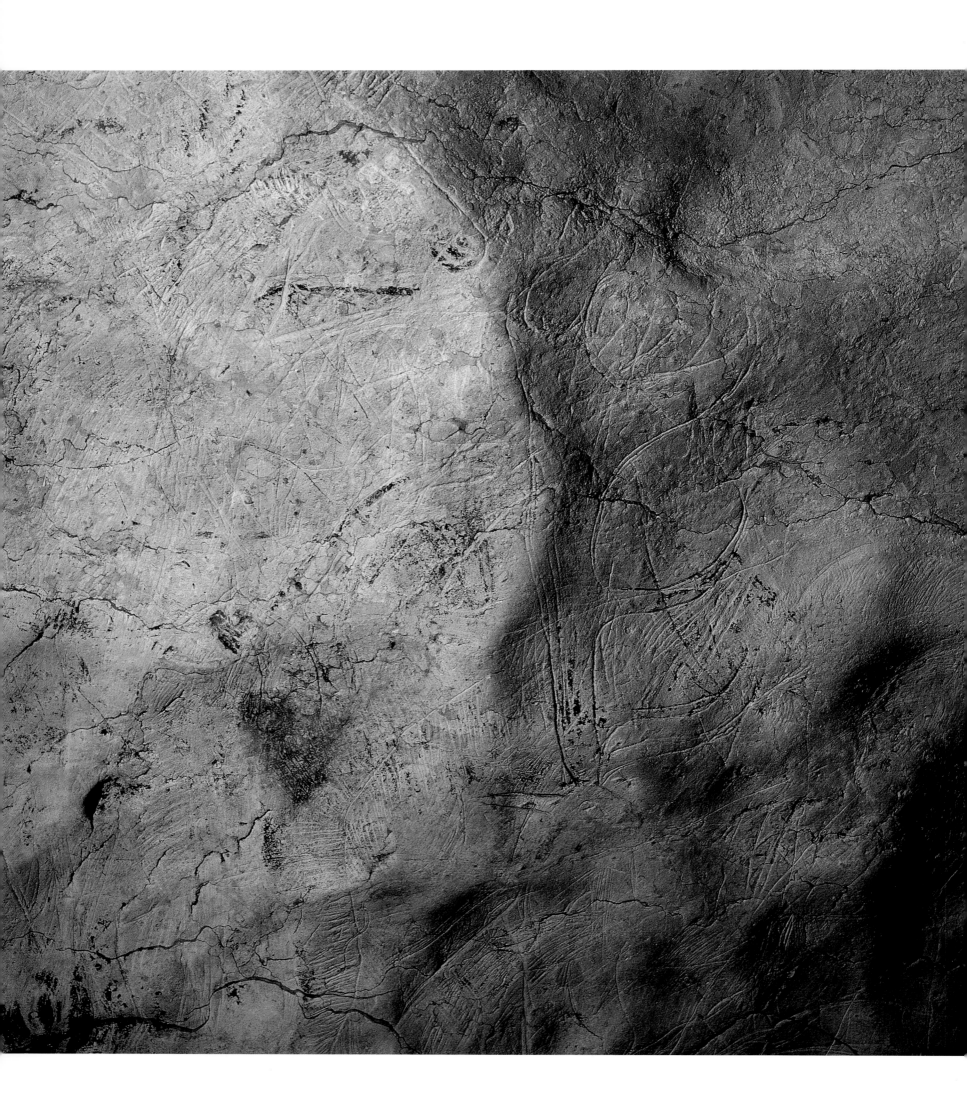

generated by the multiple superimpositions of horses, stags and other bovines.

The second section of the panel is merely a continuation of the first. The evident chaos of the images persists, but two large cervids can be distinguished at the centre, the one following the other. The head and the neck of the 'fend-la-bise' Stag (ill. 109), stretched out towards the ceiling, and its thrown-back antlers accentuate the animation of the body, below which the hindlimbs are extended and the forelimbs bent. Caught between a leap and flight, this figure exudes a sense of exhilaration. It appears to participate in the same composition as the Major Stag (ill. 110) engraved directly in front of it. The hindlimbs folded below the belly, the body thrust towards the floor, the head, neck and line of the back engraved on the same alignment and strongly inclined towards the front are some of the features that contribute to the unique vigour of the Major Stag. Its antlers are characterized by a single beam rising vertically. They are unusually thick, which no doubt contributed to its interpretation as a fallow deer in the past. Deep engraving and painting accentuate this feature further.

Two figures show the originality of the signs here: one located above the croup of the 'fend-la-bise' Stag, the other in front of the Major Stag. The former is a new structure 1.4 metres high, consisting of a series of long bands of striations joined at their top and spread in the form of a mitre at their base. This type of structure is found again on this same wall in the shape of the Small Sorcerer, as well as on the facing wall (with the Hut and the Great Sorcerer, which will be described in detail later). The second schematic representation is unique, both in terms of its size (almost 1.5 metres in length) and its form. It is a long, sinuous line with many bilateral barbs, forming a feather-like structure.

A less conspicuous but similarly decorated frieze underlies these two panels. Less than

Below:
111 Horse engraved on the entablature commanding the entrance to the Passageway. On its chest there is a sign that is unique in its composition of arched and symmetrical elements.

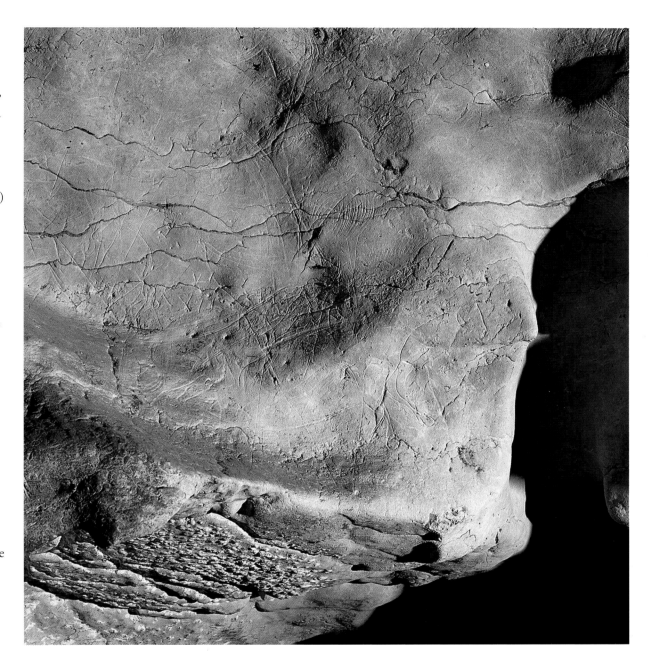

50 centimetres wide, it features numerous depictions of appropriate proportions along its elongated surface, a composition that is joined by three small aurochs.

The parietal art of the third and last section of this panel (ill. 111) is partly found above the opening overlooking the Passageway, which would have presented problems of accessibility. As a consequence, there is a smaller number of figures. A very

Opposite:
110 The single, massive antler of the Major Stag follows the stony ridge of the wall. Its bearing is one of the most unusual, with a body incline 45° to the front, the neck extended and the limbs flexed.

large stag, facing towards the left this time, merges with the image of a horse of identical size. These two figures are located at the edge of the engraved area. The quadrangular signs, which accompany this imposing composition as far as the Major Stag and cover almost all the walls of this hall, are joined by signs with nested elements (ill. 112), a theme

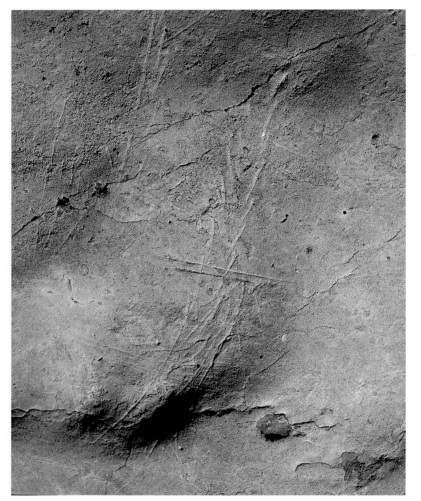

Above:
112 Sign with convergent nested elements.

Opposite:
113 The appearance of this stag, with a light outline against a black background, recalls a drawing rather than an engraving.

reproduced twice on the flanks of these two animals.

The third level, partly buried beneath the sediments of the floor, extends at the opposite edge, immediately below the long horseshoe-shaped frieze that we have just passed. Only the left edge by the entrance to the Nave is decorated. A dark brown coating covers its entire surface as a result of long exposure to dust. In the same band, the backdrop also preserves the lighter colour of the rock, where material was removed during the alterations. This chromatic difference highlights the original level of the floor.

On the surviving tableau, which is very dirty, it is not easy to make out the figures at first glance. However, more careful observation reveals the outlines of a large black cow with a detailed muzzle. The edges of the limbs and the ventral line are emphasized by a series of scrapes. In front of this animal, which faces right, is one of the most remarkable figures of the Apse: the outline of a stag, reproduced in its entirety (ill. 113). It looks more like a drawing than an engraving, with light lines against a black background. There is no need for the play of light and shade here. A few animal figures are associated with this pair of drawings, including a 'carnivore', located between the cow and the stag, and a cervid head on the lower edge of the panel.

The signs are just as interesting because they diverge from the conventional forms in this cave. Above the stag, a series of quite structured, arc-shaped striations, referred to as 'Hut', raises several questions regarding interpretation. The second construction, the enigmatic Great Sorcerer, obliterates the central section of the black cow. Breuil believed it to be a sorcerer's mask of braided fibres. It represents a series of long, finely engraved bands converging at the top. This classification was made using ethno-analogy. This approach is applied more cautiously today, but it was used profitably during the first decades of research into Palaeolithic art.

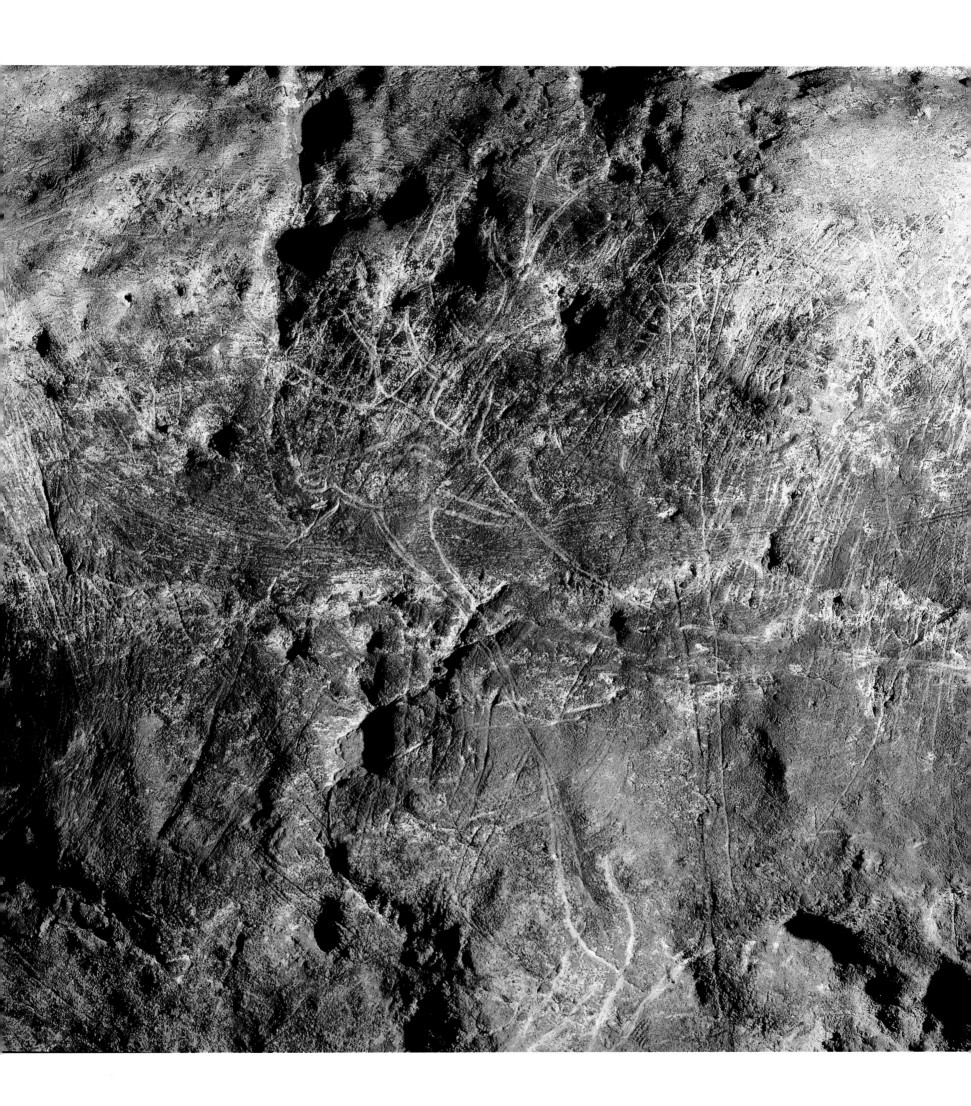

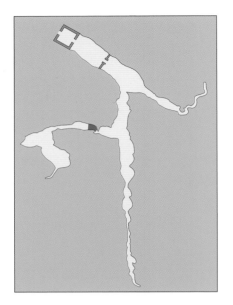

The Shaft Scene

The way to the Shaft lies at the back of the Apse. There is a fixed ladder to facilitate the 6-metre descent. At its foot and on the facing wall is one of the most remarkable compositions of prehistory: the Shaft Scene. Despite the numerous possibilities offered by the vast wall surfaces here, only a very localized fraction of the space was exploited. These drawings have provoked numerous observations in the attempt to identify the connections that may exist between the different subjects represented.

The originality of this panel resides in its narrative potential – a quality based on the distribution of the figures and their animation. It is dominated by the confrontation between the man and the bison (ill. 115). This theme is present at several other Palaeolithic sites, but here it is infinitely more dramatic and evocative. This monochrome group in black brings together four animals and one human, in an association of themes that contrasts with the other compositions at the site. While the image of the horse (ill. 114), which is set apart and isolated on the facing wall but nonetheless capable of being integrated into the Scene, is universal at Lascaux, the bison is very rarely represented (4.3 per cent of the bestiary) and the man, the bird and the rhinoceros are only found in this sector.

The unusual character of the panel rests not only in the rarity of the themes and in their animation, but also in the partial misrepresentation of the ithyphallic man, whose bird head is absolutely identical to that of the bird below. An extended visit to the site led Jean Clottes[24] to assign to the bird the role of psychopomp, or conductor of souls, an image divided in two and transferred to the man, thereby repeating the message of the scene. The similarity is even more significant if the geometric signs are considered. The one with disconnected segments, commonly referred to as the 'spearthrower' is present in the majority of the sectors of the cave, and the double series of three dots is comparable to the sign marking the end of the Chamber of the Felines, although a different colour.

Two techniques have been used in conjunction: the bird, the signs, the upper part of the man and the fore- and hindlimbs of the bison were produced with a brush; the horse, the rhinoceros, the upper line and the belly of the bison, the pelvis and the legs of the human were sprayed.

We cannot be absolutely certain that the rhinoceros, on the one hand, and the other figures of the panel, including the horse, were executed at the same time. In fact, there is a certain difference in the graphic treatment of the figures. The outlines of the rhinoceros are less precise, and the drafted strokes along its lower line are not found on any other figure at the site. Furthermore, its presence is, in terms of climate, not very compatible with the group of themes represented, in particular the red deer and the aurochs – unless it is a steppe rhinoceros (*Dicerorhinus hemitoechus*), although this is merely hypothetical. This is why this animal was interpreted as an unrelated element very early on.

This opinion was confirmed by a series of pigment analyses,[25] which revealed appreciable differences of composition and texture. The colouring agent is an oxide of manganese and barium without associated binding agents; its preparation simply required crushing and the addition of water. The product was applied in fine layers on all of the figures, except for the rhinoceros, on which the thickness of the material is appreciably greater. Furthermore, the analysis found evidence of important differences in the crystalline structure of the pigments. While this body of arguments contributes even more to isolating the drawing of the rhinoceros, it demonstrates the very great unity of the other protagonists of the Scene.

Opposite:
114 Rarely mentioned, the horse of the Shaft confirms the ubiquitous character of this theme in the ensemble of the sanctuary.

Overleaf:
115 The dramatic appearance of this composition, assembling figures that – with the exception of the bison – are only found in this sector, has inspired numerous interpretations. Nevertheless, several clues show that the rhinoceros remains extraneous to the scene.

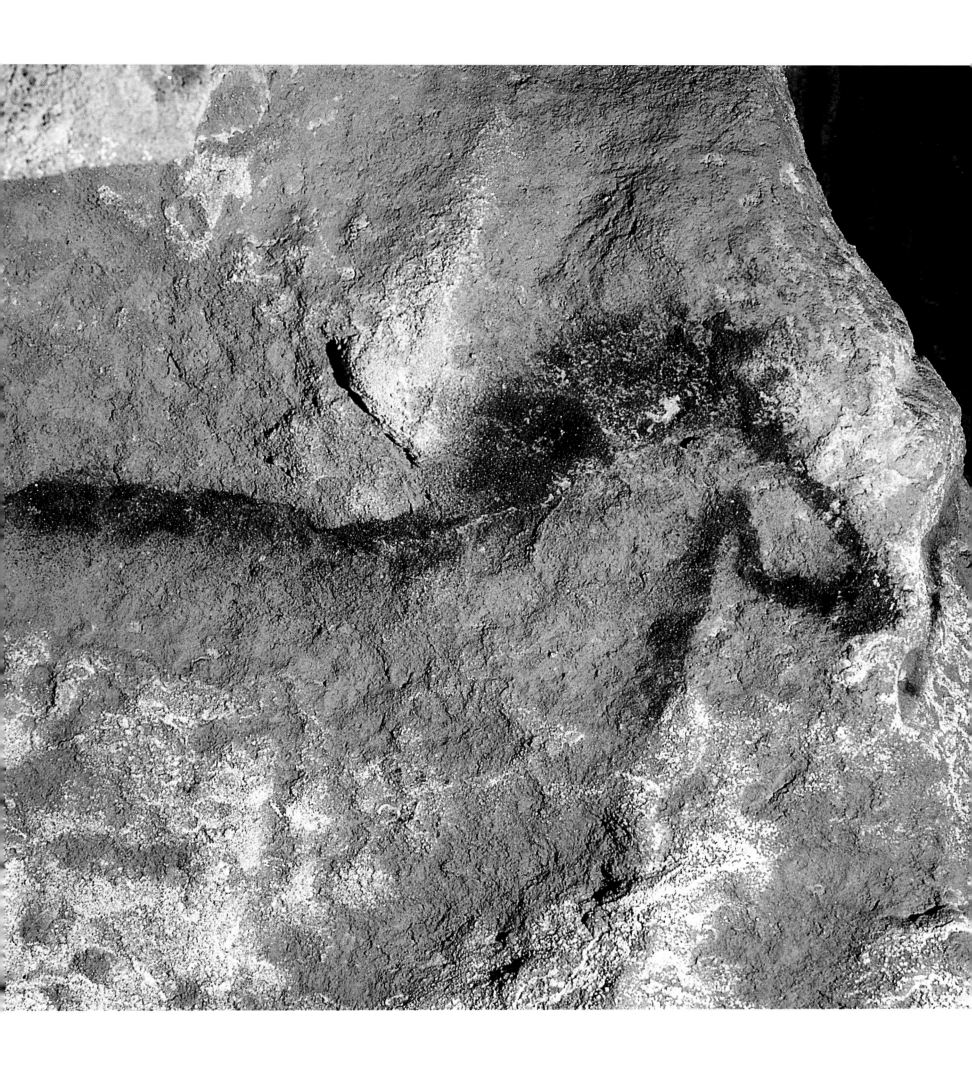

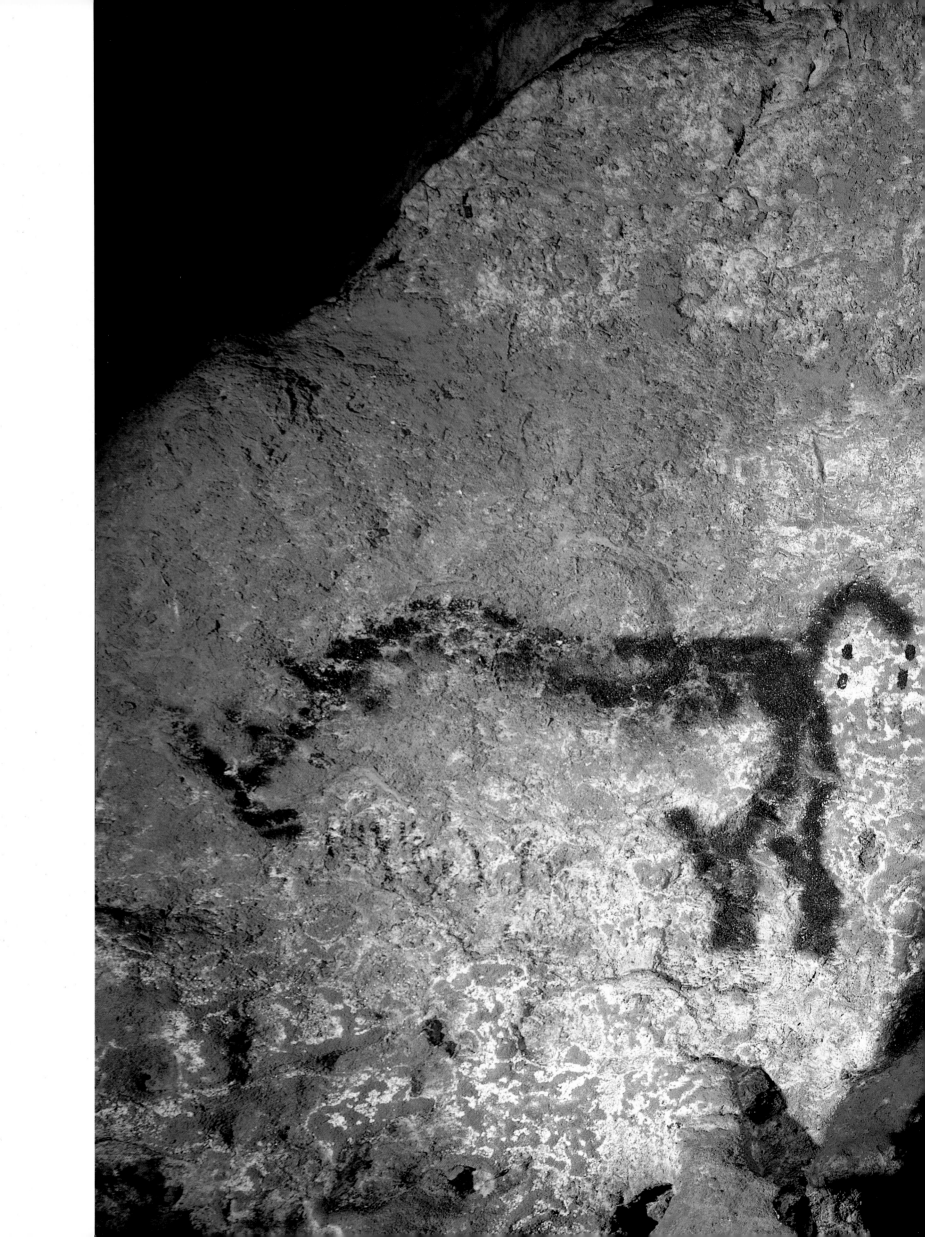

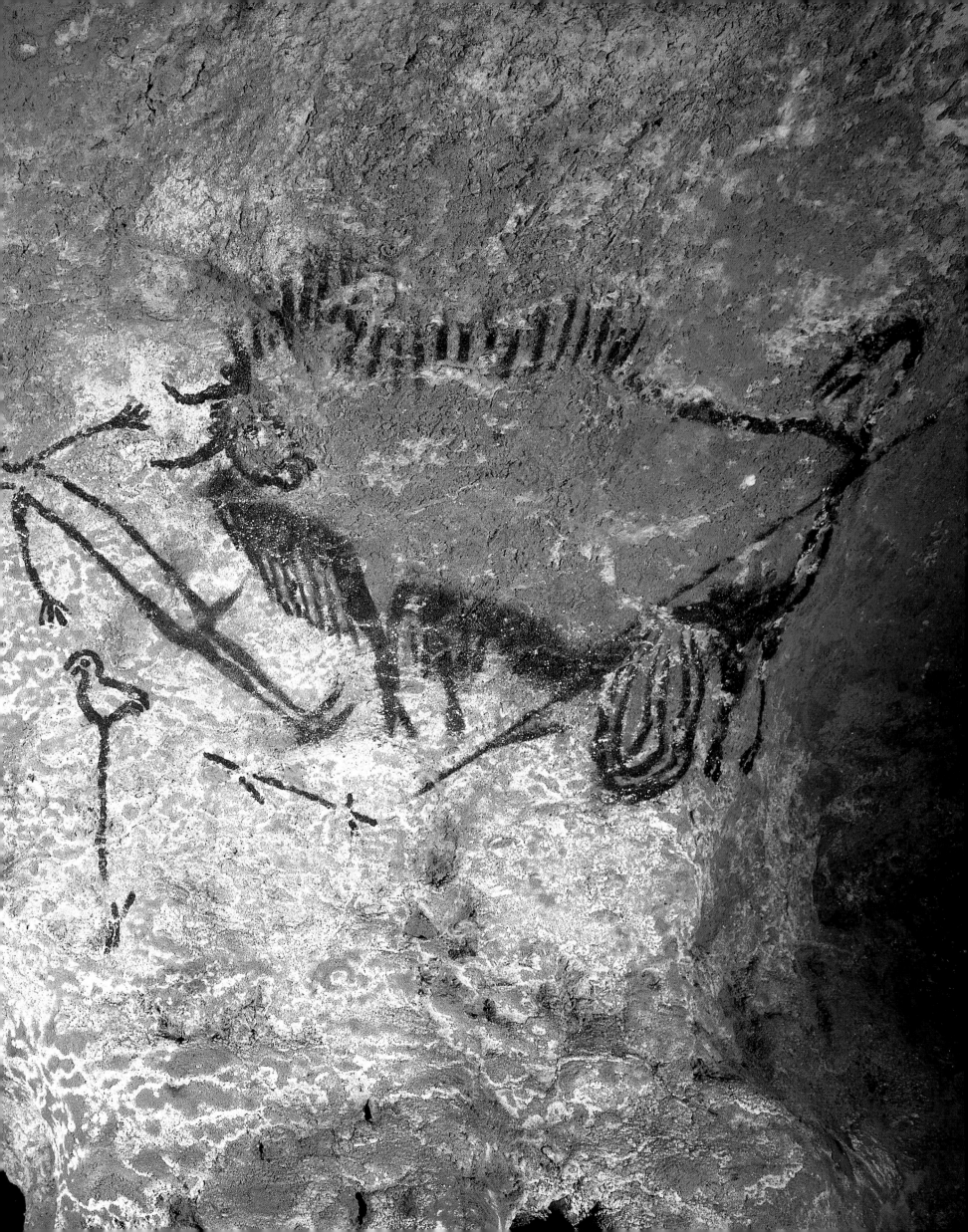

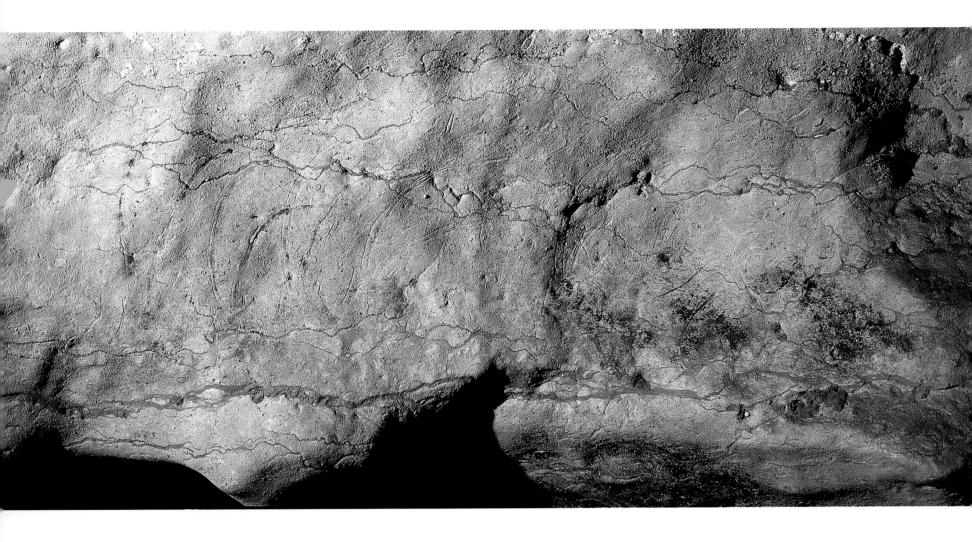

The Nave

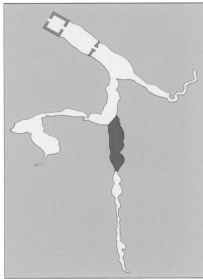

Above:
116 At the entrance to the Nave, on the left wall, there is an inconspicuous frieze of seven ibexes with painted and engraved horns, heads and necks.

Beyond the intersection connecting the Passageway to the Apse is the entrance to a gallery of more imposing proportions: the Nave. The tunnel, which was originally restricted to a low corridor before the floor was lowered, becomes significantly broader here. Twelve metres long, it increases in width from 2.5 to 5.5 metres, and in height from 2.4 to 6 metres. A broad oblong dome covering the whole of the hall gives this space its keeled form.

Of the seventy-nine recorded figures, some fifty animal figures and twenty-four signs could be identified. By looking at the morphology of the walls, the choice of themes and the organization of the motifs at the heart of each concentration, it is possible to subdivide the sector into five panels. These five pictorial groups are divided asymmetrically on both sides of the hall: four are on the left wall (the panels of the

Ibexes, the Imprint, the Great Black Cow and the Crossed Bison) and there is a single one on the facing wall (the Swimming Stags).

This subdivision is accentuated by a distribution on three levels. The upper level is decorated only by the frieze of the Ibexes at the entrance of the hall. Three of the five panels extend over the central part: the Imprint, the Great Black Cow and the Swimming Stags. The Crossed Bison are on the lower level. This gives the figures maximum diffusion.

With the exception of the Crossed Bison, these compositions all have a similar construction. In each panel, there is a dominant figurative theme, made up of a large number of animals arranged in a frieze, and a second theme of single subjects, facing in the opposite direction to the group.

THE FRIEZE OF THE IBEXES

From the entrance into the Nave, the frieze of the Ibexes extends on the left over 1.2 metres. Seven males are aligned at the same horizontal level, facing towards the exit. Only their neck and head are shown, crowned by a pair of developed horns. This frieze is divided into two groups: four individuals on the left and three on the right, separated by an engraved quadrangular sign. They are far from identical. Some have a more delicate head, others a more developed neck. As with most of the figures traced on the relatively friable rock surface, the ibexes were painted and then engraved. The group on the right are red, while those on the left are brown, with a field of colour extended to the horns. The second theme represented is the hind, which is also limited to the head and the neck. Set off to the right, this hind looks towards the back of the gallery.

THE PANEL OF THE IMPRINT

Immediately underneath, in a broad recess in the wall, the Panel of the Imprint (ill. 118) extends over 4 metres. Its location and its proximity to the floor make it the least conspicuous of the major compositions of the cave. Nevertheless, it contains no fewer than twelve figures, divided between two themes: nine horses, the most accomplished of which face the exit, and three bison, two of which are incomplete. All the species have a technical unity due to the combined use of painting (to fill in the outlines) and engraving (for the structure). Two colours were used: brown for the body and black for both the fore- and hindlimbs and for certain other anatomical elements, such as the mane of the horse and the horns of the bison. The successive removal of material during engraving produces straw-yellow lines, which contrast with the darker background.

The bison on the right has several outlines, which may simulate movement but could also represent the superimposition of figures in their own right. The horns of

this large bovine are confused by a second pair of horns in the background. The croup and the hindquarters of a third bison obliterate these two neighbouring images (ill. 118). The central subject of the frieze of the horses also shows signs of animation (ill. 120), bringing together six superimposed and associated heads and manes. The agitation demonstrated by this multiplicity of forms, the powerful neck and the covering of the croup of

the equid in front, possibly a mare with more rounded outlines, all support the argument that this equid is male.

There are horse heads at each end of the panel: two on the left, close to a quadrangular sign, another to the right, associated with an identical sign. These same quadrangular motifs are found on the neck of the horse at the base of the panel and between the two large equids of the upper level. There are further signs on these last two equids. On the left, a series of nested elements is found next

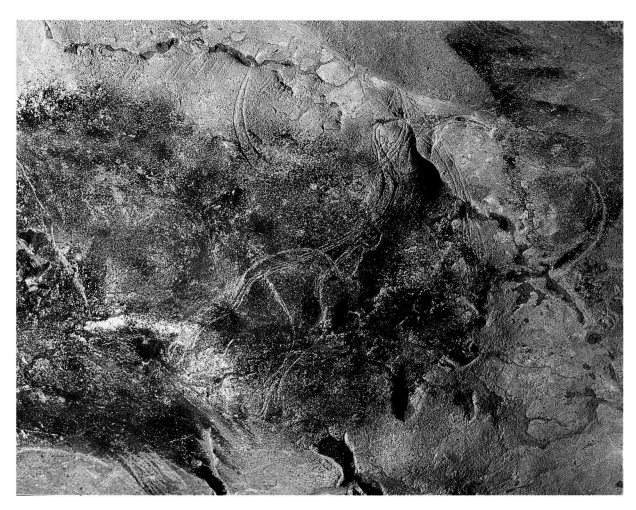

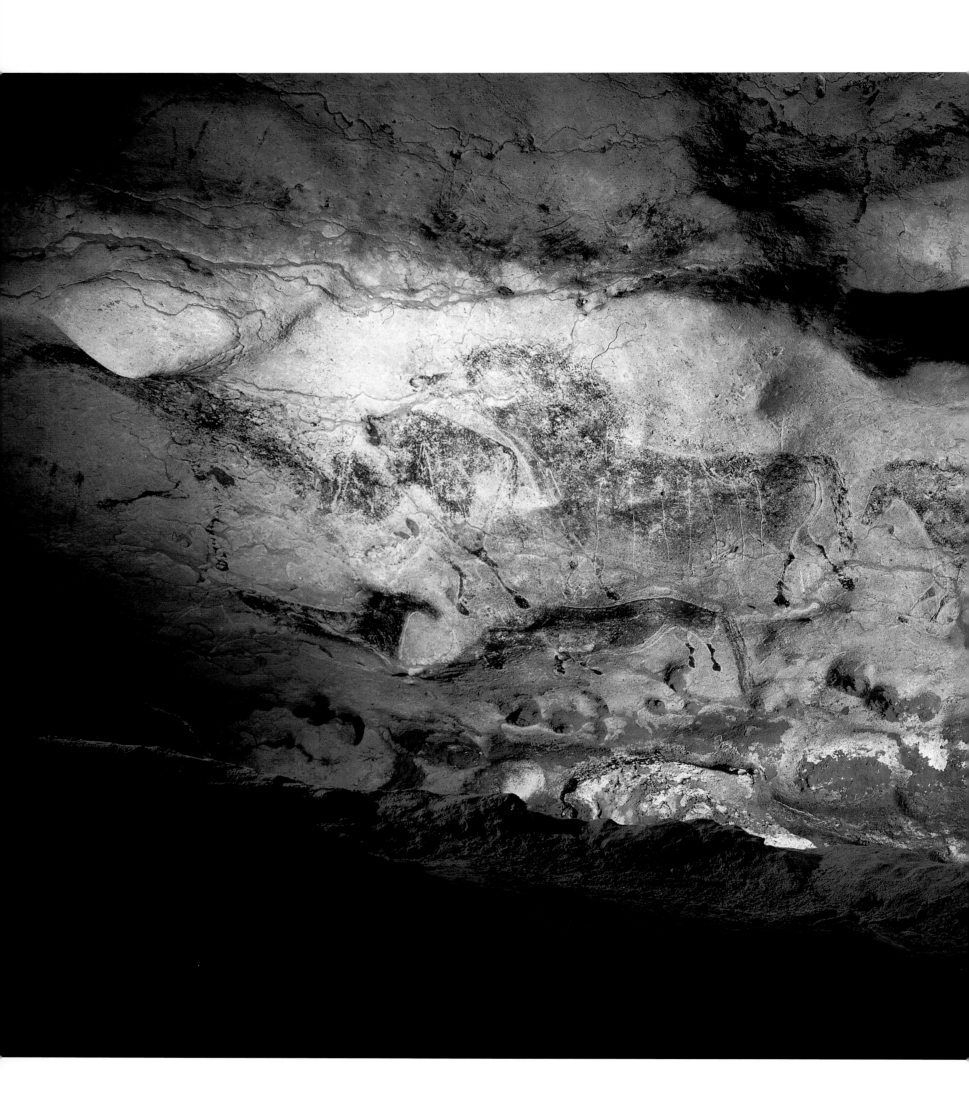

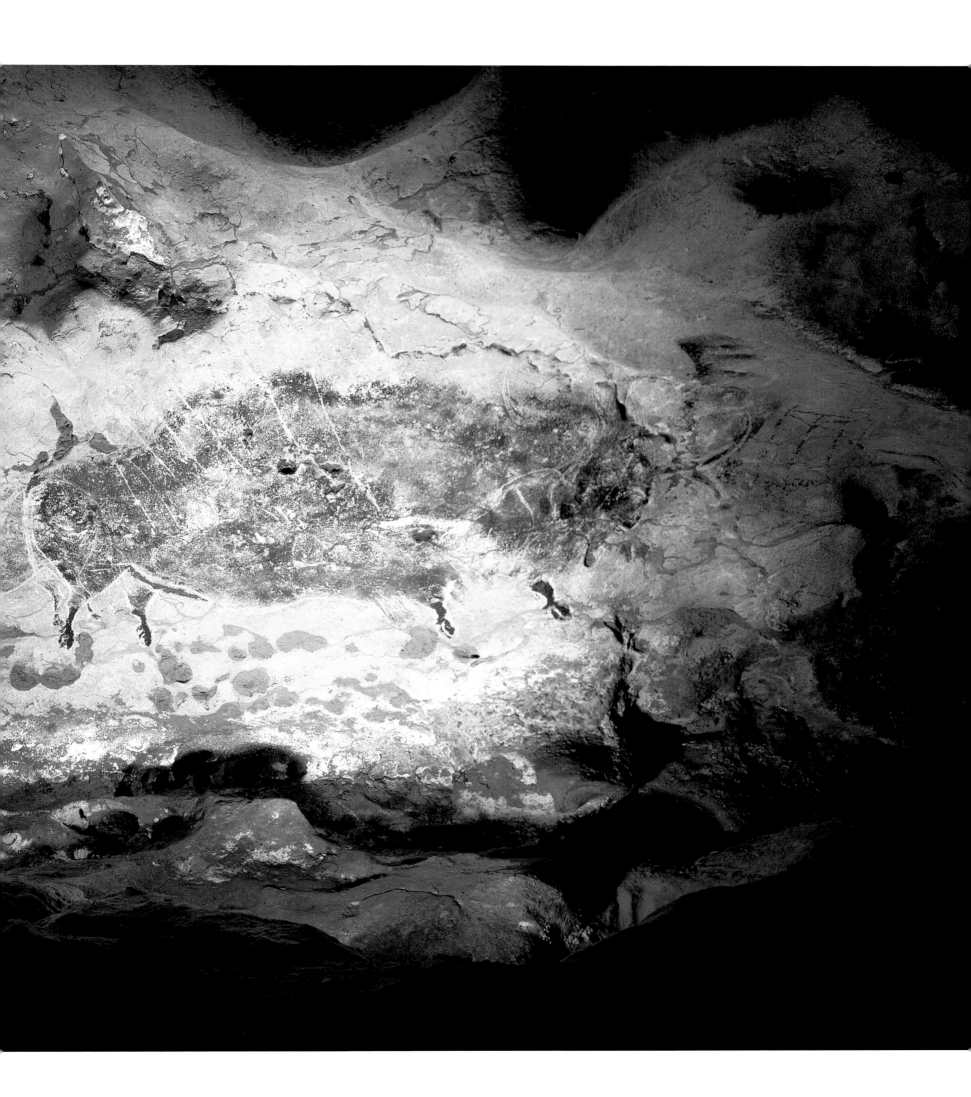

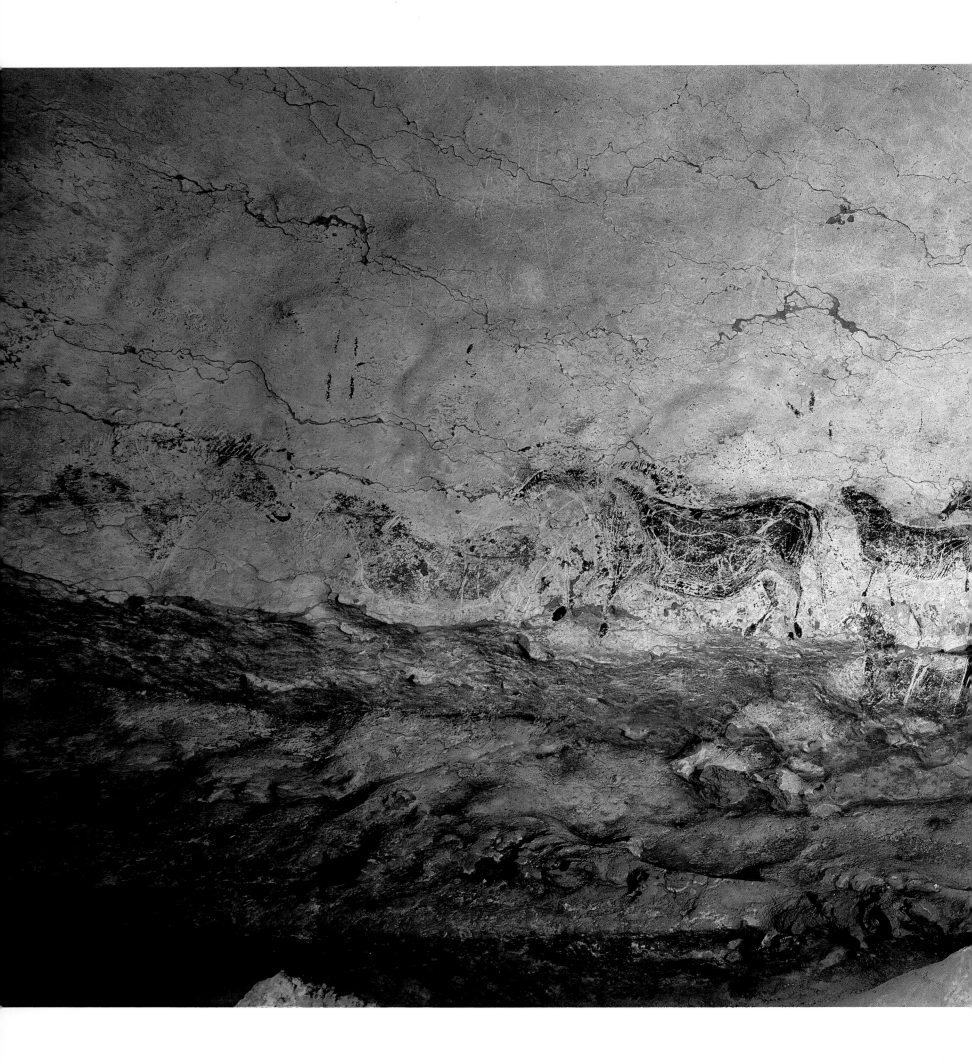

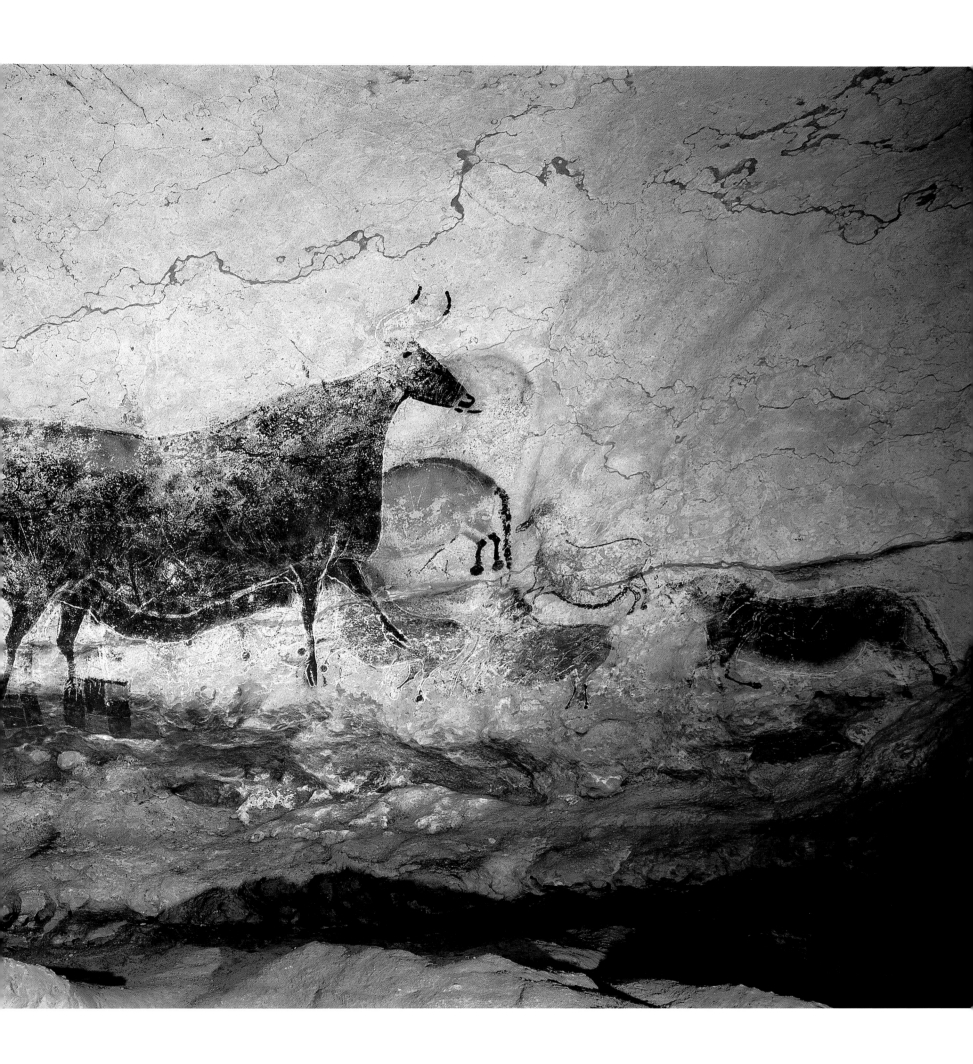

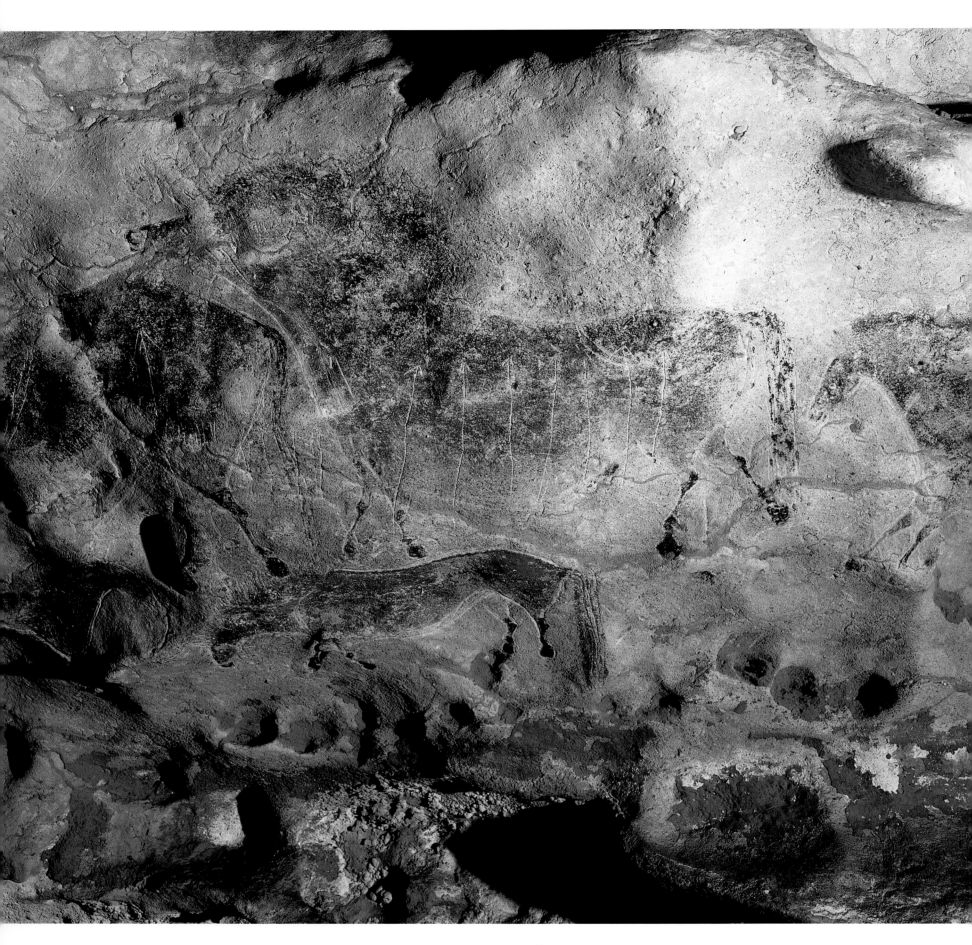

Above:

120 The animation given by the repetition of the lines of the head and the mane, the powerful neck and the covering of the croup of the horse in front, a mare with a more rounded outline, show that this horse is male.

to a barbed sign with a long central branch. Seven equally barbed signs are aligned along the flank of the stallion to the right. There is an identical number of oblique, hooked traces on the flank of the bison.

THE PANEL OF THE GREAT BLACK COW

The panel of the Great Black Cow stands on the left wall (ill. 119), in the centre, and extends horizontally, in contrast to the sloping floor. Over the entire 7-metre length of the composition, this creates a significant difference in height relative to the floor, from 1.8 metres close to the entrance to 3.5 metres at the far end. The panel lies on the overhang and covers two adjacent cavities of unequal size. The vertical ridge, which marks their division some three quarters of the way along, follows the front line of the Great Black Cow. This panel is underlain by a continuous ridge covered with a very dark deposit. A platform of irregular width provides access to all its areas.

The organization of the panel centres on bovines and equids. Nevertheless, after careful examination, a small engraved head and two pairs of ibex horns (ill. 121) were identified, on the flank of the horse furthest from the entrance. This association of figures is not unlike that of the panel of the Falling Cow, which has similar numbers of individuals for each theme. With the exception of one of the ibexes, the orientation of the figures also contributes to the similarity of these two panels. It is extremely rare to discover such convincing analogies in Palaeolithic parietal art, particularly from the same site.

Some twenty horses face the entrance, in a single or double line. This herd is partially obliterated by a very large black cow (ill. 122), which is 2.15 metres long and looks in the opposite direction. It is distinguished from the other female aurochs by the numerous repetitions of the outlines of the upper and lower lines, as well as the

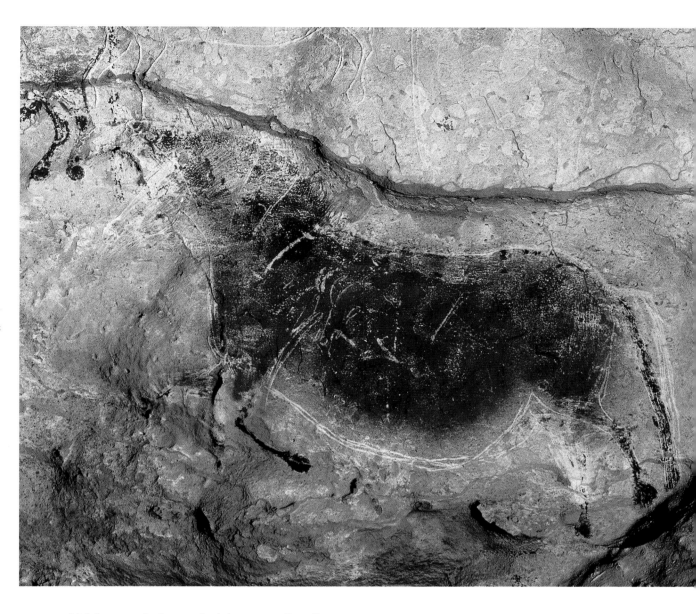

croup, which have made the cow look larger. Only the tips of the horns, the muzzle and the lower lip are drawn with a brush. The outline is covered by a field of even black colour, which is completed in its upper part by a brown band emphasizing the line of the back. Over time, weathering has created several fine lines or gaps in the colour. These marks may look like subsequent engraving, but they are entirely beneath the colour. The passage of the engraver's tool across the wall had the effect of increasing the friability of the rock locally, which weakened the adherence of the pigment to the wall.

The horses at the periphery are not the only figures to have been obliterated by the Great Black Cow. Overlapping the belly of the cow is a complete equid (ill. 123), whose hindlimbs extend beyond the boundary of

Preceding pages:
119 This elongated herd of horses, partially hidden by the Great Black Cow, extends across several metres. The majority of its subjects face the entrance. Only the separate heads face the back.

Above:
121 Two incomplete engravings of ibexes disturb the homogeneity of the brown coat of this horse. Thematically, their presence is somewhat reminiscent of the panel of the Falling Cow in the Axial Gallery. This latter composition also contains numerous horses and a cow, turned in the opposite direction.

Overleaf:
122 The Great Black Cow obliterates numerous horses and signs. Its outline shows traces of a number of adjustments, particularly on the croup, the back and the line of the belly.

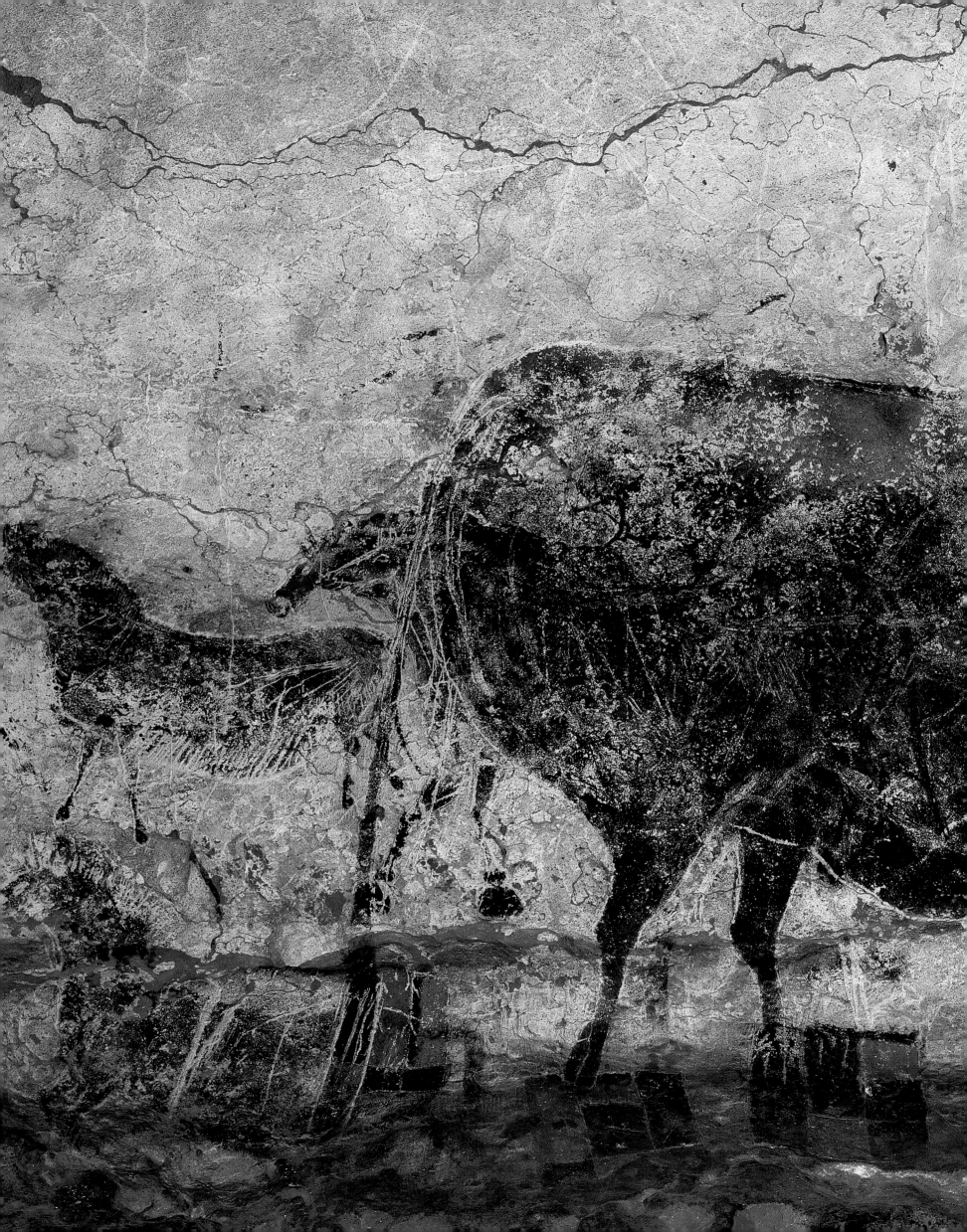

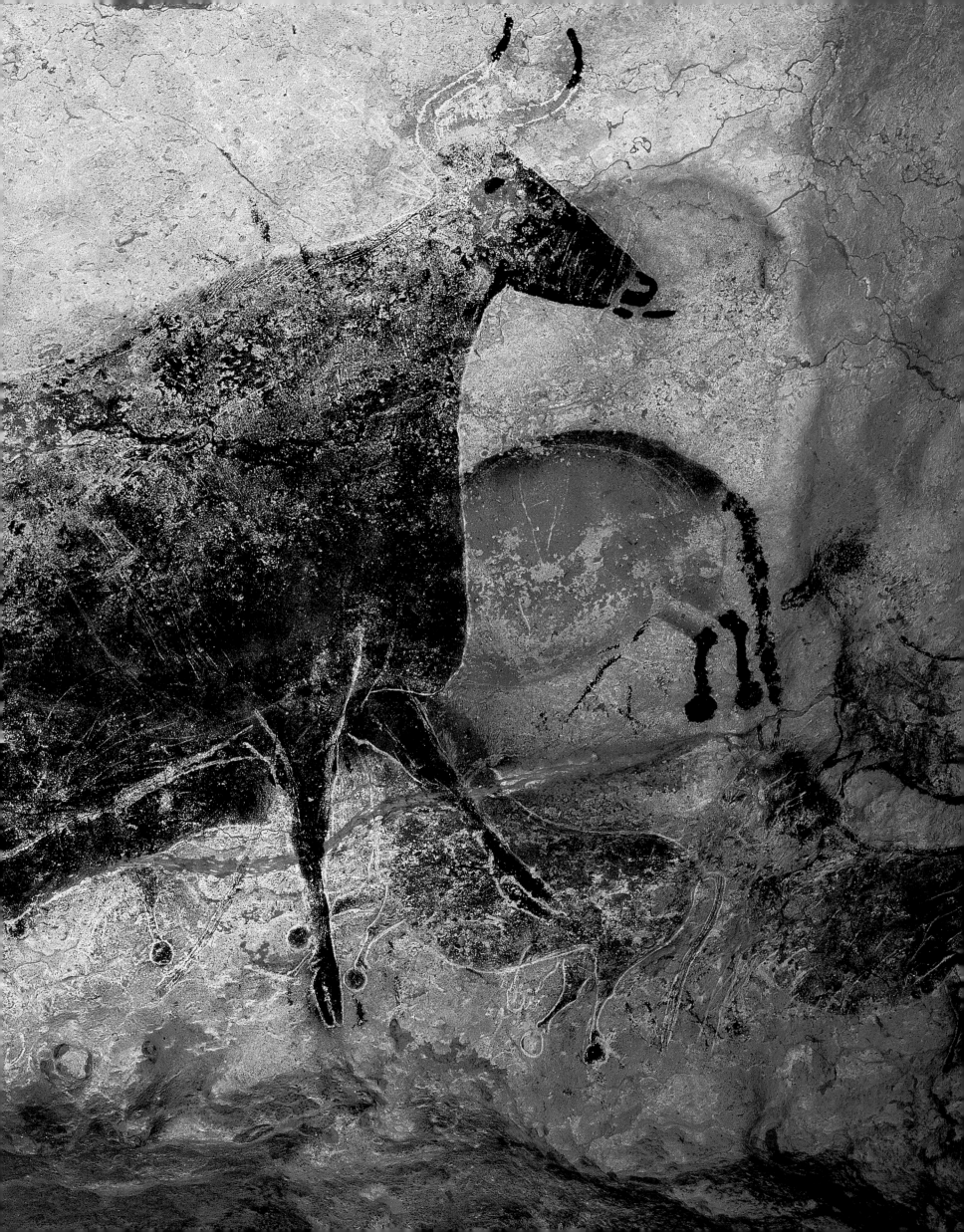

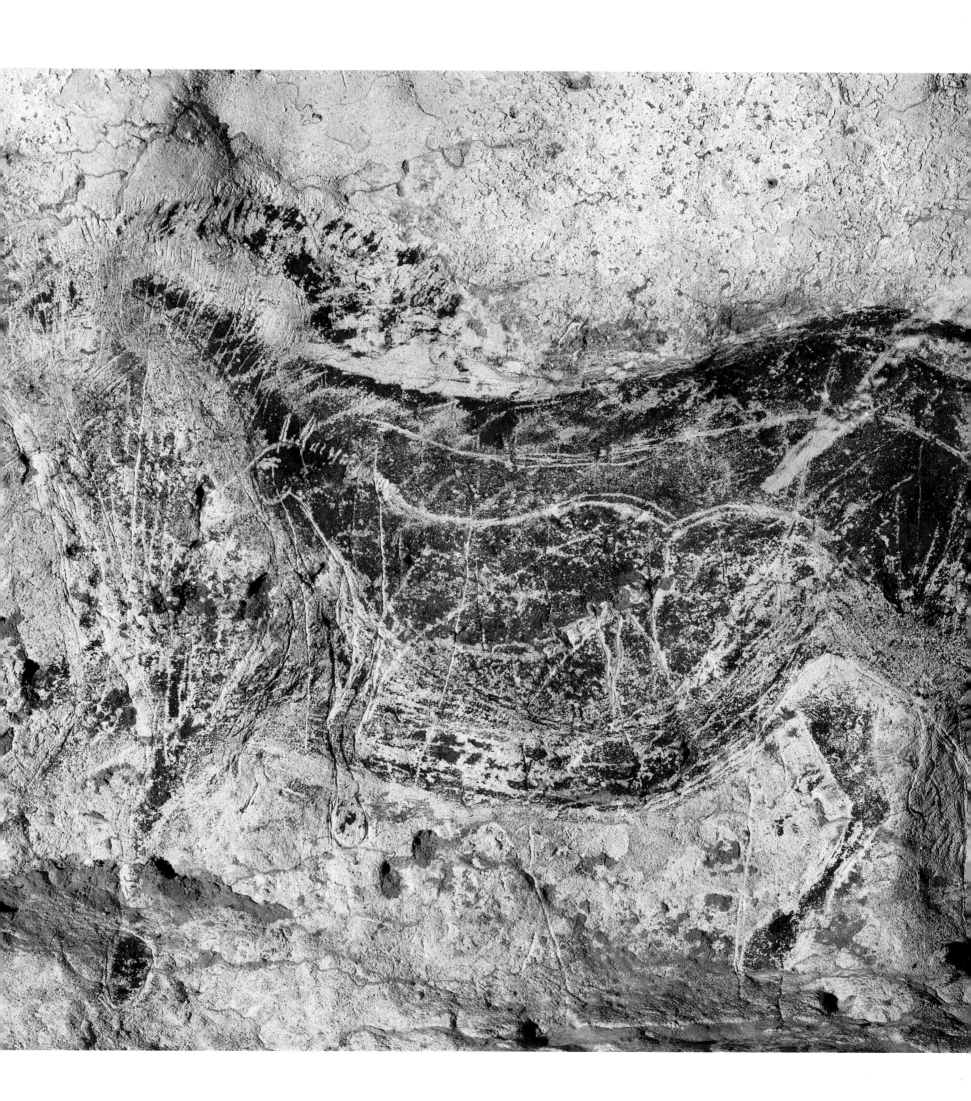

123 It is difficult to make out this engraved outline of an equid, which rears up at the centre of the broad expanse of black colour of the coat of the Great Black Cow.

Right:

124 At the left edge of the panel of the Great Black Cow, on the flanks of a brown horse outlined in black, a smaller, engraved horse can be detected inside its silhouette.

the aurochs. This horse is rearing up and has remarkable vitality. The partial horses along the first metres of the panel are turned towards the back of the gallery. There are two heads straddling a third individual, whose outline is completed by the line of the back. Beyond this, there is a long procession of seventeen equids facing the entrance, all painted and engraved. The technique, very dependent upon the support, is identical to that used for the Imprint. A faint line, incised for the pre-positioning of the figure, defines the limits of the field of colour applied by

spraying (ill. 124). Peripheral elements, particularly the fore- and hindlimbs and the tail, were painted with a brush. In a final stage, the outline was accentuated by engraving or scraping. As in the previous panel, certain anatomical elements have a double or even triple outline, an operation often preceded by scraping, as if it had been necessary to suppress the original image (ill. 125). These successive corrections affect the tail, the head and the fore- and hindlimbs.

This herd is divided graphically into two parts. The boundary is the aurochs, which masks subjects belonging to each of the groups. The morphological variations, although recognizable, nonetheless remain insufficient to be able to identify a different artist. The observed similarities are more numerous than the differences. The horses placed behind the Great Black Cow have, among other details, a slightly more gracile form and oblong hooves, whereas the equids located at the front are stockier and have round hooves (ill. 126). This difference is not specific to this panel since it is found in other sectors of the cave. In fact, the first group has similarities to the red horse and the brown horse in the Hall of the Bulls, while the second resembles the group of black painted horses immediately underneath, but also those of the Axial Gallery and, more specifically, the Chinese Horses.

There are far fewer geometric signs than figures. Nonetheless, the panel contains a total of three quadrangular signs (ill. 127), at the centre of the composition and underneath the large bovine. The extremities of the hindlimbs and the tail of the cow touch the left upper line of each one. They are all constructed on the basis of juxtaposed coloured fields of rectangular shape. An engraved line completes their partitioning. The colours are identical to those used for the animals. Nevertheless, two of the elements of the quadrangular sign on the left are mauve (ill. 145). This colour is found only exceptionally.

Above:

125 The original position of the head of this horse may not have conformed to accepted conventions because it was subsequently scraped and then redrawn.

Opposite:

126 The silhouettes of the painted and engraved horses in front of the Great Black Cow differ from those of the second group on the other wing of this panel.

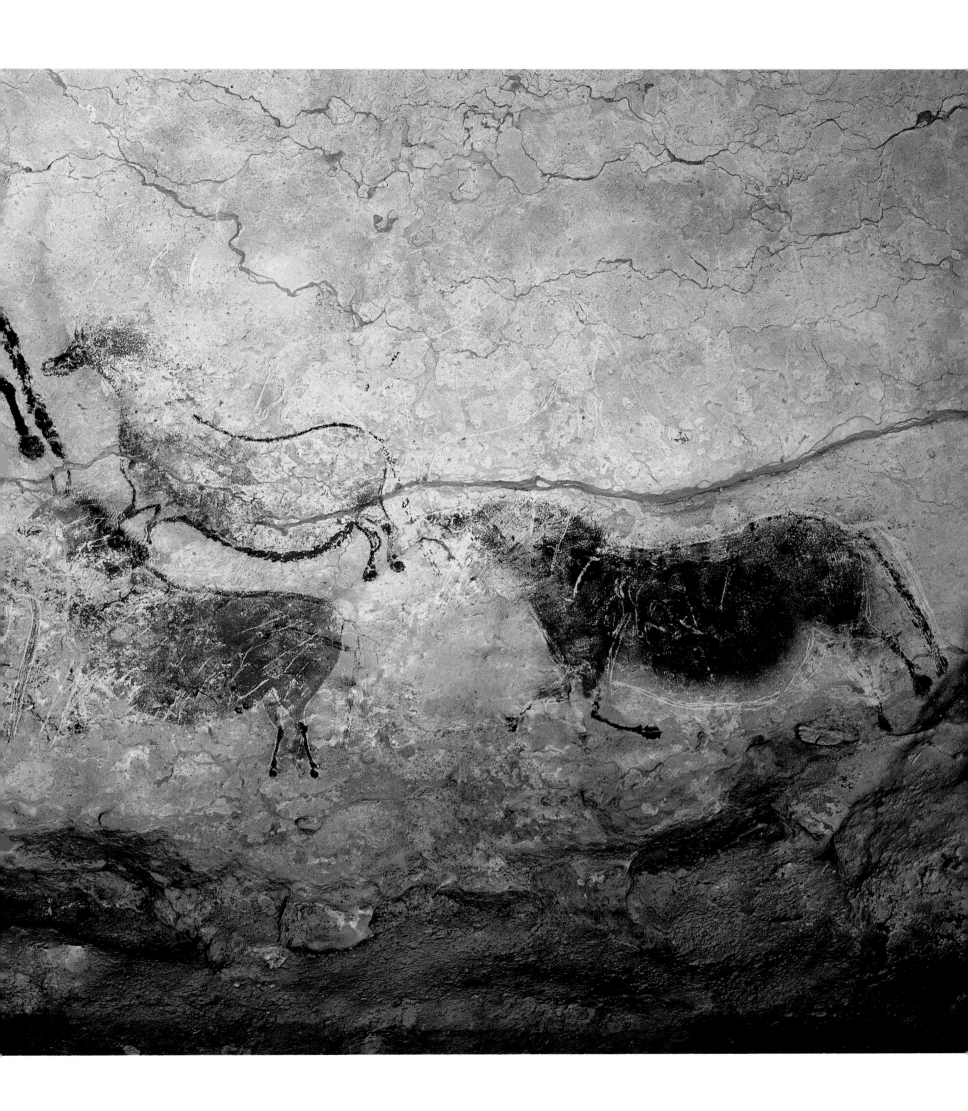

127 Numerous quadrangular signs punctuate the majority of the decorated walls. The most accomplished belong to the panel of the Great Black Cow. They are blazons and have been painted by juxtaposing small squares or rectangles of composite colours with deeply engraved outlines.

THE CROSSED BISON

In the most remote part of the hall, below the panel of the Great Black Cow, the wall curves inwards. It is the only regular surface of this level. This recess is below an overhang, and the wall at this point forms an angular interface. The particular configuration of the location must certainly have influenced the position of the figures, since each plane integrates only one of the two representations of this composition. This diptych bears testament to the fact that the visual impact of a work is not proportional to the number of figures it holds. It shows two bison moving away from each other (ill. 128). Their croups are superimposed, which in no way alters the individuality of the two subjects. Indeed, a reserve left uncoloured

around the thigh of the left bison gives the impression that it is in the foreground. The simulation of the third dimension is a constant in the great majority of the animal depictions at Lascaux. The panel of the Crossed Bison unites the graphic conventions developed by Palaeolithic man to achieve this effect. These processes will be expanded upon in the following chapters.

This panel is also distinguished by the absence of engravings, as spraying and brush techniques were used to paint the two representations. The mode of graphic expression used here was determined by the unusual hardness of the rock, contrasted with the relatively fragile character of the background of the previous panels (since the entrance into the Passageway). This phenomenon is related to a change in the level of the stratification of the rock. Identical conditions are found on the walls of the Shaft Scene, a composition located at the same level.

A field of black colour covers practically the entire body of the left bison, with an irregular internal area marked in red, possibly representing the spring moult. The construction of the bison on the right is different, not in its very dense covering of pigment, which here also covers the whole of the animal, but through the presence of distinct violet patches (the result of a mixing of red and black pigments or the superimposition of a second projection of black colouring on to an initially red field of colour). The external anatomical parts – the horns, tails and limbs – are drawn with a brush, except for the horns of the bison on the right. Here, a hand was used as a stencil during the spraying of the pigments. The eye is absent from both figures. The yellow mark on the left bison, which might be interpreted as an eye, is only the scar of a small flake that detached from the wall after the wall was painted – a fortuitous accident that was to lead a good number of observers to misinterpret this mark. This natural deterioration is not an isolated incident: there are small signs of exfoliation over the entire surface.

THE SWIMMING STAGS

The panel of the Swimming Stags decorates the right wall (ill. 129), rising 1.8 metres above the floor near the threshold and 2.5 metres at the far end. The frieze assembles five large stag heads, all turned towards the back of the gallery, and also the less conspicuous partial head of a horse, which is of much more modest proportions and faces in the opposite direction to the stags. This horse was executed in the same way as the other horses of this hall, with a black mane, a brown back and an engraved upper line. A series of seven sprayed brick-red dots (ill. 130) underlines the small sketch of the equid. The only primarily engraved element of the panel is situated to its right. With all due precaution, it could be interpreted as the back line of a quadruped.

The five large stags were painted with a brush. Calcite outgrowths present on the wall and white excrescences younger than the figures give the lines a segmented appearance. The four figures on the left are black, while the one on the right is ochre-coloured. The material used for tracing the outline of the latter might have been clay, fragments of which were found on the narrow ledge that underlies the beginning of the panel. This juxtaposition of stags, limited to the neck, head and antlers, all noticeably distributed along a line following the same slope as the floor, suggests a herd crossing a river. It is perhaps not essential to attach too much importance to the narrative potential of the panels as it would then be necessary to extend this interpretation to other friezes constructed in a similar way, such as the ibexes in the same hall or the yellow bulls in the Axial Gallery. Nevertheless, this frieze looks set to remain 'the Swimming Stags' for a long time to come.

Overleaf:
128 The last major composition before the Chamber of the Felines, the diptych of the Crossed Bison combines all the graphical conventions of perspective.

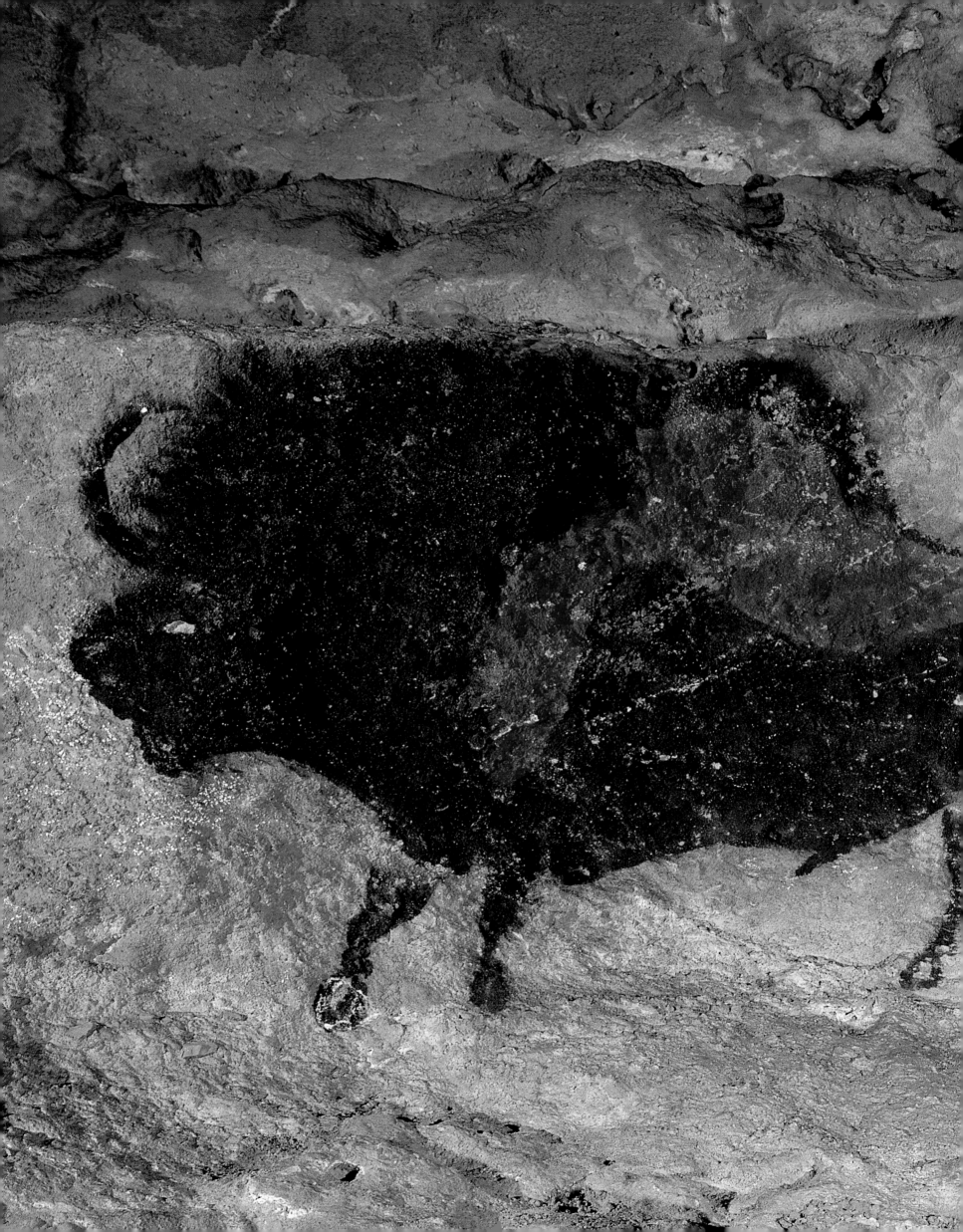

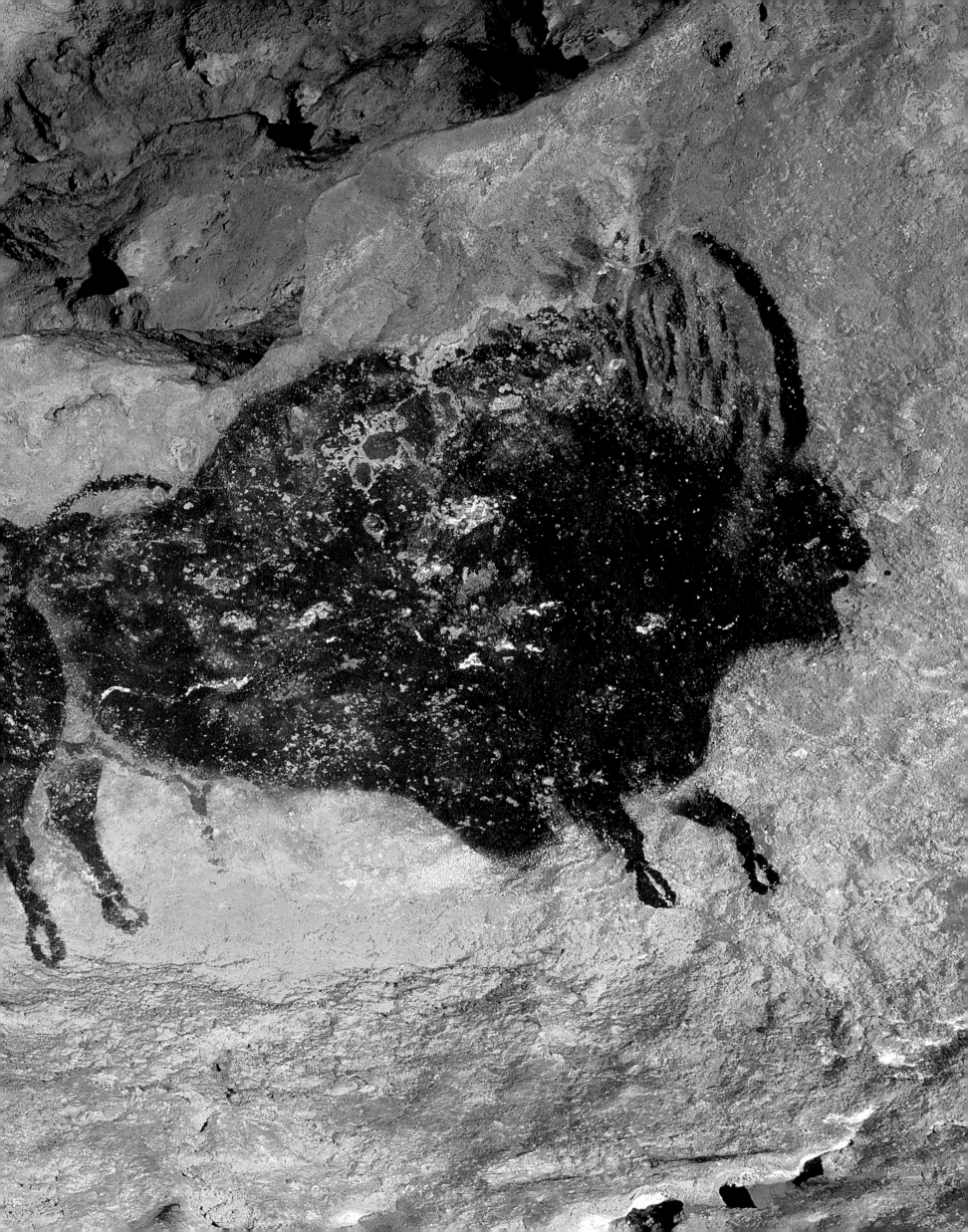

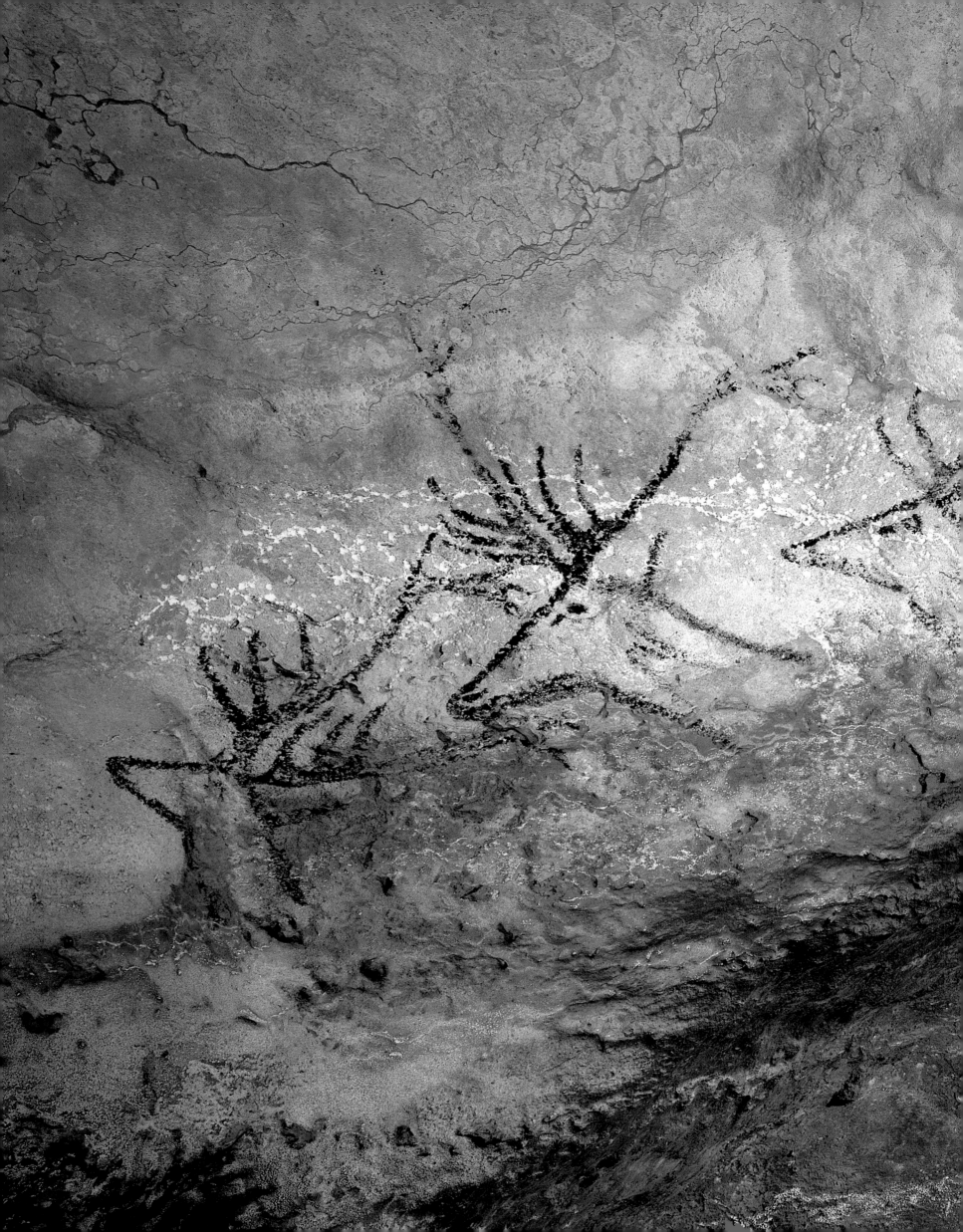

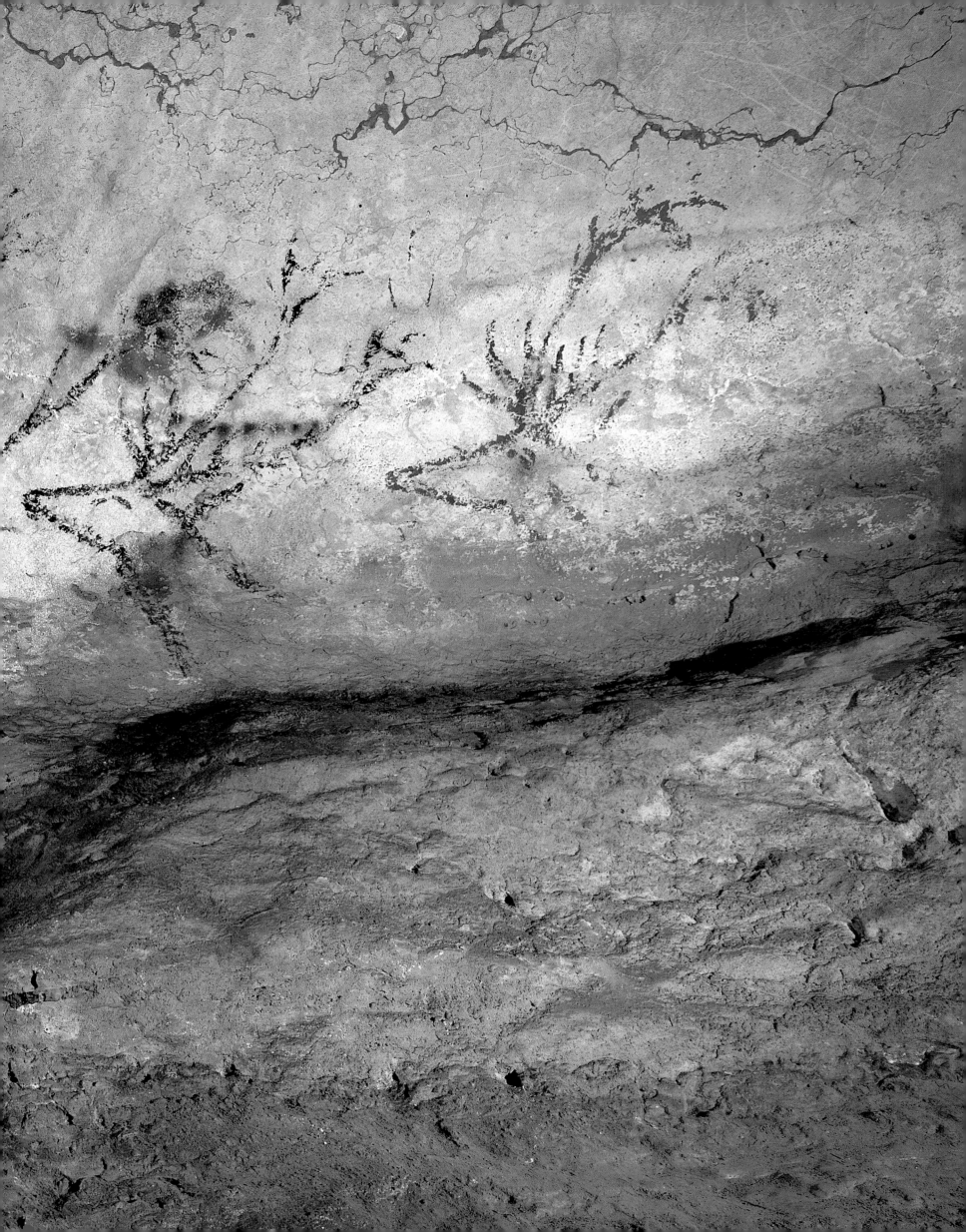

The Figures of the Innermost Depths

On the axis of the Nave and beyond the undecorated Mondmilch Gallery there is a straight, and sometimes very narrow, corridor. This is the Chamber of the Felines, the final retreat of the sanctuary. The

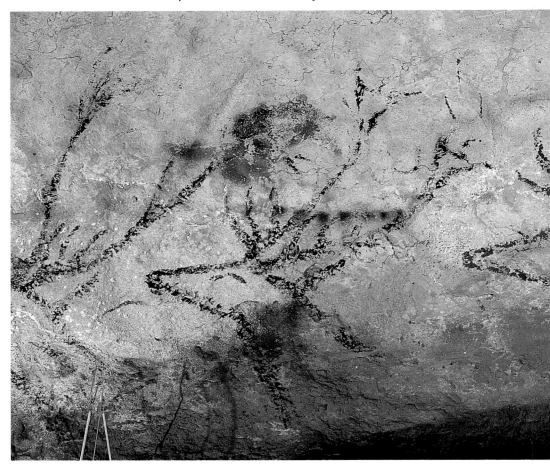

figures. As in the rest of the sanctuary, the horses dominate, making up twenty-nine of the fifty-one identified animals. The bison, in second place with nine subjects, here replaces the aurochs, which does not

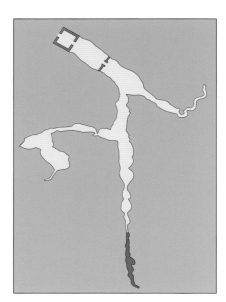

excavations led by André Glory in the first part of the sanctuary brought to light an irregular floor, with hollows rendering its passage arduous as far as the southern Shaft. After this last obstacle, the second part extends for a further 22 metres. The Chamber of the Felines contains only 10 per cent of the figures in the gallery: the unusual architecture of the tunnel dictated a distribution of the figures in small groups, separated from each other by the vertical ridges of the hollows.

The huge compositions of the spaces traversed so far are succeeded by more modest formations. The bestiary is, in part, faithful to that already discussed, except for the presence of six felines. There is a fairly significant number of partial or fragmentary

have a single representative. The remainder is divided between stags and ibexes, with three and four motifs respectively.

The first third of the gallery – the most densely decorated zone – is subdivided into three sections of noticeably equal length, although they are different morphologically. They are in fact two local enlargements separated by a section of tunnel with a very low roof.

The compartment closest to the entrance is dominated by the feline image. There are three felines on each wall. Two other figures, with less conspicuous outlines, may also be felines, although it is impossible to identify them accurately. The orientation of the figures shows the same symmetry in each group: two of the three subjects are turned

towards the back of the gallery. The felines drawn head to tail are associated with hooked lines. One of the felines on the left wall bears eight of them. The very summary character of the Palaeolithic representations of carnivores has often been highlighted. Those of Lascaux are no exception. Their identification is nevertheless well-founded, thanks to the low carriage of the head, the semi-circular ears, the square muzzle and the tail prolonging the line of the back. Their sex, rarely represented in parietal art, is here well marked on the most accomplished feline on the right wall (ill. 131). At the base of the tail, the observed protrusion indicating the scrotum proves that this is a male. Two sinuous, parallel lines were engraved here, representing the marking of territory, as André Leroi-Gourhan pointed out. The animation is completed by a series of parallel lines coming out of the mouth, which could represent either the breath of the animal or the vomiting of blood following an internal injury, or even a graphic metaphor for roaring.

The same alcove is occupied by many other figures, most of them located on the right. At the opposite edge of the panel and on the same horizontal line as that of the felines, three (perhaps even as many as five) male ibexes are recognizable due to their very developed horns. The most complete ibex has its head and neck, as well as the lines of the eye, the nostril and the ear. This group, which was originally more legible, suffers from graphic overcrowding owing primarily to the outline of the hypothetical seventh feline. Some of the engravings of the upper level are only partially finished, especially those of the bison and the horses, while others show a certain originality. Included among the latter is a very delicate representation of a hind, recognizable by its very long neck and lack of antlers. Another original figure, a horse viewed head-on (ill. 132), is in the centre of the panel.

This perspective is very rarely reproduced in this Palaeolithic context.

The right wall and part of the ceiling of the tunnel section of the gallery are characterized by the presence of two large engraved quadrangular signs. The panel of the Crossed Bison extends along 1.5 metres of the facing wall. Here, there are several overlapping figures with incomplete outlines. This is certainly intentional, since the conditions of preservation in the Chamber of the Felines are better than in the Apse or the Passageway. Three images emerge from this confusion of lines and images: the very precise outline of a small equid, traced at the left edge of this group;

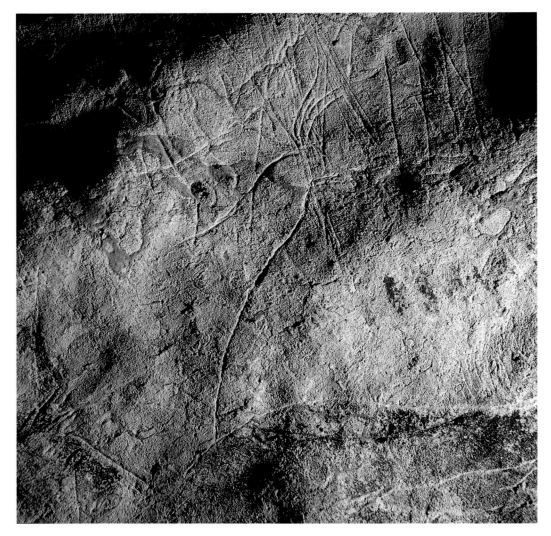

133 Stag isolated in the midst of a herd of eleven horses.

and two very partial bison, one represented by the croup, the tail and the hindlimbs, the other only by its horns, in the form of a crescent moon.

The most detailed group of the gallery, the panel of the horses, is situated on the right wall of the second alcove, at the far end of the tunnel, and is 3.5 metres long. With the exception of one depiction of a stag (ill. 133) in the centre, this last great composition is dedicated to eleven horses. All face the exit, except for the two in the margin (the first on the right, the second in the upper part). Technically, they differ from the preceding figures, as the central horses are painted. Nevertheless, the pigment – black for some and brown for the one on the right – does not follow the engraved outlines exactly; the fields of colour are not strictly superimposed over the incised figures, unless they have been painted over twice. A sign on the neck of one of these horses at the centre of the panel used to be interpreted as a 'hut perched in a tree' (ill. 134). The facing wall is less decorated. Some rare, mostly incomplete or indeterminate, figures have been inserted between two series of parallel lines. On the right, the lines appear more explicit. Four cruciform signs with disjointed branches are deeply engraved into the wall. Immediately below, the last figure is a headless quadruped.

The beginning and the far side of the southern Shaft are marked by fragmentary drawings, integrated into the contours of the walls and reminiscent of those of the preceding spaces, with simple or double parallel lines, one a branching figure, another with nested segments. The final figurative image, a bison shown only by its forehead (ill. 135), is framed by a cruciform sign painted in black, which is associated with three parallel lines, the whole strangely evocative of the Roman number XIII, and a double row of red dots (ill. 136) on the facing wall, which are the last graphic evidence from this southern branch of the cave. The location, at the deepest extremity of the decorated zone, and the form of the sign as a paired alignment make it the exact duplicate of the sign in the panel of the Shaft Scene, although the colours differ.

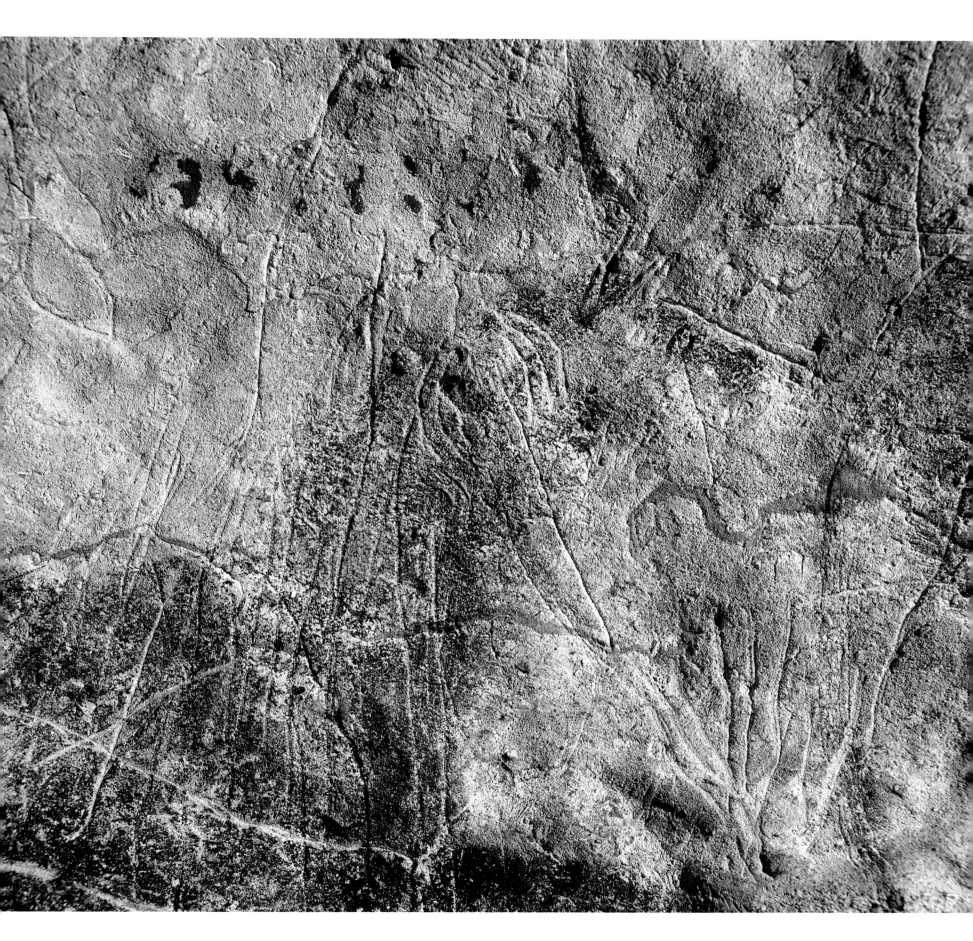

134 The iconography of the Lascaux Cave features strange figures, such as this tree house. Its meaning remains an enigma to us.

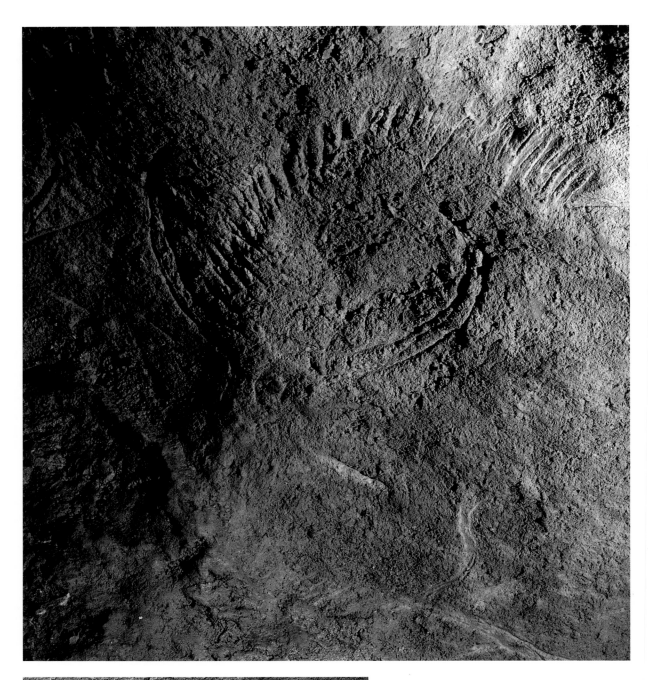

Above:

135 A few metres from the bottom, on the right wall, the final animal theme is a bison, only the head and horns of which have been represented by forceful engraving.

Left:

136 Group of six red dots. They are highly reminiscent of those that mark the end of the decoration of the Shaft. The same graphical units are found again at the end of the Chamber of the Felines. Only the colour is different. The other two paler red dots, located immediately below, are recent.

The Animals of Lascaux: An Ethological Approach

The naturalism of the majority of the animal representations at Lascaux allows us to recognize seasonal features. Nevertheless, not all the figures lend themselves to this study, and their interpretation is sometimes disturbed by significant erosion. As we have seen, phenomena of corrosion are present to a greater degree in the Passageway and the Apse. The fragmentary nature of some figures limits the possibilities of interpretation further. Finally, several animal species, such

gives…the appearance of ancient Chinese paintings.'[26] André Leroi-Gourhan also commented on 'these Bassett hound animals, all belly'.[27]

This particular morphology may be related to stylistic conventions. Nevertheless, no other representative of the bestiary, aurochs, stag or ibex, possesses an outline that is similar or, more precisely, as distinctive. These horses have often been interpreted as pregnant mares. This is a

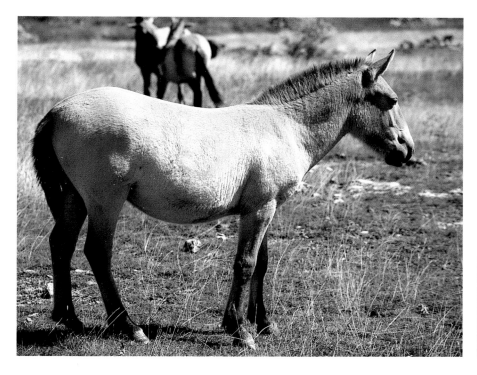
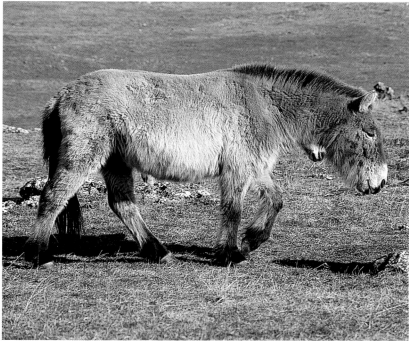

as the bear, the feline or the bird, are present in such limited numbers or possess too slight variations to draw conclusions from them. In numerous cases, these factors can coincide. For these reasons, the ethological study has had to be limited to the three most frequent species: the horse, the aurochs and the stag, which together represent more than 80 per cent of the bestiary.

THE HORSES

Descriptions of the Lascaux horses generally concentrate on their thickset outline and their underdeveloped fore- and hindlimbs. As Henri Breuil said, 'Their legs are very short and their bodies very thick, which

possibility, but it is interesting to emphasize that this condition can be difficult to recognize in nature if the animal is viewed in profile. The diagnosis is more appropriate if the horse is viewed from the front, where it is possible to recognize a bulge on each flank, which is more pronounced on one side than on the other. Despite the large size of the foetus, the external symptoms remain subtle, even during the last months of gestation.

Observation spread over several months of the year has allowed us to analyse, among other things, the morphological development of horses of the Przewalski species during the different seasons. These animals are kept in a wild state with no

137 Winter–summer variations of the coat of the Przewalski species are significant. They affect not only the hide but also the tail.

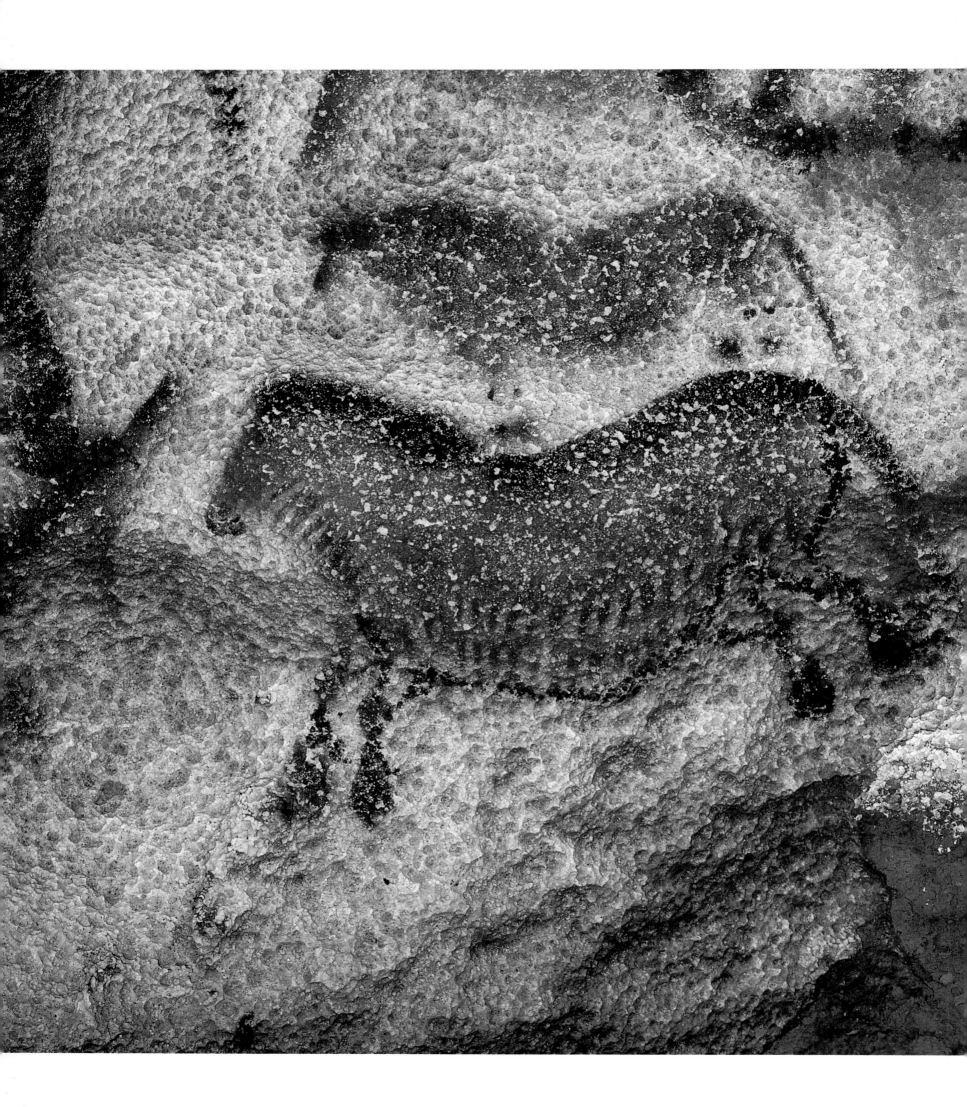

138 The horse in front of the Falling
Cow, in the Axial Gallery, has the same
winter coat as present-day wild horses.

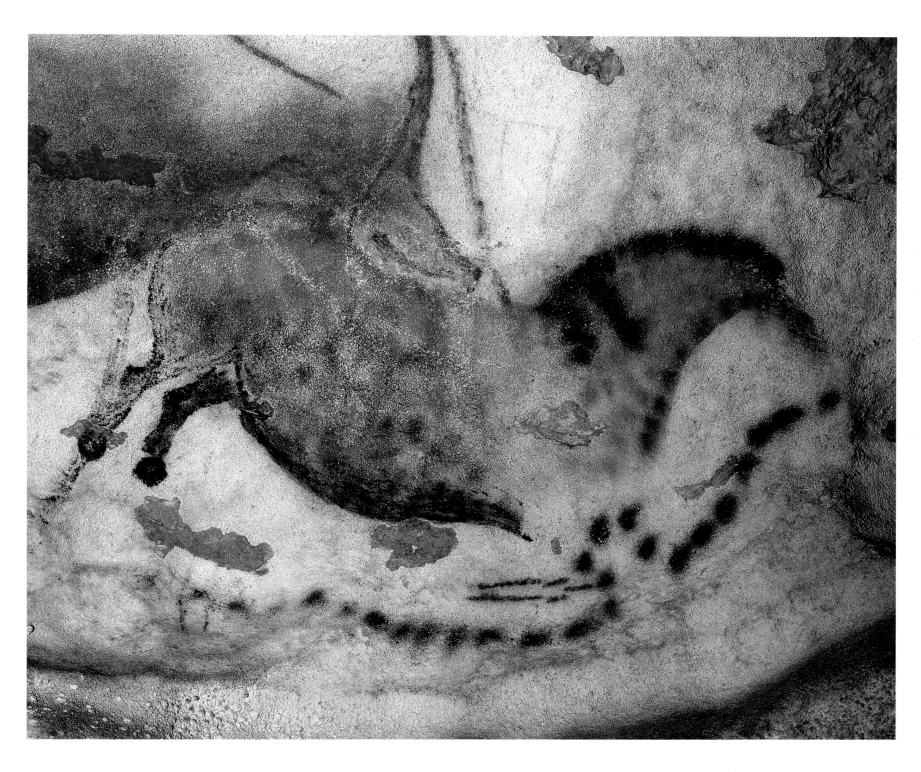

human intervention, even during very harsh
winters, and are divided between three herds
scattered over a vast area of the Causse
Méjean Plateau in Lozère.[28] Their appearance
changes throughout the year, as their coat is
thicker in the winter than in the summer
(ill. 137). During the entire winter period,

but also at the beginning of spring, the
silhouette of the horse retains a bulkiness
very similar to that seen on the Palaeolithic
representations at Lascaux.

Other indications, present on several
equids in the cave, also suggest a winter coat.
In the locality of the Upside-down Horse,

Above:
139 The pronounced development
of the tail of the first Chinese horse,
in the Axial Gallery, is also a seasonal
indicator. It shows that it is winter.

on the flank of the yellow horse, for example, there are groups of three parallel streaks, which are darker than the rest of the field of colour. Identical features are found more distinctly on the third Chinese horse and also on the very accomplished figure located in front of the Falling Cow (ill. 138). The manifestation of seasonality is also reinforced by the very marked development of the tail, a feature shared by the majority of the Lascaux horses (ill. 139). It always reaches the hooves and sometimes even extends beyond the imaginary line of the ground (the first Chinese horse, for instance).

The difference in bulkiness between summer and winter is more marked in females than in males, which are much more active. The end of winter is the mating season. Fights between males occur constantly and are sometimes violent; the animation of certain subjects portrays this aggressive behaviour, which precedes the phase of copulation. Raising the forelimbs depicts one of the gestures of the mating display (ill. 140) or the confrontations between males. This behaviour is easily recognizable and is found on several occasions, particularly in the first Chinese horse, or the subject on the left of the frieze of the black horses in the Hall of the Bulls. More rarely, the horse is shown rearing up, such as the figure inside the outline of the Great Black Cow.

All these indications combine to show that the Lascaux horses were painted, drawn or engraved with specific features representing a period extending from the end of winter to the beginning of spring.

THE AUROCHS

Sexual dimorphism in the aurochs shows itself in many ways. The horns of the males are more developed and thicker (ill. 141), whereas in females, the much more delicate horns have a much shorter span across their curvature (ill. 142). Furthermore, the outline of the cows is more gracile. In males, their stockiness is exaggerated by the short

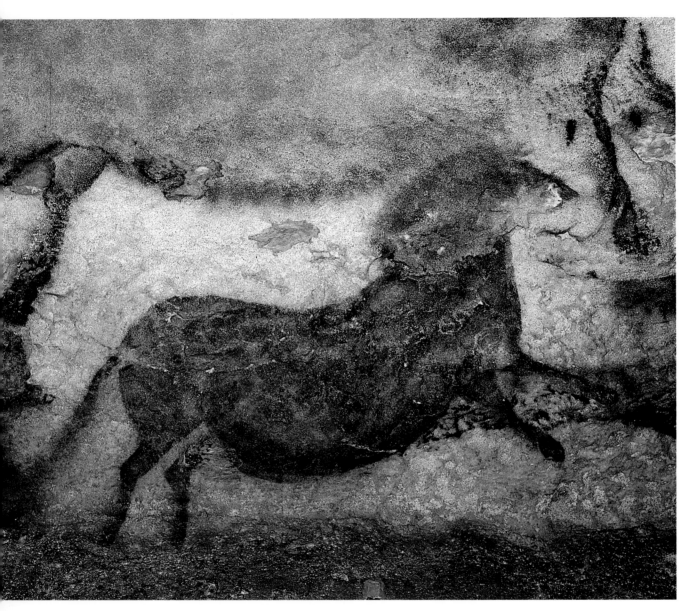

Above:
140 The black horse, in the Hall of the Bulls, raises its forelimbs, showing one of the gestures of the mating display. During the mating season, confrontations between male horses are frequent.

Opposite:
141 Second bull, Hall of the Bulls. Sexual dimorphism in aurochs is shown by more developed and thicker horns in the males.

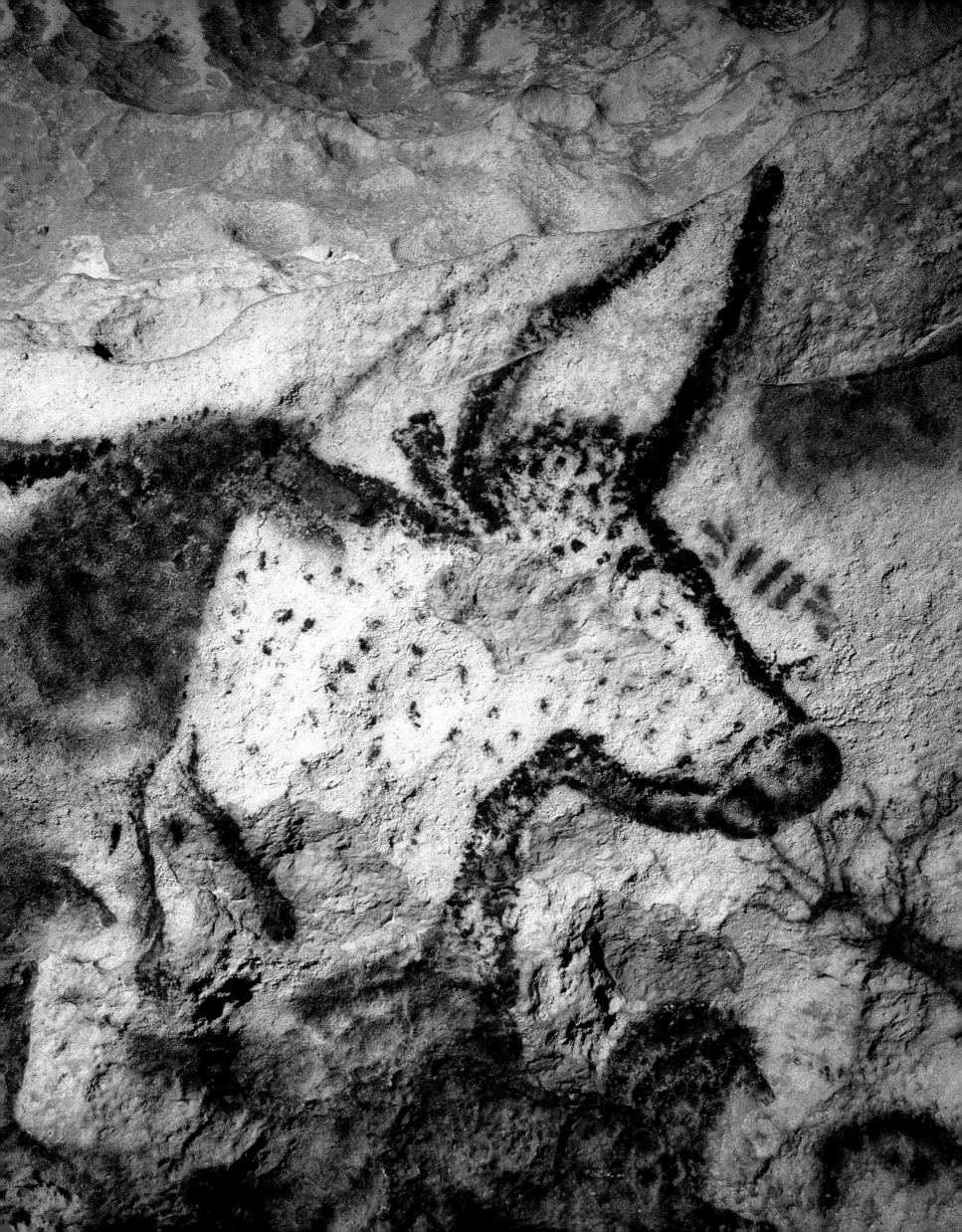

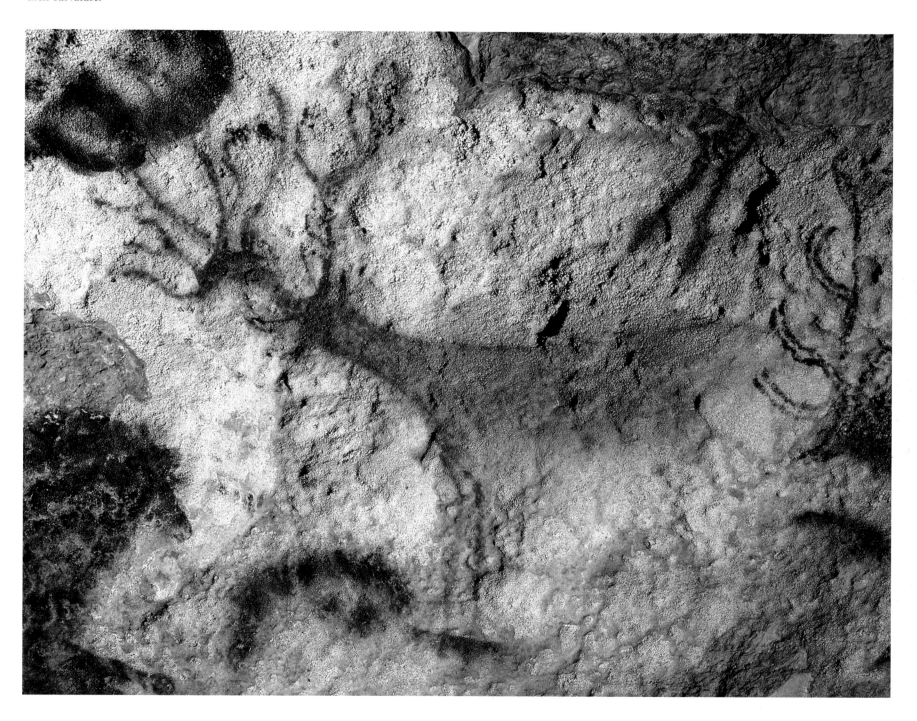

forelimbs and a highly expanded chest, while
the facial angle is more open.

These features were interpreted by Breuil
as possibly belonging to two distinct varieties
of aurochs: 'Cattle-bulls…are only really
abundant at Lascaux, where two species are
represented: first *Aurochs primigenius*, then
Aurochs longifrons.'[29] This hypothesis was
contested by Koby,[30] who showed that these

differences were due to the respective sex
of the animals. The coat allows a similar
distinction between males and females. This
difference is recognizable on the forequarters,
more particularly on the shoulder and
the head. The male aurochs has a scatter
of dots, which can extend to the dewlap.
This detail is found on the majority of the
bulls, particularly those of the Hall of the

Above:
143 Red stag from the group between
the two great confronted bulls of the
Hall of the Bulls. At Lascaux, antlers
– a clear seasonal indicator – take on
impressive dimensions.

Opposite:
144 Black stag, Axial Gallery.
The thrown-back head and antlers,
the open mouth and the rolled-back
eye are distinctive signs of the rut.

Bulls. It is found on three of the four heads underneath the upper line of the Great Black Bull in the Axial Gallery. On the facing wall, the head above the Falling Cow does not bear this scatter of dots, which does not mean much as this figure was unfinished (the eye was also not drawn).

The use of colour inside the outline of the head and the beginning of the body show a highly localized development of the coat. In the male, the difference between the thickness of the hair of the forequarters and the hindquarters is much more marked in summer than in winter, and from this observation it seems that most of the male aurochs represented at Lascaux were depicted in their summer form. The entire group of female aurochs, with their lack of hairiness, confirms this interpretation.

The outline of a young bovine (ill. 54) located behind the fourth bull of the Hall of the Bulls corroborates this analysis. The outline of this calf is closely dependent on the image of the red cow located in front of it, with which it is integrated graphically. The spaces between the head and thigh demonstrate that the calf and the cow belong to the same painting. They are not two juxtaposed painted figures, but one and the same entity, and the proportions of one subject to the other are rendered faithfully. The size of the calf, which places it well below the dorsal line of the cow, and its very developed forelimbs indicate an age of between three and five months. This suggests that the young bovine is, like the adults, an animal in summer.

THE STAGS

The seasonal characteristics of the male red deer are even more marked than those of the aurochs or horse. They are predominantly visible in the growth of the antlers (ill. 143). At Lascaux, this attribute is all the more revealing as, in the majority of stags, it takes on enormous proportions. The brow and the bez tines are very developed, as is the crown,

and there is also a systematic bifurcation of the trez tines, although this is exceptional both in recent red deer and among palaeontological remains. Whether they are drawn in a frieze or painted at the heart of a different composition, the Lascaux stags often form part of a group, as in the frieze of the Swimming Stags. The presence of antlers and the representation of a gregarious behaviour indicate a quite specific time of the year: male red deer band together shortly before the mating display at the beginning of autumn. The agitation of the black stag at the entrance to the Axial Gallery corroborates this observation. The head and the thrown-back antlers (ill. 65), the open mouth and the rolled-back eye are typical of the rut (ill. 144).

OBSERVATIONS

Analysis of seasonal indicators establishes that each species represented at Lascaux represents a very specific period of the calendar. The horses mark the end of winter or the beginning of spring, the aurochs high summer, whereas the stags have been represented with the attributes of autumn. This is not by chance. Each of these species has been represented at a quite explicit phase of the annual cycle, at the beginning of mating. At this time, they are extremely active and animated. From this point of view, the animal figures of Lascaux contrast with those of numerous other decorated sites, where the images present a much more static outline. The iconography of this cave is, above all, a fantastic ode to life.

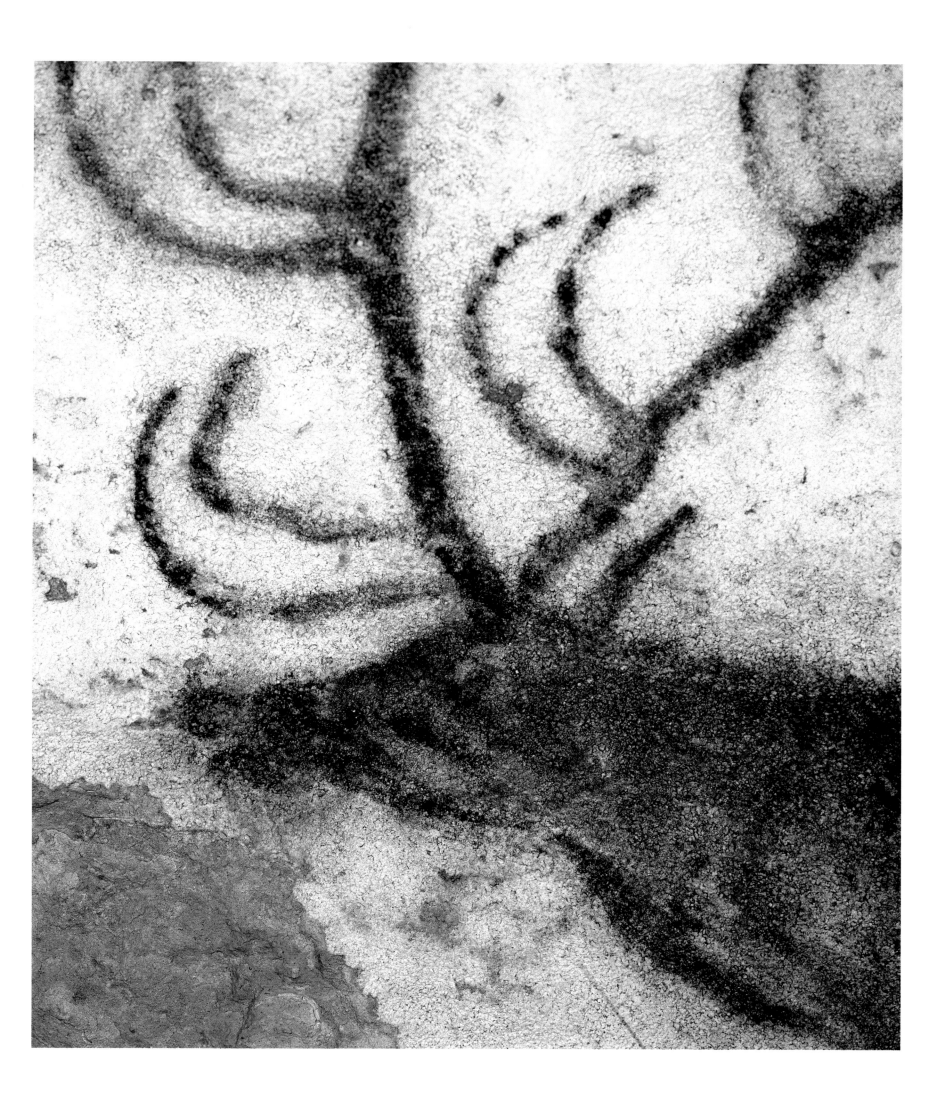

The Raw Materials

Technology of the Figures

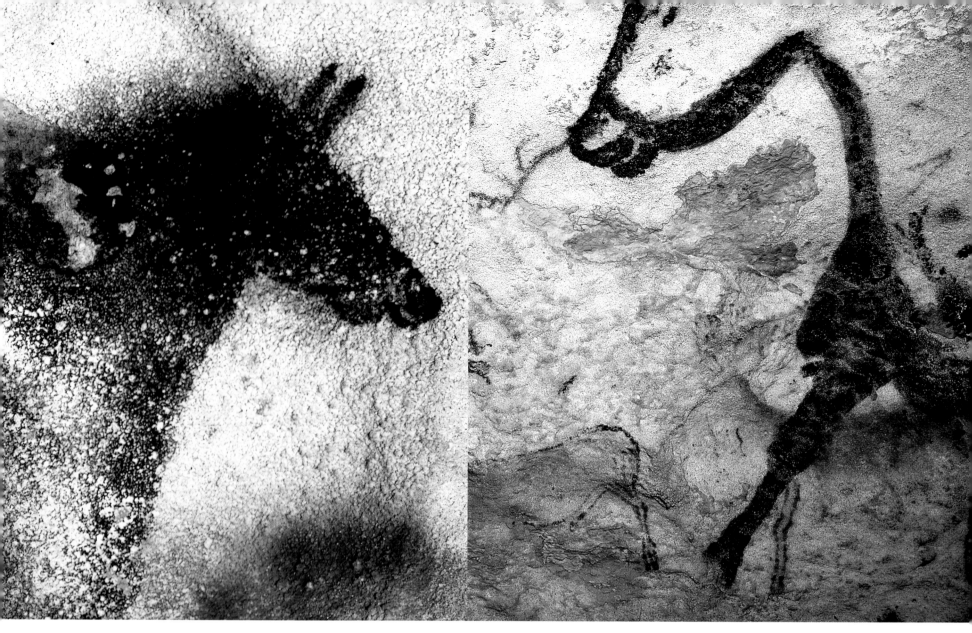

The Construction of the Images

CHAPTER 6
The Construction of the Images

The drawing of an animal or a sign and, beyond that, the project of decorating a cave in its entirety necessitated the pooling of multiple abilities. The natural constituents of the site, such as space, the underlying rock, indeed the conditions of access, are going to influence, and are closely bound up with, the execution of works of art. This approach implies a true synergy between man and the cave itself. It entails genuine organization, which assumes the continuous anticipation of events and leaves only limited room for improvisation.

First it is necessary to select tools for engraving and painting and collect the raw materials for colouration. This requires a comprehensive knowledge of the potential offered by the natural surroundings, from both a geographical and a geological point of view. The execution of the different panels *in situ* necessitates an optimal knowledge of graphical technology, a great mastery of gesture and the unfailing ability to adapt to the specific morphology of the walls. It will sometimes be necessary to modify less accessible areas, which is impossible without specialized equipment. Finally, the different symbolic and mythological aspects of

converting a site into a sanctuary demand a shared idea or thought process, subject to a precise ritual.

The Raw Materials

The palette of colours used by Palaeolithic people, essentially composed of elements of mineral origin, is relatively limited. It combines black with a range of warm colours, from dark brown to straw yellow, passing through all the shades of red. Colours that diverge from this, such as the mauve sections on the 'blazon' (ill. 145) below the Great Black Cow of the Nave, now under study, are exceptional.

Current methods of pigment analysis require only tiny amounts of material. It was therefore possible to remove perfectly innocuous samples from the parietal works of art, thus allowing multiple sampling, a more precise identification of the pigments and a possible interpretation of the techniques employed. These studies showed that all the painted and drawn figures were essentially made using powdered metallic oxides derived from iron and manganese.

Iron oxides, such as haematite or goethite, are common and widely distributed across

more or less the entire region. Our frequent prospecting has led us to the higher regions of the plateaux in particular, where there are numerous sites capable of providing these pigments, which are essentially minerals derived from surface formations and collapsed karst cavities. They are distributed over a huge area between the Vézère and the Dordogne and they are also present, in a more scattered fashion, in the north-west of the studied region. These ferruginous deposits, formerly scattered, temporally diverse, are located at the summit of the Cretaceous formations.

Studying the materials sampled from the cave paintings showed that the black shades were essentially manganese-based.[31] Carbon (wood, bone charcoal or natural) has rarely been identified to date.[32] This makes it impossible to determine the age of the works by radiocarbon analysis – the method used to date other sites in France, such as Niaux[33] (Ariège), Cosquer[34] (Bouches-du-Rhône), Chauvet[35] (Ardèche) or the caves of the Lot.[36]

Similar older analyses carried out at other ornamented caves in the Dordogne – Rouffignac and Villars – confirm the exclusive presence of manganese. The systematic usage of this mineral in the Perigord prompted me to prospect the perimeter of the drainage basin of the lower Vézère, and part of that of the Dordogne. I also examined documentation[37] regarding the exploitation of mines in the region, from the sixteenth to the twentieth century. It turned out that the region was one of the most important centres in France for the exploitation of manganese.

Known as 'savon des verriers' ('glassmakers' soap'), this material was used in the purification of glass. It was used above all in the nineteenth century in the smelting of iron, and also in the manufacture of chlorine and antiseptic products. In its calcined form, it changes colour from black to mauve – a property exploited for the decoration of enamels and ceramics. During the second half of the nineteenth century, numerous mining concessions were allocated, particularly in the northern part of the Department and between the Vézère and the Dordogne. Well before the production was increased, it had been used for several centuries in a more limited range of applications. The 1778 edition of the *Encyclopédie* of Diderot and d'Alembert[38] declares, under the rubric Périgueux: '…name of a black mineral substance, heavy and dense, difficult to pulverize. It is found in Perigord, Gascony and Dauphiné; one also calls it Perigord or Perigord stone…. There is reason to believe that this substance is none other than better-known magnesium or manganese'. In 1578, Blaise de Vigenère[39] used the term *pierigot* to designate this same mineral in his work *Tableaux de platte peinture des deux Philostrate*.

There thus exists a long tradition of the production of this material. These studies largely explain the exclusive use of manganese as a black colouring agent by Palaeolithic people. They had it in large quantities and within easy reach. One of the closest manganese sources is only 2.5 kilometres west of the Lascaux hill, on the right bank of the Vézère. Owing to recent exploitation, only a few square metres remain. At other sites, its formation may be quite different.

In the northern region of the Department manganese is found in a stratified position, closely associated with deposits of clay. It occurs in an extremely hard form and was, until the beginning of the last century, mined extensively. The great thickness of the covering clay forced the excavation of large and deep trenches down on to the mineral layer. This took place over very large areas. It is improbable that this variety was used in prehistoric painting, as it is too difficult to grind and access to it is not easy.

In the south of the Department, the formation is very different. On the other

Opposite:
145 The 'blazons', painted at the base of the panel of the Great Black Cow (Nave), reproduce almost completely the palette of colours used on the walls of the site. The use of mauve on two of the six elements that make up the sign is remarkable as it is rarely encountered.

hand, the majority of the sites here are of karst origin (ill. 146). The manganese partially – and in some cases completely – fills certain cavities. These concentrations often stretch over several hundred cubic metres. The manganese trapped in these formations is found in a less hardened form and is easily extracted and altered.

It is often found associated with calcite, however, which would have made it unsuitable as a pigment in the Palaeolithic, given Palaeolithic man's limited means. More rarely, it has been found in the bed of the Vézère, in the form of small, moderately indurated pebbles. Manganese was clearly not in short supply in the Palaeolithic, but it nevertheless presupposed a certain knowledge, both of the physical environment and of its natural resources.

Preliminary studies to determine the pigments sampled at Lascaux show the absence of any intentional ground mineral extender. Studies at Niaux have shown that this type of preparation,[40] through the addition of constituents other than the pigments, was used 'to obtain good qualities of adhesion to and covering of the painting…and possibly also [to] save, in some cases, the precious pigment'.[41] We agree with the latter interpretation, which might signify a certain deficiency of this colouring agent in the Ariège, as opposed to the Perigord. The profusion of colouring material explains the absence of an extender and its use in pure form in the Lascaux paintings in particular, and in those of the other decorated caves of the Department.

146 The majority of the localities where manganese is found are of karstic origin. Trapped in these formations, the material partially (and in some cases completely) fills the cavities, often representing several hundred cubic metres.

Technology of the Figures

The artists had to draw their figurative works from memory. The gap in time between the observation of an animal and its representation, in addition to the huge difference between the exterior landscape and the interior of the cave, must have played a part in the way the figures at Lascaux were depicted. Only the essential elements of the model are registered and reproduced, sometimes at the expense of graphical reality.

Two forms of graphic expression dominate Palaeolithic parietal art: drawing and engraving. Nevertheless, it is a far less

widespread technique that takes on monumental dimensions at Lascaux: painting. In France, comparable examples of these painted figures are rare and are generally isolated – at Labastide (Hautes-Pyrénées), Portel (Ariège) or Cosquer (Bouches-du-Rhône), for example. At Lascaux, painting is found in all sections of the cave, whatever the nature of the underlying surface. The method used for the creation of panels of colour – the spraying of pulverized pigments – adapts to all the conditions dictated by the natural environment.

ELEMENTARY MARKINGS AND INSTRUMENTS

The elementary marking, as we define it, is the smallest constituent of the figure. It is equivalent to each effect of the action of a tool on the wall, by deposition (pigment) or by removal of material (engraving). It may be in the form of a dot, a line or a surface. The multiplication and the ordered assembly of these units, but also their simultaneous employment, create signs, humans or animals. The graphic analysis involves breaking down the image into all the individual elements, and extending this to the figure as a whole.

The dot is obtained either by the projection of a spray of colouring matter on to a wall or by the deposition of pigment with the help of an instrument or a finger. Whether marked out singly or in interrupted groups, the dots define more or less regular lines or accumulations. In general, they form one of the principal characteristics of the signs.

Spraying has been used with the three techniques mentioned. It gives a diffuse edge to the dots. Experimentation shows that the projection of powdered pigment through a tubular instrument also stains the base of the

147 Sign associated with the black stag in the Axial Gallery. The linear trace is replaced by an alignment of dotted elements. Note the heart-shaped imprint of the impacts, produced by spraying.

148 When repeated, these dots, created by several impacts of pulverized colouring material sprayed on the wall, reproduce very varied shapes, such as this 'curly bracket' sign on the panel of the Chinese Horses, Axial Gallery.

wall or the ledge, which collect the particles rejected by the damp wall or projected with insufficient force. Traces of colour on the ridges at the edge of concavities are due to abrasion by the artist rather than residues of spraying. No residual traces potentially related to this work have been found on the ledges of the Hall of the Bulls or the Axial Gallery. It therefore seems that the material was used in solution rather than in a dry state.

Studies conducted by Michel Lorblanchet, based on experimentation[42] and on experience gained among the Aboriginal Australian painters, suggested that colourants were sprayed with the mouth.[43] We have reproduced these actions[44] and analysed them, in particular by densitometry. The results obtained are similar; the only difference is that the projected particles have not diffused on to the interface, as they have in the cave (owing to the passage of time). If colourant is projected through a tube, the mark produced is denser and tighter than the effect obtained by releasing the pigments straight from the mouth without an instrument. The two dots in the Hall of the Bulls illustrate this technique – the red dot below the second bull, and the black dot within the forelimbs of the third bull. In alignment, these elementary forms sometimes boast remarkable organization, such as the line of units (ill. 147) and the 'curly bracket' (ill. 148) located on the right wall at the entrance to the Axial Gallery.

The second instrument used to create a dot shape is the swab, which produces an imprint with very clear edges (ill. 149). This technique requires more pigment than spraying because it needs a lower fluidity and consequently less dilution.

For the Palaeolithic artists, the line was technically the prolongation of the dot. It was obtained by juxtaposed and joined impacts, using the spraying technique or successive applications with a swab. The use of crayons made from blocks of colourant has

yet to be proven, despite the presence of fragments of ochre or manganese on the archaeological floors which show traces of use associated with sharpening. The scratches on these objects suggest that they may have been used to draw the outlines or to pre-position the figures.

Several animal figures were executed by grouping sprayed dots, including the two Confronted Ibexes of the Axial Gallery (ill. 150). The same technique has been used for the different colours of the outlines, one

149 Group of dots, located above the Great Black Bull in the Hall of the Bulls. The pad, an instrument often used on the walls of Lascaux, leaves an imprint with very clear edges.

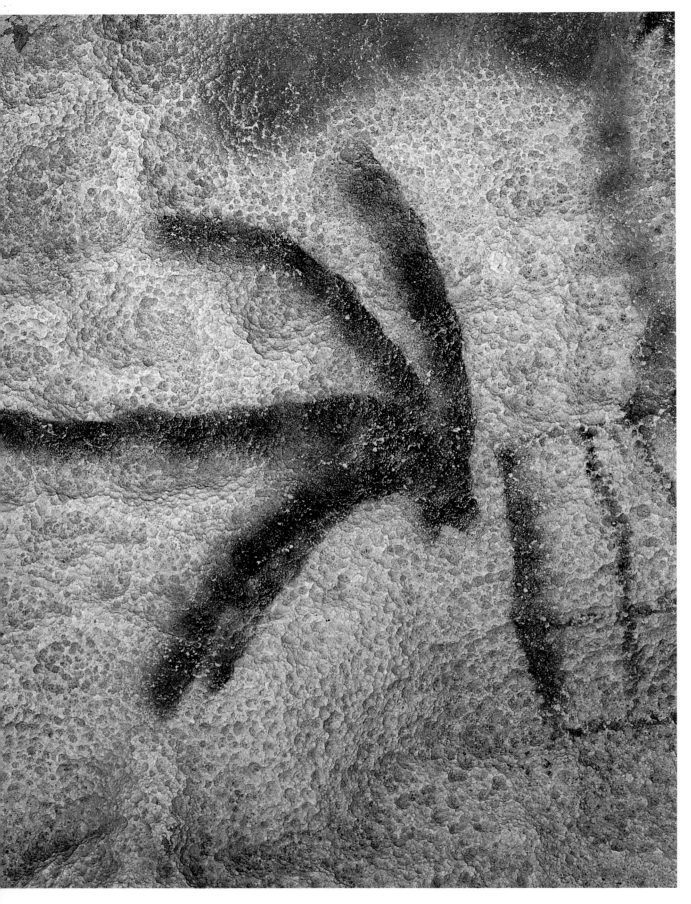

150 Several animal figures were executed by spraying dots in groups, including this black ibex on the panel of the Falling Cow, Axial Gallery.

black, the other yellow. The bulls of the Hall of the Bulls show a similar method, but this time the dots were made with a swab. The bridge of the nose, the horns, the withers and part of the upper line all demonstrate this technique (ill. 151). Two forms of instrument seem to have been used here, distinguishable by the diameter of their distal ends – 15 and 30 millimetres – corresponding to the mean values of the respective imprints.

The continuous line – used for the signs (notably the barbed or quadrangular ones) and the structural lines of the animal figures (to emphasize the outline) – can be created with a brush or by spraying pigment. The former leaves a line with clear edges (ill. 152), while the latter produces a line that is slightly faded on either side.

The line of a brush derives from the friction of the instrument with the wall. The mark left depends on the fluidity of the product, the granularity of the surface and the speed of execution. Some outlines were produced in a thorough fashion, such as the curved lines of the backs of the equids; others result from a much more rapid action, such as the branching sign drawn to the left of the Upside-down Horse. In the latter case, only the irregularities of the wall (outgrowths of calcite) have held the colouring matter, giving this figure a dotted outline. This technique was used discretely in a number of places: in the Hall of the Bulls, notably for the stags grouped below the two great aurochs; in a more regular manner for the red cows and certain horses at the entrance to the Axial Gallery; and for the yellow heads drawn below the Great Black Bull.

Engraving belongs to the category of elementary techniques. It was applied to all the themes in different ways. In the majority of cases, the incision brings about the removal of the outer layer of the rock and generates a variation in colour. The result resembles a drawing – a pale line emerging from a darker background. Certain traits take

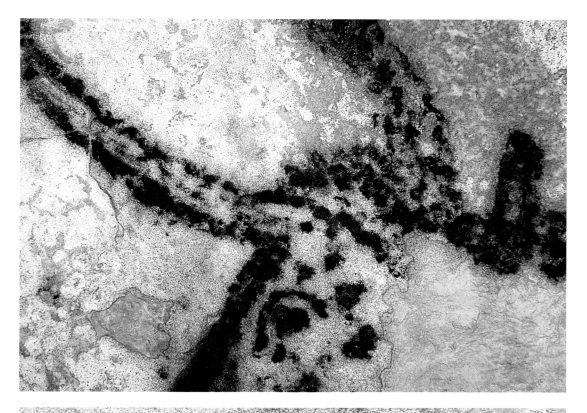

Left, above:
151 The head of the great bull in the Hall of the Bulls. This feature demonstrates how a line or an area can be realized by the juxtaposition of a series of small dots.

Left, below:
152 The line may also be the result of a single stroke of a brush, exemplified by this hooked sign in the Hall of the Bulls.

the place of the structural lines of animals, a role otherwise reserved for colourants.

The painted figures of Lascaux were essentially sprayed, which allowed very large surfaces to be covered with a limited amount of material. Uniform hues were produced through the juxtaposition of sprayed impacts, placed densely enough to produce the illusion of a regular field of colour. Nevertheless, on many subjects it is possible to distinguish the punctuated units of the

153 Great Black Bull, Axial Gallery. The use of a stencil to delimit an area of colour implies a certain degree of mastery of the method. Seen at very high magnification, the edge often shows very great precision.

field, particularly on the red flank of the Red Cow with the Black Collar.

Spraying is the only procedure that enabled the artist to apply colourant to the walls of the small hollows, even in very marked cavities. At the base of the black mane of the Upside-down Horse, for example, there is a cavity 10 centimetres deep with an opening of only 2 centimetres, but the whole of the surface of this hollow is coloured. The pronounced granularity of the 'cauliflower' calcite encrustation necessitates a method of spraying with sufficient covering power that even the smallest holes, particularly the surfaces underlying the

macro-topography, will be saturated with colour. To reduce the gaps in the covering, several angles of projection on to the same target are necessary. On some figures, the regularity of the distribution of materials, applied without visible interruption of their continuity, suggests that certain fields of colour may have resulted from spraying continuously or at least in long sequences.

In the absence of specific limitations, such as inaccessibility or the lack of space, applying colour to an animal outline by spraying pigment essentially followed the same procedure. Analysis of the direction of the projections of material reveals a pattern reproduced on many representations. Inside the area within reach, the movements of the artist remained limited. Most of the time, he maintained a central position relative to the subject, guiding the impacts of colourants from the middle to the periphery of the field. However, not all the subjects lent themselves to this method, and some needed to be adapted to the very localized physical limitations. In certain rare cases, there are clear gradations of colour – over more than 12 centimetres, for example, on the croup of the red cow on the right wall at the entrance to the Axial Gallery (ill. 69). This effect is often found at the edge of fields made without masking, such as the boundary of the twofold division of the coat of the second Chinese horse. In this case it is less important, between 5 and 15 millimetres wide.

The representation of a well-defined boundary, such as the chest or the dewlap of the bovines (ill. 153), necessitated the use of a cut-out stencil. Experimentation shows that the stencil had to be kept a few centimetres away from the wall, otherwise the colours would have stained the zone left blank. The transition between the two areas is then much more distinct. We see the precision of the technique in the outline of the Great Black Bull's head. Even when the transitional line of Lascaux's stencilled images

is magnified, it retains its clarity, showing a perfect mastery of this skill. It is often difficult to identify the device used, although rare, slight irregularities have shown that Palaeolithic man sometimes used his hand as a stencil. (…)

The amount of material applied also depends on the colour used. Generally, one observes a lesser density of material for the red pigments than for the yellow or black ones. Haematite (a red or brown iron ore) is particularly effective at covering surfaces, which may partly account for this disparity.

COMPOUND AND POLYCHROME TRACES

The graphic techniques employed at Lascaux are based on painting, drawing and engraving. The clear technological diversity derives from a combination of the three. They can be used independently or in pairs, and in some very rare instances they are all used together.

With the exception of certain figures in the Apse, it is relatively easy to differentiate between the different techniques. Corrosion, which affects painted surfaces more than their engraved counterparts, sometimes makes it difficult to judge the exact state of the works and distinguish between very degraded painted and engraved figures and those that have been primarily engraved. In certain cases, this becomes possible when incised outlines cut into fields of colour belonging to older figures within the tangle of motifs. Like the elementary forms, the distribution of composite markings depends closely on the mechanical properties of the supports and this applies equally to both the drawn and the engraved parts. This is why the same anatomical feature can be depicted in different ways depending on its location in the cave: hence, for the neck and body of an animal, the structural lines will be fashioned with a brush in the first sector (the Hall of the Bulls and the Axial Gallery) and by engraving in the other parts of the sanctuary.

Technological choices can indeed depend on factors such as the architecture of the surroundings, the topographical connection of the galleries or the chosen procedure. Nevertheless, it would be imprudent to

attribute some value or other to a particular graphic idiom and then establish a hierarchy between them. It seems that, quite apart from their dimensions and the reproduced themes, the symbolic power of a painting is identical to that of a drawing or an engraving.

This interpretation would no doubt be supported better if based on the execution or the degree of accomplishment of the figures, which is cruder in the depths of the cave – some figures in the Chamber of the Felines, for example. A horse and a bison at the far end of the Axial Gallery, at the level of the Red Panel, are also less accomplished than their counterparts in other locations.

154 Together with Font-de-Gaume, Lascaux is one of the few French caves to have been decorated with polychromatic figures. Nonetheless, the use of several colours was without doubt not essential to the creative process, as is shown by this discrete sketch of a horse, Hall of the Bulls.

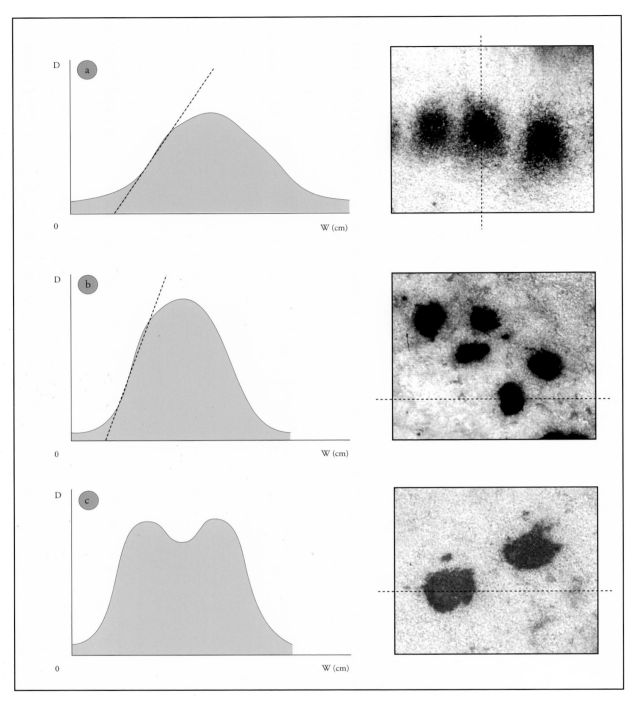

155 Densitometrical curves taken on dots created by spraying (a), using a pad (b) and using a pad under rotation (c).

The same questions can be asked of colour, indeed of the associations of colours, which at Lascaux play an exceptional role, increased as much by the qualities of the support, with its very high reflective powers, as by the richness of the palette of pigments and the combinations employed. What is popularly described as polychrome is here limited to bi- and trichrome (ill. 154). The composition of colour is subject to variations of three components: colour, saturation and luminosity.[45] In other words, the polychrome effect is not limited to a juxtaposition of fields of colour or lines of distinct colours, but is a result of different colours, saturation and luminosity. It is only with this proviso that Lascaux paintings can be described as polychromatic.

Mastery of several graphic techniques allowed Palaeolithic man to create bichrome figures using a single block of pigment. Several animals were reproduced in this way, most notably the four red cows at the entrance to the Axial Gallery, but also the first two elements of the frieze of the Small Horses. Drawing the outline of these figures required a greater amount of material for an equivalent surface than that needed for the sprayed field of colour covering the body. This change of technique brought with it a variation in the chromatic density, which is higher for the peripheral line than the filling.

There are numerous examples of bichrome painting in the Hall of the Bulls and the Axial Gallery, as well as from the Passageway to the Chamber of the Felines. Of the 93 animals depicted in the first two halls, 24 are drawn, 20 are monochrome paintings, 35 are bichrome and 14 trichrome. There seems to be a connection between, on the one hand, the theme represented and, on the other, the technique and colours used. Black drawings are associated with the bulls more than the cows, which are mainly painted in red. Black is also used more in the Hall of the Bulls than in the Axial Gallery, which has warmer colours.

These technical combinations have been studied, above all, in the context of the brown horse of the locality of the Upside-down Horse, which assembles practically all of the techniques linked to painting. Painted in two colours (black and yellow), using two techniques (the brush and spraying), this figure has most of the anatomical details associated with the parietal bestiary, except for the eye, which is often absent on the depictions of horses and cows at Lascaux.[46]

Variations in the density of the colours depend on the dilution of the colourants and their mode of application. Diluting a pigment does not weaken the original colour, but distributes the elements of the pigment in a different way. It is possible to identify the degree of dispersion by using a binocular: the further away the particles of matter are from each other, the higher the reflection of the original colour, and vice versa.

Densitometrical sections of the markings (tail, dorsal line and mane) allow us to estimate the distribution of the particles and the concentration of the products (ill. 155). This is at its greatest in the tail. The gradients of the curve at both sides of the mark are steep, which indicates a very high concentration and the use of a brush coated with a relatively plastic paint. In contrast, the mane was sprayed with a very diluted pigment. The curve shows a significant dispersion of the particles of matter. The dorsal line is intermediate. The dispersion of pigments is limited, but it does exist, caused by a dilution of the paint.

This succession of operations shows a desire to structure forms, and prompts the question of whether the figures were pre-positioned or not. As for the other horses of the cave, so far we have been unable to find any evidence of pre-positioning, with one exception: the second Chinese horse. Some corrections in the first third of the Axial Gallery show the absence of true preliminary sketches, which is backed up by the observation that there is no underlying line when the definitive line is broken.

DISTRIBUTION OF TECHNIQUES

There is a particular distribution of the graphic techniques at Lascaux, closely linked to the nature and mechanical properties of the support. The carbonate covering is found practically everywhere on the walls of the Hall of the Bulls and the Axial Gallery, but it is very patchy in the Passageway and non-existent in the galleries. The very hard and coarse-grained encrustation of the first two sectors is succeeded by a softer surface, which is slightly ochreous and fine grained in the Passageway and the Apse, and friable in the Nave and the Chamber of the Felines.

The analysis of the rock wall permitted the separation of eight types of support, showing appreciable differences of structure and, above all, surface appearance. Almost all of the works are distributed on three formations of this sequence. The properties of these surfaces are very distinct from each other, and this heterogeneity has generated specific graphic techniques. The three formations, of unequal topographic significance, are ordered without interruption from the Hall of the Bulls to the Chamber of the Felines.

The Hall of the Bulls and the Axial Gallery form the first group. The walls of these two spaces are characterized by a white calcite covering with high reflective powers, which is very hard and consists of relatively coarse grains, from 5 to 20 millimetres in diameter. These features dictated the choice of technique: essentially painting (ill. 156) and drawing, methods involving the addition of material. Scrape marks, a few millimetres wide, are the only traces of removal of material. They are scars left behind after calcite efflorescences (shallow growths) were removed from the walls, and their number is limited. Two lines frame the articulation of the right knee of the third bull in order to separate it from the black field of colour

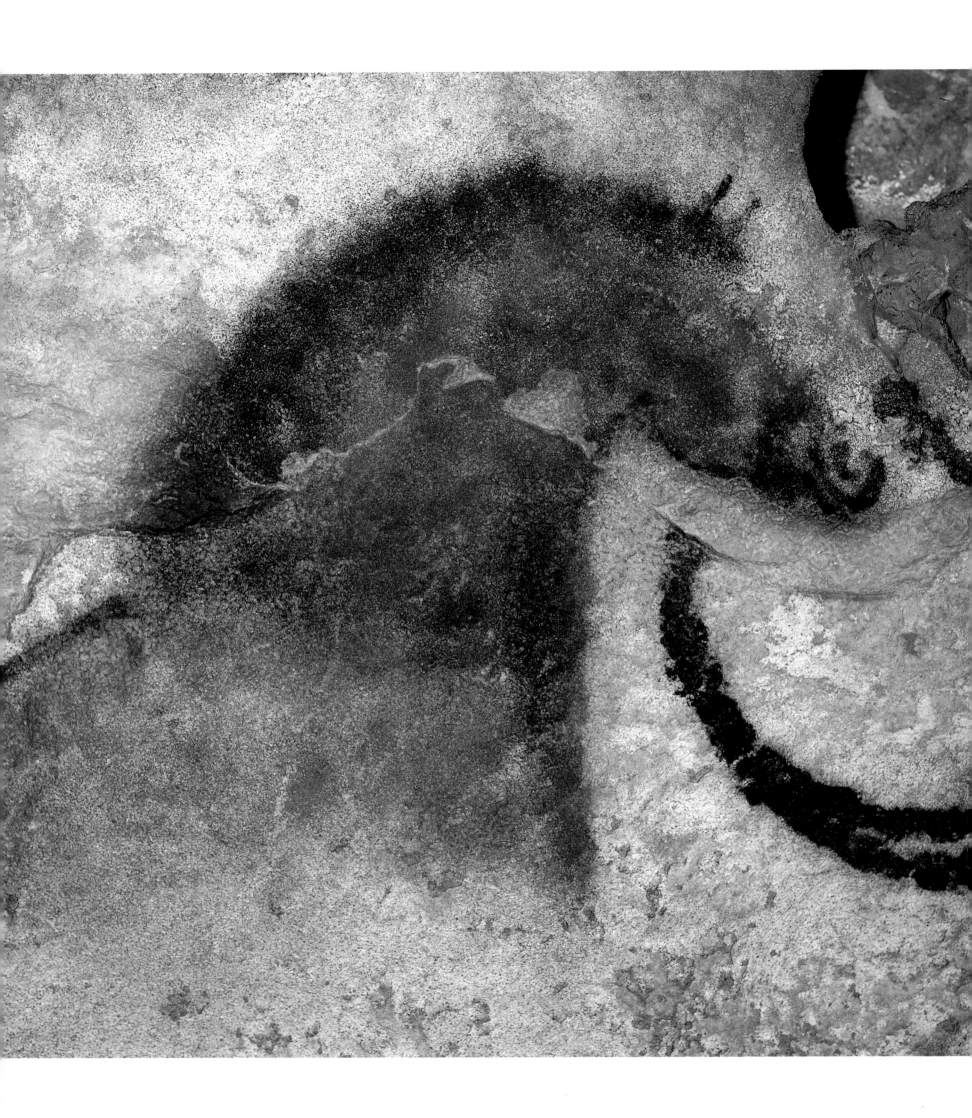

on the flank of the equid located in front. In effect, this gesture shows more similarity with a reserve left uncoloured than with a structural outline. Other indeterminate marks, executed in a similar way, are found on the flank of the Red Cow with the Black Collar on the facing wall.

The Passageway, the Apse, the Nave and the Chamber of the Felines represent the second group. The very delicate walls have been subjected to significant corrosion, leading to the destabilization of elements of the rock face, the carbonate matrix, fossils and grains of silica. These changes made the support less resistant to material alteration and, more specifically, to engraving. This friability also ruled out the application of any pigment by pad or brush: this action would have removed part of the outer mineral layer, thus preventing any deposition of colour. The figures present in this enormous group bear witness to these constraints. The brush was abandoned in favour of spraying and engraving (to structure the outlines), and tools involving rubbing were abolished.

The last formation examined includes the Shaft and the diptych of the Crossed Bison. These two panels are located well away from each other, but they belong to the same stratum. Over a surface limited to the lower level of the Great Fissure, on the one hand, and the Nave, on the other, the ochreous wall is covered with a film of transparent calcite. This has hardened the surface. In this place only, painting and drawing were undertaken, but no trace of engraving has been found. Analysis of painted or drawn markings shows a certain homogeneity in the techniques, with local variations caused by the animal themes, the nature of the support, the conditions of access to the walls and, in certain examples, the integration of the contours of the natural relief.

CONSTRUCTION OF THE FIGURES

For each animal species, one or more anatomical sections enable us to identify the figures: the horns for the ibex, the antlers for the cervids, the head and the horns for the aurochs, and the upper line (from the neck to the croup) for the horses. When we first visit a decorated site, these are the elements that primarily attract our attention. Evidently the same was true of Palaeolithic man, as the study of certain friezes shows, particularly the heads such as the Swimming Stags on the right wall of the Nave. Friezes of heads only relate to those animals with horns or antlers. The horses are excluded from this, and their heads are always isolated. This difference underlines Palaeolithic man's special interest in this part of the body. In the majority of cases the outline of the head is limited to the bridge of the nose, with an indistinct mark simulating the cheek, the muzzle and the lower line. (…)

Analysis of the construction of figures reveals variations that could be linked to the themes evoked, the dimensions of the work and the morphology of the support. The study of the horses, the most prevalent theme at Lascaux, was particularly comprehensive. For example, by studying certain representations, it is possible to recognize three stages in the construction of a horse's head. One figure, in front of the yellow stag on the left wall of the Hall of the Bulls, represents the first stage. It has an arched oblong patch (the mane), created by spraying, followed by two patches (neck markings) of the same colour (ill. 157). Some 80 centimetres to the left, the same motif is repeated on another horse, this time with the addition of the poll and the bridge of the nose (ill. 158). You have to pass the frieze of the black horses and the Unicorn before you find a comparable figure (ill. 159), but here the lines of the forehead and the back are joined by the muzzle, the throat latch and the line of the throat. (…)

The construction of complete representations of horses shows many similarities with the reduced form (the head). The three Chinese horses and their

Opposite:
156 Head and neck of the brown horse, left wall, Hall of the Bulls. The nostrils and the lower lip were outlined using a brush.

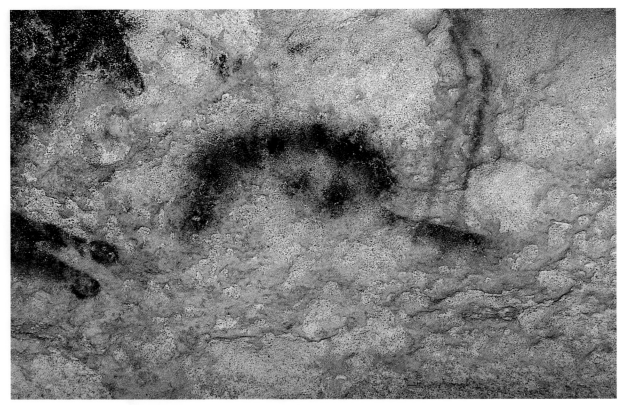

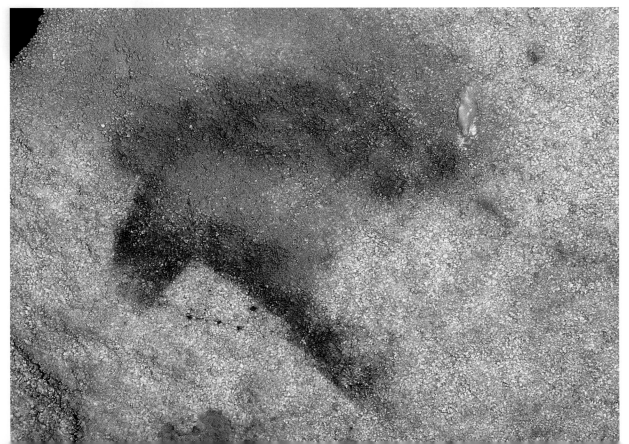

counterparts on the facing wall support these observations, as do those of the locality. The use of pigments of similar colour to construct the outline and fill in the black horses of the Hall of the Bulls made it difficult to achieve a precise diagnosis. The horses of the Axial Gallery, with distinguished anatomical sectors, made a contribution to this element.

The representation of a horse involved three stages. First, the artist would depict the mane and the underlying dots, a group rendered by a series of fields of black colour (ill. 160). Then, the shape of the body and the neck were painted. Finally, the artist structured the fields of colour, the upper and lower lines, the fore- and hindlimbs and the outlines of the head and the tail. This sequence is identical for all of the representations of horses analysed. The clear variations in the appearance of the structural features are linked to the granularity of the wall. With unduly large elements (greater than 5 millimetres) and large figurative segments (above a decimetre) the brush was abandoned in favour of spraying. The dorsal line and the outlines of the four limbs of the yellow horse of the locality, for example, were created with a stencil, but the brush was used for the short lines, such as those of the nostrils and the tail.

In the engraved and painted sector of the Nave, the same succession of actions is found over and over again, except in the peripheral lines, which were traced by engraving rather than the application of a colouring agent (ill. 161). However, whereas no traces of pre-positioning were discovered in the first sector, in the second part (notably the Nave) there are very fine engraved lines on several figures which were made before the flank and the neck were painted.

The panel of the Falling Cow is remarkable for the sheer number of subjects of modest size, particularly in the frieze of the Small Horses. The surface upon which they were painted has fairly coarse grains, measuring between 8 and 15 millimetres

in diameter. These two features – one dimensional, the other related to texture – led to the use of a single technique: spraying. The second horse is the only exception, as the tip of its nose and lower lip were emphasized with a fine brush. Three of the sprayed horses have neither structural lines nor any trace of detail.

Beyond the accessible area, within which most horses are located, other forms of construction were used. As the size of the field increases, so too does the optical role of the morphology of the background. One example is the aurochs of the Hall of the Bulls. It is important to remember that their huge dimensions take some parts of the body well beyond arm's reach. Furthermore, the wall here follows an overhang at a mean angle of 60° to the vertical, with a reversion in its lower part. As the artist projected his mental image on to the wall, a scatter of dots were used to mark out the position of the ends of the extremities and later the feet, the horns and the tail, as well as the hollow of the back and the line of the belly. Certain unobtrusive marks might belong to this first phase, but others seem to have been swallowed up in the fields of colour added in the final phase.

The granularity and the micro-porosity of the support, together with the mineral nature of the pigments, demanded a confident motion for the reproduction of the figures. Effectively, each impact of colour on the wall and each removal of material was indelible, however unobtrusive they might be. Every attempt at removing a line or a dot would have left an imprint. Despite this and the very high number of animal figurations recorded, the number of corrections identified is extremely limited. Imperfections could be identified at the entrance to the Axial Gallery on the four female aurochs.

The difficulties in the execution of these figures are related to their impressive dimensions and the particularly difficult shape of the passage. Each figure extends

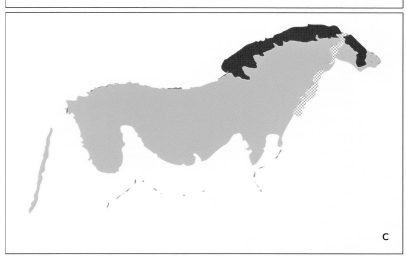

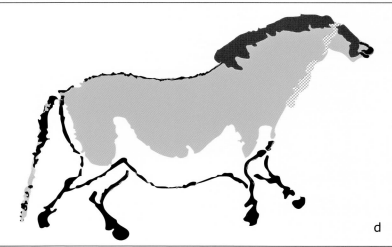

Opposite, top:
157 This elongated black mark and the two dots located below it on the left wall of the Hall of the Bulls represent the mane and the two neck markings of an equid respectively.

Opposite, centre:
158 Scarcely more accomplished than the preceding figure of a horse, this second partial image of an equid, also on the left wall of the Hall of the Bulls, features the bridge of the nose and the beginning of the line of the back, as well as the mane and the two neck markings.

Opposite, bottom:
159 Here, the lower line is added to the upper and frontal segments to give the complete image of the head of a horse, left wall, Hall of the Bulls.

Left:
160 The creation of the horse: (a) line of the mane and the bridge of the nose, (b) sketched outline, (c) the field of yellow colour of the body and neck, adding structure to the form by drawing the body outline, the limbs and tail (d).

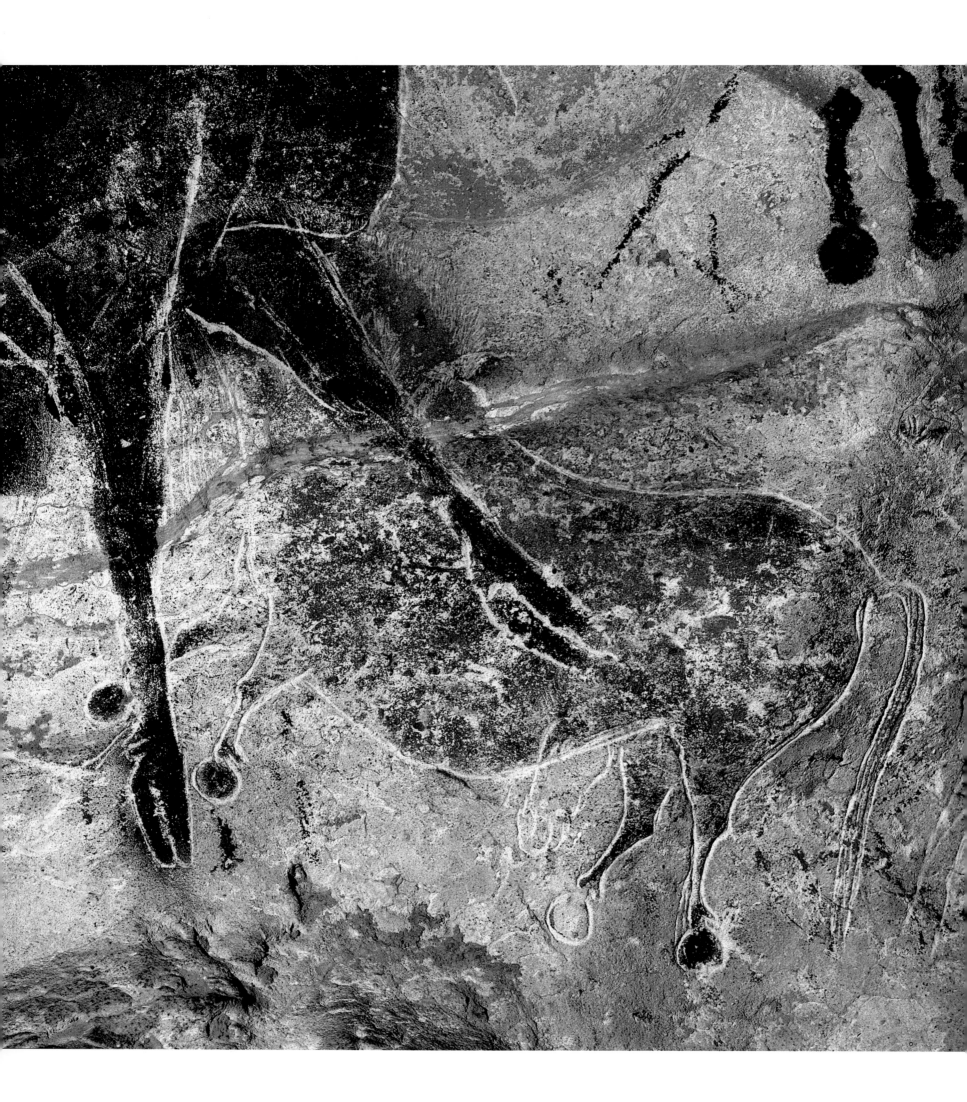

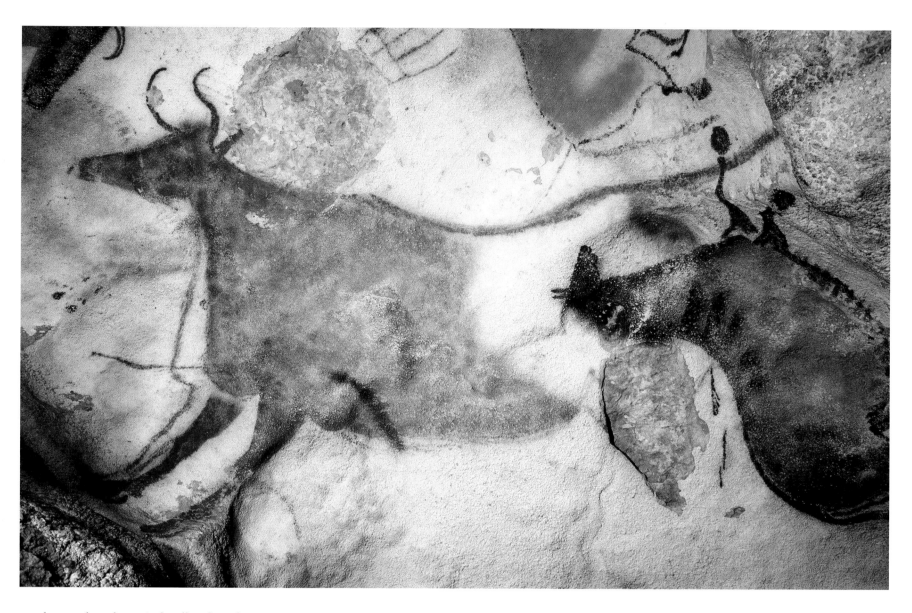

partly over the sub-vertical wall and partly on to the beginning of the overhanging roof. The corrections are always present in the topline, apart from the cow on the underside of the vault, in which they are restricted to the forelimbs (ill. 162).

PERSPECTIVE

It is very difficult to capture the three-dimensional elements around us, animated or static, on a two-dimensional plane, and the transcription of a volume on to a surface implies a certain amount of abstraction, the anticipation of gestures, and a study of the

graphic substitutes capable of recreating the illusion of depth.

Palaeolithic man could not avoid this rule, as the paintings at Lascaux show. The suggestion of depth takes place at various levels. You encounter it in the smallest anatomical details and in the entirety of the subject, as well as the allocation of the different figures that enter into the composition of the panel.

Henri Breuil defined three modes of perspective: twisted, semi-twisted and normal. André Leroi-Gourhan added the absolute profile: when the body of the subject

Opposite:
161 Painted and engraved horse within the forelimbs of the Great Black Cow, Nave.

Above:
162 The techniques and materials used for painting or engraving are unforgiving of mistakes. Nonetheless, corrections are the exception. The revision of the forelimb of this red cow in the Axial Gallery shows the difficulties encountered during the execution of this very large figure in a space with a very uneven structure.

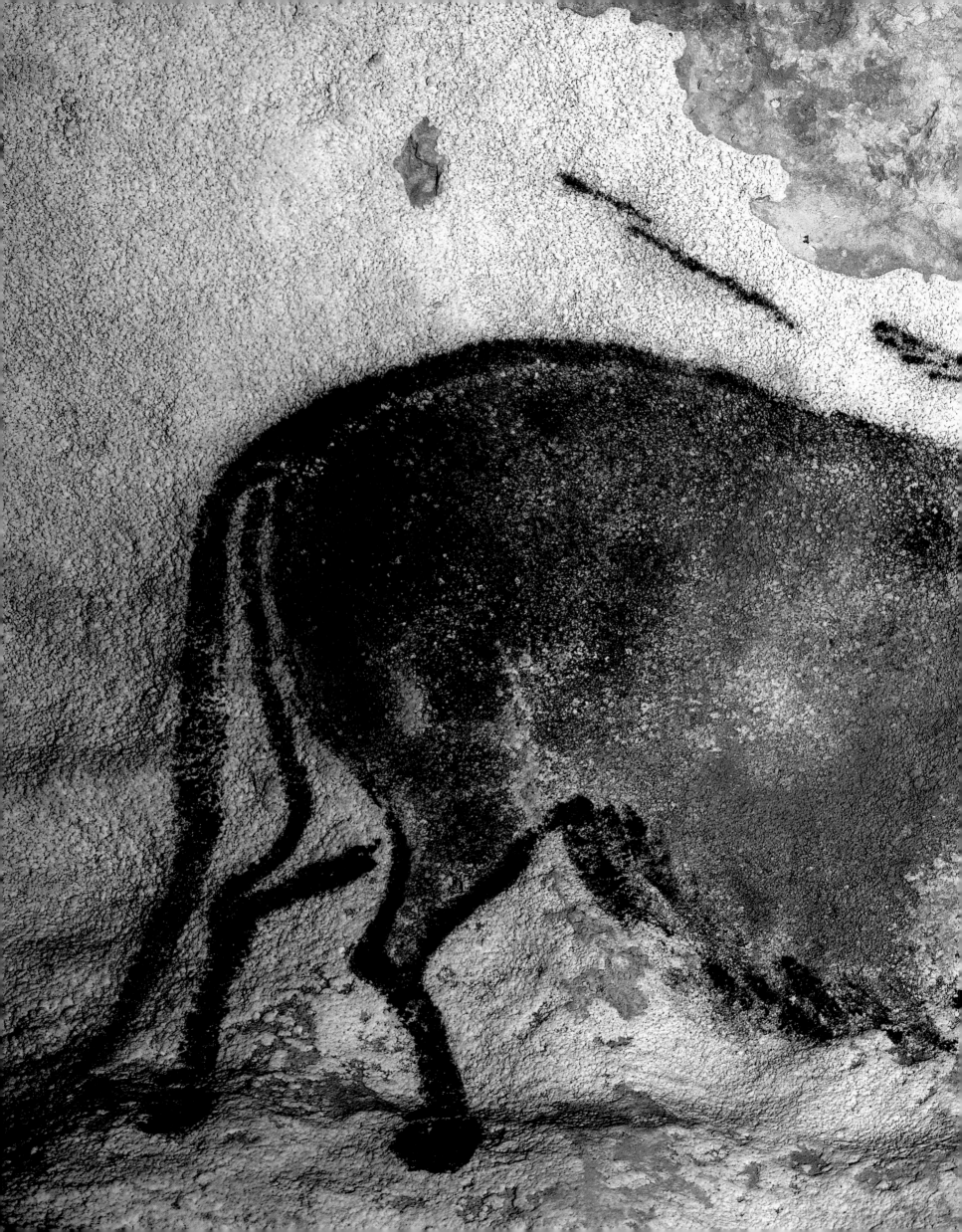

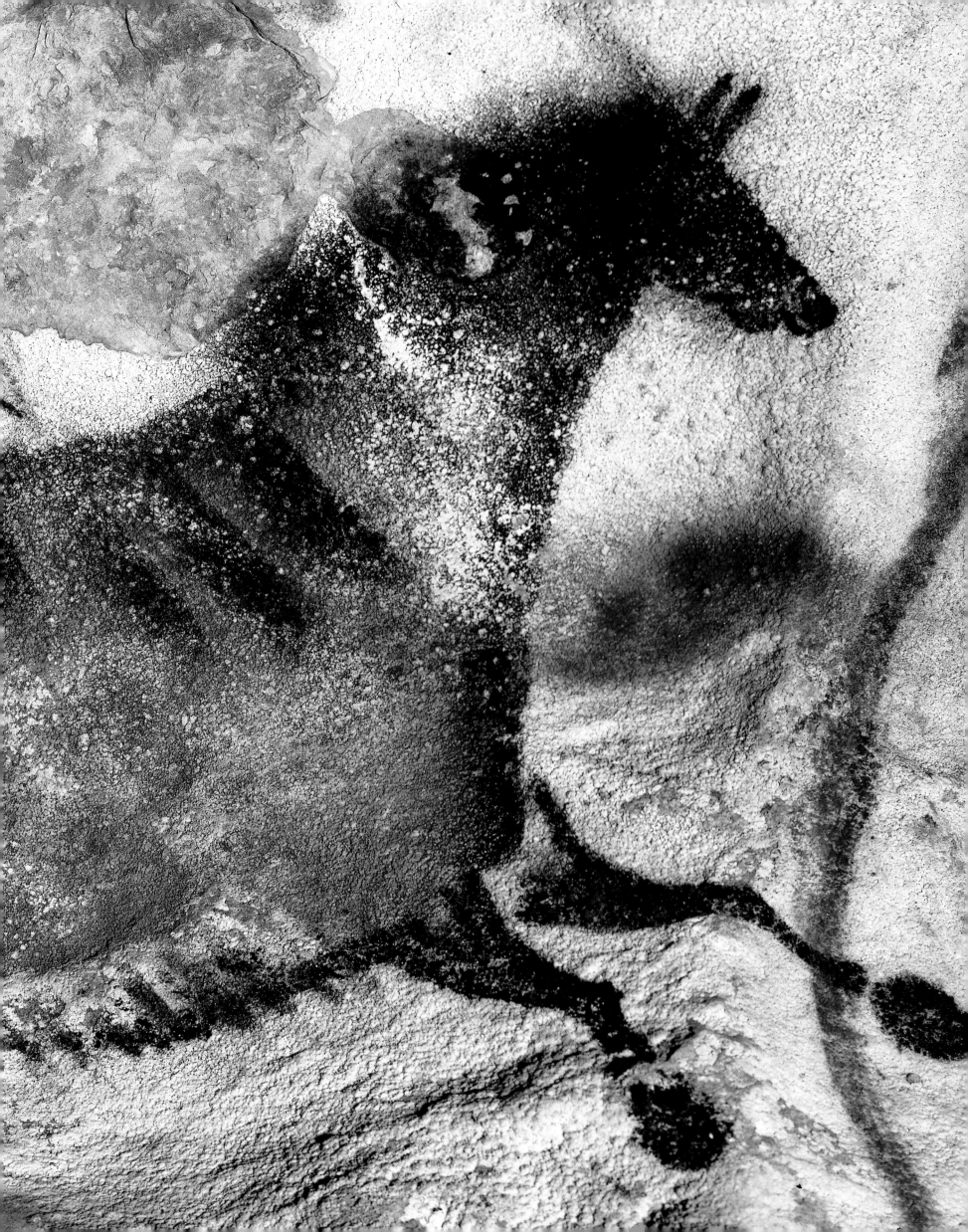

is represented in profile and, of the paired organs (legs, ears, horns or tusks), only the one in the foreground is indicated.

In the twisted, or straight bi-angular perspective as Leroi-Gourhan called it, the subject is seen alternately from the front and in profile, allowing it to be represented in an explicit manner. The body is seen in profile, but the paired elements undergo a rotation through 90°. The archetype of this is the bison of the cave of La Grèze (Dordogne). The semi-twisted or oblique bi-angular perspective is expressed by a rotation of the paired elements through 45° relative to the body. The hooves of the cervids or the bovines are seen in a three-quarter perspective, thereby preserving their cloven character. The same is true for the antlers and the horns. With very rare exceptions, all the animal figures of Lascaux would fall into this category, reinforcing the coherence of the whole.

The treatment of anatomical elements in the background by use of a reserve (or a blank) is another convention that creates the illusion of depth. In this mode, a patch of lighter shading or an uncoloured space is left between two segments, usually in contact or superimposed. In this way, from the observer's perspective, two planes located at different depths will be separated. The method is used above all in the depiction of the background fore- and hindlimbs (ill. 163): their articulation is not joined to the body, which distinguishes them from the limbs in the foreground. More rarely, this technique exists when the limbs in the foreground carry out a particular movement, such as in the representation of the Falling Cow. The general lines of this animal form a trapezoid, due to the twisting movement given to the body. The hindlimbs are flattened against the abdomen, the one on the right following the outer edge, the one on the left drawn along the flank. The course of the left hind leg, in an identical colour to the hide, is surrounded by a blank, allowing it to be distinguished from the black surface of the flank.

Other expressions of perspective have been recognized. They can perhaps be evoked by the single diptych of the Crossed Bison, which bears testament to Palaeolithic man's skill in a number of ways. This final painted panel of the Nave contains only two figures, both male bovines. We have seen that they are two bison moving away from each other symmetrically. However, they are not totally separated because the respective outlines are superimposed at the level of the croups. The artist needed to show the perspective and the movement of the two animals simultaneously. He used a reserve on the fore- and hindlimbs of each bison, and the same technique during the application of the fields of colour, at the height of the croups (ill. 164), marking the boundary between these two surfaces with a white fringe. This space is, on average, 20 millimetres wide and emphasizes the separation between the two masses, following the curve made by the thigh of the bison on the left and detaching it clearly from the black field of the bison on the right. The edges of this reserve are not identical: the left border, corresponding to the external outline of the croup, is clear; the other is a fading black, so that the transition with the second figure is less abrupt.

The hooves of the forequarters of the Crossed Bison (ill. 165) are also better formed than those located at the rear. While the hooves in the foreground display their cloven character, those behind are basic outlines. (…) In the wild, the bison looks massive, with short limbs at the front. There is a clear disproportion in their bulk, and the forequarters look enlarged in comparison with the finer lines of the hindquarters. On the wall, the different representations of the fore- and hindquarters is far more striking. Defining a point at the centre of the picture from which all the elements of the image diverge, the artist increases the impression of flight and movement, thus stressing the characteristic might of these animals.

Preceding pages:
163 The limbs in the background of the third Chinese horse, Axial Gallery, are not graphically joined to the body. The space left blank permits a three-dimensional view of the subject due to the better differentiation between the legs.

Opposite:
164 The dissociation of the two silhouettes of bison in the diptych of the Crossed Bison, Nave, is intensified by leaving a blank space at the level of the croup.

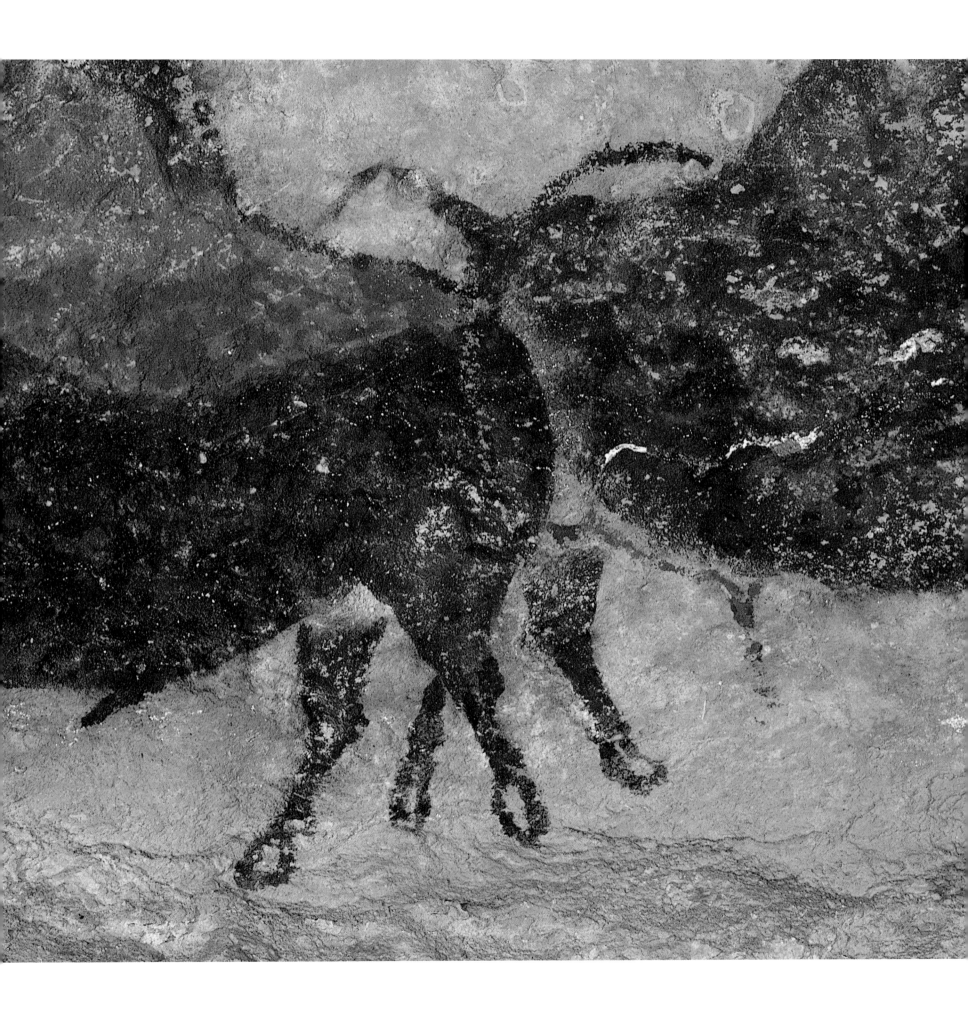

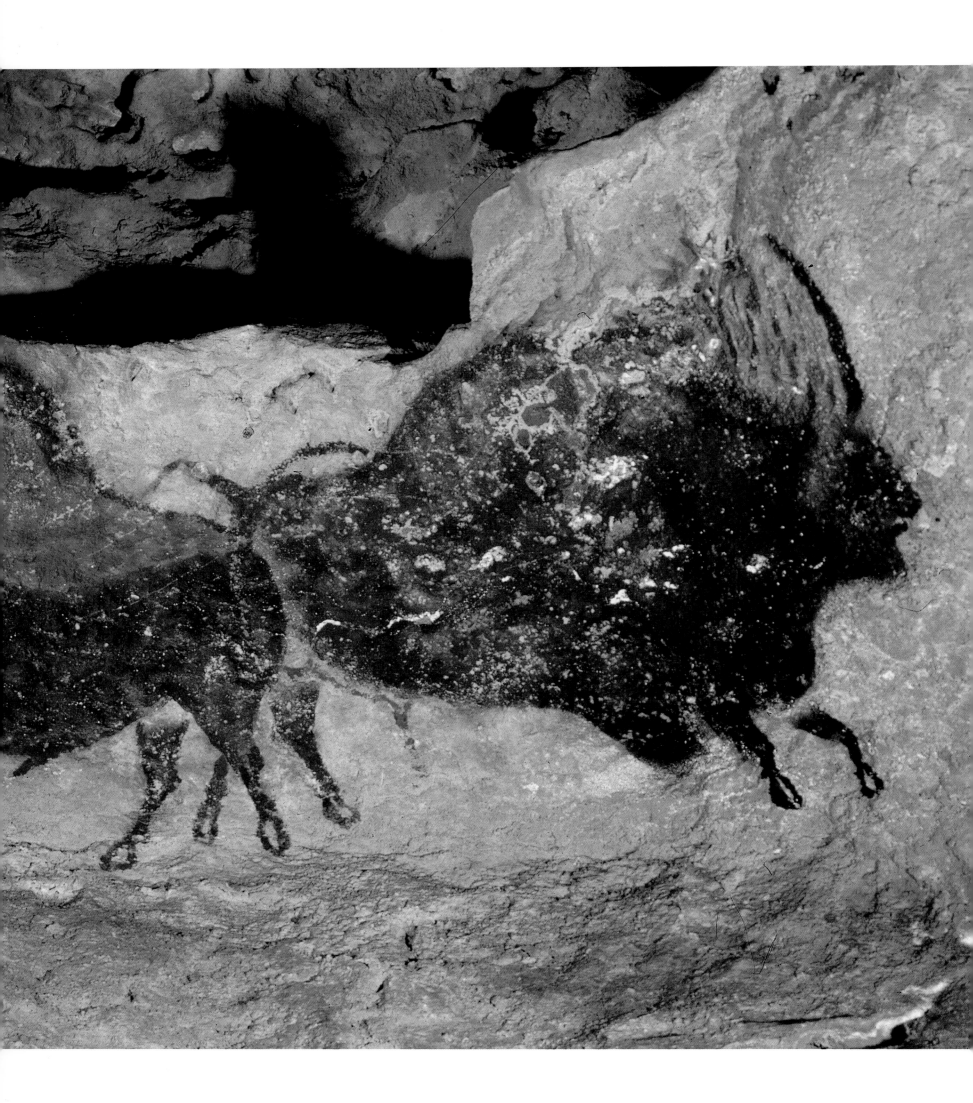

The choice of the wall was not left to chance. In order to increase the effects, the artist needed to select a surface with the geometry of a very open interfacial angle, then to paint a bison on each of the planes. Furthermore, the interface is not vertical but slopes forwards. The resulting overhang creates the illusion that the bison are plunging towards the observer and gives the impression of accelerated movement.

Other less conspicuous procedures demonstrate an uncontested mastery of motion and perspective, such as corrections to the dorsal line of the Red Cow with the Black Collar. They highlight the difficulties of implementation, undoubtedly linked to the 'keyhole' cross section of the gallery and to their topographic situation. A study of traces of metallic oxides at the base of the tunnel showed that the level of the floor has changed little since the time of Palaeolithic man. When the fresco was painted, the ceiling height must therefore have exceeded 3.5 metres. Some form of structure was essential to gain access to the upper level of the wall and to the ceiling: the installation of wooden scaffolding.

The line of the back of the Red Cow with the Black Collar is overlain by a continuous line, from the withers to the pelvis. This line changes direction: it starts to mark out the curve of the croup several decimetres in front of the definitive line. This hesitation indicates that the artist realized that his very elevated position would produce a geometric distortion of the image once it was viewed from the floor. In this part of the gallery, the left wall forms an interface along a horizontal axis. The lower level is located on the vertical part of the wall, the upper one at the beginning of the depressed arch of the ceiling. The configuration of the support prompted the artist to position part of the cow's body on the vertical section and the other on the underside of the ceiling, with the line of the interface passing through the central part of the chest and the thigh. From the scaffolding,

this rotation of the plane would give a horizontally dilated form to the figure (ill. 166), but for a visitor standing on the ground the proportions of the animal would be correct (ill. 167). This is a true example of anamorphosis. Only by means of this artifice could the artist surmount the obstacle of this particular section of the gallery.[47]

Anamorphosis is also found in the fourth bull of the Hall of the Bulls (ill. 168). The distortion is caused by the proximity of the panel to the entrance to the Axial Gallery. At the boundary between the two, the front part of the aurochs, notably its forelimbs, has been traced in the beginning of the gallery. The aurochs's forelimbs are almost 30 per cent longer than those of the other two similar-sized aurochs surrounding it (ill. 169). The distortion was produced deliberately so that, from the centre of the Hall of the Bulls, the outlines of the animal preserve proportions similar to those of the other two bovines. The extension of the gallery creates an optical illusion – a phenomenon compensated by the more advanced position of the forelimbs in the direction of the back of the tunnel, formed by the prolongation of the Hall of the Bulls. Moreover, as a result of this particular topography, the space between the right and left forelimbs and hooves of the same animal was accentuated in order to correct the optical compression of the figures.

The graphic translation of the third dimension is not only applied to individuals but also to the animal figures assembled at the heart of the same composition, when the subjects form part of a single theme. This presupposes that the location of each of the elements of the group had been defined before it was executed. Two groups capture our attention: the frieze of the Small Stags in the Hall of the Bulls and the group of horses painted in front of the Falling Cow in the Axial Gallery. The frieze of the Small Stags is located at the base of the panel, between the second and the third bull of the left wall

Opposite:
165 Depth is restored in the diptych of the Crossed Bison, Nave, by a deliberate weakening of the anatomical details. For the rendition of this perspective, the hooves of the hindlimbs are shown much more summarily than those of the forelimbs. Their cloven character, in particular, is unclear.

Overleaf
Left:
166 The angle of observation immediately next to the subject, the position occupied by the painter, provides an anamorphic image of the Red Cow with the Black Collar, Axial Gallery.

Right:
167 To the observer on the floor, however, this image of the Red Cow with the Black Collar does not look distorted.

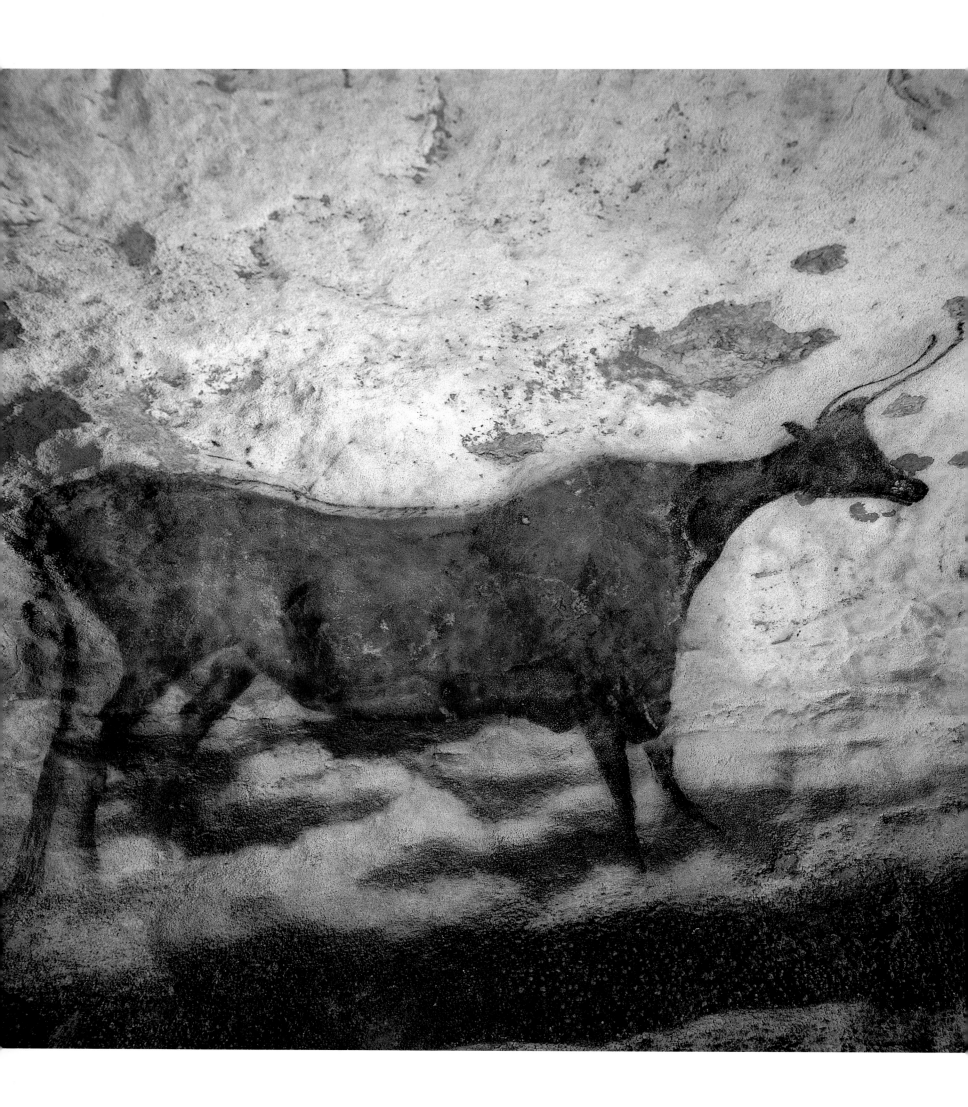

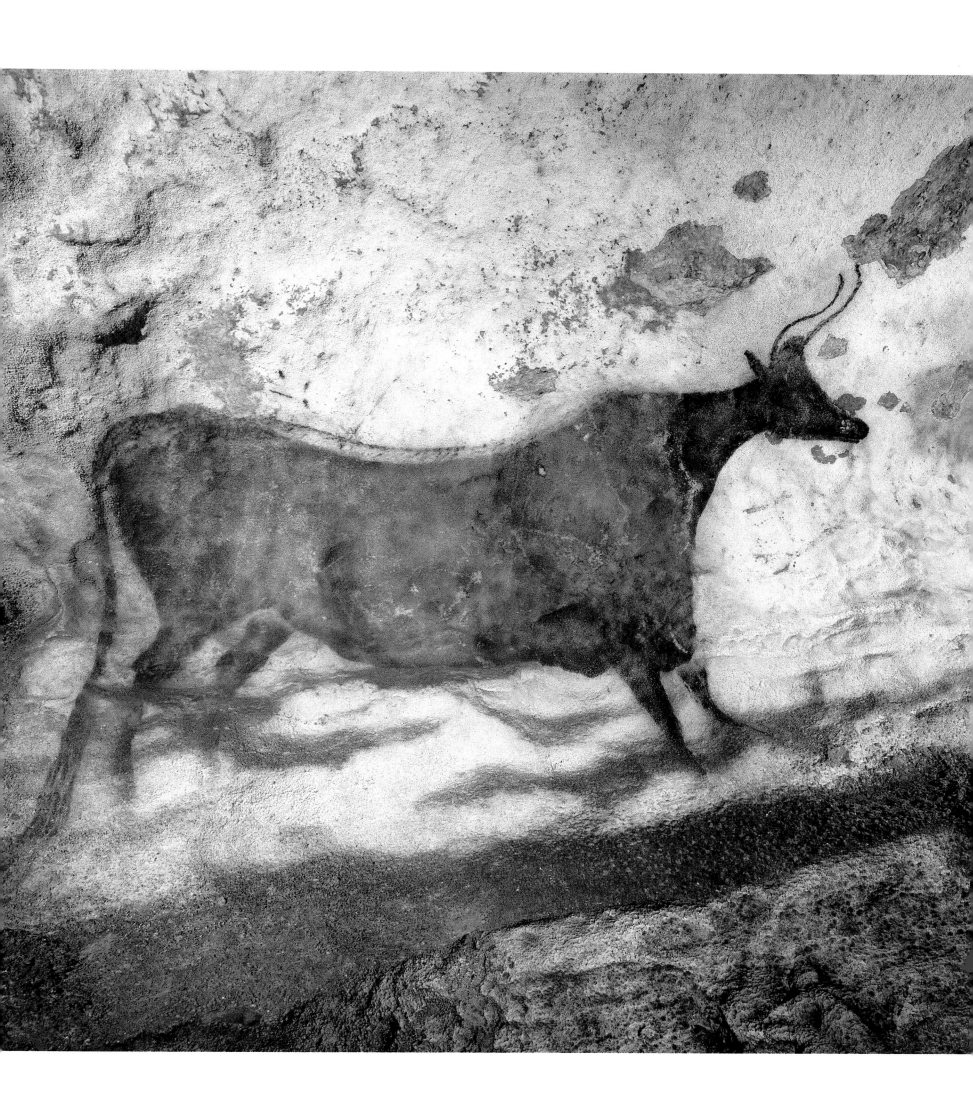

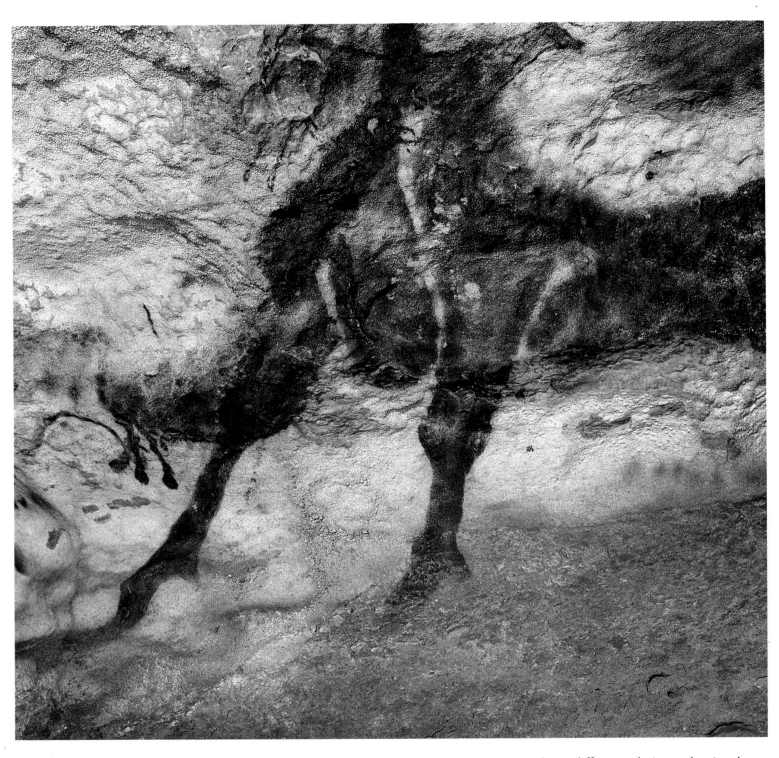

168 Standing at the centre of the Hall of the Bulls, you get a true perspective of the forelimbs of the fourth great aurochs.

(ill. 170). This group comprises five individuals, all facing the entrance of the cave. The composition has a pentagonal form, implying that the figures were not all painted at the same ground level but on three. The yellow stag in the foreground possesses all of the attributes specific to the species. The artist has displayed great precision, both in the realization of the figure in general and in the rendition of the slightest anatomical details, such as the eye, the hooves or the tail. The animal is painted in yellow and black

with two different techniques, showing the high level of accomplishment of the work. Certain parts of the body of the animals in the second plane are simplified. The croup of the stag on the left is not drawn, with a concavity in the wall acting as a substitute for the hindquarters. The right-hand stag no longer has a head, while its croup and hindlimbs disappear in the field of black colour covering the chest and forelimbs of the second bull, which was already in place. The subjects on the third level are limited.

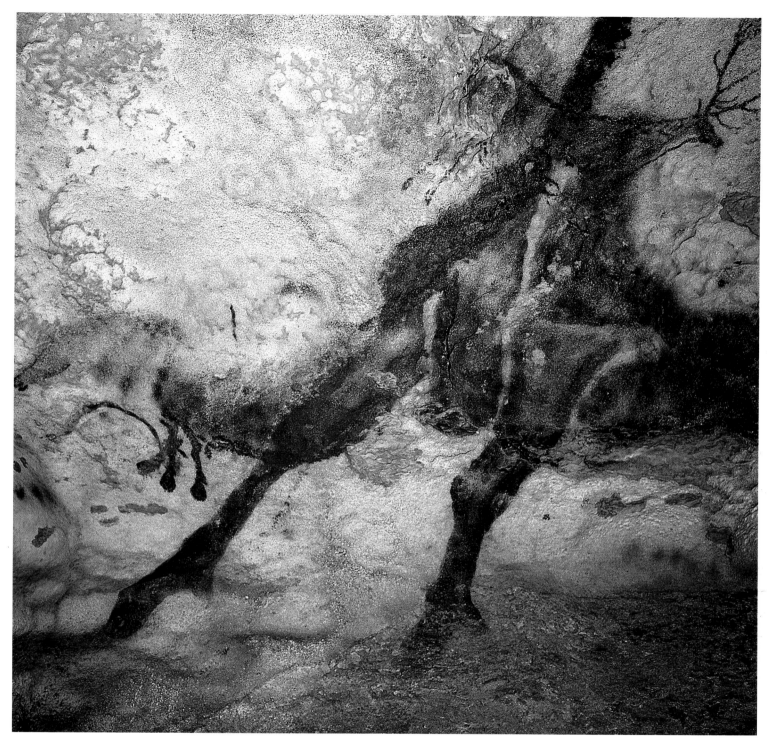

The headless stag on the left has an incomplete body and antlers, suggested by the scars of natural flaking on the wall, while the stag on the right only has its black antlers, linked to another scar (which may simulate the outlines of the body). Although atmospheric factors may have played a part in the staggered deterioration of the stags, these observations indicate that they may have been constructed differently according to their position in order to render perspective, a progressive alteration of the representations from the base (the most complete in terms of anatomical details) to the upper part of the panel (the most incomplete).

The second example concerns the group of horses located below and in front of the Falling Cow (ill. 171). The panel, containing four painted figures, is of smaller dimensions than the preceding group. The same observations apply here too. The horse in the foreground has a lot of anatomical details. Despite an increased roughness of the wall and a miniaturization of the subject,

169 The deliberate deformation of the forelimbs of the fourth bull can only be perceived when the observation angle is perpendicular to the figure, at the entrance to the Axial Gallery. This transformation of the image is a record of genuine anamorphosis.

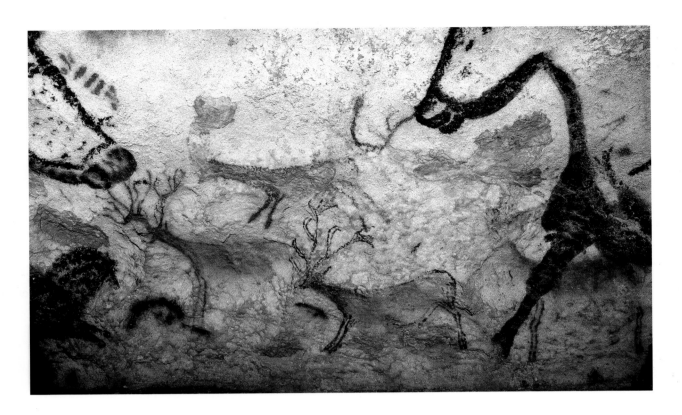

Above:
170 When the subjects of a monothematic composition – such as the frieze of the Small Stags in the Hall of the Bulls, above – are not aligned in the same horizontal plane, their positioning sometimes resembles a view that is both atmospheric and staggered. The subject closest to the floor is very detailed; the others have increasingly simple outlines.

Opposite:
171 A second example of combined perspectives is shown by this group of horses located in front of the Falling Cow, Axial Gallery.

this animal preserves the totality of its outline. The care taken is such that even the muzzle, with the lower lip and the nostrils, is emphasized. Furthermore, the indications of seasonality are rendered by a series of parallel lines at the base of the neck and the flank. With the female aurochs, this is the most accomplished figure of the panel. The second level shows the silhouette of a horse without a structural outline. The four hooves are realized by the same number of dots. Beyond this, at the top of the panel, there are two oblong marks, one yellow, the other orange. Each very approximately reproduces the head, the neck and the back of a horse. Not only does this second example of group perspective show that the animals have fewer anatomical details the further away they are from the observer, but also that the four horses decrease in size, which is a very rare feature.

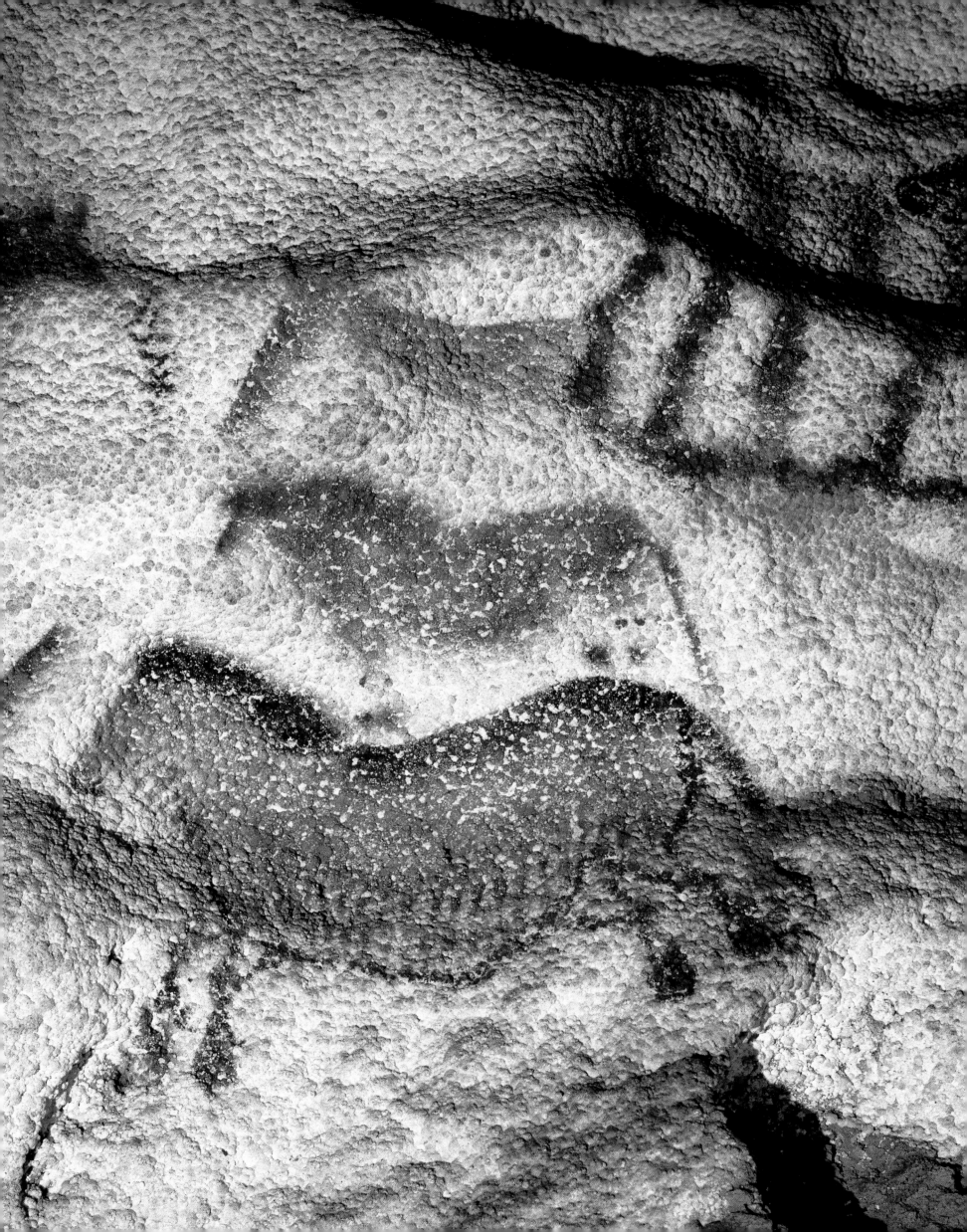

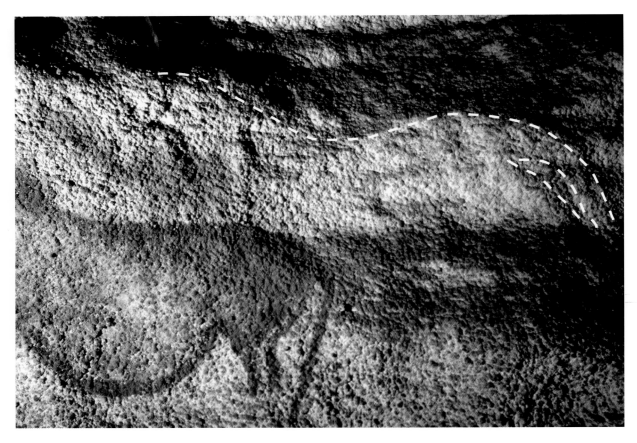

Above:
172 This horse in the panel of the Hemione, Axial Gallery, provides us with an extreme example of the involvement of the background relief in the lines of the animal. The interpretation of the lines of the head, the neck, the back, the croup and the tail makes use of natural elements. Only the lower part of the neck was painted.

Opposite:
173 The involvement of the background relief can affect only a single anatomical part, as in the case of the yellow stag (the frieze of the Small Stags, Hall of the Bulls), in which the eye is replaced by a calcite growth.

From a very early stage, studies of parietal art drew attention to the particular treatment of certain figures, which ostensibly look rough but are in fact completed by the integration of the natural relief or unevenness of the rock, the shapes of which suggest the missing parts of the body.[48] In many caves, there is a lot of potential for natural forms to be transformed into animal or human representations, but the number of figures constructed in this way remains limited. While the direct participation of the wall in an outline is marginal, it may play a major role under certain circumstances. This use of the natural surroundings can occur on various scales, from taking into account a single contour that evokes a simple anatomical form, to including the multiple forms of galleries or halls, which then determine the construction of pictorial compositions.

Lascaux's lack of classic concretions, such as stalactites, flows or curtains, may partially explain the limited number of examples observed. Indeed, concretions only rarely take on large enough dimensions for the realization of animals and are often limited to a simple encrustation a few millimetres thick. Furthermore, the rock often does not have an accentuated relief or pronounced fissures. Only the scars of flakes along the junctions of strata attracted Palaeolithic man's attention.

The wall and its contours could be used in a number of ways: as a simple component in a work, as the substitute for one or another of its elements or even to suggest a guideline to the artist. The natural component brings a supplementary dimension to the interpretation of the relief. The eye of the yellow stag (frieze of the Small Stags, Hall of the Bulls) is one example, created from a calcite growth some fifteen millimetres in diameter (ill. 173).

The use of the contours of the wall as a guideline is the most widespread procedure. Palaeolithic man used this method in the Hall of the Bulls, on the yellow stag. The stag's bez tines and forehead follow the ridge of a concavity, projecting the image of the animal into the foreground. This hollow formation is also used to give form to the hindquarters of the red stag immediately in front. The brown horse above the frieze of the Small Stags has the same characteristics. Only its head, neck and back have been drawn, and the arc formed by the upper line follows the natural curve created by the exfoliation of the support. Nonetheless, the structural line of this animal only partly follows the discontinuity, over a few decimetres. The way in which the bend radius of the edge of the flake increases towards the front of the horse clearly did not suit the artist. It would have required moving the head and neck too close to the upper edge of the panel, or indeed crossing its limits.

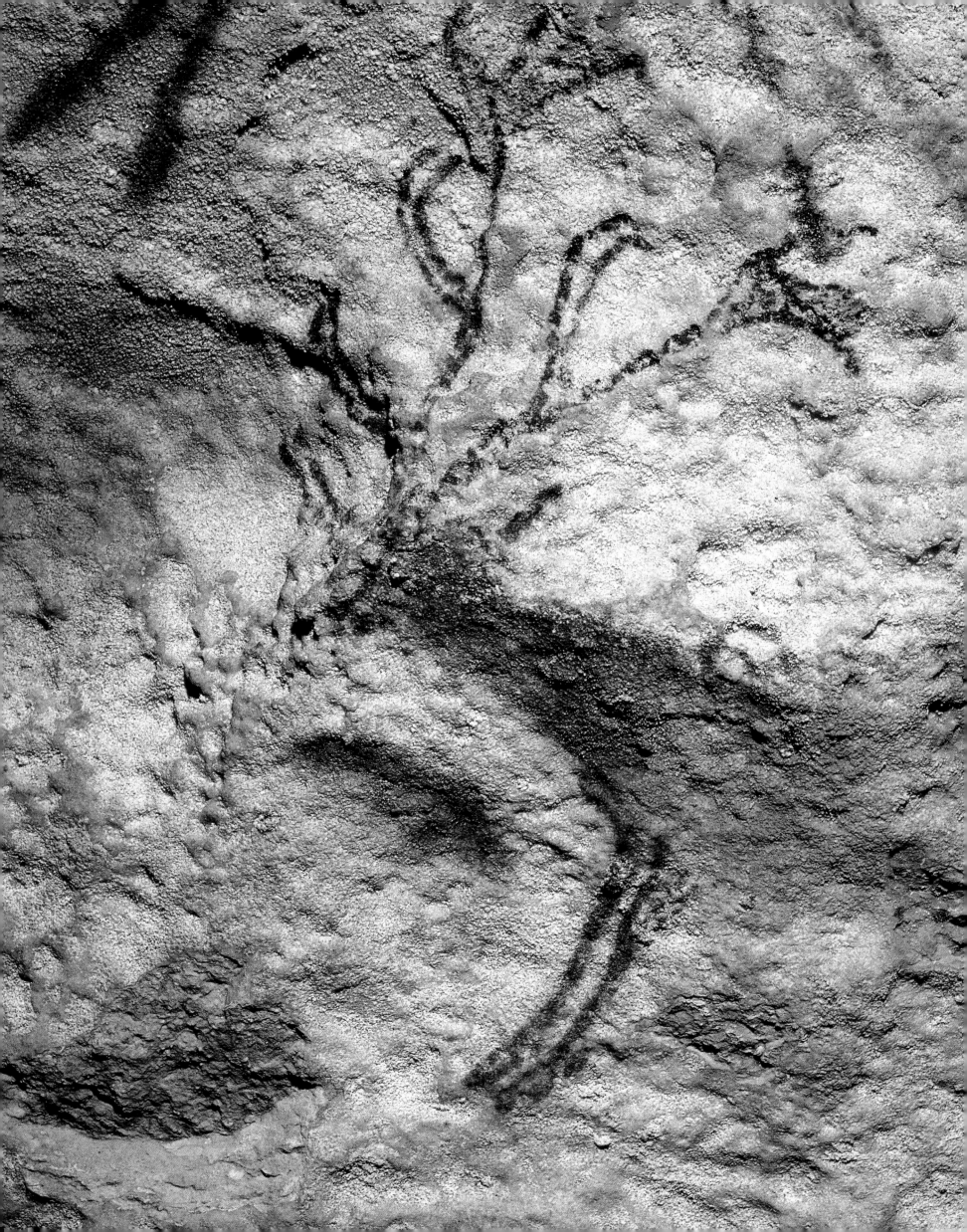

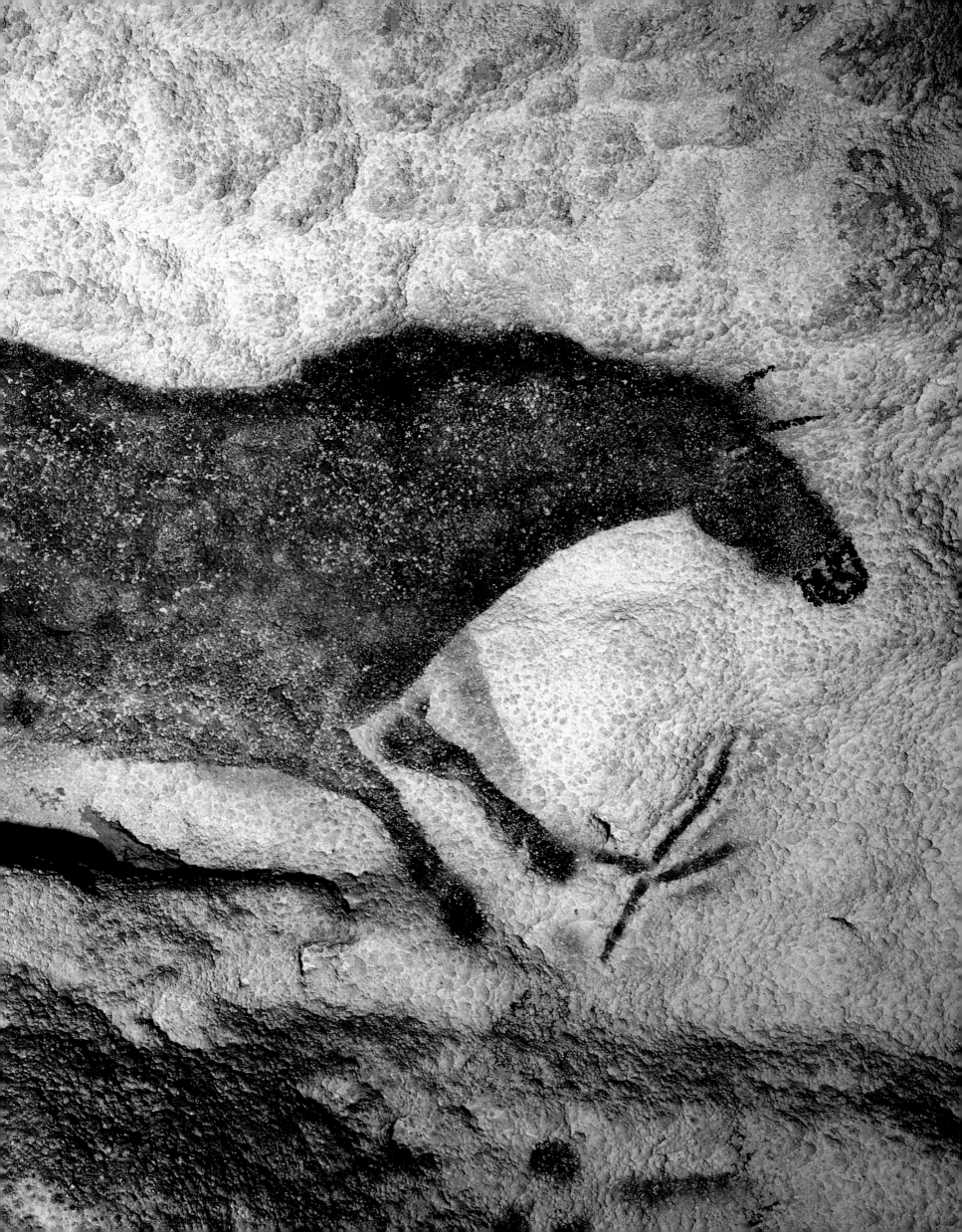

Sometimes a relief is substituted for a marking in order to represent an important surface of the subject. In this case the outlines obtained for the animal tend to merge with those of the peripheral contours (ill. 172). The horse above the Hemione contains only a single painted element, a very elongated yellow patch, inclined at 40°, which maintains a constant width over the first 30 centimetres, then flares into a sub-triangular shape. The interpretation of the figure is simplified by the proximity of a field of colour, in form analogous to that which traces the lower line of the neck of the Hemione. The painting technique is identical, in the treatment and the placement of the stencil and in the orientation and inclination of the drawing. The upper line of the panel, which is highlighted by lateral lighting, allows us to understand the work because it sketches the neck, the line of the back and the croup without interruption. Furthermore, the specific morphology of the wall suggests the presence of the tail and the beginning of a hindlimb. Two cervids in the frieze of the Small Stags were constructed using the same principle. They have anatomical parts borrowed from the negatives of flakes, the head and the antlers for the stag on the left, the entire body, neck and head for the one on the right. This suppresses the subject, projecting it into the second plane.

On the smaller surfaces, from a few centimetres to a metre, the association of markings and the forms of the wall sometimes evokes the line of the ground. This occurs repeatedly at Lascaux (Hall of the Bulls, the panel of the Great Black Cow in the Nave, the Great Black Bull in the Axial Gallery). The line of the ground is here formed by a stratigraphic discontinuity, followed underneath by a reversion of the wall to the front. This so-called exogenous formation, in the sense that it does not participate directly in the outline of the animal figure, plays a role only in the positioning of the figures.

Careful observation allowed us to recognize other, admittedly less obvious, applications of this principle, the primary function of which is to accompany the animation given to certain figures. These examples are located in the same place, around the Upside-down Horse. At the left of this panel and at the beginning of the locality the Galloping Horse is seen behind the Great Black Bull (ill. 174). Its limbs, at their maximum extension, do not all rest on a horizontal line; only the hindlimbs rest on a discontinuity of the surface, that is on a deep incision bordered at its base by a ridge of the wall. This fissure, which begins 50 centimetres behind the animal, is interrupted below the chest, while the two forelimbs extend beyond it. The slight inclination of the horse towards the front, around 15°, suggests the beginning of a falling motion, an impression confirmed by the very localized absence of the line of the ground beneath the front part of the animal.

The Falling Cow is on the facing wall, dominating a long procession of small horses. It has many similarities with the previous subject: the use of the same colours, the very precise reproduction of the outlines, the care taken over numerous details and the similar animation, all of which allow the two works to be attributed to the same artist. The twisting motion given to the hindquarters of the bovine and the position of the hindlimbs, gathered up under the belly, show that the cow is falling. The raised head, with the forehead painted horizontally as an extension of the line of the back, reinforces the suggestion of instability. This cow is partly twisted into the hollow of a large horizontal depression, the lower edge of which follows the contours of the croup, the belly and the chest. The outstretched forelimbs extend beyond this hollow to simulate the absence of the ground. These examples show the use of natural forms for an identical goal, but a hollow was used for the horse and a projection for the aurochs.

Opposite:
174 The line of the ground, shown by a deep natural ledge on the wall, falls back behind the forelimbs of this horse in the panel of the Great Black Bull, Axial Gallery, suggesting that the animal is falling.

The third example is the Upside-down Horse (ill. 175), whose fall is indicated by the vertical orientation of the body. The line of the back and the croup follow a projection of the wall over a double gradient forwards and to the right. The animal was painted in the convex part of a meander, which is a distinctive feature given the generally straight alignment of the gallery. The base of this false buttress lies 40 centimetres above the floor of the gallery. The relief has been used in two ways: to accompany the line of the back and to suggest emptiness through the marked discontinuity at the base of the panel.

The narrowing of the gallery at the threshold makes the morphology of the entrance to the locality of the Upside-down Horse look like a gaping chasm. This constriction is marked on both sides by broad red stains. The topography of the location places the Upside-down Horse close to the two above-mentioned figures to each side of the gallery on the final panels before the locality. These three works, located within a limited area, are commonly treated separately, because they are on different panels. However, several arguments suggest that they are related: they show the same animation, and the morphologically different but functionally identical natural elements were taken into account. Such commonalities enable us to envisage real connections between these three animals.

In the course of this relative study of the use of the wall, it is important to remember the role played by natural elements in the representation of the third dimension. Thus, a natural concavity may, under certain angles of illumination, paradoxically evoke a convexity suitable for the outline of the flank of an equid or a bovine. The outlines of the Red Cow with the Black Collar, for example, are associated with elements of the relief: the belly lies in a very large concavity, which is brought out by oblique lighting. The outlines of the croup and the hindlimbs of the red stag between the first bull and the black and yellow cervid in the Hall of the Bulls are simulated by an oblong concavity that prolongs the silhouette.

The wall support is also an important influence on the structuration of the panels, not only on the individual animals but, in most cases, the graphic compositions as a whole. From this point of view, it forms one of the major constituents of the art of Lascaux and plays a fundamental role in the spatial organization of the works. To some extent, the structure and the type of available surfaces have dictated the structure of the panels without influencing their themes or their composition. Certain morphological or chromatic variations of the walls, or indeed the two combined, play a decisive role.

The heterogeneity of the different stratigraphic units of the wall generates specific patterns in the sections of the galleries. These are caused by differences in the hardness of the rock and the ways in which the cave was cut. As a result, there are ridges, faults, platforms and recesses all over the walls. The horizontality of the strata creates regular and unbroken forms within the same space. They can also lead to architectural similarities between one hall and the next, such as those observed in the Hall of the Bulls, the Apse and the Nave. The most appropriate surfaces and levels are exploited. Equally, the lines marking the transition between these geological formations will be perceived as lines of structure. Their forms are generally ridges, due to the juxtaposition of concavities or the superimposition of layers. Examples of lines created on the basis of localized concretions are rare. This participation of the support can be reinforced by changes in its colour. The decorated band of the Hall of the Bulls extends between a ridge running along the top and a projecting formation below. This change of level is accentuated by a difference in colour which develops from a slightly stained white to a very pronounced brown.

Opposite:
175 The false pillar, around which is wound the figure of the Upside-down Horse, Axial Gallery, is not attached to the floor. The void suggested by this feature contributes to the falling motion of this figure.

Access to the Walls

Opening the site to the public necessitated modifications to the underground space. The floors were heavily altered. Mounds of clay covering the bottom of the ledges in the Hall of the Bulls were removed, at the same time increasing the distance to the parietal works. It was the same in the Passageway, which was originally very low. Today, a trench more than 1 metre deep and 2 metres wide impinges on the centre of this gallery. Beyond this, the front part of the Apse and, to a lesser extent, the back of this hall were emptied, in order to facilitate access to the Shaft. The Nave suffered an identical fate in order to give the passage a less pronounced slope. These modifications made it more difficult to access some of the walls, particularly where Palaeolithic man had resorted to the use of scaffolding in the first place.

These problems of access were not encountered in the Passageway, the Shaft or the Chamber of the Felines, where the decorated surfaces are all located less than 1.5 metres from the floor. In the Apse, however, some of the engraved and painted figures are quite some distance from the observer. After the discovery, as we have mentioned, the floor was lowered between 1 and 1.5 metres over the entire area of the hall. Before the alterations, almost all the works were therefore within arm's reach. Only the large stag located below the intersection and the figures of the vault required extra equipment in order to gain access. In the Nave, the artists profited from the proximity of the wall in the case of three panels, the Ibexes, the Imprint and the Crossed Bison. Between the latter two compositions would be inserted that of the Great Black Cow, with its long procession of horses extending over 7 metres. Between the two ends, the floor level drops significantly. A horizontal shelf underlines this panel, a platform of irregular width, ranging from 50 centimetres at the near and far ends to 1 metre in the centre. The three-dimensional nature and the scale of this long fresco showed us that the artist stood on this narrow edge without the use of scaffolding in order to execute all the figures. On the facing wall, only the frieze of the Swimming Stags was drawn. This group of aligned figures noticeably follows the slope of the floor. Here and there, short, more or less sloping ledges give purchase, a particular feature of this wall that enabled the artist to dispense with any form of structure. In the same space there are long incised lines at the base of the domes of the ceiling, at an inaccessible level. We have not been able to discern any shape in this lattice of lines. The inaccessibility of these surfaces and the random nature of the marks make us think they were drawn with the help of sticks held at arm's length, as the rock is soft enough here to be marked without too much pressure.

These problems of access have been discussed since the first studies of Lascaux, and the placement of the painted figures on the underside of the ceilings of the Hall of the Bulls and the Axial Gallery has been the subject of numerous investigations. André Glory[49] provided the first answers, claiming to have 'identified, on the sides of the Axial Gallery, the stalagmite encrusted placement of interlocked beams which were used in the painting of the Great Black Bull'. However, the calcification of the clay deposits occurred much earlier than the passage of man. This is demonstrated by the markings painted on top of these formations, in particular the hooves of the Great Black Bull or those of the aurochs of the Hall of the Bulls. If the carbonates had been deposited later than the markings, the paintings would have shown this. The identification of imprints of the ends of beams in certain cavities or on ledges was a result of a poorly argued hypothesis.

On the other hand, the excavations carried out by Glory did bring to light many fragments of charcoal, distributed in all the archaeological layers (end of the Axial Gallery, the Shaft and the Passageway).

Opposite:
176 The outlines of the fifth bull of the Hall of the Bulls have been executed using two techniques: the front parts were sprayed with pulverized pigment, while a brush was used for the less accessible segments. The entrance to the Passageway opens beneath the hindlimbs.

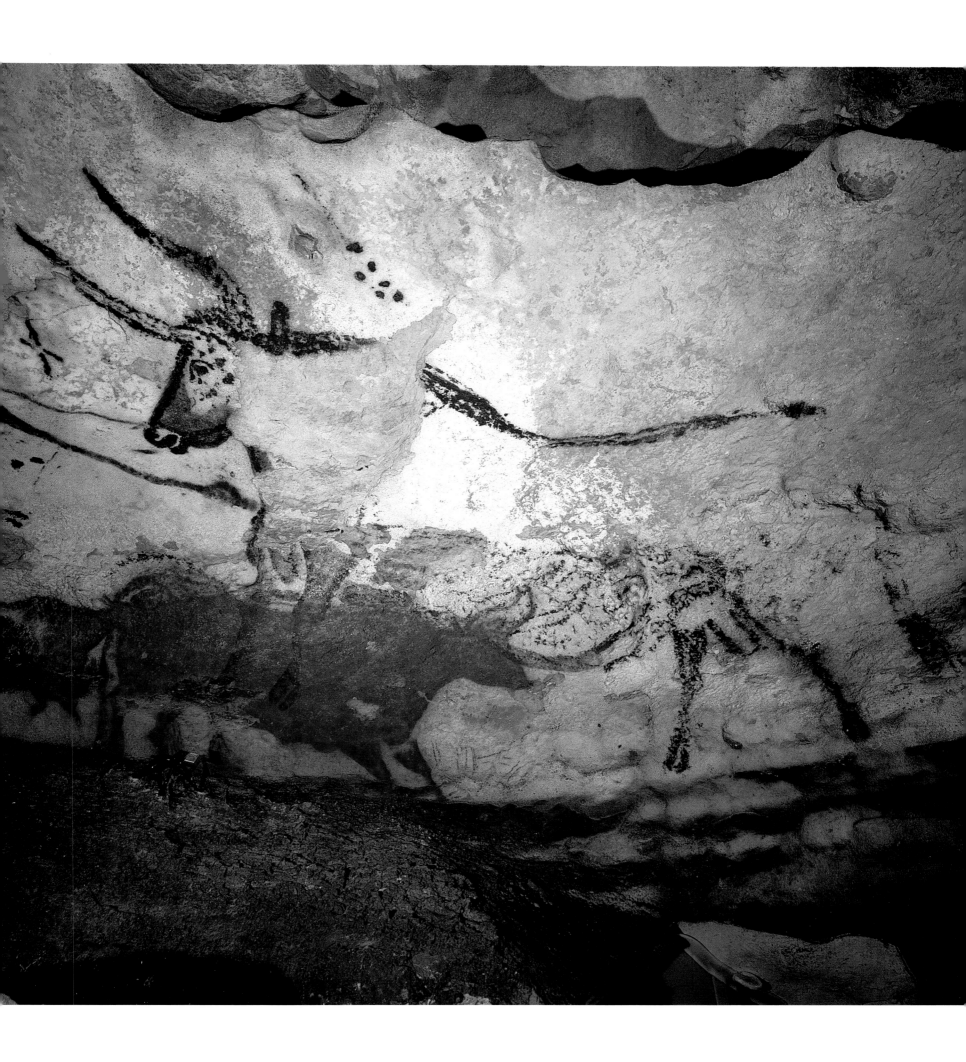

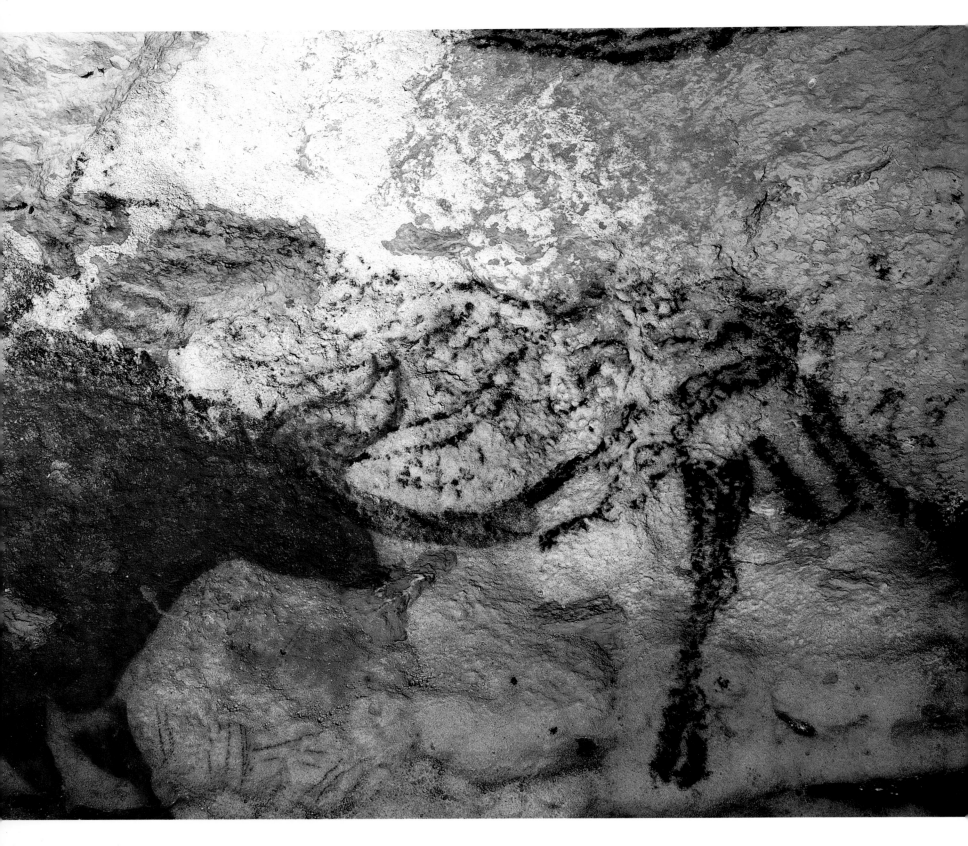

177 At the height of the line of the belly of the fifth bull in the Hall of the Bulls, the transition marking the change of technique is immediate.

The identification of the wood revealed the presence of deciduous oak and juniper and, in smaller proportions, pine, birch, alder and hazel. Most of the fragments had narrow tree rings, particularly those of juniper, some pieces of which were recovered from the lamps where they functioned as a wick. On the other hand, the oak and the pine had growth rings with a greater radius of curvature, showing that wooden elements with larger diameters were brought into the cave, possibly to construct equipment with which to access the walls, but also to feed the hearths used for lighting.

Claude Barrière and Ali Sahly conducted many studies on this subject.[50] In the Axial Gallery they noted the presence of a series of small cavities and ledges, spaced more or less regularly and located on both sides of the gallery, at the height of the lower level, which might have served as scaffolding holes. Furthermore, they recorded imprints of timber on the argillaceous ledge underlying the frieze of the Small Horses of the panel of the Falling Cow, possibly showing the use of such wooden structures.

In fact, the hypothesis that scaffolding was used in this gallery cannot be dismissed. In the first third of the Axial Gallery, the absence of ledges on which Palaeolithic people could have climbed in order to reach an adequate height implies the positioning of such constructions, since here the painted works are located between 3 and 4 metres above the ancient floor. In the publication directed by Arlette Leroi-Gourhan and Jacques Allain, a chapter is dedicated to this theme.[51] The authors discuss the same observations, extending the principle to the entire Axial Gallery, despite the absence of relevant evidence. Although it appears quite possible that scaffolding was used, this does not mean that the principle can be extrapolated generally: the technical analysis of certain paintings confirms this.

In the Hall of the Bulls, the problem applies to a section of the works. The cross section of this hall presents an overhang at a mean angle of 60° relative to the vertical. The figures close to its upper border are therefore displaced towards the central part of the hall, in such a way that they were executed on the ceiling rather than on a wall. For most of them, the artist could dispense with scaffolding with a simple change of technique, by extending his reach: for example, by using a brush with a longer handle. As for the sprayed figures, it was absolutely necessary to be as close to the wall as possible, in particular for the bichrome horse and the brown horse on the left wall. The respective dimensions of these two figures are sufficiently modest that the artist did not have to change his position much during the course of his work. The use of a small wooden structure placed below the figures gave him easier access to the wall. Furthermore, the use of surfaces towards the middle of the gallery ruled out any abutting against the wall. These observations suggest that small wooden structures, which can perhaps be compared to stools, were used only very intermittently, when the painting instruments had reached their limits.

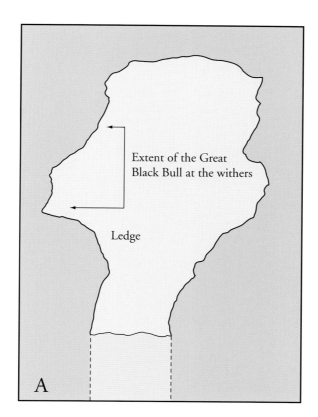

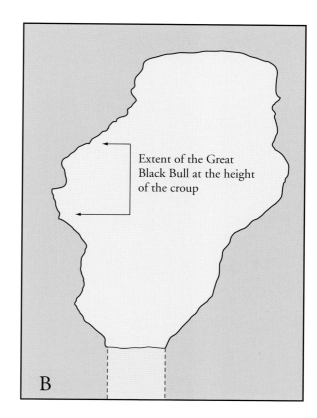

178 Transverse sections of the gallery at the level of the Great Black Bull, Axial Gallery. Note the absence of a ledge in the section of wall traversing the rear part of the aurochs.

Another illustration of the interdependence between the artist and the wall is given by the fifth bull of the Hall of the Bulls. This is a drawing in which only the outlines of the muzzle, the chest, the forelimbs and part of the line of the belly have been traced by spraying, whereas the hindquarters and the upper line were drawn with a brush (ill. 176). Those of the withers, the head and the horns were executed by a juxtaposition of connected dots, from 2 to 3 centimetres in diameter, which gives a greater precision to the alignment of the lines and thus permits a more accomplished outline. The particularly clear technical break is seen at the height of the line of the belly (ill. 177). The sprayed part is interrupted two thirds of the way along the curve, where it is replaced by a section drawn with a brush. The origin of these changes can be traced in constraints in the morphology of the gallery: the ledge of the wall, upon which it is possible to climb in order to be at the desired height, only underlies the left part of the figure. On the right, the opening of the Passageway lies below, impeding access to the wall. Moreover, the strong overhang, which extends across the entire useable surface, from the edge to the centre of the Hall of the Bulls, distances this from the ridge at the base of the wall. Access to the upper level is thus only possible with the use of brushes or pads at the end of a handle long enough to execute the outlines of this very large figure.

In the Axial Gallery, the base of the panel of the Great Black Bull lies some 1.9 metres above the level of the floor (ill. 179). Two techniques were used for this second large representation. Whereas the lower two thirds of the figure were executed by spraying, the upper line, the top of the head, the horns and the tail have been traced with a brush. This was once interpreted as repainting, even as an episode at a later period. Closer examination reveals that this change occurs as a curve extending from the poll and crossing the middle of the thigh. On the

Opposite:
179 Two graphic techniques were necessary to complete the Great Black Bull, Axial Gallery. The head and two thirds of the body were sprayed, while a brush was used for the upper part and the tail. This procedure is primarily dependent upon constraints of access to the walls.

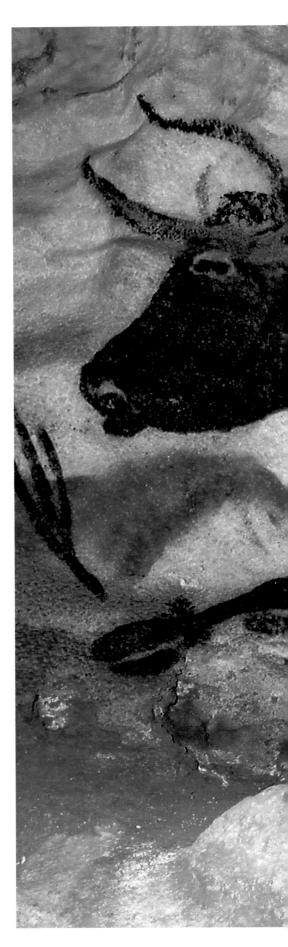

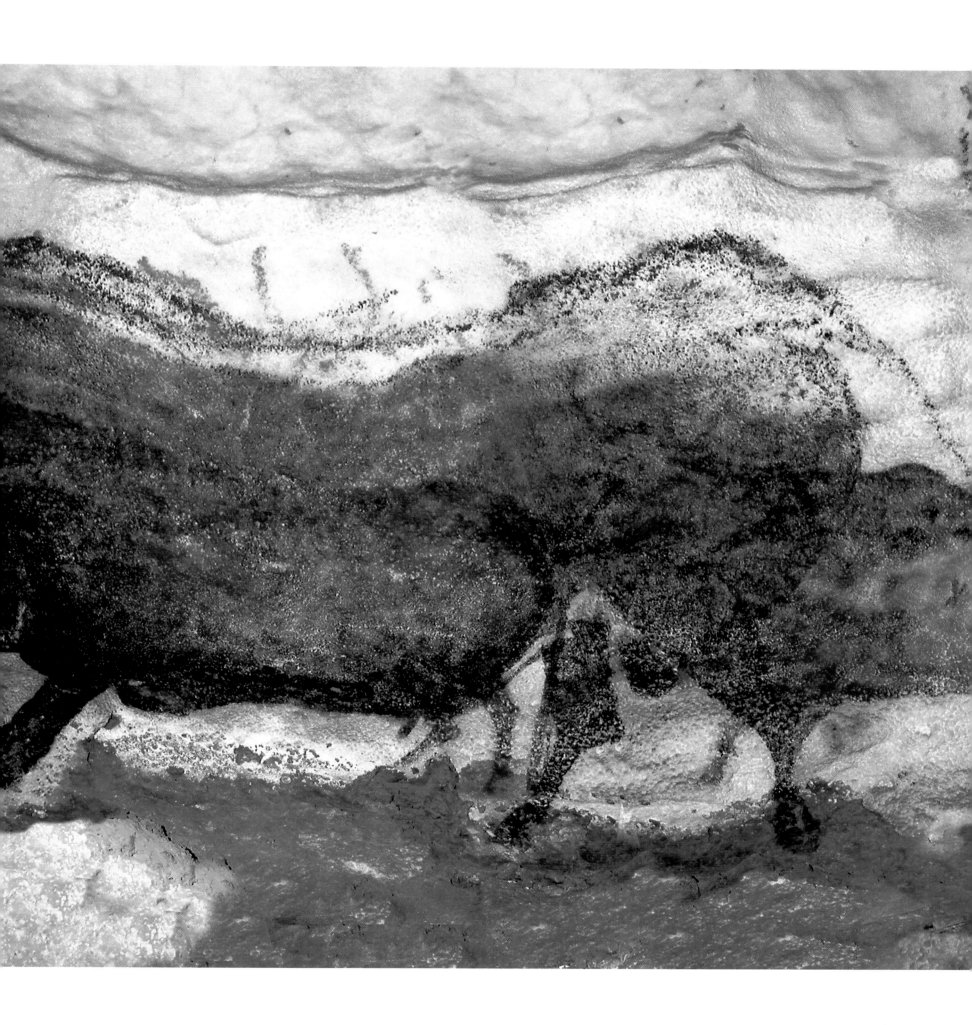

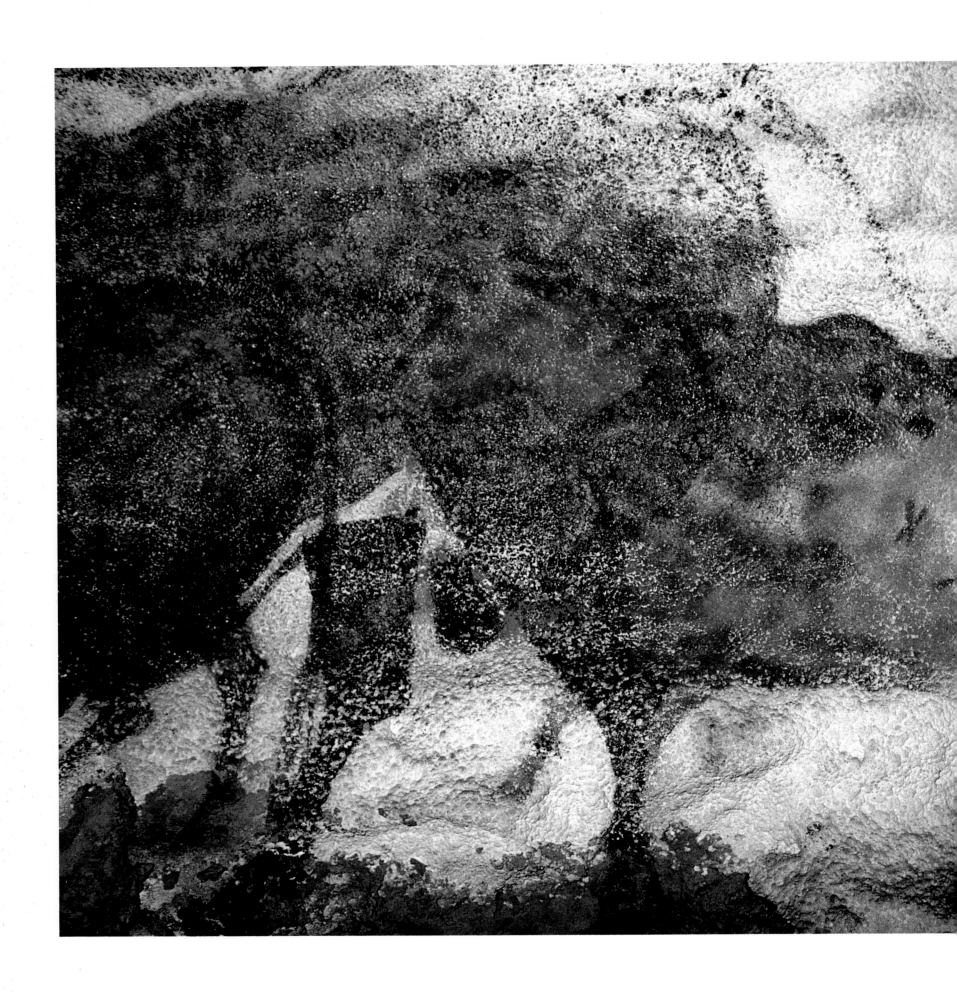

other hand, the cross section of the ledge below the animal is at an angle (ill. 178), which renders the shelf broader at the front of the animal than at its right extremity, where the space available to stand upright diminishes significantly before disappearing altogether. These two observations reveal that the part created by spraying is found at the level of a man perched on the ledge. Beyond this point, the artist, unable to continue using this technique, executed his line with a brush, artificially increasing his field of action. The use of scaffolding was thus unnecessary.

The same panel shows a second example of the same sort. Behind the Great Black Bull are the incomplete outlines of a female aurochs overlying the left hindlimb (ill. 180). Its partial character (only the forequarters were painted) is related, above all, to the morphology of the wall. The ledge is interrupted at the level of the forelimbs of the bovine. Looking at the orientation of the sprayed pigments says a lot about the position of the artist. From the head to the neck the axis of spraying remains perpendicular to the wall, but becomes increasingly inclined moving towards the back, which must have brought the artist very close to the wall. The density of the pigment decreases from the chest to the right edge of the flank due to the growing masking effect of the microstructures of the wall. Beyond the clearly incomplete field of colour a weak angular brush stroke gives form to the section formed by the line of the belly and the beginning of the left hindlimb. This final addition demonstrates the impossibility of access to this zone, despite the evident wish to complete the drawing.

These observations show that the realization of a work or composition was largely determined by the morphology of the support, which sometimes forced a change of technique. The artists knew how to adapt themselves to situations and how to make the best possible use of them.

Opposite:
180 The decrease in colour intensity observed on the right section of the coat of this cow, in the panel of the Great Black Bull (Axial Gallery), was caused by the way in which the artist sprayed the pigments. In the absence of a step, which could have provided access to this figure, the further away the surface is from the standpoint, the shallower the angle of projection of the pigment. Correspondingly, the pigments have been spread more thinly – hence this clear fading.

Construction of the Panels

In this section we deal more specifically with the dynamic aspect of the iconography of the site – that of the 'layout' of the figures. The aim is to identify the many episodes represented by the works in the different sectors of the cave and to evaluate the respective roles of space and time which determined man's activities at Lascaux.

The studies conducted by Max Raphaël,[52] and then by Annette Laming-Emperaire[53] and André Leroi-Gourhan,[54] showed that, despite the apparently random distribution of the figures, it was possible to identify a certain spatial structuring, firstly at the level of the panel and then, by extension, the site as a whole.

The overall reading of the panels very often masks the modes of their organization. Their identification is not immediately obvious, because it complicated the grouping and association of animals of different species. Separating the elements of the bestiary theme by theme enables us to see the layout of the families (or monothematic groups) and to recognize their spatial structuring. In this way, alignments of motifs, symmetrical or superimposed constructions emerge, which may be repeated from one panel to the next or even in the same composition. Noticeably, within these monothematic groups, the figures have the same dimensions. This feature appears to be significant. Nevertheless, several grouped aggregations often do not conform to any of these defined layouts.

We have also noted the existence of a close agreement between the geometry of the work and the shape of the wall, something which once more confirms the existence of intimate connections between the natural setting and the modes of association of the figures. These may be distributed horizontally, vertically or in the form of a cluster. The themes represented in these groups are in each case uniform (one animal species per group). The repetition of this phenomenon shows that the art at Lascaux is not fortuitous but the result of precise layouts and preconceived concepts.

HORIZONTAL DISTRIBUTION OF THE FIGURES

There are two forms of distribution of figures on the horizontal axis: the most common is in a frieze, the other is symmetrical. In a frieze, the represented animals extend along the same level, most often following the line of a natural formation, a discontinuity between strata or a fault. The number of individuals varies from three to a maximum of fifteen in the case of the long procession of horses on the panel of the Great Black Cow (ill. 181). The figures of the group may possess all of their anatomical elements (such as the animals in the frieze of the Small Horses and the Chinese Horses) or be limited to the head (such as the frieze of the Swimming Stags and those of the Ibexes in the Nave and the aurochs overlain by the Great Black Bull in the Axial Gallery). Nevertheless, entire animals may be associated with reduced examples of the same species, such as the black horses of the Hall of the Bulls and those of the panel of the Great Black Cow. It should be noted that, in most cases, the most detailed subjects of such a group occupy a central position, whereas one or several heads are found at the margins. The same is true of incomplete animals when they are associated with a polythematic composition. In these cases they occupy either the upper part of the panel or its base. The panel of the Chinese Horses illustrates this through an equid head in its lower part. The same can be said for an isolated horse head to the right of the panel with the Unicorn.

To these properties of the friezes (alignment along the same level, identical size of the motifs) can be added a third: orientation. All the animals of the simple

groups face in the same direction. With mixed associations, on the other hand, the disconnected heads often face in the opposite direction to that of the more complete figures (the frieze of the black horses in the Hall of the Bulls, panel of the Great Black Cow in the Nave, or the single equid head painted at the far left facing the other representations of horses).

This inversion of the orientation of the animals, which can be observed in many monothematic compositions, can also be applied to the complete animals. Here it suggests confrontation. Up to six subjects may be associated on the same horizontal line. The large bulls of the Hall of the Bulls are the model for this. Their distribution is asymmetrical, with both complete figures and others limited to the forequarters or reduced to a head, the latter located at each end of the long panel. This distribution is not a frieze, nor is it symmetrical, but it represents an intermediate situation. There are only a few symmetrical constructions. The Confronted Ibexes in the Axial Gallery are distinguished only by their colour, and the stags engraved on the left wall of the Apse are also symmetrical. By contrast, the Crossed Bison in the Nave are painted with very slightly overlapping outlines in a diverging position.

VERTICAL EXPANSION

Vertical expansion can be related to constraints of topography or perspective, or a combination of the two. The constriction at the locality of the Upside-down Horse prevented any horizontal expansion over the left wall, but the Red Panel is on the facing right wall. The Upside-down Horse takes the form of an interface. A very large branching sign extends regular limbs on to each surface of the wall and forms the ridge between them. These surfaces are taller than they are broad, and encouraged the representation of a vertical composition with pairs of superimposed figures, on both the left and the right panels, thereby giving this

composition a certain symmetry. Once more, under these conditions the incomplete figures occupy a position at the edge.

As we have mentioned in the chapter relating to perspective, the vertical element is also employed for representing staggered depictions. This distinctive form of depiction was generated by a multiplication of the number of planes and leads to an alteration of outlines which becomes progressively more pronounced the further away the observer is from the subject. The examples of the frieze of the Small Stags or that of the group of horses located in front of the Falling Cow illustrate this type of layout.

IRREGULAR FORMS

In some cases the walls of the cave present highly varied conditions which permit a diversification of parietal patterns in contrast with the uniformity of the majority of the galleries. These irregular forms cover the Passageway, the Chamber of the Felines and the Apse in their entirety.

The Passageway, a straight gallery in general form, nonetheless presents a meandering shape, with a succession of alcoves separated from each another by vertical ridges. This arrangement divided the available space into as many useable surfaces as there are concavities. The sense of discontinuity was increased by difficulties of movement, the height of the ceiling varying between 1 and 1.5 metres, which limited the view of the gallery as a whole and exaggerated the segmentation of its space. In terms of the gallery as a whole, the figures are not arranged geometrically, but on the smaller, more regular surfaces they return to a more formal composition. The overall irregular character of the motifs appears to dominate. One can say the same of the figures in the Chamber of the Felines.

The Apse has an almost ovoid form. Certain surfaces, particularly at the base, might have lent themselves to an organization of figures similar to those

Overleaf:
181 Lascaux or the art of the frieze. The frieze of the Small Horses, Axial Gallery, is a model example, with a development along a single horizontal line, subjects of similar dimensions, the same orientation and, often, a simplification of the outlines of the lateral motifs.

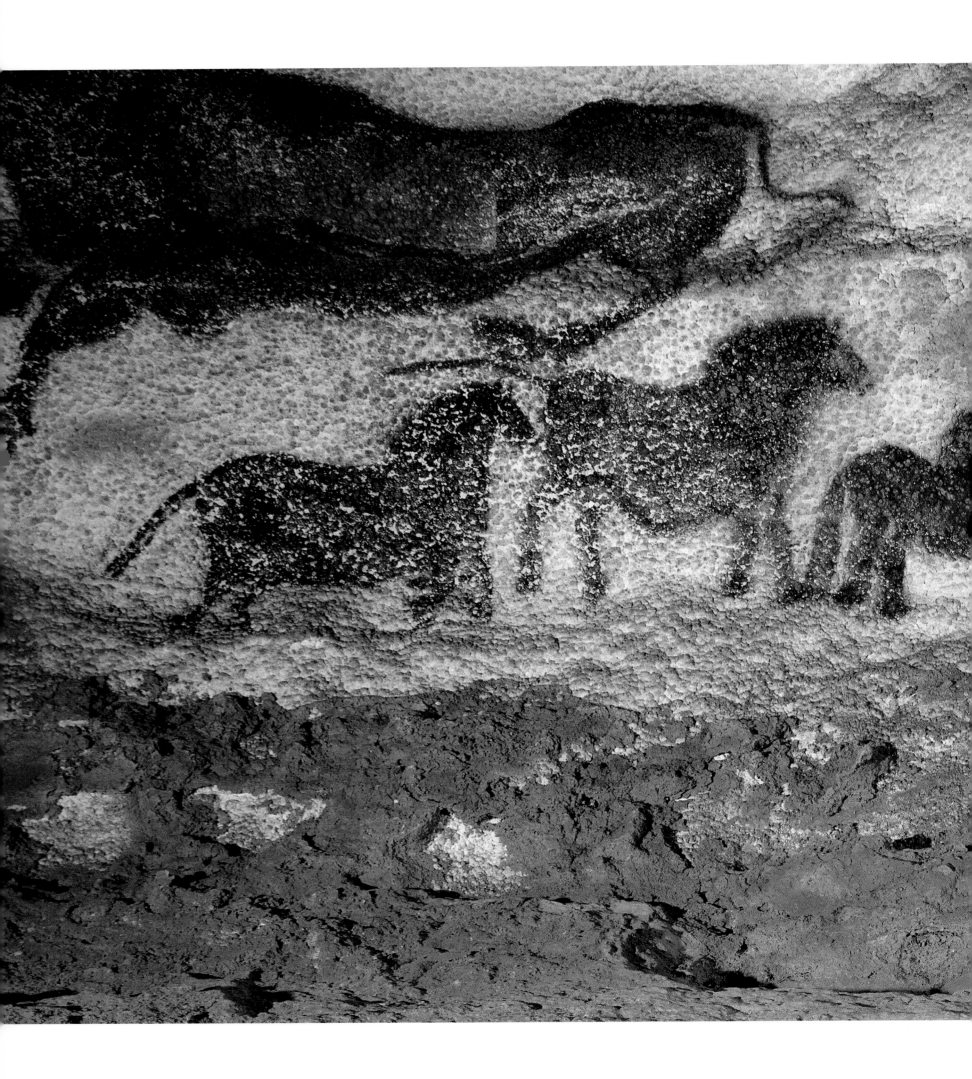

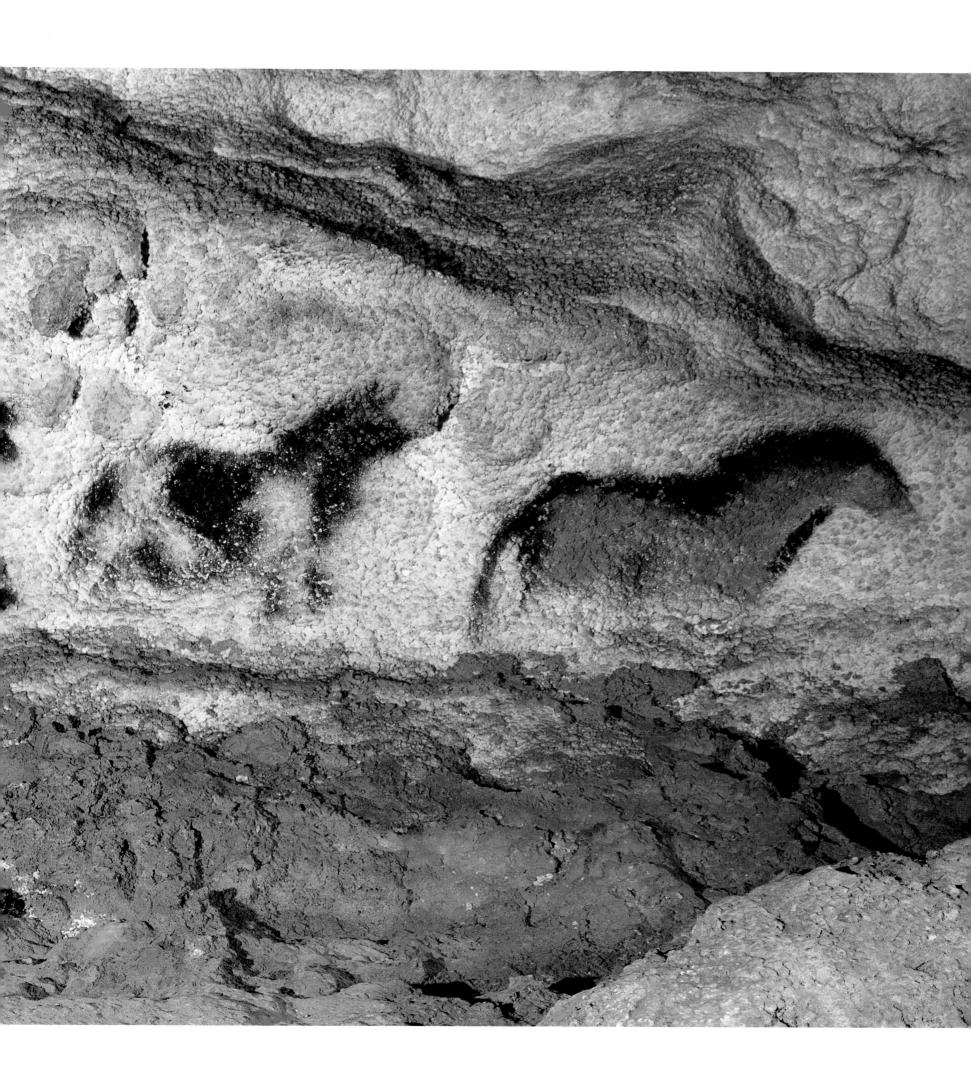

of the Hall of the Bulls, but the steep slope of the floors was a major obstacle. The desire to produce works of imposing dimensions could restrict the creation of a frieze with multiple elements. The sequence of the large stags might be identified as such a composition, but their movement, which is very different from one subject to the next, would suggest that this procession is made up of a number of individuals. On the other hand, some compositions of this type do exist, but with subjects of much more modest proportions (the confronted horses on the ceiling, the confronted stags of the middle level, the frieze of the engraved and painted Small Stags of the Apsidiole and the Crossed Bison). The rather restricted dimensions of the Apse (with only a few tens of square metres of surface) contrast with the high density of painted or engraved figures. In this confusion of figures it is difficult, with the possible exception of the largest figures, to recognize any organization of motifs comparable to that of the immediately adjacent and similarly formed Hall of the Bulls or Nave. With its highly irregular distribution of figures, in the sense that this does not respect any geometrical rules, the Apse must have played a specific role very different from that of the other sectors.

The shapes and the surfaces of the walls materialize in rough outlines, attracting their attention and dictating in some way the organization and the geometry of the compositions. This interplay of the natural environment and human creation is continuous. It is a true symbiosis.

Nevertheless, it seems difficult to know whether Palaeolithic people wanted to take up all the available surface with an unlimited number of themes, or restrict their different compositions to a preconceived message.

Chronology of Parietal Events

This final discussion introduces the notion of time in the construction of the various compositions in order to identify their relative chronology and attempt to determine the major sequences that led to the positioning of the iconography.

The high number of figures per panel and the impressive size of some of them lead to numerous overlaps. Most of these remain partial, limited to very short sections (ill. 182), but some cover a large part of the underlying images, or indeed hide almost the entire subject. The superimpositions, which are sometimes inconvenient for the interpretation of the works, have an obvious advantage when it comes to identifying and classifying the different episodes during which they were executed. This path of research was followed by André Glory.[55] He concluded that the whole ensemble was realized in six periods, defined by their themes and by the techniques employed, which revealed several occupations of the site during part of the Upper Palaeolithic.

We analysed the figures stratigraphically in order to determine the order in which the different animal motifs within each panel were positioned, no longer looking at them from a technological angle, but rather a thematic one. The great alteration of the walls in the Apse and the Passageway, together with the absence of relevant examples in the Shaft and the Chamber of the Felines, prompted us to take into consideration only the Hall of the Bulls, the Axial Gallery and the Nave. Furthermore, with very poorly represented themes such as the bird, the rhinoceros or the feline, it is not possible to record any superimposition. The analysis is therefore based on the equids, the cervids and the bovines, but also on special cases such as the Unicorn and the bear. We limited the study to eight themes: bull, cow, bison, ibex, horse, stag, bear and undetermined (the Unicorn). Forty-seven superimpositions were recorded involving these figures. They are distributed in approximately equivalent numbers in each of the three areas, but in unequal proportions

in relation to the number of animal figures. We counted sixteen cases in the Hall of the Bulls, sixteen in the Axial Gallery and fifteen in the Nave. Of all the potential superimposition of the different themes we identified only fourteen. This imbalance derives both from the limited number overall and from a very important numerical disparity between the different themes. Exceptional subjects, such as the bear and the Unicorn, lie next to the more common species, such as horse, aurochs or stag. On their own, these three species make up 97 per cent of the bestiary of the Hall of the Bulls, 93 per cent in the Axial Gallery and 71 per cent in the Nave.

There are remarkable repetitions in the positioning of the different themes. They are regularly found across all the panels, which has enabled us to demonstrate that the horse came first. In fact, its image is always below that of the aurochs, just as the latter is always below the stag. This is true of all the analysed superimpositions. This repetition of the sequences is based on a precise thematic order, horse–aurochs–stag, and reveals a very strict arrangement of the figures, which had already been suggested in the study of spatial structuring.

Moreover, the uniformity of the works at the centre of the monothematic groups is remarkable, not only in terms of their formal characteristics but also their techniques and colours. The fact that the animals of the same group have an identical orientation, that they are regularly spaced and that they show a similar animation suggests that extremely close links existed between them. The numerous examples include almost all the figures of the Hall of the Bulls, the Axial Gallery and the Nave. There are other examples in the rest of the cave, although less conspicuous.

In the majority of cases, the similarities of the animals are the result of the underlying form given to the outline to be reproduced. The artists thus had a pre-existing virtual

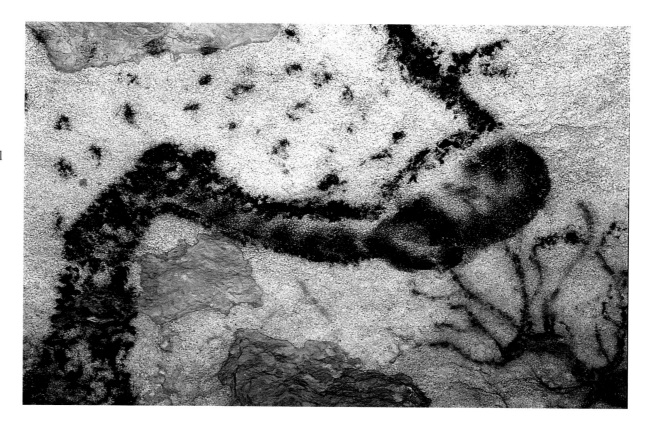

shape in their minds. This is recognized in the overall perception of the works and serves as a guiding framework, on to which the anatomical details are later grafted. The construction of the frieze of the Swimming Stags, for example, relies upon a series of 'X'-shaped forms, the upper branches of which replace the two antlers, and the lower ones marking out the line of the neck and the forehead. In the same way, the position of the engraved and painted frieze of the Ibexes on the facing wall reveals a similar preliminary sketch in a series of alternating, sub-parallel arcs for the horns of these animals.

There is less variability in the formal, technical, chromatic and ethological characteristics of animals of a group. This homogeneity indicates that the assembly of figures in a monothematic group was created at the same time and by the same person. The construction of the panels is therefore not limited to a simple juxtaposition of motifs – it translates the desire to treat all the elements of a monothematic group in an integrated fashion and give them great cohesion. This reasoning, based on the stratigraphic analysis of the figures on the

182 The numerous superimpositions of images have allowed recognition of the order in which the different subjects of the panels were painted, drawn or engraved. Here, the antler of one of the red stags covers the muzzle of the second bull, Hall of the Bulls.

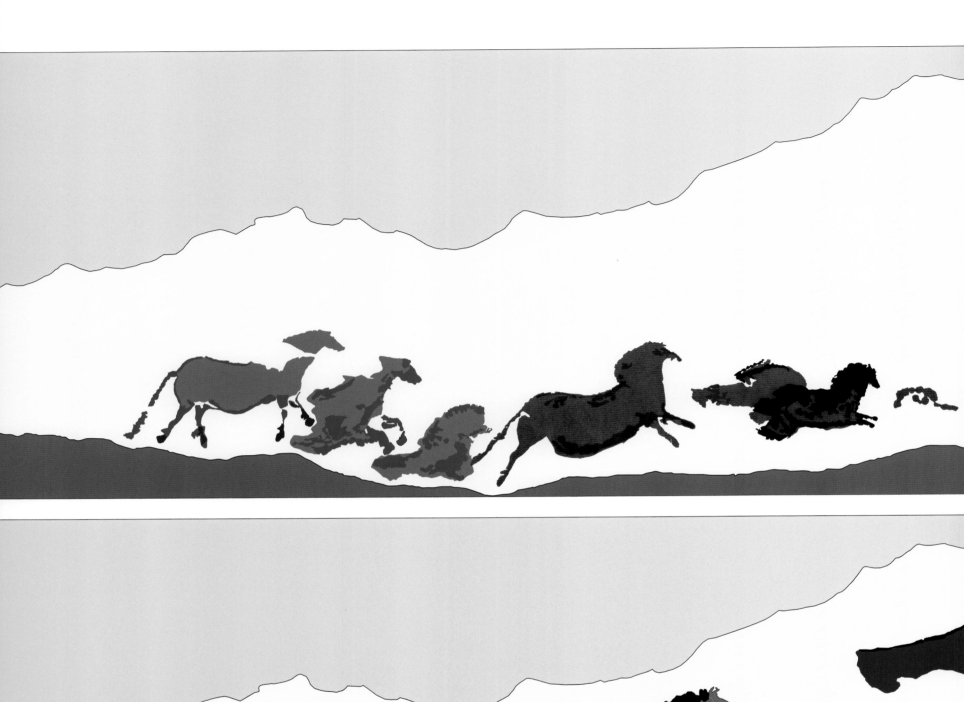

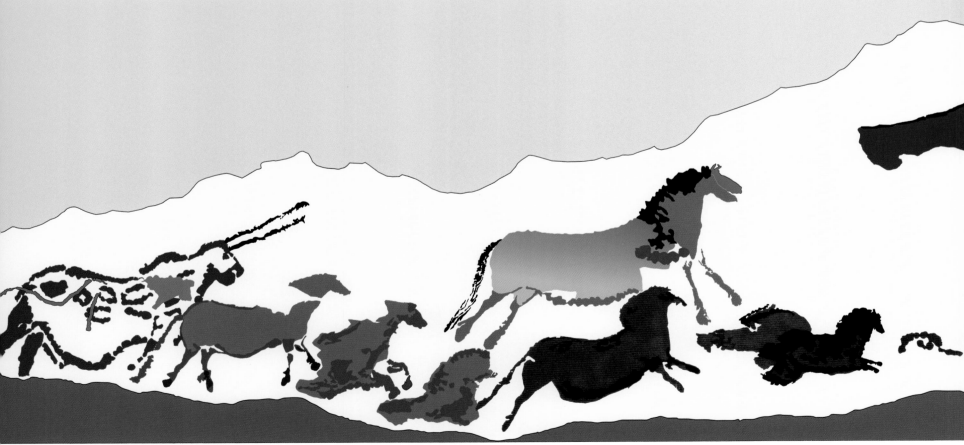

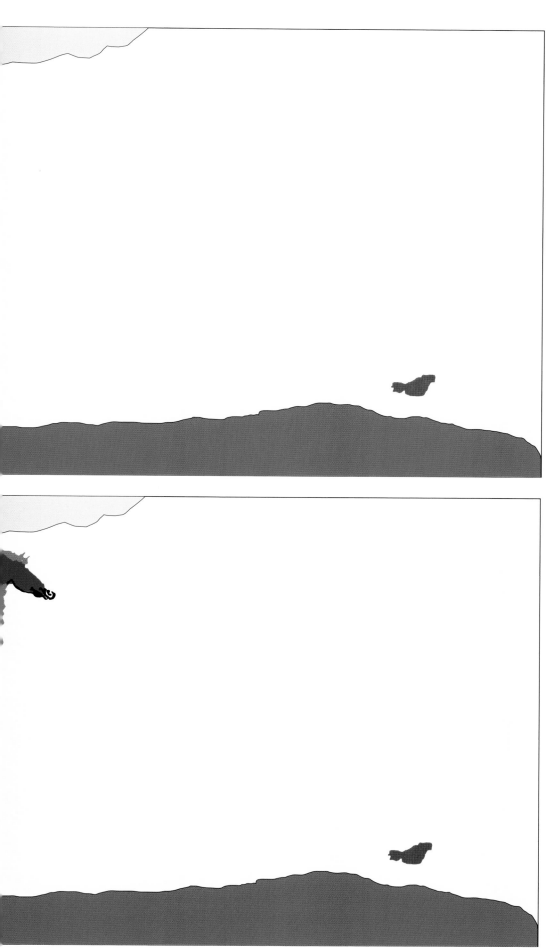

one hand and the observation of the thematic uniqueness of the groups on the other, allows us to define the modalities of the construction of the compositions and to recognize a sequence of events for each panel, in each space studied. The composition of figures in the Hall of the Bulls is the prime example. The positioning of the groups was carried out in several successive phases. The first consists of the long frieze of the black horses (ill. 183), including the isolated head on the left and the two sketches on the right. Then the Unicorn enters the composition, followed by the second series of red and brown equids, spread out in a sloping line (ill. 184), including the large polychrome horse, with motifs sketched on its flank, and the horse on the right between the horns of the two great bulls. Next is the group of bovines (ill. 185) with, in order, the large black bulls, then the red cows and the calves. Later, the space between the second and third bulls was filled by the frieze of the Small Stags (ill. 186). The bear took its place during this final phase, although we are unable to define when this was relative to the cervids.

In the first third of the Axial Gallery, the animals respond to the same logic. The two friezes of three horses – that of the Chinese Horses and its pendant on the facing wall – are earlier than the group formed by the four female aurochs. An identical chronology is seen on the panel of the Swimming Stags, with precedence of the horse relative to the stags, and on the panels of the Great Black Cow and the Imprint, upon which the bovines (aurochs and bison) came later than the horses.

Opposite:
183 The construction of this composition begins with the frieze of the black horses.

184 After the Unicorn, a second frieze of horses, this time coloured, takes its place on the wall.

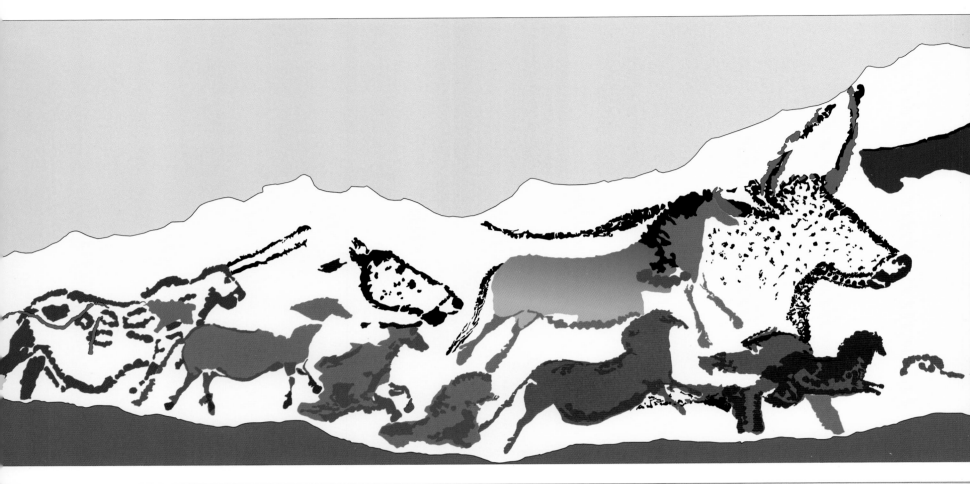

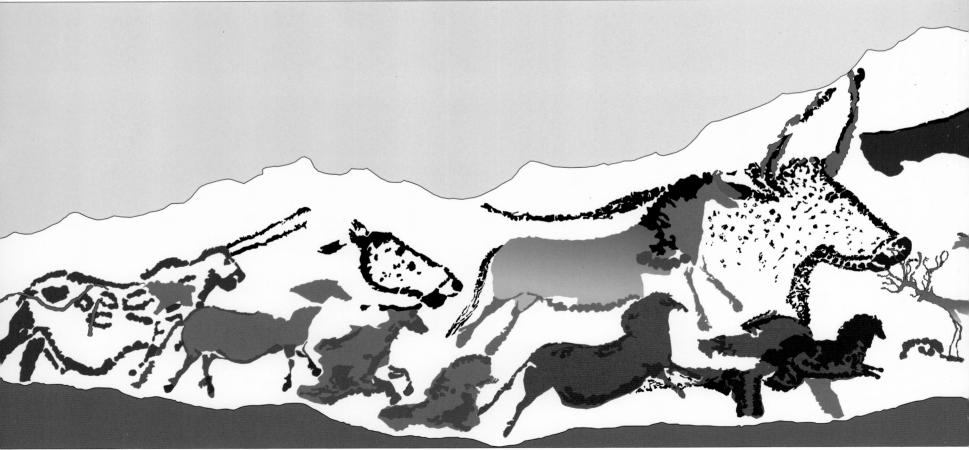

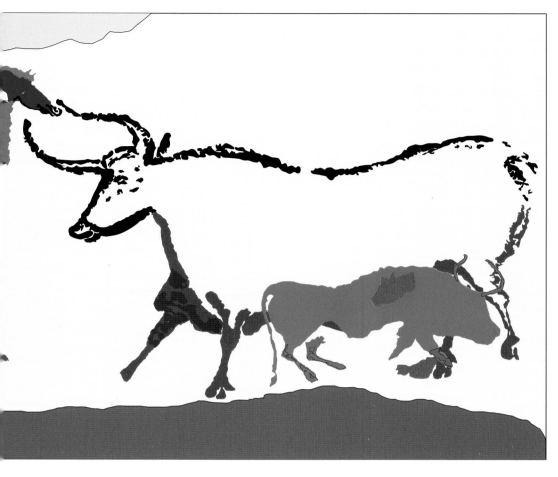

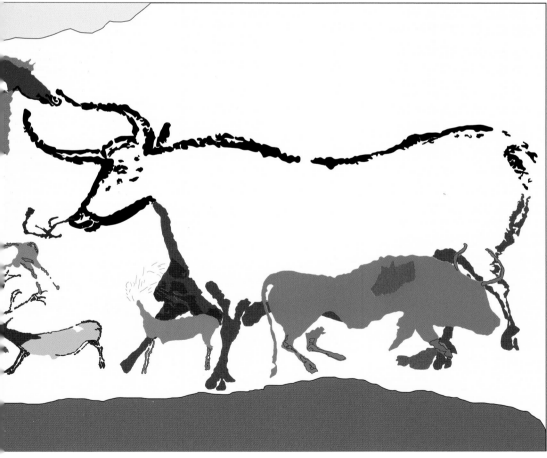

Opposite:

185 The very segmented image of the second bull represents a period of enhancement following that of the horses.

186 During a final stage in the construction of this panel, the space left free between the two large confronted bulls is filled with the group of the Small Stags, Hall of the Bulls.

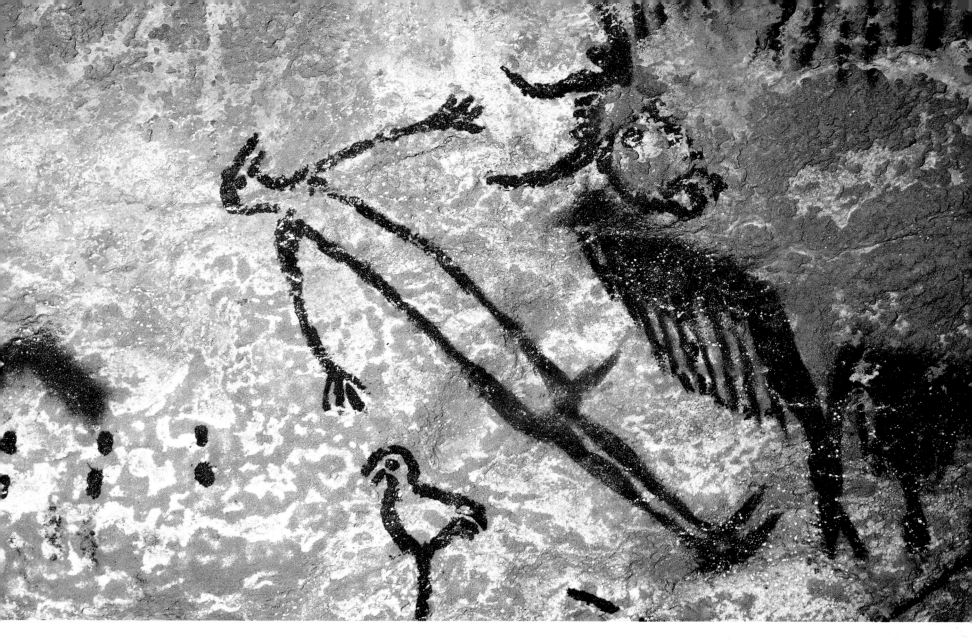

Gesture, Space
and Time

CHAPTER 7

Gesture, Space and Time

This study of Lascaux is the result of several years of observations carried out, above all, with the eyes of a naturalist. The data gathered over the course of time thus relate to very different scientific fields, such as archaeology, ethology or geology. They link anthropic phenomena with natural ones, man with animal and the profane with the sacred.

It should be emphasized that scientific doubt was always present during this enquiry and, as a result, we refrained from all unfounded opinions, indeed from all thoughts of a dogmatic nature. Faced with the monument that is Lascaux, and despite the relatively large amount of time devoted to its study, we remain convinced that we have succeeded in identifying and decoding only a fraction of its message. This most exceptional theme of decorated caves remains all the more difficult to grasp in that some of its numerous aspects lie on the threshold with the irrational. Here, we encounter a world in which the temptation to overstep its limits is sometimes great, if we allow our imagination to wander even slightly.

This study has motivated us not only to examine the site itself, but also to reconnoitre the whole of the underground environment of the Black Perigord accessible today. It relies upon the analysis, at different scales, of the natural context and the parietal works. This course was to lead us from the Vézère drainage basin to Lascaux, from the figures on the walls to the forms of the walls, from rudimentary traces to the spatial and temporal organization of the decorated ensemble, each stage bringing its yield of

information. It was possible to obtain a number of partial answers concerning, on the one hand, the selection and occupation of the site and, on the other, the ways of dealing with the pictorial use of the underground space and the construction of the panels. A geomorphological approach to the region revealed important variations in the landscape, due in large part to the petrographic characteristics of the Upper Coniacian and to its remarkable homogeneity. These properties favoured the formation of entablatures, or cliffs, resulting from the down-cutting of the Vézère and its tributary streams such as the Beunes, the Vimont or the Manaurie. To both sides of this steep-sided zone, upstream from Castelmerle, in the region of Lascaux, and downhill from Saint-Cirq, to the west, the landscape changes, presenting a more hilly appearance, with subdued slopes. This phenomenon is related to a decrease in the homogeneity of the rock and to the replacement of the Upper Coniacian horizon by that of the Campanian, in particular – a unit less conducive to this type of steep topography. These changes created a surrounding landscape that is more open in contrast to the more constricted central area.

At the base of the Upper Coniacian we have recorded a change in the texture of the rock. Its greater porosity has led to the formation of a level of rock shelters along both sides of the Vézère and, to some extent, in the valleys of its tributaries. This long horizontal recess, interrupted by the areas of confluences, maintains the same character throughout the

entire steep-sided region of the Vézère drainage basin, between Thonac and Les Eyzies. It favoured the establishment of habitation sites throughout the Upper Palaeolithic, such as those at La Madeleine, Laugerie-Haute, Laugerie-Basse or Gorge-d'Enfer. On the other hand, we have noticed that this hollow formation is no longer visible in the adjacent small valleys. It is buried below valley bottom deposits formed since the Neolithic. The deposition of these materials during the Postglacial covered the rock shelters, notably those in the Beunes, leaving the ancient occupation sites inaccessible from that time on. These geological conditions have left the Upper Palaeolithic habitation sites with a relatively singular distribution: their number is greater in the valley of the Vézère and far smaller in the small tributary valleys.

This is not the only example of the influence of geology on the motivation and manner of human settlement in this region. At the very heart of this level of the Upper Coniacian, more precisely within its upper part, another layer is characterized by karstic properties that are more marked than elsewhere. In fact, almost 70 per cent of the 306 known sites (including Lascaux) are here.

We have emphasized that the state of preservation of this highly karstified level presented significant differences. Destroyed by erosion in the valley of the Vézère, which may explain the small number of caves recorded, it retains its integrity in those of the Beunes, from the confluence to the upper reaches of their valleys, hence the higher number of caves.

Furthermore, access to the systems appears much more problematical in the main valley because the cliffs do not feature any secondary projections. This gives the entire outcrop an absolute verticality, which can exceed 40 metres. Without special equipment, this type of profile impedes access to the karstified level and hence to the caves. On the other hand, in the tributary valleys and, most particularly in those of the Beunes, the elevation of the

formations is divided into terraces. These successive platforms favour movement from one to the other and thus the approach to the entrances of the caves.

In summary, this analysis has revealed a high concentration of rock-shelter habitation sites in the valley of the Vézère, in contrast to the valley of the Beunes. As for the deep caves, the proportions are reversed. This major tributary can boast, within a relatively limited area, more than a third of the decorated caves in the Department of Dordogne, including Font-de-Gaume, Les Combarelles and Bernifal. We thus observe that the ancient distribution of the habitation sites on the one hand and the decorated caves on the other – two clearly distinct groups – results from a combination of phenomena essentially geological in origin, which are linked with the formation of the landscapes and the caves, processes of erosion of the cliffs and the infilling of the bottoms of the valleys. Upper Palaeolithic people knew their territory perfectly and exploited it optimally with regard to the possibilities offered, the result of very ancient natural phenomena. These geological phenomena have continued and have hidden some of the habitation sites. It is necessary to bear them in mind during the study of human settlement patterns or while prospecting for sites.

Beyond the local geological constraints, a second factor intervenes, which is apparently cultural in origin. There is a particular concentration of decorated caves dating to the period from the end of the Solutrean and the Lower Magdalenian, including Lascaux, Saint-Cirq, Bara-Bahau, Gabillou (in the valley of the Isle) and Villars (further to the north in the drainage basin of the Dronne). These sites have been attributed to the same period, in part based on formal analogies in their depictions, but also because one sees at them the repetition of exceptional themes – for example, the quadrangular sign, which is present at Lascaux, Gabillou and

Bara-Bahau, or the theme of the man opposite a bison, which one finds in a more complete form at Lascaux and Villars or more reduced at Saint-Cirq, Gabillou and Bara-Bahau. Again, all the caves are located in similar landscapes, on the flanks of gently sloping hills, which distinguishes them from the sanctuaries of the Middle Magdalenian – Font-de-Gaume, Rouffignac, Les Combarelles or Bernifal, for instance – which are in much more steep-sided landscapes. The choice of the site of Lascaux therefore seems to be determined as much by the geomorphological properties of the region as by the conditions of access – with no particular constraints – and by the inconspicuous character of the entrance, which is less easily detectable than an opening with a porch at the foot of a cliff. (…)

The morphology of the engraved or painted surfaces, which often extend into an overhang or indeed a vault, to a large extent conditioned the execution of the decorated panels, the framework of the different compositions and the animation of the animals, sometimes even suggesting a three-dimensional graphic approach.

The presence of a significant portable lithic and bone assemblage, scattered throughout the cave, and the numerous markings on the walls, executed as far as the most remote zones, attest to the wish to explore everything and to take over the whole of the subterranean space. This is true of the majority of the great decorated sites, no matter what the period, including Niaux, Chauvet or Cussac,[56] and shows all the signs of sacralization.

The contrasting surfaces, resulting from the specific mechanical, granulometric and chromatic properties of the rock, encouraged a certain variation in the methods used. The support thus appears to have been another major element affecting the choices made and the decisions taken by Palaeolithic man. Its variations caused a very marked topographical division, as the Hall of the

Bulls and the Axial Gallery are different from the other sectors of the cave. The calcite encrustation, which covers almost the whole of the walls of these two spaces, has a reflective power that marks them out. In the other caves of the Vézère drainage basin we have observed this formation very rarely, in most cases over only a few square decimetres; moreover, it is often associated with elements that interrupt its homogeneity or present such large gaps that the underlying rock, which is always chromatically more dense, appears over large areas.

The exceptional optical properties of the wall support in the Hall of the Bulls and the Axial Gallery, together with its increased hardness and light relief, encouraged the artists of Lascaux to paint it and to choose appropriate tools. In the other parts of the cave, the friability of the rock necessitated the use of a range of complementary tools, particularly for engraving. The methods employed imply an experienced hand because the application of colour to the painting or the removal of rock by cutting are unforgiving of mistakes and leave indelible traces on the support. The rare corrections show the very great skill of these people in overcoming difficulties of access and the irregular character of the morphology of the support.

The art of Lascaux is characterized by the sheer number of figures represented, accounting for almost a seventh of all known examples of parietal art in France. Of the 1,963 representations counted, 915 are animal figures, 434 signs, 613 indeterminate figures and 1 is human. They occur in relatively uniform concentrations, except in the Passageway and the Apse. In this last space, with its very modest dimensions, there are no fewer than 1,073 figures. This number alone far exceeds that of any other of the great sites of Palaeolithic parietal art. It is a sanctuary at the heart of a sanctuary.

The bestiary is largely dominated by the theme of the horse (ill. 187), with 364

Opposite:
187 Head and neck of the yellow horse, locality of the Upside-down Horse.

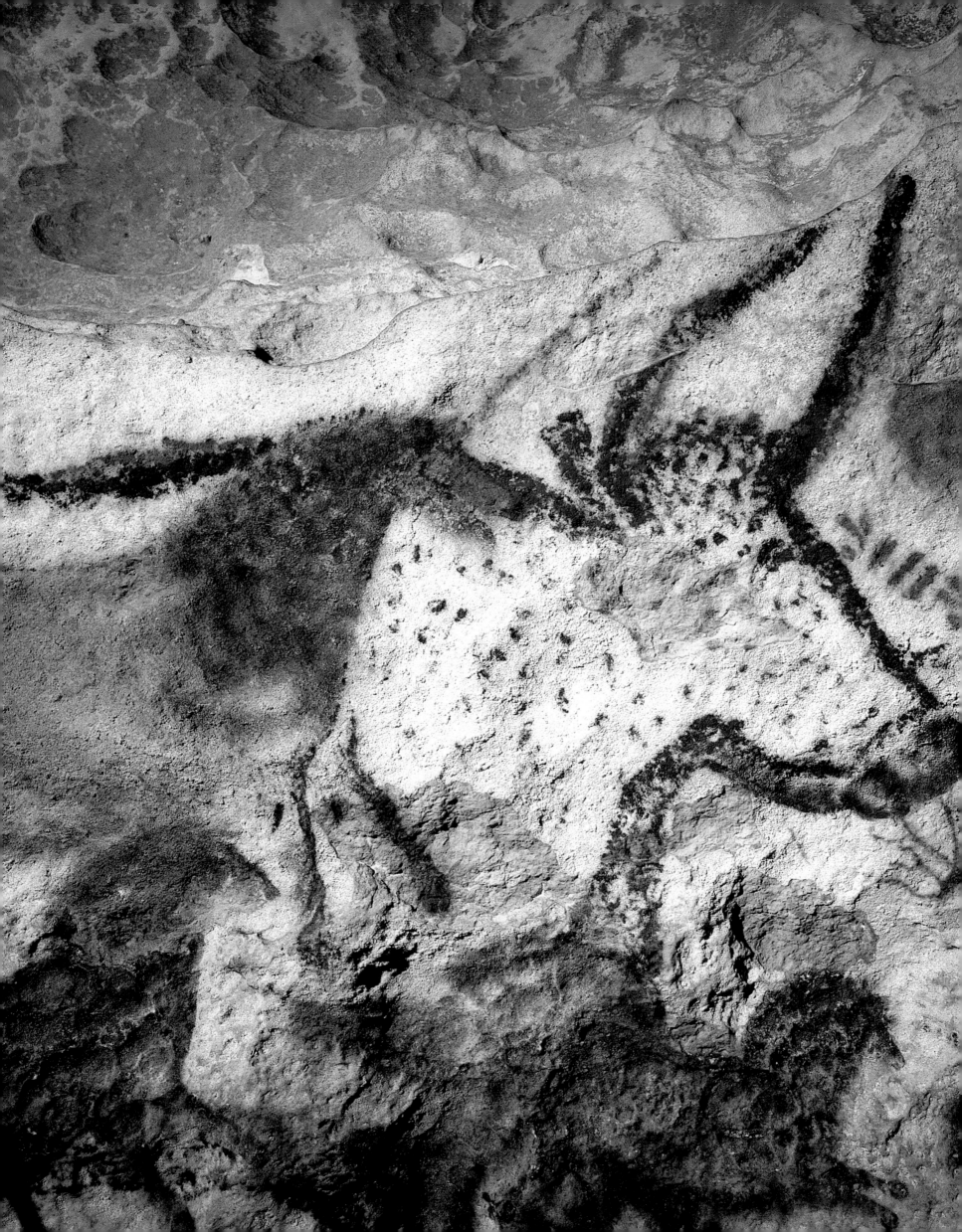

representatives. There are just 28 aurochs
(ill. 188), but this theme nevertheless
remains prominent due to its visual impact
in the first two sectors, where the animals are
huge. Beyond this point, it tends to recede
in favour of the image of the bison. This last
animal, represented 26 times, is found at the
three extremities of the cave (locality of the
Upside-down Horse, Chamber of the
Felines and Shaft). The ibex accompanies
it on several occasions, but with a certain
discretion, on dividing panels such as that
of the Falling Cow close to the Red Panel or
that of the frieze of the Seven Ibexes engraved
immediately above the Panel of the Imprint.
On the other hand, the stag (ill. 189), in
second place with 90 representatives, remains
some distance away from these animals but
comes closer to the horses and the aurochs.
The carnivores, bear (ill. 190) and felines
(ill. 131), are less numerous and have a very
inconspicuous presence. The creation of
these works, whether they are figurative
(the animals and the man of the Shaft)
or geometric (the signs), follow well-defined
rules, specific to each painted or engraved
theme, and a remarkable adaptation to the
support that testifies to a natural determinism,
as in numerous other circumstances.

The study of the representations of the
equids, which we have stressed, shows that
the methods of constructing each image and
the positioning of the different anatomical
elements rely on a recurring chronology.
This process, conducted in successive stages,
implies the use of implements adapted to the
morphological and physical properties of
the wall. The first actions involved spraying
colouring materials to portray the mane, then
the neck and the flank of the animal. It is
in the course of the following phases that
the techniques diverge, more particularly
during the rendering of the outlines and
the anatomical details, such as the fore- and
hindlimbs, the tail, and the bridge and tip of
the nose. The variations recorded depend on
the degree of hardness of the support.

Opposite:
188 Head and neck of the second
aurochs, Hall of the Bulls.

Drawing was used for the hardened surfaces of the Hall of the Bulls and its axial extension, and engraving for the friable supports of the Passageway and the sectors beyond. This striking difference might, in a superficial interpretation, suggest the involvement of two distinct groups, but this is not the case. As we have seen, the repetition of the actions, the persistence of the themes and the construction of the figures are all indications of the uniformity of the ensemble of these parietal works.

We have also shown that change of technique is not only related to the nature of the support. On several occasions, and very locally, the tool has been changed in order to define the outlines of the same animal – the neck, the croup or the flank – which cannot be attributed to constraints of access to the walls.

The first studies at Lascaux emphasized the difficulties of access to the upper levels of the galleries and the halls and suggested that Palaeolithic man may have used scaffolding. This hypothesis makes sense for a few rare sections of the galleries, notably the Axial Gallery, but its extension to the whole of this area does not seem feasible. As already mentioned, numerous ledges underlie the panels apart from in the first third of this gallery. These projections would have given the artist access to the walls and thus placed the majority of the surfaces to be painted or engraved within easy reach. For the zones beyond reach, we have observed a change of technique, such as for the black bull of the Axial Gallery or the one in the Hall of the Bulls above the entrance to the Passageway. In these two cases, spraying, which requires a certain proximity to the wall surface, is replaced by a drawn line. The extension of the manual reach created by an instrument used as a brush or a pad permitted access to the entire surface to be painted, without the need for an artificial structure.

The expression of the third dimension constitutes one of the distinctive features and one of the strong points of this art. It is effective at several levels, from the smallest anatomical details to the subject as a whole. It also appears in the distribution of the different elements represented in the composition of a panel. The interpretation and the rendering of the relief presuppose the anticipation of an action and the pursuit of a graphic technique that can achieve the illusion of depth, as is shown by many examples.

The most common convention was to leave a reserve (a blank), thus isolating the body from the fore- and hindlimbs located in the background. This gap reduces their graphic importance relative to those located on the side of the observer. However, this three-dimensional approach went much further. On certain figures, in particular those of the diptych of the Crossed Bison, a difference of construction between the fore- and hindlimbs is noticeable, the latter being distinctly more elementary because they are placed in a more remote position. On the same panel, the composition benefited from the morphology of the wall's angled interface, with each plane receiving one of the two representations. Moreover, the forward-sloping line around which these images are joined reinforces the symmetrical movement of the two animals away from each other.

With a desire to execute figures with optimal proportions, the artists resorted to distorting some of them deliberately through anamorphosis. (…) We have observed a similar approach in the layout of certain panels constructed around a single theme. The frieze of the Small Stags and the group of horses located in front of the Falling Cow also obey the same criteria of adapting their lines relative to their position in space. The animals in the foreground are presented with all their detail; the others are progressively less detailed the further away they are from the observer, thus conveying distance.

These graphic inventions in the paintings of Lascaux constitute one of the great

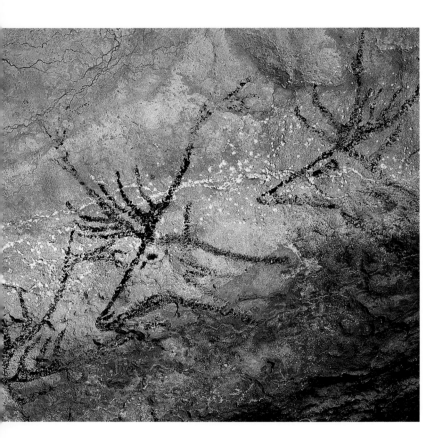

189 The central subject of this frieze of the Swimming Stags, Nave, is the most detailed drawing of the panel, resembling many other examples in the compositions of the friezes.

moments of pictorial art – in no other sanctuary is it carried to this level of perfection. At many sites with parietal art, the natural relief or irregularities in the rock (fissures, concretions, flake scars) are provide the basis for the creation of horizontal fields, which are generally clearly developed. They are also potential surfaces for expression. Palaeolithic people exploited these configurations of the walls to position linear

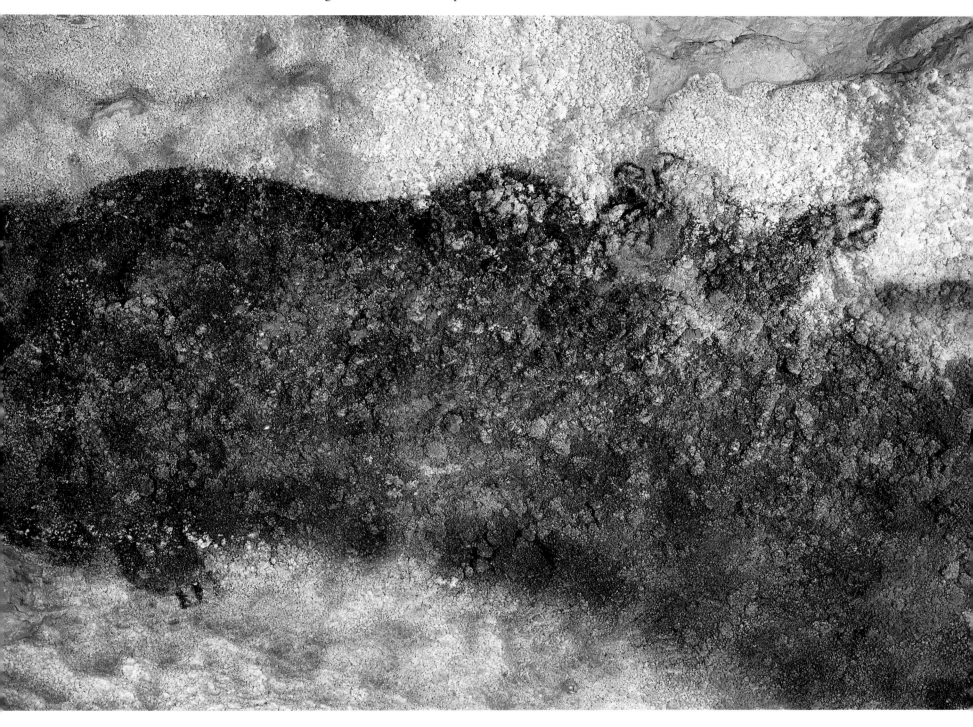

occasionally used as substitutes for certain anatomical details of the animals represented. This is rare at Lascaux. On the other hand, the structural heterogeneity of the wall, the interfaces of strata or the channel of the roof, and also the variations of shapes produced by overhangs, projections of the wall or ledges, compositions that can extend over several tens of metres, as in the Hall of the Bulls. These shapes create natural frameworks that delineate the work, and indeed provide the draft of a composition: they hold the eye and direct, in some way, the spatial distribution of the figures. Even if the natural setting does

190 Of the outline of the bear painted in black, only the upper line, the frontal section and the tip of the right hindlimb extend beyond the edge of the very broad ventral band of the fourth bull, Hall of the Bulls.

not, perhaps, influence motivation, it does to a large extent determine the form. This characteristic is due in large part to the specific architecture of the site. Indeed, one sees a very marked twofold topographical division in the morphology of the galleries. The art appears to complement this very closely. There is a sort of opposition between the very structured assemblages (the Hall of the Bulls, Axial Gallery, Nave, Shaft [ill. 191] and Chamber of the Felines) and the other locations (the Passageway and, to a lesser extent, the Apse), where the distribution of the figures seems to be more confused, even if this is mere appearance.

The structure of the compositions in a frieze depends on particular, horizontally very extended surfaces. Each associates animals of the same species, forming what we have termed monothematic groups. The analysis of the form and technique of each motif demonstrates the individuality of the gesture. The homogeneity of the dimensions of each figure, their regular spacing and their alignment along the same line show that each of these assemblages was created at a single instant. The strength of the image is reinforced when the drawn animal occupies a dominant spatial position. Its power is increased tenfold by the accumulation and the repetition of the motifs. The convention behind the construction of these pictorial groups is thus not limited to a simple juxtaposition of the themes: its purpose is, above all, the creation of homogeneous monothematic ensembles.

Analysis of superimpositions showed that, on all the panels in which these animals were represented, the image of the horse is always placed under that of the aurochs, while the latter is always below the stags. The theme of the horse was thus depicted first; it was followed by that of the aurochs, then the stag. These sequences are repeated persistently in all sectors of the cave.

This 'horse–aurochs–stag' order had its rules and demonstrates once more the structured and deliberate nature of this parietal art. Another conclusion follows on from this: the distribution of the works is not limited to an ordered repetition of the motifs on the panels, but also follows a precise chronology. The systematic linking of the animal images shows that there existed a structuring not only in space, as was demonstrated by Max Raphaël, followed by Annette Laming-Emperaire and André Leroi-Gourhan, but that at Lascaux this construction also enters another dimension, that of time.

The comparative study of the coats of the animals and their peculiarities showed a close relationship between the species shown and distinct seasons. The analysis of seasonal characteristics revealed that the horses were represented with features corresponding to the end of winter and the beginning of spring, the aurochs during summer and the stags in autumn. For each species, these periods correspond to the mating season, an event never itself reproduced on the walls. This in no way implies that the works were necessarily created during the season depicted.

It is appropriate to combine these observations with the sequence in which the paintings and engravings were created, and indeed there is a close correspondence between the two. The chronology of the parietal works follows closely that embodied by the annual variations of the coat and behaviour of the animals (ill. 192). The 'spring–summer–autumn' cycle can be superimposed on the 'horse–aurochs–stag' sequence, which also incorporates the first indications of the animals mating. The organization of the ensemble of figures at Lascaux acknowledges a structure, both in terms of its creation and meaning, that is determined by time.

This interconnection of graphic sequences and biological cycles reinforces the very great unity of the sanctuary. The creation of the parietal works stems from a rational design, which is shown by a

Opposite:
191 The man, the bison and the bird of the Shaft, more than all the other compositions, have prompted a large number of interpretations.

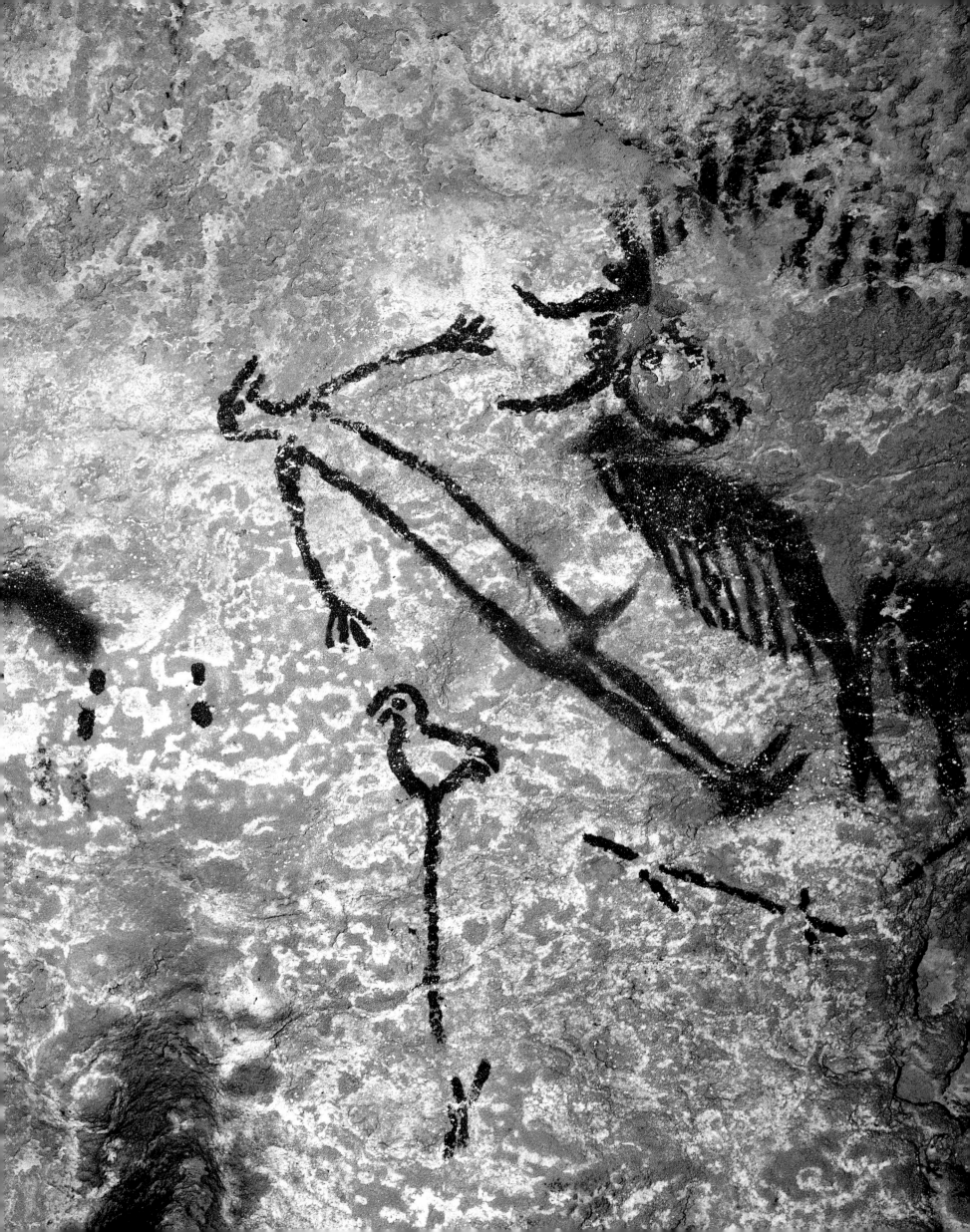

rigorous spatial organization of the figures and a precise temporal logic. These observations suggest that the art of Lascaux is largely the product of an activity limited in time and possibly belonging to a single generation. The last chronological estimate, 18,600 years BP, is based on a radiocarbon test on a fragment of a spearhead found during the excavation of the Shaft. It therefore pushes back previous datings of around 17,000 years BP. These archaeological remains ought thus to be placed in the period of time covering the end of the Solutrean and the Lower Magdalenian. The art of Lascaux would foreshadow the great parietal expansion of the Middle Magdalenian while still preserving the Solutrean tradition.

From the Upper Palaeolithic period and, without doubt, well before, man has formulated rules in order to codify and order all the activities of his life, whether profane or sacred – the two being inseparable most of the time. The history of religions shows that certain customs or traditions were shared by the majority of so-called primitive societies. These universals recur irrespective of time – from our origins to the present day – and irrespective of place – from Siberia to the Amazonian forest. Among these practices, that relating to the sacralization of a place remains invariable. Sacralization transforms a cave into a closed space because it is explored over its entire extent. The way is lined by a succession of markings applied to the walls or the floors as a sign of occupation. Structured in this way, this closed setting contrasts with the conditions outside, where space is boundless and associated with chaos. This process must have led to a gathering of people, indeed to a degree of sedentarization.

This concept of the sacralization of the underground environment inevitably raises questions about the spiritual meaning of the evidence, even though we are unable to come to any solid conclusions in this area. Several studies have attempted to discover the meaning of this legacy by means of numerous theories, some of which take a cosmographical approach. The line of argument made in support of the latter interpretation often consists of reproducing the geometry of a field of stars and superimposing it over a scatter of dots created using specific anatomical details of a group of animal figures or signs. Although, by taking into account the movements of the stars, it is relatively simple to recreate the image of the sky as it would have appeared to Palaeolithic people, 18,000 years ago, the selected photographs or sketches of parietal figures not only lack any metrical properties, but are normally affected by serious distortions, especially at Lascaux, where the highly irregular walls and the 'keyhole' cross section of the galleries greatly accentuates this problem. Furthermore, the integration of the two topographical models, stellar and parietal, offers so many combinations that any interpretation becomes impossible.

Nevertheless, the link between these two components – the one astronomical, the other derived from the underground environment – should certainly not be rejected: it is the argumentation and the precise interpretation drawn from it that must be reconsidered. We have considered this possibility since 1972, without ever obtaining sufficient credible evidence to permit progress to be made in this direction. Meanwhile, thanks to our investigations, we have discerned a more plausible alternative path. Definite clues encouraged us to proceed in this direction

The numerous studies carried out on Lascaux and its natural context, which extended to the whole of the region of the Black Perigord, reveal the organization of the relationship between the three inseparable elements represented by gesture, time and space. They are at the origin of the creation of this image of the Palaeolithic world, a vast fresco that reproduces a sublime model. With its overhanging walls

and paintings extending to the ceiling, recurring features from the Hall of the Bulls to the Nave, the morphological characteristics of this cave bear some resemblance to the architecture of the celestial vault: this is the major contribution of the natural context.

The second contribution arises from the chronology and the primary meaning of the works. We have established that the creation of the panels followed an immutable scheme ('horse–aurochs–stag'), over the course of which the space acquires its full value. As we have seen, this sequence follows a biological progression, revealed by the seasonal characteristics of the animals depicted. The different phases of these biological cycles, involving horses, aurochs and stags in succession, indicate the onset of mating – the animal ritual from which life arises. Beyond this surface interpretation lies the rhythm, indeed the regeneration of the seasons, which is symbolized by this phenomenon. The phases of spring, summer and autumn thus form a metaphorical evocation which, in this context, links biological and cosmic time.

This series of observations and associated deductions has led us to think that it is, after all, not rash to imagine that these vast painted or engraved compositions might be a testimony to spiritual ideas, the symbolic import of which is founded upon a cosmogonic perception. From the entrance to the cave depths, this record of the first mythologies unfurls before our eyes, with its central theme, the creation of life, and, beyond that, the origin of the world.

In the framework of this study I have had the privilege of visiting Lascaux many times, often alone. With the work accomplished, I would linger for a few moments, either at the foot of the great bulls in the Hall of the Bulls

or on the stairs in front of the entrance to the Apse. This allowed me to adjust my vision. It was during these brief moments that contact with this special world was the most bewitching. Some days, imperceptibly at first and then overwhelmingly, I had to cut short

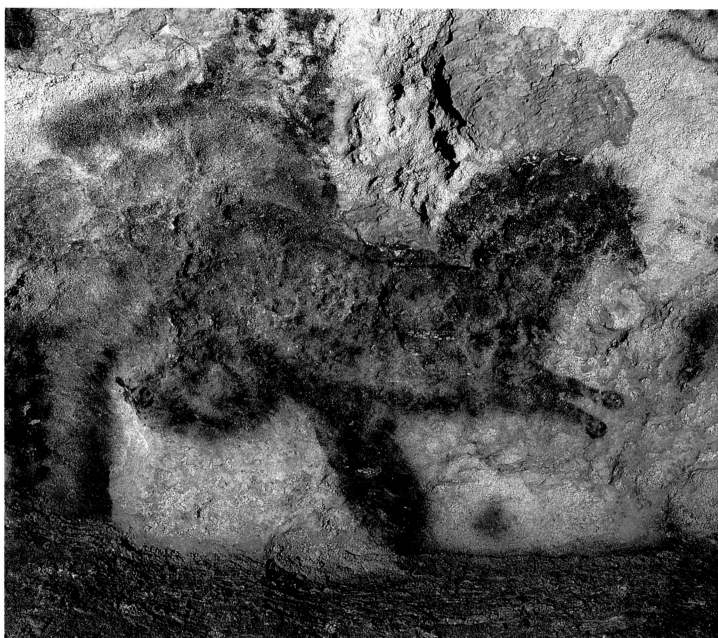

192 Horse with extended forelimbs, Hall of the Bulls.

this contemplation when it all became too emotional. Beyond the excellence of the works themselves, Lascaux draws its power of suggestion from the constant presence of an image: whatever your position, an animal is watching you, questioning you. Aurochs, horses, stags, bison and ibexes are omnipresent and, through them, the dominating impression of man.

Discovery, Research and Conservation

The escapade that led to the discovery of one of the most prestigious pieces of archaeological evidence in French prehistory resembles a work of fiction. On **12 September 1940**, four adolescents – Jacques Marsal, Georges Agnel, Simon Coencas and Marcel Ravidat, under the leadership of the latter (the eldest among them) – went towards the commanding hill to the south of the town of Montignac. One of the incentives driving this small team was a desire to finish off unblocking a 'foxes' earth', which they had

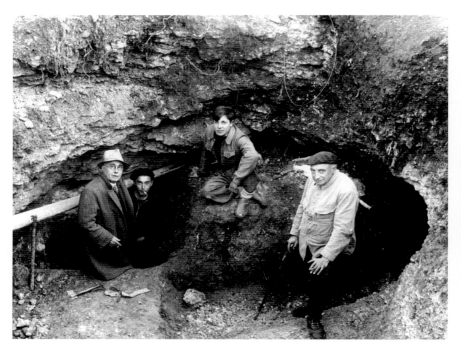

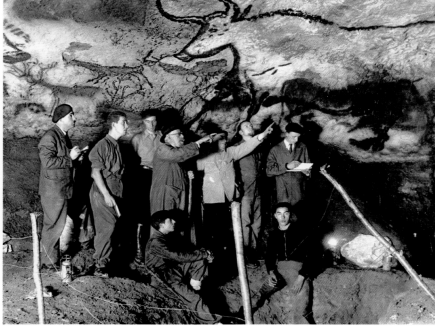

Above, left:

193 Entrance to the Lascaux Cave at the end of September, 1940. From left to right: Léon Laval, Marcel Ravidat, Jacques Marsal and Henri Breuil. Successive alterations would bring about an important widening of the entrance, enlarging it from the sub-vertical shaft through which the discoverers had entered the cave for the first time, to the entire breadth of the gallery.

Above, right:

194 Visit to Lascaux by Abbot Breuil and Count Bëgouen, on 24 October, 1940. Sitting in front of them, Jacques Marsal, left, and Marcel Ravidat, right.

begun the preceding Sunday. According to the stories of the village elders, this foxes' earth led via an underground passage to the manor of Lascaux, located down on the western slope.

After enlarging the passage, they threw a stone into the narrow hole they had made. It rolled for quite a long time, indicating that the hole was very deep. After much discussion and hesitation, it was Marcel Ravidat who decided to cross this first obstruction. He slipped into the vertical hole and set foot on a steeply sloping floor, which he traversed over a distance of several tens of metres. The very low ceiling forced him to crawl at first, but it was succeeded by a space of increasingly more comfortable size and proportions. Having arrived at the foot of a

large scree deposit, which had until that day covered the original entrance to the cave, he called to his friends to follow him. Once assembled, they ventured into a much larger space, today known as the Hall of the Bulls, the entire breadth of which was occupied by a series of petrified pools, surrounded by natural dams of calcite, which caught the percolating water streaming over the scree from the entrance. After progressing several tens of metres they arrived at the entrance of a noticeably rectilinear gallery, which was higher than it was broad: the Axial Gallery. The greater confinement here and familiarity with the darkness, discreetly disturbed by the light of an unsteady flame, were bound to favour the observation and recognition of the

first animal figures, painted on the ceiling and the walls.

During this preliminary visit exploring almost the entire system, it dawned on them that this must be one of the most magnificent collections of Palaeolithic parietal art to date.

13 September 1940

With the greatest possible secrecy, they returned to the site in order to continue their exploration, particularly beyond the Apse and the Shaft. Using the most rudimentary means – a simple rope they had brought with them – they descended some 6 to 7 metres. In the single underlying gallery they recognized a panel with a man and a bison: the Shaft Scene.

18 September 1940

They invited their teacher, Léon Laval, to share their discovery, but the opening to the cave was too small. He was unable to enter until the following day, after the passage had been widened.

21 September 1940

The first scientists of the day travelled to the locality – Henri Breuil, in the company of Doctor Cheynier and the Abbé Bouyssonie. Maurice Thaon had preceded them the day before and had made some preliminary sketches to give a first impression. According to André Glory, in one week 1,500 visitors entered the sanctuary, under the supervision and guidance of Ravidat and Marsal. He added, 'that…the visitors…did not ransack the cave due to the devotion of these young boys.' The portable objects littering the floor and the ledges of the walls required the same amount of care and attention as the parietal works. According to the descriptions of the first initiates to look over the different galleries of this cave, there were numerous remains of bones and stone artefacts, which singles out this site even more, since, with a few rare exceptions, such evidence is always very limited in this type of setting. For example, in Cussac in the Dordogne, the last decorated cave to be discovered, a very low quantity

of material was discovered on the floor. Some uncommon flakes and blades of flint form the portable material at this site, at least to date.

In order to avoid the dispersal, indeed the destruction of the portable material, Ravidat and Marsal, together with Laval, began to collect the most vulnerable stone and bone objects. This collection, a significant group of material, includes a long and decorated reindeer antler rod, bone points, shells and some flint artefacts.

October 1940

Fernand Windels initiated the first campaign to photograph the parietal works of art at the site. The sanctuary attracted numerous personalities (ill. 194), but also a whole host of curious people from the entire Department and beyond.

Abbé Breuil worked in the cave until mid-December (ill. 193).

December 1940

Lascaux was classed as an historic monument.

1941

Breuil entrusted recording the work to Thaon, which he carried out using a camera lucida. He was to reproduce some thirty paintings and a single engraved figure. The images were reproduced at a scale of 1:5 on yellow-brown card.

1947–48

Building work, begun in June 1947, facilitated access to the decorated galleries and enabled tourists to explore the site. The site was opened to the public a year later on 13 July 1948.

Windels produced the first description of the most important parietal works and published, together with Annette Laming-Emperaire, the first work on this site, illustrated with numerous photographs: *Lascaux. Chapelle Sixtine de la Préhistoire.*

1949

Breuil, Blanc and Bourgon began the first test excavations, carried out on this occasion at the foot of the Shaft Scene. They yielded numerous plaques of limestone used as

lamps. Some of these, concave at the centre due to an artificial hollow, contained remains of coniferous charcoal. The bone industry was also represented in the form of fragments of spearheads, sometimes ornamented (grooves, convergent or parallel lines), and awls. They collected the charcoal for the first radiocarbon tests.

1952–63

Despite the extraordinary discovery of Lascaux, Breuil had only sketched out the record of a few figures in the cave. A few months before the discovery of the site an accident had deprived him temporarily of his sight, and he only recovered it a few weeks later. After this episode his activities in the Perigord slowed down. It fell upon Abbé André Glory to continue his work. The remarkable results of the first two years, spent carrying out an inventory of practically all of the images of the cave, and the succeeding nine years, recording the majority of the images, enabled him to raise the number of identified representations to 1,433. The inextricable tangle of the figures engraved from the Apse to the Chamber of the Felines inspired a rigorous approach using suitable equipment. Access to the upper level of the Apse required the construction of tubular metal scaffolding, which helped to trace the figures. Abbé Glory chose to trace the images on to a transparent material, in this case a film of cellulose or cellophane, impregnated with rubberized material to render it impervious to the humidity. Nevertheless, the limestone, which in places is very powdery, prohibited placing the sheet directly or entirely against the wall. A soft pencil and other, coloured ones, made the differentiation of the Palaeolithic lines and the natural contours, fissure or calcite deposits more intelligible. Painted lines were separated from the engravings and recorded on different tracing paper. Once finished, the record was stretched over a drawing board for control and to intensify the principal lines. A final assessment involved replacing the copy

in its original position. Measurements taken *in situ* permitted the readjustment of each element of the mosaic, an operation carried out at the base of the original panel. After assembly, the montage was reduced to a scale of 1:5 or 1:10 with a camera lucida.

1955

The first signs of deterioration appeared on the walls: the formation of droplets of water which, as they trickled down, removed prehistoric pigments. A study was able to establish that an excess of carbon dioxide, produced by the breath of the visitors, brought about an acidification of the water vapour, which was condensed and corroded the underlying rock and the calcite. The phenomenon was exaggerated by natural processes, related especially to the presence, at the base of the Shaft, of an intermittent source of carbon dioxide issuing from the lower levels of the system.

1957–58

Following repeated observations of the first traces of the degeneration of the substrate, an air-conditioning system was installed below the entrance stairs, designed primarily to get rid of the excess carbon dioxide. The installation of this bulky equipment meant that the entire entrance zone of the cave had to be cleared – the whole of the cone of scree, from its foot, adjoining the Hall of the Bulls, to its summit at the present-day entrance.

As a result of these measures, Glory had to keep track of the day-to-day construction work and initiate several test excavations and studies of sections, particularly in the present engine room and along the course of pipes for the extraction of air, from the Hall of the Bulls to the distal end of the Axial Gallery and from the former to the entrance of the Mondmilch Gallery.

He carried out the stratigraphic recording of some fifteen sections in the sections open to visitors and in the engine room. The latter, no less than 11 metres deep, was the most important.

The air-conditioning system was designed to allow filtration and removal of carbon dioxide from the air, to stabilize temperature at a level of 14° and to provide the air with a stable level of 98 per cent humidity. The number of visits was not reduced, despite all this, and reached 1,000 visitors a day at its peak.

1960

Max Sarradet, then Conservator of French Monuments (Bâtiments de France) and, more particularly, of the Lascaux Cave, noticed that green stains were slowly developing on the walls.

1960–61

Glory resumed excavations at the foot of the Shaft Scene. He dug up other lamps and, in particular, the lamp of pink sandstone and the fragment of a second lamp that had been made in exactly the same way.

1962

During the winter of 1962–63, it became noticeable that green stains immediately next to some of the figures were developing more rapidly. They showed the presence of colonies of algae brought in by tourists and the artificial air-conditioning system. The phenomenon was sustained by inadequately subdued lighting and the ambient temperature, which was several degrees too high.

1963

Despite ozone filters having been inserted in the air-conditioning system, the colonies of algae increased. A decision was taken to stop the machine. Faced with the proliferation of micro-organisms, the Minister of State in charge of Cultural Affairs had the cave closed to the public in April and, in the same year, appointed a scientific investigation committee for the preservation of this national heritage.

An antibacterial chemical treatment helped to combat the contamination, and a decline was recorded. Some time later, the 'green leprosy', as it had been called, disappeared completely.

By cancelling the visits, eliminating the causes of deterioration and restoring climatic conditions, the works of Lascaux were able to return to their original brilliance, at least that at the time of their discovery.

As a result, far more stringent regulations were implemented regarding public access to caves and rock shelters. The number of visits was limited, determined specifically by the particular cave in question, and surveillance of the walls and floors was increased in those caves in France open to the public.

1965–67

Initial work was carried out to dismantle the air-conditioning machine, and equipment was installed to control and regulate temperature and humidity levels. By taking this approach, the natural conditions of circulation of the masses of air by convection were recreated. A low temperature was maintained in the engine room – before the earliest construction work, the underground stream that used to flow over the scree cone at the entrance had played this role.

A protocol for the surveillance of the cave was set up. A chronicle of the measurements of different parameters was established – covering temperature, humidity and CO_2 levels. This has since been carried out by the Historic Monuments Research Laboratory and the Laboratory for Hydrogeology of the University of Bordeaux 1.

1966–70

As a prophylactic measure the Conservation authority of the French Monuments of Aquitaine (Bâtiments de France d'Aquitaine) asked the National Geography Institute to carry out the stereo-photogrammetric recording of all the decorated sections of the cave. The possibilities for reproduction offered by this type of recording prompted a suggestion: the construction of a replica of the cave.

1972

The civil society, which owned the Lascaux Cave at that time, purchased the replica project. Part of the funds necessary for

financing such a project came from the sale of the original to the state in the same year. The entrance to a quarry 200 metres downhill from the original cave was chosen as the site. Only the Axial Gallery and the Hall of the Bulls, the most representative sectors of the monument, would be replicated.

1975–76

On the initiative of Arlette Leroi-Gourhan, the excavation data and records of Abbé Glory, who had died prematurely in 1966, were re-examined. The multidisciplinary team assembled on this occasion was to present its contribution to the study of the geology of the site and the stratigraphy of the soils, and to proceed to the analysis of the portable objects found since the discovery, the lithic industry, the lamps, the bone industry, the shells, the fauna and colourants.

1979

Lascaux inconnu was published under the direction of Arlette Leroi-Gourhan and Jacques Allain.

1980

The civil society, which was in charge of the replica, handed over its rights to the Department of the Dordogne. Under the directorship of Daniel Debaye, the Departmental tourist service took up the torch. A concrete construction, covered eventually by a layer of arable soil, served as a receptacle for the copy. Inside this building, a concrete shell, some 10 centimetres thick, was constructed,

which gave a good approximation of the internal volume of the original. Its dimensions were established using cross sections specified by the IGN. Once the metal framework and its concrete lining (ill. 195) were in place, the relief was created in two stages: the study and materialization of exceptional positions on the wall, followed by their modelling. The National Centre of Prehistory (CNP) was entrusted with relaying information, from the *in situ* recording of morphochromatic data to their transferral into the heart of the replica. Monique Pétral was to devote herself to the work of reproducing the entire collection of drawings and paintings of the two sectors forming the subject of this construction, the Hall of the Bulls and the Axial Gallery. Towards the end of the decade, the Departmental tourist service extended this action at the site of Thot (Thonac) by taking on Renaud Sanson to create a copy of the Shaft Scene and the two great panels on the left wall of the Nave: the Crossed Bison and the Great Black Cow. A second team, directed by Jean-François Tournepiche, was entrusted with the reproduction of the frieze of the Swimming Stags.

1982–83

Cinematographic documentation of the cave was shot, directed by Mario Ruspoli.

1983

Opening of Lascaux II to the public.

1988

The Ministry of Culture suggested the production of interactive video discs about the iconography of the cave. The department of parietal art of the National Centre of Prehistory was charged with the scientific supervision of this operation. 'Lascaux: Paintings and Engravings', a programme designed for museums, universities and other research centres, assembled sequences filmed in 1982–83 by Mario Ruspoli. The CNP added a number of documents to this, including several hundred graphic and photographic items. A second programme,

'Lascaux Revisited', aimed at the general public, was produced using the same data but in a less analytical form.

1989

At the request of the urban community of Bordeaux, the National Centre of Prehistory contributed to the production of the replica of the frieze of the Stags. This was to feature under the theme 'From Lascaux to Hermes' in the Exhibition of the Pacific Countries at Fukuoka in Japan, a town twinned with the regional capital of Aquitaine.

1989–99

Norbert Aujoulat (CNP) began his studies of the parietal art of the Lascaux Cave and its physical environment. His work is the subject of this book.

1990

The symposium on the fiftieth anniversary of the discovery of Lascaux started in September at Montignac, organized by the CNP and the Superintendence of Prehistoric Antiquities of Aquitaine, Ministry of Culture and Communication, under the direction of Jean-Philippe Rigaud, the conservator at that time.

1999

At the request of the Research and Technology Mission, Aujoulat produced the official Internet site for the Lascaux Cave, which was recognized in the following year by the Webby Awards 2000 in the category 'Science'. Due to renewed alterations to the entire entrance zone of the cave, research was stopped at the beginning of autumn 1999 for an indefinite period.

2000

During June, work began in the engine room to replace the cave's climatic regulation system, which had become too obsolete. It was finished at the beginning of 2001.

2001

A short time later, at the start of summer, Bruno Desplat, the technician in charge of the supervision of the site, reported the appearance of mould in the airlocks of the site entrance. Over a few days to a few

weeks, a white blanket of filaments covered the floors and ledges of all the decorated sectors except the Shaft.

The most prolific pathogenic agent, *Fusarium solani*, was quickly identified by the research laboratory of the historic monuments research laboratory. This fungus lives in symbiosis with a bacterium, *Pseudomonas*, which is able to break down fungicides. This is why it was so difficult to eradicate these micro-organisms. Action was carried out very rapidly. Quicklime, spread over the affected floors, stopped the spread of the fungus immediately. Pads soaked in a remedial product, combining a fungicide and an antibiotic, were applied to the ledges. The biological proliferation was suppressed, but the mycelium responsible still resisted treatment.

Furthermore, during May, the development of another fungus was noticed on the walls. It took the form of dark, circular patches, from 10 to 15 centimetres in diameter. They spread progressively into the cave, from the entrance airlocks towards the Apse.

2002
At the beginning of July, the Ministry of Culture and Communication created the International Scientific Committee for Lascaux Cave, under the presidency of Marc Gauthier. Within the framework of the Direction of Cultural Affairs of Aquitaine, it brought together some thirty administrative personnel and researchers, notably microbiologists, hydrogeologists, chemists, archaeologists and climatologists.

2003
Despite the permanent treatment of the floors and walls, since the first *in situ* interventions, the mould continued to develop. The chemical process had revealed its limitations, and as a result a programme commenced that involved cleansing the surfaces through the injection and extraction of a special material. This process allowed the removal of sediments deposited on the ledges during the course of millennia. These function as veritable collectors / gutters for organic alter material, creating a nutritive environment promoting the renewed outbreak of destructive agents. Since the summer, the materialization of these pathogenic agents has declined, and their appearances have become increasingly rare and inconspicuous.

2004
By January a clear improvement was recorded regarding the state of the cave. Nevertheless, the entire apparatus of surveillance and maintenance remains in place, as it is still unclear whether this improvement is permanent or temporary. The risks to the preservation of parietal works, and current thinking concerning the problems of conserving this heritage at Lascaux, are relevant to all the decorated caves in Western Europe, whether they are open to the public or not. These considerations can apply equally to rock art. From this perspective, these investigations may be of benefit for all the decorated sites worldwide.

Notes

1. The study of karst, limestone formations favourable for the development of caves.
2. The study of animal behaviour.
3. The entire group is classed by UNESCO as a World Heritage Site.
4. In the geomorphological definition, use of the term cliff ('falaise') is reserved for coastal formations. Nevertheless, in this context, tradition encourages us to retain it.
5. Occupied from the Middle Ages until the end of the sixteenth century, this site, which is today open to the public, is one of the most important troglodyte cities in France.
6. Vouvé, J., in Leroi-Gourhan, A. et al., 1979.
7. Bouchud, J., in Leroi-Gourhan, A. et al., 1979.
8. Schœller, H., 1965, internal report.
9. A sedimentological analysis ought to be carried out on the two entrance formations.
10. Breuil, H., 1950.
11. Information obtained at the locality on 3 January 1992.
12. Couraud, C., Laming-Emperaire, A., in Leroi-Gourhan, A. et al., 1979.
13. Taborin, Y, 1979, in Leroi-Gourhan, A. et al., 1979.
14. Leroi-Gourhan, A., 1971.
15. Ibid.
16. Leroi-Gourhan, A. et al., 1979.
17. (GIF A 95582). Aujoulat, N. et al., 1998.
18. Blanc, S., 1948–50.
19. Clottes, J. et al., 1990.
20. Delpech, F., 1992.
21. Delluc, B. and G., 1990.
22. Vialou, D., 1979.
23. Clottes, J. et al., 1990.
24. Clottes, J., 2003.
25. Aujoulat, N. et al., 2002.
26. Breuil, H., 1952.
27. Leroi-Gourhan, A., 1971.
28. On this causse (limestone karstic plateau) the WWF is establishing a stock of Przewalski horses to be then re-established in their country of origin, Mongolia.
29. Breuil, H., 1952.
30. Koby, N. 1954.
31. Aujoulat, N. et al., 1998.
32. Here it is appropriate to mention the works of Sylvie Demailly on this subject (Demailly S., 1990). She notes the presence of a carbonaceous deposit in one of the samples taken in the Hall of the Bulls, more precisely from the small head of a horse painted in the right hind hoof of the second bull. A subsequent sample taken at the same location was unable to rediscover it.
33. Clottes, J. et al., 1990.
34. Clottes, J., Courtin, J. 1994
35. Valladas, H. et al., 2003.
36. Lorblanchet, M. et al., 1990.
37. DRIRE –Department of Mines (regional direction industry research environment) and Archives of the Department of the Dordogne.
38. Diderot D. and d'Alembert J., 1778, *Dictionnaire raisonné des sciences, des arts et des métiers, par une société des gens de lettres*, 1. XXV, 17.
39. Vigenère, 1578, t. 1, f° 241 r°.
40. Clottes, J. et al., 1990.
41. Ibid.
42. Lorblanchet, M., 1993.

43. Lorblanchet, M., 1980.

44. For ethical reasons the site chosen for experimenting with the different methods of application of pigments was an underground mine (Mauzens-Miremont) and not a natural cave, so that there could be no possibility of confusion in future centuries with true Palaeolithic images. The marks of colouring materials, in particular the iron oxides, remain very difficult to eliminate.

45. Translated into the language of the graphic arts, these are, respectively, tonal range, saturation and brightness.

46. When the identification as male / female is made possible by the presence of antlers, in the case of cervids, or of more developed and massive horns for the aurochs, it is noticeable that, in the majority of cases, the eye of the male is shown. On the other hand, this is not observed on the representations of female bovines.

47. Aujoulat, N., 1985.

48. Although not very numerous, images of this type are encountered in several sites in the Perigord, such as at Font-de-Gaume, where an often quoted specimen, located immediately next to the 'Carrefour', shows only the outline of a croup, while the hindlimbs of the horse are represented by a block of stalagmite. In the majority of cases, these interpretable wall formations make up only a fraction of the animal outline. Nevertheless, there exist examples for which the opposite is true. They are more difficult to recognize, because it is sometimes very hard to find marks of indubitably human origin. This is the case at Bernifal, where the very thick formation of calcite lends itself perfectly to this utilization of the backdrop and where a few rare examples have been recognized, among them a bear, on the right wall, some metres from the entrance. The entire body is natural; only the eye, marked by a black dot, and the curved line of the mouth bring the outline to life. The facing wall offers a similar example, by the presence of a corresponding head of a bovine: the outline, from the poll to the beginning of the neck, is natural; only the eye and the nostrils are emphasized in red. At Combarelles I, examples are more numerous. Some thirty specimens have been recognized, no doubt due to the extreme unevenness of the surfaces, upon which some of the protrusions have been altered and transformed into human or animal shapes. The chosen areas embody virtually the entire outline of the subject, while a few lines added by the artist allow it to be interpreted.

49. Glory, A., 1960.

50. Barrière, C., Sahly A., 1964.

51. Delluc, B. and G., 1979.

52. Raphaël, M., 1986.

53. Laming-Emperaire, A., 1962.

54. Leroi-Gourhan, A., 1971.

55. Glory, A., 1964.

56. The determination to explore everything takes on a much greater importance at the latter site. Effectively, after travelling 1 kilometre, progress was halted by a stalagmitic curtain blocking the entire width of the gallery. The desire to take possession of the whole of the cave prompted them to stave in this curtain by breaking off numerous concretions several centimetres in diameter to gain access to the sectors forbidden just a moment before.

Bibliography

ALLEMAND, L., 2003, 'Qui sauvera Lascaux?', *La Recherche*, no. 363 (April), pp. 26–33

AUJOULAT, N., 1985, 'Analyse d'une œuvre pariétale paléolithique anamorphosée', *Préhistoire ariégeoise* 40, pp. 185–193

AUJOULAT, N., 1990, 'L'espace suggéré', *Les Dossiers de l'archéologie* 152, pp. 12–23

AUJOULAT, N., 1988, *Lascaux: peintures et gravures*, French Ministry of Culture and Communication, Direction du Patrimoine, CNC, CNMHS, CNP, directed by J. Willemont, Laservision videodisc

AUJOULAT, N., 1989, *Lascaux revisité*, INA-Theorem, directed by J. Willemont, Laservision videodisc

AUJOULAT, N., 1999, *The Cave of Lascaux*, official Internet site, part of the *Great Archaelogical Sites* network run by the French Ministry of Culture and Communication. Winner of the Science category in the Webby Awards 2000. http://www.culture.fr/culture/arcnat/lascaux/en

AUJOULAT, N., 2002, 'Lascaux. Le rôle du déterminisme naturel: des modalités d'élection du site aux protocoles de construction des édifices graphiques pariétaux', thesis, Université de Bordeaux I

AUJOULAT, N., CHALMIN, E., VIGNAUD, C., GENESTE, J.-M., MENU, M., 2002, 'Lascaux: les pigments noirs de la Scène du Puits', 10es Journées d'Étude de la SFIIC, Paris, 23–24 May 2002, *L'Art avant l'Histoire: la conservation de l'art préhistorique*, pp. 5–14

AUJOULAT, N., CLEYET-MERLE, J.-J., GAUSSEN, J., TISNERAT, N., VALLADAS, H., 1998, 'Approche chronologique de quelques sites ornés paléolithiques du Périgord par datation carbone 14, en spectrométrie de masse par accélérateur, de leur mobilier archéologique', *Paléo* 10, pp. 319–323

AUJOULAT, N., GENESTE, J.-M., RIGAUD, J.-P., ROUSSOT, A., 1991, *La Vézère des origines*, Guides Archéologiques de la France 22, Paris: Imprimerie Nationale

BATAILLE, G., 1955, *Lascaux, or The Birth of Art: Prehistoric Painting*, Geneva: Skira

BARRIÈRE, L., SAHLY, A., 1964, 'Les empreintes humaines de Lascaux', in *Miscelánea en homenaje al abate Henri Breuil (1877–1961)*, Barcelona: Instituto de Prehistoria y Arqueología, pp. 173–180

BLANC, S., 1948–50, 'Grotte de Lascaux, commune de Montignac-sur-Vézère (Dordogne)', *Gallia* VI, part 2, pp. 395 and 397–398

BLANC, S., 1953, 'Lascaux. Quelques vues personnelles', *Bulletin de la Société d'étude et de recherche préhistorique des Eyzies*, no. 3, pp. 21–22

BOUCHUD, J., 1959, 'Étude de la faune de la grotte de Lascaux', *Bulletin de la Société d'étude et de recherche préhistorique des Eyzies*, no. 9, pp. 30–31

BREUIL, H., 1941, 'Une Altamira française: la caverne de Lascaux à Montignac, Dordogne', *Comptes rendus de l'Académie des Inscriptions et Belles-Lettres*, pp. 347–376

BREUIL, H., 1950, 'Lascaux', *Bulletin de la Société préhistorique française* 47, pp. 355–363

BREUIL, H., 1952, *Four Hundred Centuries of Cave Art*, Montignac: Centre d'Études et de Documentation Préhistoriques

BREUIL, H., 1954, 'Les datations par C14 de Lascaux (Dordogne) et de Philip cave (S.W. Africa)', *Bulletin de la Société préhistorique française* LI, 11–12, pp. 544–549

BREUIL, H., 1956, 'La caverne peinte de Lascaux à Montignac (Dordogne)', *Les Cahiers techniques de l'art*, Strasbourg, pp. 5–16

BRUNET, J., VIDAL, P., VOUVÉ, J., 1985, 'Exemple d'étude de l'environnement climatique et pictural appliquée aux grottes sous climat tempéré. Cas de la cavité de Lascaux, France, Conservation de l'art rupestre', *Études et documents sur le patrimoine culturel*, UNESCO, pp. 1–66

CLOTTES, J., 2003, 'Retour à Lascaux', in *Passion préhistoire*, Paris: Maison des Roches

CLOTTES, J., COURTIN, J., 1994, *La Grotte Cosquer: peintures et gravures de la caverne engloutie*, Paris: Éditions du Seuil

CLOTTES, J., DUPORT, L., FERUGLIO, V., 1990, 'Les signes du Placard', *Préhistoire ariégeoise* XLV, pp. 15–49

CLOTTES, J., MENU, M., WALTER, P., 1990, 'La préparation des peintures magdaléniennes des cavernes ariégeoises', *Bulletin de la Société préhistorique française* 84, part 4, pp. 170–192

DELLUC, B. and G., 1990, 'Essai de lecture de trois figures de Lascaux', *Bulletin de la Société historique et archéologique du Périgord* 117, pp. 130–139

DELPECH, F., 1992, 'Le monde magdalénien d'après le milieu animal', Actes du Colloque de Chancelade, *Le Peuplement magdalénien. Paléogéographie physique et humaine*, 10–12 October 1988, Paris: Éditions du CTHS, pp. 127–135

DEMAILLY, S., 1990, *Premiers Résultats de l'étude des peintures rupestres concernant la grotte de Lascaux (Montignac – Dordogne – France)*, Journées internationales d'étude sur la conservation de l'art rupestre, Périgord (France), 20–23 August 1990, ICOM, Périgueux: Atelier de recherche et d'étude du Périgord, pp. 101–116

ELIADE, M., 1961, *The Sacred and the Profane*, New York & Evanston, IL: Harper & Row

FÉLIX, T., 1990, 'Quelques peintures peu connues de la Salle des Taureaux et du Diverticule axial', *Bulletin de la Société historique et archéologique du Périgord*, 117, pp. 40–48

FROIDEVAUX, Y.-M., 1955, 'Aménagement des grottes de Lascaux', *Monuments historiques de la France*, no. 3, pp. 97–105

FROIDEVAUX, Y.-M., 1960, 'Protection de la grotte de Lascaux: installation d'une ventilation conditionnée', *Monuments historiques de la France*, no. 4, pp. 189–202

GENESTE, J.-M., HORDE, T., TANET, C., 2003, *Lascaux, une œuvre de mémoire*, Périgueux: Fanlac

GLORY, A., 1959, 'Débris de corde paléolithique à la grotte de Lascaux (Dordogne)', *Bulletin de la Société préhistorique française*, Paris, pp. 135–169

GLORY, A., 1961, 'Le brûloir de Lascaux', *Gallia-Préhistoire*, 4, pp. 174–183

GLORY, A., 1961, 'L'interstade climatique de Lascaux', *Antiquités nationales et internationales*, year II, part I–II, pp. 2–10

GLORY, A., 1964, 'La stratigraphie des peintures de Lascaux (France)', in *Miscelánea en homenaje al abate Henri Breuil (1877–1961)*, Barcelona: Instituto de Prehistoria y Arqueología, pp. 173–180

GLORY, A., 1965, 'L'énigme de Lascaux', in *Congrès préhistorique de France*, XVI, 1959, Monaco, pp. 586–595

GUYON, P.-M., 1980, 'La conservation des peintures pariétales. Contribution aux travaux de la

Commission scientifique de Lascaux', *Revue de synthèse*, III, no. 97–98, pp. 115–144
ICHAC, P., 1941, 'Un Versailles de l'art préhistorique: la grotte à peintures de Montignac, en Dordogne', *L'Illustration*, no. 5104, 4 January, pp. 9–16
JACQUIOT, C. and HERMIER, M.-C., 1959, 'Détermination de bois fossiles provenant de la grotte de Lascaux, Montignac-sur-Vézère (Dordogne)', *Comptes rendus des séances de l'Académie des Sciences* 249, pp. 2375–2377
JACQUIOT, C., 1960, 'Détermination de bois fossiles provenant de la grotte de Lascaux, Montignac-sur-Vézère (Dordogne)', *Bulletin de la Société de botanique de France* 107, pp. 15–17
KOBY, F., 1954, 'Y a-t-il eu, à Lascaux, un "Bos longifrons"?', *Bulletin de la Société préhistorique de France* 51, pp. 434–441
LAMING-EMPERAIRE, A., 1959, *Lascaux: Paintings and Engravings*, Harmondsworth and Baltimore, MD: Penguin
LAMING-EMPERAIRE, A., 1962, *La Signification de l'art rupestre paléolithique: méthodes et applications*, Paris: Picard et Cie
LAMING-EMPERAIRE, A., ROUSSEL, M., 1950, *La Grotte de Lascaux*, Paris: Caisse Nationale des Monuments Historiques
LAPORTE, G.-S., 1972, 'Au chevet de Lascaux', *Bulletin de l'Ordre des pharmaciens*, no. 143
LEFEVRE, M., 1974, 'La maladie verte de Lascaux', *Studies in Conservation, the Journal of the International Institute for Conservation of Historic and Artistic Works*, 19, Amsterdam, pp. 126–156
LEROI-GOURHAN, A., 1971, *Préhistoire de l'art occidental*, 2nd ed., Paris: Mazenod
LEROI-GOURHAN, A., 1976, *Les Religions de la Préhistoire*, Paris: Presses Universitaires de France
LEROI-GOURHAN, A. et al., 1984, *L'Art des cavernes: atlas des grottes ornées paléolithiques françaises*, ed. André Leroi-Gourhan, Paris: Imprimerie Nationale, Ministère de la Culture
LEROI-GOURHAN, A., ALLAIN, J. et al., 1979, *Lascaux inconnu*, Paris: Éditions du CNRS (suppl. to *Gallia Préhistoire*, XII)
LORBLANCHET, M., 1980, 'Peindre sur les parois des grottes', *Les Dossiers de l'archéologie*, no. 46, pp. 33–38
LORBLANCHET, M., 1993, 'Pochoir et soufflé', in *L'Art pariétal paléolithique. Techniques et méthodes d'étude*, Paris: GRAPP, Ministère de l'Enseignement Supérieur et de la Recherche, Comité des Travaux Historiques et Scientifiques, Documents Préhistoriques no. 5, pp. 257–260
LORBLANCHET, M., LABLEAU, M., VERNET, J.-M., FITTE, P., VALLADAS, H., CACHIER, H., ARNOLD, M., 1990, 'Étude des pigments de grottes ornées paléolithiques du Quercy', *Bulletin de la Société des études du Lot*, part 2, pp. 93–143
PEYRONY, D., 1950, 'L'industrie de la grotte de Lascaux', *Bulletin de la Société préhistorique française*, no. 3–4, pp. 135–137
RAPHAËL, M., 1986, *Trois essais sur la signification de l'art pariétal paléolithique*, Limoges: Couteau dans la Plaie/Kronos
RUSPOLI, M., 1987, *The Cave of Lascaux: the Final Photographic Record*, London: Thames & Hudson
SAINT-MATHURIN, S. C. de, BERGER, M.-T., 1986–87, 'L'abbé Breuil et Maurice Thaon à Lascaux', *Antiquités nationales*, 18/19, pp. 123–132
SARRADET, M., 1970, *Lascaux en Périgord: travaux de conservation*, Périgueux: Fanlac

VALLADAS, H., TISNERAT, N., ARNOLD, M., EVIN, J., OBERLIN, C., 2003, 'Dates of the Incursions into the Cave', in *Return to Chauvet Cave: Excavating the Birthplace of Art: the First Full Report*, ed. Jean Clottes, London: Thames & Hudson, pp. 32–33
VIALOU, D., 1984, 'Les cervidés de Lascaux', in *La Contribution de la zoologie et de l'éthologie à l'interprétation de l'art des peuples chasseurs préhistoriques*, Actes du 3e Colloque de la Société Suisse des Sciences Humaines, 1979, Sigriswil, pp. 199–216
VIALOU, D., 1984, 'Lascaux et l'art magdalénien', *Les Dossiers Histoire et Archéologie* 87, pp. 61–69
VIALOU, D., 1987, *L'Art des cavernes: les sanctuaires de la Préhistoire*, 'Sciences et découvertes', Monaco: Éditions du Rocher
VIALOU, D., 1990, 'Lascaux architecture de l'art souterrain', *Les Dossiers de l'archéologie* 152, pp. 38–43
VIALOU, D., 1991, *La préhistoire*, 'L'univers des formes', Paris: Gallimard
VOUVÉ, J., 1958, 'Géologie, colline de Lascaux, détermination d'un modèle karstique original en pays calcaire', *Comptes rendus de l'Académie des Sciences*, CCLXVI, Paris, pp. 2139–2142
VOUVÉ, J., 1975, 'Étude en hydrogéologie et paléohydrogéologie karstiques', thesis, Université de Bordeaux I, 2 vols
VOUVÉ, J., BRUNET, J., VIDAL, P., MARSAL, J., 1982, *Lascaux en Périgord noir: environnement, art pariétal et conservation*, Périgueux: Fanlac
WINDELS, F., LAMING, A., 1949, *The Lascaux Cave Paintings*, London: Faber & Faber

Acknowledgments

Without the unfailing support of the Ministry of Culture, the sub-directorate of archaeology, the regional archaeological service of Aquitaine and the National Centre of Prehistory, this research could not have been brought to a successful conclusion. It necessitated several years of observation, data collection and a great number of analyses. During the different stages of this journey, I was led to associate with and seek out the skills of many people – prehistorians, geologists, ethologists, the owners of sites or the custodians of caves. All of them presented me with a contribution from their own field.

Patrick Monod, at the time Director of the sub-directorate of archaeology, and subsequently Jean-François Texier, in the same capacity, encouraged me to pursue and publish these studies.

It is also a pleasure for me to express, in these lines, my enormous gratitude to Jean-Philippe Rigaud, at that time Director of the National Centre of Prehistory and of the Institute of Prehistory and Quaternary Geology, UMR 5808 of the CNRS, Jean Clottes, former Conservator General for Heritage and Director of the collection 'Arts rupestres' of the Éditions du Seuil, Javier Fortea, Professor at Oviedo University, Jacques Jaubert, Professor at the University of Bordeaux l, Jan F. Simek, Professor at the University of Tennessee, and Jean-Pierre Texier, Director of research at the CNRS.

I would like to express my sincere appreciation to Dany Barraud, Conservator General for Heritage (SRA Aquitaine), to Jean-Michel Geneste, Conservator of the Lascaux Cave, and to Max Sarradet, his predecessor in this capacity; who initiated the first measures for the preservation of the site.

My warmest thanks go to my friends in the Compagnie des Beunes, Christian Archambeau, Bernard, Jean-Pierre and Michel Bitard, but also Danilo Grébénart, Christian Lamaison, Jean Lentisco, Hugues Nielsen and Francis Theil.

Without their contribution the chapter dealing with to the endokarstic environment would not have been as comprehensive. Our prospecting has led us to the most remote sites in the Black Perigord in order to explore even the slightest underground developments. Furthermore, they have led us to the discovery of several decorated Palaeolithic caves, such as Cazelle and Puymartin, but also Vézac or Redon-Espic.

What can I say of the role played by Marie during the whole of this journey? There would not be enough room to say everything. She has always taken care that her archaeologist husband, one minute irritable, the next enthusiastic, has enjoyed the most tranquil

working conditions. I am indebted to Jean-Jacques Cleyet-Merle, Conservator of the National Museum of Prehistory, for having authorized me to publish documents relating to the portable archaeological material found during the first excavations of the Shaft.

Nicole Dauriac, who left us much too soon, was responsible for the correction of the manuscript and the structuring of the documentary and bibliographic part of this work.

Gabriel Karnay informed me regularly about the progress of his work, during the survey for the geological map of the Bugue region for the records of the BRGM. Jean-Pierre Capdeville, of the same institution, shared with me his knowledge of the cartography of the Vézère drainage basin, thereby expediting the graphic rendition of my observations. My thanks go also to Bertrand Kervazo, Valérie Feruglio and Guy Célérier, with whom I have always appreciated our wide-ranging discussions about the essential meaning of prehistoric art, whether portable or parietal, debates in which we indulge regularly.

My gratitude also goes to Claude Bassier who let me profit from the various surveys of the topography that he had carried out at the Lascaux Cave.

This book also owes a lot to Françoise Peyrot, Valérie Gautier and Charlotte Debiolles, of the Éditions du Seuil, who contributed their skills to the production of this work.

Bruno Desplat and Sandrine Van Solinge always welcomed me at Lascaux with the same kindness and took care that these weekly visits took place in the best possible circumstances.

It was in 1972 that I was to meet Jacques Marsal for the first time, in the context of a traditional visit to the site. Some years later, he was to accompany me regularly during the sessions of recording. He imparted to me knowledge of the site and its figures which he alone then possessed. His premature passing would deprive us of one of the most significant recollections of Lascaux.

Together with Michel Menu, research technician, Colette Vignaud and Émilie Chalmin, of the Centre for research and Restoration of the Louvre Museum, we were to carry out several campaigns of sampling colouring materials for their determination.

My thanks go out also to Jean-Luc Holubeik, engineer / technician at the DRIRE, Subdivision Dordogne, to the Conservator of the Departmental Archives of the Dordogne and to the staff of these services for having provided me with access to documents, and also to Christian Faure and Jean Tarallo, who received me on several occasions in the premises of the Departmental Base of the Ardèche.

To each and every one, may you find in these lines the proof of my gratitude.

Index